Coming into Focus

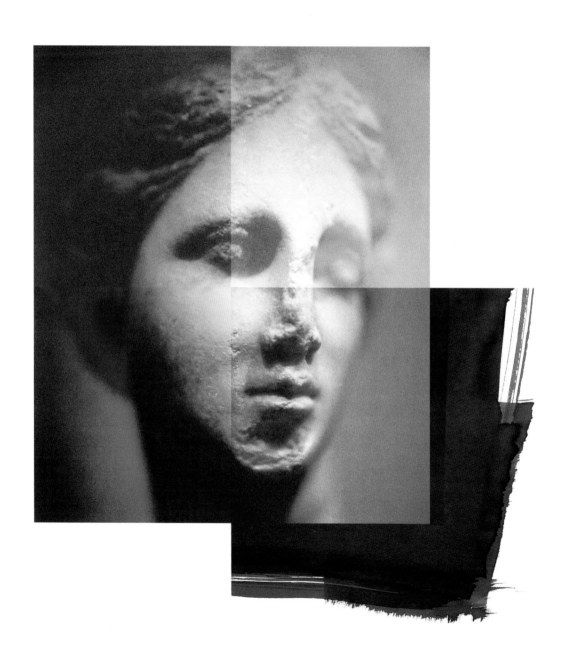

Coming into Focus

Edited by John Barnier

A Step-by-Step Guide to Alternative Photographic Printing Processes

CHRONICLE BOOKS

SAN FRANCISCO

Acknowledgments

Thanks to all of the contributing writers whose considerable talent and patience made this book possible. Also to Jim Henkel, who opened the door; to Doug Munson and Lynn Smith, for their indispensable support; to Dick Sullivan, for his genius; and to David Featherstone, for his clarity.

Special thanks to Russ Young, whose insights and belief in my work over the years have been steadfast and sincerely appreciated.

Compilation copyright © 2000 by John Barnier

See Chemical Hazard Warning on page xxiii.

Library of Congress Cataloging-in-Publication Data:

Coming into focus : a step-by-step guide to alternative photographic printing processes / edited by John Barnier.

 p. cm.
 Includes bibliographical references and index.
 ISBN 0-8118-1894-2 (pbk.)
 1. Photography—Printing processes. I. Barnier, John.

TR350.C66 2000
771'.44—dc21 99-088461

Printed in Hong Kong.
Designed by Rob Hugel, Little Hill Design
Typesetting by Little Hill Design

Distributed in Canada by Raincoast Books
9050 Shaughnessy Street
Vancouver, British Columbia V6P 6E5

10 9 8 7 6 5 4 3 2 1

Chronicle Books LLC
85 Second Street
San Francisco, California 94105

www.chroniclebooks.com

To Cate, Gabriela, and Antonio with love
—J. B.

Table of Contents

Introduction

The history of photography is long and rich and varied. William Henry Fox Talbot, Louis Jacques Mandé Daguerre, Joseph Nicéphore Niepce, Sir John Herschel, and others pioneered early photography by exploring the chemical and physical phenomena that define the medium as we know it today. During the past 160-plus years, these early pioneers and countless other workers expanded photography's creative possibilities and added rich layers to the fabric of photographic imagemaking.

Most early processes enjoyed only a brief life span, usually between ten and forty years, after which they were pushed aside by the next technique to come along and relegated to the murky backwater of "antique" photographic processes. Their procedures were largely forgotten; their materials ceased to be produced.

Beginning in the late 1960s, however, a few adventurous photographers began resurrecting many of these procedures. They added their own improvements, variations, and modifications, basing them on contemporary materials. Because of that work, a renaissance of early processes has steadily developed and grown, gaining great momentum in the last few years. What we now call "alternative" and "non-traditional" photographic processes have become a rich resource for creative artistic work. Although historically based—and in fact they are the truly *traditional* processes—these procedures offer modern photographers vast possibilities for contemporary expression.

Coming into Focus is intended to encourage that work, and artists, students, and professional commercial photographers alike will find this book a valuable resource.

For those largely interested in the process aspect of photography, this book offers a wealth of procedures to explore, test, and analyze. For those who see a photographic process merely as a means to produce an image, knowledge of these processes will greatly enrich the toolbox from which they can select. And for commercial photographers, these processes offer new image-making possibilities that will appeal to clients and creative directors always on the lookout for new ways of presenting imagery.

Coming into Focus expects an understanding of basic photographic concepts. Knowledge of both common photographic terminology and principles of exposure and development is assumed, yet for those who are relatively new to photography, there are processes that are very easy to handle and are sure to encourage further exploration. Traditional cyanotype, for instance, is the perfect first-time alternative process. It is simple, it uses only two inexpensive and readily accessible chemicals, it can be exposed in the sun—and it develops in plain tap water. There's also no need for a formal darkroom. Many of the processes presented in this book can be done at home, in a darkened room, using plain tungsten lamps as safelights (note the warning in the next section, Basics). All you need is a room with some open counter space, running water in or near the room, and an ultraviolet (UV) light source such as the sun for exposure. One particularly good maker of cyanotypes I know uses a corner of her garage. On the other hand, there are processes in this book that do require specialized darkroom equipment, and they are guaranteed to test the skill and patience of even the most weathered worker.

In putting this book together, I have relied not only upon my experience in alt-photo processes, but also on the experience of other workers. Each of the contributors to this volume is a true expert in his or her respective processes, and I felt it appropriate to invite them to contribute directly rather than to distill their knowledge myself. Several contributors have added their own improvements to established processes, while others have steadfastly followed historical techniques, using nothing but historically correct equipment and materials. Still others have invented new processes outright. Although I have inevitably edited the manuscripts to fit a consistent format that will allow the reader to move between chapters easily, I have tried my best to retain each author's voice as fully as possible. Each writer is unique in his or her point of view, procedures, and image-making, and each has a distinctive and special personality.

The term alt-photo *has come into use as a shorthand reference. First coined by the photographic community in Great Britain, it is now universally used.*

You will notice that some authors have seemingly opposite points of view about certain preferences or procedures. I've intentionally left these variations in, not only to retain the character of each author, but also to show the broad range of choices one can make in alt-photo processes. In addition, since each person's working environment is unique, one thing the alt-photo worker quickly learns is that what works for one person may not work for another. Some say it's the water; some say it's the gods. Regardless of the reasons, exploration and discovery are inherent qualities of alt-photo work, and for many this is what makes it such a rich and satisfying experience.

Some photographers already experienced in alternative photographic processes will no doubt find fault with some of the methods and materials described here that they find contrary to their own. This is to be expected. Many alt-photo types choose not to use off-the-shelf or pre-made process materials as they develop their own specific methods and procedures. This is good. The opposite points of view that emerge only highlight the richness of alternative photographic processes, and encourage discussion and discovery for everyone concerned.

If one method doesn't work for you, try another. Or vary it slightly. Or add a little of this or a little of that. Or take away a little of this or that. Or think about why an image looks a certain way—and how might it be different by trying more or less of a certain chemical, changing papers, or changing a certain procedure. The options are almost endless.

This book provides a foundation from which you can build your knowledge and skills in each alternative photo process; yet at the same time the book is merely a starting point. New materials and products constantly come onto the market, and procedures undergo refinement; some of the methods proscribed here may be deemed unnecessary or outmoded. But that's the nature of what we call alternative photographic processes: Always changing. Always timeless.

How to Use This Book

The structure of this book is designed to present sometimes-complex information as clearly and thoroughly as possible. Chapters are arranged according to the relative chronology of the process in the history of photography, but keep in mind that most processes overlap with others and several emerged at nearly the same time.

Each chapter has been constructed around a similar organizational strategy. First, there is background on the process, followed by lists of the chemical and material requirements. Following that are the various procedures—and interspersed, depending upon process, are modifications and additional informa-

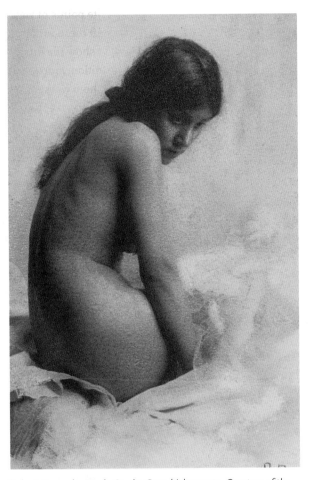

Robert Demachy, Nude Study. Gum bichromate. Courtesy of the Royal Photographic Society of Great Britain.

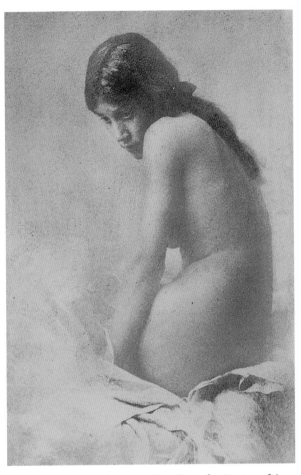

Robert Demachy, Perplexité. Rawlins oil transfer. Courtesy of the Royal Photographic Society of Great Britain.

tion specific to those processes. Obviously, there are variations on this basic structure. Some processes don't use paper, others don't use negatives, and some are sufficiently complicated that this structure simply doesn't work. Nevertheless, every effort has been made to present each chapter as clearly and simply as possible, with a logical and orderly presentation of the information.

This structure will help you organize your materials and workspaces for careful preparation, as well as allow you to find and relate information between chapters more easily. For example, if you need to know whether or not calotype uses potassium dichromate, you can look at the easy-to-read list of chemicals in the front of that chapter. If you want to review the sequence for mixing argyrotype chemistry, you can easily find the step-by-step procedures.

Constructing each chapter in a similar manner makes it much easier for you to see "the big picture" of alternative processes and to establish a firm foundation on which to build your knowledge. It also helps you understand the interrelationships of the processes, which in turn demystifies and simplifies them and leads you into these processes with as much confidence and enthusiasm as we can provide.

Near the end of the book are several chapters that do not describe specific alternative processes, but give information you will find helpful in a number of processes. Chapter 17, Digital Negatives for Alternative Processes, explains how you can utilize the most up-to-date digital imaging techniques to create negatives not only for use in three-color gum printing (described in Chapter 18), but for many of the processes in this book.

Chapter 19, Using Step Scales, explains how you can use transparent tonality step wedges to streamline the process of finding the correct negative density and printing exposure time. Since much of the success one achieves with alt-photo processes comes through trial and error, this information will help you establish your working procedures more efficiently.

Enlarged Negatives, Chapter 20, discusses several ways to produce the large negatives necessary for creating large contact prints. Alternative processes do not lend themselves to the photographic enlarging techniques used in traditional black-and-white or color printing processes, and the information in this chapter will help you explore alternative processes even if you do not have a large-format camera.

Chapter 21, Paper, is a guide to selecting the proper paper for alternative printing processes. It discusses the characteristics of various papers and suggests a number of classic choices that give good results.

Finally, the appendix, Resources, lists manufacturers for many of the specific chemicals, materials, or equipment introduced in this book. It also includes sources for additional information about alternative photographic processes.

Basics

Working with alternative photographic processes requires some specialized equipment, but not nearly as much as you might assume. If you have access to a basic black-and-white darkroom, you will have an advantage, mostly in terms of time and effort-saving convenience. But even if you have no darkroom at all but can dedicate an unused room for a brief time, you can still produce prints from many of the processes described in this book. Kitchens, bathrooms, and bedrooms are *not* recommended, however, because those spaces can become contaminated with photographic chemicals.

Basic requirements include a room that can be made dark, running water in or near your work space, and—although it can be a luxury sometimes—enough counter or table space to sensitize paper and set out three or four processing trays.

This chapter gives you an overview of the equipment needed for alternative photographic processes. It also provides some instructions for basic procedures—such as weighing and mixing chemicals, washing prints, and hand-coating solutions onto paper—that are common to most of these processes. You should become familiar with the basic information presented here before attempting any individual process.

Producing alt-photo prints frequently requires negatives with different values than those used for traditional photography. Most processes, like cyanotype, platinum/palladium, and especially argyrotype, need negatives that would be characterized as high in contrast. Other processes, like bromoil and gum, favor negatives of lower contrast. Because negative requirements are so

process-specific, each chapter addresses the optimum qualities for negatives used in that process.

Equipment and Materials

In addition to your immediate working environment, you will need certain materials and pieces of equipment. Not all processes in this book require every item in this list, so please consult each process chapter for the materials it requires. Remember, attempting a process for the first time can be confusing enough. Keeping your materials organized and close at hand will make your work much easier and much more efficient.

For Handling and Mixing Chemicals

- Chemical balance or scale that measures accurately to 0.5 grams
- Measuring graduates in several sizes; minimum of four 1000 cc and two 2000 cc size
- Glass or plastic stirring rods
- Glass mixing beakers: Pyrex labware or similar type, four 300 cc size
- Brown glass storage bottles with droppers: various sizes, depending upon process, 25 cc to 100 cc
- Filters: either lab-style paper filters or simple coffee filters, both cone and basket style; cheesecloth, cotton balls, or cotton wool also work
- Measuring syringes: syringes without needles, such as the Micro Mixer sold by Photographers' Formulary
- Eyedroppers: four or five, preferably all the same make and size since different eyedroppers produce different-sized drops
- Shot glass or other small glass or plastic container
- Single-burner hot plate
- Medium-sized saucepan, to be used *only* in the darkroom
- Measuring spoons: tablespoon, teaspoon, etc., to be used *only* in the darkroom

For Exposing and Processing Prints

- Plastic photo developing trays, one size larger than your prints (such as 11" x 14" trays for 8x10 prints)
- Print washer or tray siphon
- Fiberglass drying screens
- Clothesline with 20 to 30 clothespins

- Print tongs
- Latex gloves
- Respirator mask
- Film cleaner
- Accurate thermometer: glass, dial, or digital
- Hygrometer to measure relative humidity
- Large sheet of Plexiglas mounted to a sheet of plywood for squeegeeing some prints
- Photo or window squeegee at least as wide as the narrowest dimension of your print
- Negative dusting brush or compressed air
- Cotton gloves for handling negatives
- Timer (or at least an inexpensive wall clock)
- UV light source (see below)
- Contact printing frame (see below)
- Safelight: tungsten table lamp or light fixture with a 40-watt bulb (no fluorescent bulbs, fluorescent light is not safe)
- ¼" plate glass, at least 1" larger than your print's image area on each edge
- Glass or plastic coating rods, about the same length as the longest dimension of your print's image area
- Ultrasonic or steam humidifier

Miscellaneous

- Drafting tape (not masking tape, which will tear paper when removed)
- Ruler
- Scissors
- Pencils
- Kneadable eraser
- X-Acto knife or similar knife with a supply of sharp blades
- White artist tape
- Paper towels

UV Light Source

Nearly all of the processes in this book require ultraviolet light to expose the sensitized paper. Light sources used in traditional photography don't emit enough UV lightwaves for alt-photo processes, and unless you are making enlarged negatives (see Chapter 20), photographic enlargers are useless. Both sunlight and certain kinds of lightbulbs produce adequate UV light.

Sunlight

The sun is a good, cheap source of UV light. Besides its being free, the advantages of using sunlight are that it usually takes less time to print than other sources, the quality of the images are sometimes richer, colors in gum prints are more intense, and overall contrast tends to be greater. The sun is a good light source for beginners starting to make alt-photo prints. It is also the preferred light source for albumen printing.

On the other hand, sunlight exposures are dependent upon time of day, time of year, and the amount of cloud cover, all of which can affect the amount of UV at any given time. If one is making a series of prints that requires consistency—such as a limited edition portfolio—the sun is entirely too erratic for dependable results. Also, heat from the sun can sometimes cause heat fog on the print, and with Printing-Out Paper (POP), excessive heat and long exposure times can cause the paper to stick to the negative.

Bulbs

Most—but not all—serious alt-photo workers use ultraviolet bulbs to make their exposures. If you need to print at night or on overcast or partly cloudy days, you must have a light source that can be used whenever and wherever needed (see fig. 1). There are different types of bulbs:

Bank of UV fluorescent bulbs

The designation for an appropriate 24" 20-watt fluorescent bulb is F20T12/350BL. Sylvania, General Electric, and other manufacturers all use this designation.

Note Be sure the bulbs are marked BL at the end, *not BLB*. BLB bulbs put out much less UV light; they are also more expensive.

Self-balancing mercury vapor lamp

High-intensity graphic arts plate burners, such as that made by NuArc, usually come with a vacuum frame, which is important for printing large images because of the need to maintain perfect contact between negative and paper. You can also buy the bulbs and sockets separately and make your own light source apparatus.

Both fluorescent bulbs and mercury vapor lamps produce a bright light with a high degree of UV waves. Do not look directly at the UV light source when it is on, and keep out of the direct path of the light as much as possible.

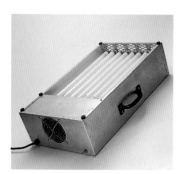

Fig. 1. *I have used this UV light source since about 1988. It is an old model made by the Palladio Company (see Resources) and has been used consistently and heavily ever since. You can make a similar unit with nothing more than a series of fluorescent ballasts, the correct type of UV tubes, a fan for cooling (configured to exhaust), and a box to house it all.*

Quartz-halogen bulbs do not work because they also emit infrared waves, which heat the paper and possibly damage both the paper and the negative.

Contact Printing Frame

A good-quality split-back contact printing frame is necessary for most of the processes in this book (see fig. 2). There are many different designs of contact frames, all based on the frames used more than one hundred years ago for printing calotypes. Later, another version was developed for printing glass negatives; it was different only in that the backs allowed space for the thickness of the glass. As far as I know, there is only one frame made today that works for glass negatives, a frame by Gravity Works that has rubber surgical tubing strung across the back. All other frames use rigid clamps or wings that can't be closed properly with the added thickness of a glass negative.

The main things to watch for when buying a contact frame are:

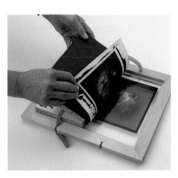

Fig. 2. *Contact printing frame. The hinged back allows the progress of an exposure to be checked without disturbing the registration between negative and print.*

- Complete contact over the entire image area. This can be a problem with some frames; it is common in sizes over 8x10. Sometimes this can be overcome by placing a few layers of paper towel between the negative/paper sandwich and the frame back.
- Scratch-free glass. Scratches on the outside of the glass are not a problem with a diffused light source such as a bank of UV fluorescents. If they are inside the glass, against the negative, they will print as white marks. With the sun or with other point-light sources, any scratches will print onto the image, whether they are on the inside or the outside the glass.
- Good UV light transmission. Some forms of Plexiglas are treated to block ultraviolet light and should not be used. Untreated Plexiglas works for smaller images; in large sizes, however, it may bow and the contact between negative and print will be lost.
- Smooth finish, good overall workmanship. A roughly finished frame can produce splinters, which will become quite apparent as you twist, turn, and handle it. Cheap clamps and wings, stiff hinges, and other awkward hardware also make handling the frame difficult. Parts should move smoothly and without much resistance. They should not have too little resistance, either; this might result in weak contact between the negative and the paper.

Procedures

Cleanliness

A clean working environment is not only nicer to work in, it is necessary. Chemical contamination can be a serious problem with any process, but it is a special concern for some.

- After each working session, scrub down your sink, clean all mixing containers, and clean all work surfaces. Periodically scrub the sink and counters with a good cleanser—and be sure to rinse off any residue thoroughly with clean water.
- Always keep stirring rods and storage containers *dedicated to specific chemicals.*
- Wash your hands regularly.
- *Never* use kitchen items in the darkroom unless they are permanently retired from kitchen use.

Calculating Percent Solutions

This book uses percent solutions throughout (for example, a 2% solution of sodium thiosulfate), and understanding how to mix them is basic to working in alternative photo processes. The calculation is very simple: 1 gram of dry chemical plus enough water to make up 100 cc of the final solution yields a 1% solution. (Note that the dry chemical is not added to 100 cc water, but added to enough water *to make a final tota*l of 100 cc once the chemical is completely dissolved.) Stronger or weaker solutions can be extrapolated from this ratio. For example, 10 grams citric acid with enough water to make a total of 25 cc of solution yields a 40% citric acid solution.

Chemical Weighing and Mixing

To formulate the various solutions throughout this book, it is necessary to have an accurate scale to weigh chemicals. The scale can be of almost any type as long as it meets a few basic requirements:

- It must be accurate.
- It should measure in grams.
- It must handle a range of weights from 1 gram to at least 500 grams.

Electronic scales are relatively inexpensive, but if they break down you have to buy another; triple-beam scales are more expensive, but they will last a lifetime.

When measuring out dry chemicals on a scale, be sure to lay a thin sheet of paper onto the surface of the weighing area first. Fold the edges up to form a basket of sorts to prevent the chemicals from spilling onto your work surface. I use basket-style paper coffee filters because they are inexpensive, they are already shaped, they are lightweight, and they are easily held while you pour chemicals into mixing containers. If you are measuring very small amounts of chemicals, be sure to allow for the weight of the paper or coffee filter or you will not get an accurate measurement.

In some processes the relative pH (the acidity or alkalinity) of a chemical solution affects its performance or the quality of the results. You can monitor the pH of a solution using litmus paper, which is available through chemical supply houses.

Always wear a protective mask or respirator when measuring dry chemicals. Inhaling the dust from some chemicals can be dangerous.

Standard Processing Temperatures

Like traditional photographic processes, the chemical reactions that occur during alt-photo processes work best within certain temperature ranges. Some chemicals need to be mixed at high temperatures in order for them to dissolve. In some processes, a developer that is too warm will ruin the image; in others, a temperature that is too cool will retard the chemical reaction necessary.

If temperature is critical in a process, that fact is addressed in the specific chapters. When no temperature requirements are given, you can assume that a standard room temperature of 68°F to 75°F is safe.

Washing Film and Paper

The issue of efficient print and negative washing has generated a lot of confusion and discussion over the years. To make things simple, you should wash all your materials with this principle in mind: *Diffusion, not force.* In other words, running a *gentle* stream of water—or even simply filling a tray with a small amount of water and agitating, dumping, and repeating—is much more efficient and much less wasteful than running high volumes of water at high pressure. The high-volume method actually does very little to clean the paper or film because the water simply slides over the residual fixer. By allowing the water to remain in more gentle contact with the fixer, free of extreme turbulence, the fixer becomes diffused into the surrounding water and can easily be washed away. Most archival washers on the market do a good job of cleaning

film and prints, and I recommend using one if possible. The information presented below is for those who can't afford them, don't have room for them, or simply don't use them.

To wash fiber prints

First treat the prints with a washing aid like Kodak Hypo Clear. For film and RC prints, the washing aid is not as critical because the fixer remains on the surface; fixer soaks into the paper more deeply in fiber prints.

1. Fill a tray with water, immerse the print in it, and agitate the tray on and off for two or three minutes, allowing the water to calm periodically.

2. Dump the water, fill the tray again, and agitate in the same manner.

3. Do this for six or seven cycles.

An alternative is to use a Kodak tray siphon. I use a 16" x 20" tray for prints up to 11x14:

1. Fill the tray and immerse the prints, no more than two or three at a time (that's for 11x14 prints; you can add more if your prints are smaller).

2. Run the water at a gentle rate for two minutes.

3. Turn off the water, push the prints down into the water, and move them around a bit.

4. Let them sit for two or three minutes.

5. Turn on the water again and repeat steps 2–4.

6. Repeat this cycle five or six times, periodically pushing and moving the prints around while the water is running. Be careful not to bend or otherwise damage the prints as you handle them.

To wash roll film negatives

There is no need to use a washing aid when washing film. This is basically the same method as recommended by Ilford for archival film washing.

1. After thorough fixing, dump or recycle the fixer in your usual manner.

2. Fill the tank with running tap water at the *same temperature* you used for processing.

3. Close the tank and invert it five times.

4. Dump this water down the drain.

5. Fill the tank again, and invert it ten times.

6. Dump the water, fill again and invert it twenty times.

7. Dump the water, fill the tank once more, and add a drying aid, like Kodak Photo Flo.

8. Hang the film to dry in a dust-free environment.

The water temperature during all washing procedures (film, RC prints, and fiber prints) must be above 65°F or the washing action will not be thorough.

To preserve the finest grain in your negatives, it is vitally important to maintain constant temperatures throughout the processing cycle, including during washing.

Although they demand regular attention, these washing procedures will save time. Most importantly, though, they will save significant amounts of water. You will also end up with cleaner negatives and prints.

Coating Sensitizer Solutions

Coating rod method

The glass-rod coating method is the most efficient means of applying a sensitizer to a sheet of paper (see also Coating the Paper with Gelatin, page 176). A glass rod uses about half the sensitizer solution used by the brush method; it coats extremely evenly and allows a much more accurate means of standardizing your procedures by applying a constant amount of sensitizer to the paper. A brush can apply differing amounts with each pass by virtue of the sensitizer migrating into the bristles. Although you may end up preferring to use brushes, I nevertheless recommend learning how to use a glass rod for coating your sensitizer solutions. It is easy and well worth the relatively small expense.

I have ten glass rods—actually hollow tubes—of different sizes that I had made by a neon sign maker before there were any commercially made products available. I designed them with the ends bent upwards at a 45° angle so I could grip them with both hands. You can also buy ready-made products like the Puddle Pusher, sold by Bostick & Sullivan, which is a straight length of glass with a little handle at the top middle you can hold with one hand. Glass rods should be as straight along the bottom as possible.

Plate glass

Coating with a rod will be much easier if you support the paper you are coating with a sheet of heavy plate glass—$\frac{1}{4}$" to $\frac{1}{2}$" thick. Glass rods don't bend and therefore don't conform to the contours of an uneven countertop. If either the rod or the countertop is uneven, firm contact will not be maintained, coating will be spotty, and the paper will have differing amounts of sensitizer across its surface, resulting in uneven density in the final print. A plate glass coating surface prevents these problems.

Always use a glass coating rod, never Plexiglas or any other plastic. Glass is dimensionally stable under most circumstances and will not bend or warp. Plastic can warp, which will produce uneven contact between the paper and the rod, which in turn will cause inconsistent coating.

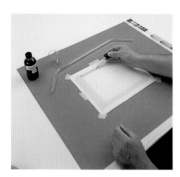

Fig. 3.

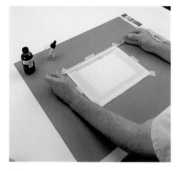

Fig. 4.

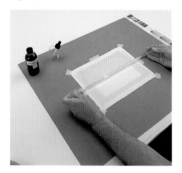

Fig. 5.

Procedure

1. Either tape off the area you wish to coat using drafting tape, or mark it with a pencil.

2. Wipe the rod to remove any dirt or grit; brush or wipe the paper with your (clean) hand as well.

3. Measure out the amount of sensitizer you will need into a shot glass or other small glass or plastic container, draw the sensitizer into an eyedropper or measuring syringe, and spread it along the longest edge of the area to be coated just outside of the marked image area (fig. 3). If you are using drafting tape to mark the image area, spread the solution onto one of the long edges of the tape itself. If you spread it onto the image area, the sensitizer would begin sinking into the paper, resulting in an uneven coating that usually shows up as an area of greater D-max (greater full black) than the rest of the image.

4. Place the glass rod just behind the bead of sensitizer solution (fig. 4), then gently run the rod along the paper (fig. 5).

5. Once you get to the end of the coating area, gently lift the rod off the surface of the paper and place it behind the bead of remaining sensitizer.

6. Move the rod back up the sheet, lift the rod, and place it behind the sensitizer. Rest for 30 seconds or so to let the sensitizer soak into the paper, then run the rod back down the sheet.

7. Do this until all or most of the sensitizer has migrated into the paper. Different papers absorb solution at differing rates, but if you have to do this more than four times, you are either using too much sensitizer or you need to add a wetting agent such as Tween 20 to aid in the absorption. Experimentation and evaluation will guide you.

8. After coating, always rinse the rod and wipe it dry.

Brush method

Although the glass-rod coating method gives a very even coating of sensitizer, some workers find it easier to use brushes. The wooden-handled short-bristle brushes available in art supply stores work well (fig. 6). Use a different brush for each kind of sensitizer. Remember that the brush will soak up some of the solution, so mix twice as much sensitizer as you would for the glass-rod coating. Be sure to tape down the paper; a sheet of plate glass is useful, but not necessary.

1. Either mark the corners of your coating area with a pencil or tape off the image area with drafting tape or other tape with low tack.

2. Measure out the appropriate amount of sensitizer into a shot glass or similarly sized glass or plastic container. Remember that you will use approximately twice the amount of sensitizer with the brush method than you do with the rod method.

Chemical Hazard Warning

Fig. 6.

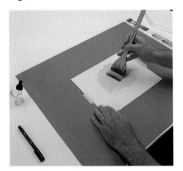

Fig. 7.

3. Dip the brush into a small container of distilled water and squeeze out as much of the water as you can.

4. Pour the sensitizer onto the area to be coated. This can be a single puddle in the middle, an X dribbled from one corner to the other, or any other pattern that suits your taste or mood.

5. Quickly brush the sensitizer in an east/west and then north/south pattern until the sensitizer is coated as evenly as possible (fig. 7). Avoid brush marks.

6. If there doesn't seem to be enough sensitizer to coat completely or evenly, throw away the sheet and start over. Use more sensitizer to coat the next sheet.

7. If extra sensitizer puddles on the surface after the sheet seems evenly coated, you probably have too much sensitizer. Brush the excess off to the side, beyond the image area, and soak it up with a piece of paper towel.

8. If extra sensitizer puddles on the surface but doesn't seem to be coating evenly, the paper may not be absorbing properly. Try adding a drop of Tween 20 to the sensitizer before coating the next sheet.

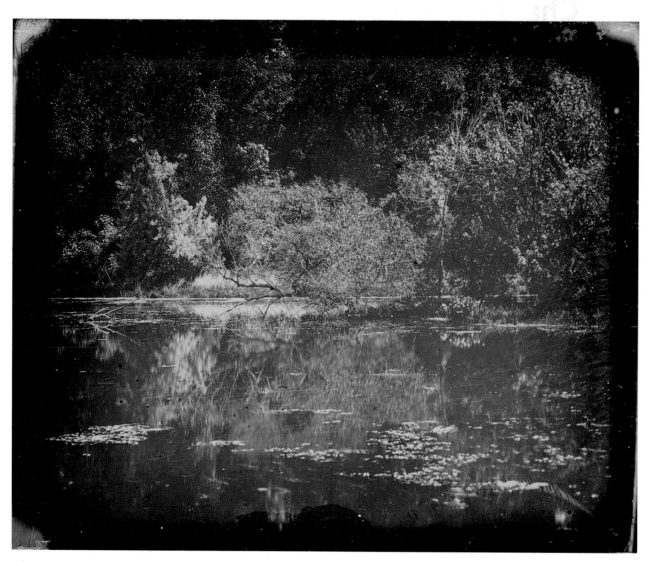

John Barnier, Pond. *Becquerel-developed daguerreotype.*

Chapter 1 Becquerel-Developed Daguerreotypes

Gerard Meegan

History

There is no accurate way to pinpoint the true beginning of photography because of the great number of developments in optics and chemistry that came together to establish what we know as the medium today. In fact, during the early decades of the 1800s, a variety of viable photographic techniques were emerging in France, England, and Norway, and as far away as Brazil. The daguerreotype, introduced by the French entrepreneur Louis Jacques Mandé Daguerre in 1839, is commonly credited with being the first photographic process to achieve widespread popularity. Daguerre's process produced images on a highly polished silver-coated copper plate. This is a direct positive process, although the image may appear to be in negative when first viewed. When light reflects from the plate at just the right angle, an exquisitely detailed image appears, a perfect miniature of the scene photographed. These images, which quickly became known as *daguerreotypes*, captivated all those who saw them.

Becquerel Development

In the process Daguerre introduced, after the sensitized silver plate was exposed in a camera, it was developed by exposing it to the fumes of mercury. This procedure yields beautifully detailed daguerreotype images; however, mercury is an extremely hazardous chemical to use, and mercury development should only be attempted today by those with access to chemical laboratories with powerful fume hoods. Fortunately, there is an alternative to mercury

development, as old as the daguerreotype itself, that makes it possible to create daguerreotypes safely.

One year after the introduction of the daguerreotype, in 1840, Alexandre Edmund Becquerel discovered that, in addition to mercury development, daguerreotype plates would also reveal their latent image if exposed to light that excluded the ultraviolet range. This is known as the Becquerel phenomenon. To date I have been unable to find any published account that actually describes how to develop plates exploiting this phenomenon. I have drawn from experiments done by Samuel Draper in 1841 and Irving Pobboravsky in 1971, and have done new tests to determine the sensitivity of daguerreotype plates developed by light. My intent is not to reinvent methods for conventional daguerreotypy, but to establish an entry point for using light to develop the plates. I believe the history of this process is still in the making, for with each new practitioner come variations and discoveries.

Overview of the Process

Daguerreotype plates are made from sheets of copper coated with silver, polished to a mirror-like finish, and then sensitized with iodine vapors. Once polished, the plate is put into a coating box that contains a small amount of crushed iodine crystals. The vapors of the iodine combine with the silver to create a light-sensitive layer of silver iodide on the plate. As this happens, the iodine vapors change the color of the silver plate. It is this color change that indicates how thick the iodide layer is and how sensitive to light it is. When the plate is coated to the desired color, usually yellow, the plate is ready to be put in the camera and exposed. After exposure, the plate is covered with a colored filter to block UV light; it is then developed by the further reaction of the exposed silver iodide to light from which the ultraviolet range has been excluded. Plate development is observed through the filter and carried out until the plate is judged done by a visual assessment. Development times may vary greatly, but I generally develop plates for eight to ten hours. The plate is then cleared of its undeveloped silver iodide using sodium thiosulfate and toned with gold chloride. The final step is to seal the plate under glass to protect its fragile surface and prevent tarnishing of the silver.

In the following instructions, I have broken the exact procedure down into numbered steps as best I can, with additional notes and commentary inserted as needed to describe the process that I use to make daguerreotypes. Written observations of what takes place are essential to learning this process. I urge you to use my comments as a guide, but to keep careful records of what happens in your experiments. What is not covered here is what happens between

the practitioners' first plate and their tenth plate, or their hundredth plate. Like tuning a piano, reading a book on piano tuning only serves as a starting point; it will not compensate for an untrained ear. Daguerreotypy relies heavily on the skill, finesse, and judgment that can be acquired only by working with the process.

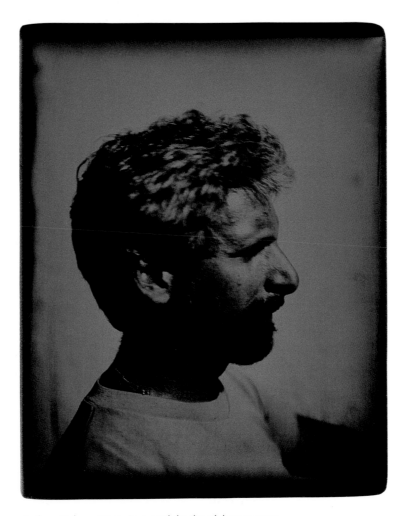

Barbara Galasso, Gino. Becquerel-developed daguerreotype.

What You Will Need

Chemicals

- Iodine crystals
- Sodium thiosulfate
- Sodium sulfite
- Gold chloride

Materials

- Electric buffing wheel
- Jeweler's rouge
- Hand buffs (see below)
- Coating box (see below)
- Hot plate
- Glass mixing beakers (300 cc and 500 cc)
- Rubylith or clear amberlith

Hand buffs

Hand buffs are made from a board wider than the largest size plate you intend to make and a length of anywhere from two to three feet. The boards are padded and covered with velvet. You will need two of these. The thickness of the padding and board are up to you, and with experience you will find a combination that works best for you. Some people use a buff $1/2$" thick, others $5/8$" thick. If you prefer cotton velvet to synthetic, I will not argue.

Coating box

The coating box dimensions are also determined by the size of the plates you intend to make. Sometimes called a fuming box, this is simply a box with a holder for the plate at the top; iodine is placed in the bottom, beneath a filter that helps distribute the iodine vapors evenly (fig. 1). I have made many boxes and have found that the only dimension that seems important is the height. The box that I use now has a distance of $2^{1}/2$" from the bottom of the box to the surface of the plate, which is put face down in a sliding board with a hole cut out to accommodate the plate. This makes it easy to slide the plate in and out of the box for inspection during coating. I have made my boxes from hardwoods, and I use lamp parts for special fittings; since the box will contain iodine vapors, it is most important to make it as airtight as possible. The iodine vapors will eventually tarnish and possibly corrode the finish on the metal parts. This is normal and unavoidable.

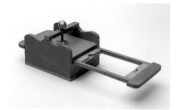

Fig. 1. *Coating box. The plate is placed face-down in the tray opening, and then slid over the iodine crystals for sensitizing.*

Procedures

Making the Plate

First determine what plate size you need for your camera. I have made plates from 35 mm to 5" x 7". When first learning the process, it is a good idea to keep the plate size small just to be economical.

If you are putting the plates into a camera like a 35mm that does not use a separate film holder, make sure to size the copper so it will fit properly into that specific camera.

If you plan on using a 4x5 film holder, make a cardboard dummy first. I have made errors in measuring the plate and have had to grind the copper down to fit. Glass plate holders can still be found in the used camera market and work great for daguerreotype plates. Be careful to get holders that are still light-tight.

Once you have the copper, you need to get it silver plated. I have used Theta Plate in Albuquerque, New Mexico (see Resources), which does good work. You will need to drill small holes in two corners of your plates so the plater can run wires through them during the plating. I drill $1/16$" holes but there is no exact size requirement. Since only one side of the copper plate will be polished, Theta plates them hung back to back in solution. This company is one of few platers who understand what we do with the plates and what a strange lot we daguerreotypists are.

Daniel Smith, an art material supply company in Seattle, sells polished copper and will cut it to size (see Resources).

Polishing the Plate

1. Using an electric buffing wheel equipped with a muslin wheel and some jeweler's rouge, buff the plate to as smooth and clear a polish as you can. Move the plate in a continuous rotation, first buffing north/south, then east/west.

2. Follow this by using the first of the two traditional hand buffs. Sprinkle the first buff with a small amount of powdered rouge and move the plate over the buff in a straight line repeatedly. This is to remove the fine scratches from the motorized buffing wheel.

3. The second buff contains no rouge or polishing aids. Use it to remove any residue of rouge. *Do not spin, curve, or rotate the plate during these final steps.*

If there are going to be any fine scratches on the plate, they will be less noticeable in the final image if they are straight and horizontal on the image. Scratches that are vertical or curved are generally more noticeable.

Coating the Plate

1. Wearing a protective mask, crush about three tablespoons (for a box that accommodates up to 5" x 7" plates) of iodine crystals in a mortar and pestle.

2. Add the crystals to the bottom of the coating box, close it, and let the fumes build up inside the box for an hour or two. The iodine should last for several weeks. You will know when to change the iodine when it takes longer than usual to fume a plate.

Under safelight conditions (red or low-level bug light):

3. Place the plate face down in the tray of the coating box and slide it under the lid. The vapors from the iodine will rise to the plate and form the sensitive silver iodide layer. The longer the silver is exposed to the iodine vapors, the thicker the iodide layer becomes.

4. As the iodide layer increases, the plate changes colors. Monitor the changes in the color cycle using the procedures described below.

5. When enough iodine has combined with the silver on the plate, the color will be yellow. At this point remove the plate and place it in the camera or plate holder.

The crushed iodine can remain in the box between coatings, but you will need to encase the box in some sort of protective enclosure. I use a plastic picnic cooler with a tight-fitting lid. Keep the box, regardless of protection, away from children and pets at all times.

The Color Cycles

It should be mentioned here that, in daguerrean terms, *darkroom* and *dim room* are interchangeable. I use a 7.5-watt bulb reflecting into a sheet of white mat board as my safelight when I check sensitization levels, but some people use bug lights or conventional safelights. Whatever you feel comfortable with for judging the colors of the plate will probably work.

Remove the plate from the coating box, and position it to reflect the mat board. The point here is to avoid pointing the plate directly at the light while inspecting for color changes. Using the plate as a mirror, aim it so that it reflects the white board. Setting up this viewing geometry provides a consistent environment to determine the plate's color changes during coating. Once you have observed what level of coating has been reached, return the plate to the coating box for further sensitization.

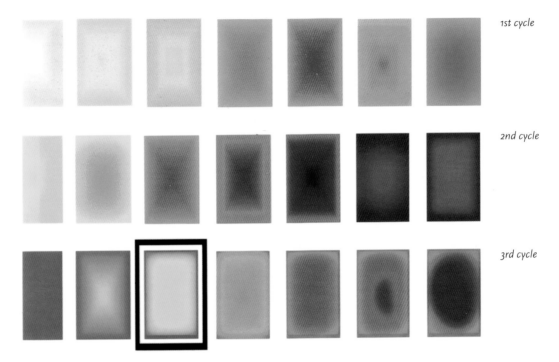

Fig. 2. *This chart shows the basic color progression of a plate through three cycles, from top to bottom, as it is sensitized by the iodine fumes. The colors become more pronounced through each cycle. Note that this chart is computer-generated; although not a perfect representation, it does approximate the colors as closely as possible.*

As it becomes sensitized from the iodine vapors, the color of the plate progresses through the visual spectrum (see fig. 2). The cycle starts with yellow, and the plate then changes to orange, red, violet, blue, and green before returning to yellow. In actuality, the transition through the spectrum is not so clear cut. During the first cycle, the colors are so light that they are hard to determine. The blue and green hues are nearly imperceptible over the silver, and there is the illusion that the plate has cleared of color before the start of the second cycle, when yellow appears again.

The second cycle is the easiest to read, and the color changes are distinct. By the time the second cycle reaches blue, the color is very strong.

Starting with the third cycle, a compression of the color differences takes place that makes certain colors not as easy to identify. At the end of the second cycle, there will be a very strong blue. As yellow returns, it changes the deep blue of the second cycle to a vivid green. Indulge me and let's agree that this green is the start of the third cycle, because the yellow is returning. The problem is that from the start of the third cycle, the pure yellow seen in the first two

cycles is not so easily defined. *The yellow of the third cycle will almost always have a border of green, and the yellow emerges from the center of the plate and reaches outward.*

The level of plate sensitization that this yellow of the third cycle indicates has given me the best results. The flag to watch for in coating is the first appearance of the strong green color that precedes the yellow. It is not a subtle shade at all. I have used the yellow shade from every cycle from the first through the fifth, and they all work; but the yellow that follows any strong green has proved to hold up well for extended development.

Note that with each cycle there is a reduction in contrast of the final image, although exposure values remain the same for all like colors. That is, the yellow of the first cycle has the same exposure value as the yellow of the third; the orange of the first cycle has the same sensitivity as the orange of the third cycle. All shades of all cycles are sensitive to light. I find the contrast level of the third cycle to be the most usable range.

There are many variables that will determine how long it takes to reach this level of coating. For reference only, not as an exact guideline, I reach this color in about five minutes. *Note that even though it might take five minutes to reach a deep green, it may take only twenty or thirty seconds more to reach the yellow coating. From the first sign of green, check the plate often.* If it takes you ten minutes or more to reach the first strong green, you should recharge your coating box. If the coating process takes too long, you will find that it becomes more difficult to coat the plate evenly.

At the start of the third-cycle yellow, stop coating. Remove the plate from the box and take a close look. The edges will most likely still be quite green, but the yellow will be covering most of the plate. If the plate has an orange tinge in the center, you went a little further than the coating stage I prefer. The more orange the color gets, the more prone the plate is to fogging during development. Finding the correct shade of yellow may take some practice, and you will notice that the characteristics of the final image will vary greatly as you hone in on the correct shade. Leaden, dull highlights, for example, are characteristic of images from plates that have too much green in them and have not fully reached the yellow stage.

Exposure

My recommended starting point for exposure is eight to ten seconds at f/2.8 with an exposure value (EV) of 14 on the light meter. My exposure times are actually a little faster, but when you start out, overexposing the plate will increase the likelihood of securing an image. The accuracy of the exposure can be more easily adjusted downward, since it is hard to evaluate your exposure if you underexpose and do not secure an image. If you are using a camera with a dark slide, you can withdraw the slide in steps a couple of seconds apart and create one plate with four or five exposure tests. Test exposures should be in steps smaller then one stop apart until you find the best results.

In order to evaluate your early trials, you need to control exposure variables, so use a consistent subject under consistent lighting conditions. If your first plate is shot with an EV of 14, then your next plate should also be. Some colors may not render as you are accustomed to—greens of grass come out very dark, for example—so a change in your subject can cause confusion with your first plates. Until you have found the correct exposure for that light level, I suggest keeping the subject the same.

Development

Development should be carried out as soon as possible. If you are photographing away from home, carry the rubylith with you and start development right away. The sooner the development starts, the more predictably the image comes up. Too great a delay may cause latent-image fading. I have not done a very controlled test, but I believe that delays of even an hour have caused plates to behave sluggishly during development.

Development is carried out by placing a piece of rubylith or clear amberlith mask (red- or amber-colored acetate) over the plate holder. Rubylith and amberlith can be found at most art or graphic art supply stores. I found rubylith to be my favorite, and I use a new piece for each plate. Cut the mask to the size of the plate holder and tape it over the window of the holder that the plate was exposed through, using any tape that you know is light tight. Regular masking tape may weaken when warmed during processing; if it detaches, the plate will fog.

Once the filter is secured to the plate holder, remove the dark slide. Put the plate, now protected by the filter, under the light you intend to use for development. In the summer, I find it easiest to set the holders out in the sun.

Start checking the plate's development at intervals of about fifteen minutes, and repeat until the plate is fully developed (see Observations on Development, page 13). When the plate is fully developed, reinsert the darkslide to cover the plate; it must be fixed to eliminate any remaining light-sensitive silver.

Development may also be done by placing the plate in a shallow, dark box, such as a used film box.

Clearing/Fixing the Plate

Before the exposed and developed plate can be inspected under bright light, it must be cleared and fixed. This process removes the residual hazy layer of the image and chemically eliminates any remaining light-sensitive silver salts that

would fog later. If the plate is still warm from the heat of the light used to develop it, let it cool before this step. The warmer the fixer, the faster it reacts with the plate, making the initial covering even more risky. Applying fixer to the plate is a delicate operation and safest with the formula below. Stronger solutions are less forgiving if the plate is improperly submerged.

1. Mix 15 grams of sodium thiosulfate and 15 grams of sodium sulfite into one liter (1000 cc) of distilled water.

2. Before using the fixer, I pour the solution through a coffee filter. I have spoiled plates when what I believe to be particle contamination or undissolved fixer chemicals have created fine lines and removed part of the image during agitation.

3. In dim light, submerge the plate into the fixer. This takes some practice, since the plate must be covered quickly and evenly. Do not pour fixer directly on the plate. Instead, pour some fixer into a tray and raise one end high enough to make a fixer-free area in the tray in which to set the plate.

4. Lower the raised end of the tray and let the fixer flow over the plate. Any hesitation during this step will likely damage the image.

5. Once the plate is covered, gently rock the tray to keep fresh fixer moving over the plate.

6. Continue to agitate for a length of time equal to twice the time it takes for the plate to clear. If the plate clears in two minutes, fix it for a total of four minutes. While plates rinsed without this extra time look clear of iodine they seem to have a higher potential for failure during gold toning.

7. Rinse the plate with filtered water, preferably with in-line filtration. If you don't have a filtration system, use spring water or any other water that you think is clear of particulates. *Do not use distilled water at this stage.* I found that rinsing with distilled water before gold toning seems to tear at the image, a strange effect both fascinating and disturbing to watch. Distilled water is "hungry" and will grab molecules wherever it can.

8. Submerge the plate in a tray of water and let the water circulate over it, but do not let the water from the hose or faucet fall directly on the plate. If water is allowed to run directly on the plate, lines will appear during toning that represent the flow of the water passing over the plate. I have a collection of plates that have radiating linear stains from holding the plate directly under the faucet.

9. Handle the plate very carefully during this process because the image is extremely fragile before it is toned.

While the savvy daguerreotypist knows it is best to go directly from the fixing to the toning procedures, it can be instructive to dry a plate at this point because much more can be learned about a plate's developed characteristics

when it is dry. You might want to try this with a plate you have no intention of toning, but keep in mind that its surface can be damaged very easily.

The observation I would like you to make is how different the plate looks wet compared to dry prior to toning, since the differences can lead to misjudging the tone of a plate. When the plate is dry, you can see more clearly the level of its development by its coloration. Sometimes a plate will look neutral right after it is fixed, but if development was stopped too early, it will have a weak blue tone when dry. Also, because of the refraction of the water on the plate, an image that appears correctly developed can show a sudden increase in brightness when it dries.

Gerard Meegan, Untitled. Becquerel-developed daguerreotype. Courtesy of John Wood.

Gold Toning

After it is cleared and fixed, the daguerreotype is toned in a gold chloride solution, which both makes the image surface less susceptible to damage (although it remains very delicate) and changes tonalities in the highlight areas. Successful toning takes some practice since the image density will change as the daguerreotype dries and this must be anticipated when the toning level is judged.

1. Mix 1 gram of gold chloride into 500 cc of distilled water to make up part A.

2. For part B, mix 4 grams of sodium thiosulfate into 500 cc of distilled water.

3. Mix equal proportions of part A *into* part B just prior to toning; do not mix B into A. The amount you need is determined by how large a tray you use to tone and how much solution it takes to cover your plate in that tray. Since gold chloride is expensive, if you're like me you will learn to use as little as possible.

4. Here, too, I use a coffee filter to filter the toner before using it. Any particulate matter in the solution can be a disaster.

5. Pour the solution into a clean tray slightly larger than the plate and bring the solution to the required temperature, 125°F to 185°F. I have tested quite a range, and have found that working within this range produces the best results. Measuring temperature in a rocking solution presents its problems. I used a digital thermometer with a remote probe immersed in the toner and not on the surface of the tray. The hot plate I use is a Cole Parmer six-inch model 4812 with a remote thermocouple to hold the temperature constant. With too low a temperature, the image never seems to brighten; a temperature that is too high tones the plate tones too quickly, and it is difficult to tell when one has gone too far.

6. Once the toner is at the desired temperature, tilt the tray in the same manner used for clearing the image and insert the plate. Set the tray on the hot plate and gently move it in small circles to keep the solution circulating over the plate. Toning first causes a darkening of the plate, an effect similar to solarization only with a violet cast.

7. This toning effect starts on the thinnest areas (shadows) of the image first and the areas of strong highlights last. The plate regains its brightness in the thinnest areas first as well. The brightening of the highlights is what should be monitored to determine the completeness of the process. Stop when the plate looks as if it has brightened uniformly.

8. Place the plate face up in a washing tray. Wash the plate in gently flowing tap water for about ten minutes.

Drying the Plate

Like all the steps in the daguerreotype process, drying needs to be done carefully. The toning has made your plate much safer to handle, but it still needs care. After rinsing the toned plate, I use a hair dryer to chase the water from the plate. Think in terms of removing water from the plate rather than drying it. If the plate just sits and air-dries, water spots may form that cannot be removed.

Sealing the Plate

Since daguerreotype is silver, it must be protected from oxidation and scratches. The plate should be matted using an acid-free and non-buffered mat board, with glass placed over the board. I use a piece of mat board behind the plate as well. Do not use a board that has been made pH neutral by the use of some buffering agent. Tape this sandwich of board, plate, board, and glass together using a non-acid tape, sealing the edges of all layers together.

Observations on the Process

Development Alternatives

I have tried other types of filters for development. I have constructed a box from UV-filtered acrylic products, but I found they all seem to fade in a very short time; and some of the colored plastic coatings do not provide even UV blocking. There may be some good alternatives out there, but I have yet to find them.

For a more controlled development setup, I use a 150-watt 3200k floodlight placed about a foot from the plate. I have done side-by-side comparisons and found no appreciable difference in development times. The only drawback to this method is that the plate and the holder heat up more and the tape is more likely to get messy or come unstuck. Use a fan to keep things cool.

Observations on Development

You should start seeing the image form within the first ten or fifteen minutes after development begins. At this point, you should see mostly highlights. The image will look veiled under a misty layer of iodide and seem to come up through the plate. The density of this layer above the image is proportionate to the opacity of the iodide layer achieved during coating; it seems more opaque the further the plate color strays from yellow. Plates coated into the fourth or fifth cycle will have a thick, misty layer that obscures the first signs of development.

If you see most of the image in less than ten minutes, your plate was most likely overexposed. It is important to monitor the plate often to learn the rate at

which a good plate reveals an image. You can then determine how over- or underexposed a plate is long before it is finished. With experience, you will learn how to get the most out of an improperly exposed plate by extending or reducing development.

The misty layer grows stronger during development, but it clears during fixing. It does, however, make it hard to tell when the plate is actually fogging. I wish I could give a more accurate description of this. Sometimes I have confused the harmless strengthening appearance of the iodide layer with fog. At times I have stopped development prematurely, and other times I have cleared a plate I was confident about and found it fogged. Fogging during extended development is less likely the closer the preexposed plate color is to yellow.

Judging the plate and knowing when to stop development is another one of those subjective decisions that you learn with experience. As with conventional black-and-white film processing, prolonged development builds particle density. Likewise minimal development produces finished plates of minimal strength. Daguerreotypists following these techniques can now use development as a tool for tone control, applying sensitometric principles as we do with black-and-white film. Exposure is used to determine the amount of shadow detail, and development with filtered light can be varied widely to control highlight formation to a greater extent than is possible with mercury-developed plates. Another advantage is that you can view the plate at all times during development.

With the build-up of density, the tone of the finished plate changes, becoming warmer as development progresses. Plates developed for an hour or less will usually be bluish, while plates developed for four or more hours will be stronger and more neutral. Plates developed from ten to twenty hours do not show much difference in tone, but the highlight intensity will continue to improve as longer development times are reached. I once felt long development times were best, but I now feel that, although a plate may achieve stronger highlights, the image becomes too warm for my taste. Purer whites are achieved in more moderate times of eight to ten hours, which obviously should be done with UV lightbulbs, rather than sunlight, for repeatable results. It is hard to get neutral shades with development times of twenty-four hours or more. This is a personal consideration, and at times I will sacrifice what might be only a slight concession in highlight strength for a more neutral tone to the final plate.

Observations on Toning

I use visual guidelines to determine when toning is complete. I believe some people use time as their only guide, but every one of my plates is different and responds differently. Plates that have large areas of highlights take longer to

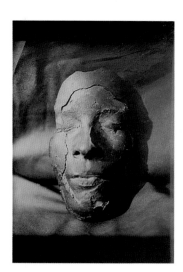

Gerard Meegan, Jan's Mask.
Becquerel-developed daguerreotype.

tone than those that have fewer highlights. You can also extend toning to bring out more shadow detail, but this usually crowds the highlights. Please be patient and watch for these changes. If toning is carried out too far the edges of the plate will darken and that darkening is my final limit; further toning will likely physically damage the plate.

A plate will tone unevenly if only the solution is kept in a rocking motion. I keep the tray in motion over the hot plate as well. The tray I use has a ridge on its underside that keeps an air space between the plate and the bottom of the tray, and this helps to distribute heat evenly. Thin plates seem to make their initial changes quickly, and continued toning will continue to brighten them. This is best observed by watching the most marginal shadow detail; you may be surprised to see how much more comes up.

Plates that are more thickly coated and that have greater image density before toning sometimes respond sluggishly and changes seem harder to monitor. Due to this sluggish behavior, I have often stopped toning prematurely and regretted it.

Some plates seem to stain with an uneven marbling effect upon immersion into the toner. If this happens, continue to tone them, for this will often level off. This distracting effect will also be reduced once the plate is dried. I believe this particular type of staining can be attributed to poor rinsing of the plate prior to toning.

Toning is always the most frightening aspect of the process. The changes the plate goes through look terrible at first, and when everything has gone well up to this point it's hard to watch these changes and not worry. The worst thing you can do is to pull the plate too soon. Be brave and let the toner do its job.

A Final Note

This is a very unforgiving process, the finished daguerreotype a product of the level of care shown throughout its creation. Any trouble encountered along the way will usually be visible in the final image. The surest way to improve quality is to handle each step carefully.

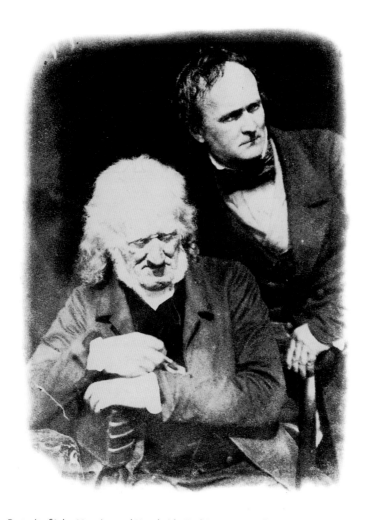

Portrait of John Henning and Handyside Ritchie, c. 1840s. This is a modern salt print by Richard Morris from a calotype negative by the famous Scottish photography partners David Octavius Hill and Robert Adamson.

Chapter 2 Calotype Negatives

Richard Morris

History

The photogenic drawing process, which produces a negative from which a positive print can be made, was discovered by William Henry Fox Talbot around 1835. The first negative/positive process, it forms the basis of photography as we know it today. Unlike modern photographic materials, however, which use transparent plastic film as the support for the light-sensitive emulsion, Talbot's process utilized common writing paper.

Talbot made the paper sensitive to light by first immersing it in a weak solution of common table salt and water, and then, when it was dry, brushing silver nitrate solution onto one side. Talbot's initial attempts at photography did not use a camera because the process was too slow to achieve good results. Instead, the object he wished to record was placed on the sensitized side of the paper in firm contact with it, often under a piece of glass, and placed in the sunlight. Exposure time would vary depending on the density of the object being copied and the strength of the sun. Once the image became clearly visible (this was a printing-out process, which means the image becomes visible during exposure), the paper was brought indoors, where it was washed and stabilized in a strong salt solution. After his paper negative was dry, Talbot then sensitized and dried another piece of paper and placed the negative face-to-face with it. He exposed the new paper through the back of the negative to create a positive image and stabilized the print in the same way.

Talbot also experimented with other stabilizing chemicals such as potassium bromide and potassium iodide. Salt-stabilized images are originally brown, but

they change to a bluish color; those stabilized with potassium iodide are often yellow, and those with potassium bromide, purple.

In August 1835, Talbot made an image of a window at Lacock Abbey (his home in Wiltshire, England) using a small camera specially made for this purpose. This is the world's oldest negative image on paper made in a camera. The process was still too slow for portraits, however.

In September 1840, Talbot made a further discovery of the *chemical* development of the latent image. This was a significant discovery, for it greatly reduced the time needed to expose his negatives, and made it possible to make portraits. His first portrait was of his wife, Constance, in October 1840. Although some of his friends called his new discovery the Talbotype, Talbot himself named it the calotype process. It should be noted that the word *calotype* refers to the paper negative process, as described in this chapter. Salt prints are sometimes, but incorrectly, referred to as calotypes. The confusion no doubt comes from the fact that the two processes are so similar in chemistry and procedures, but to call salt prints calotypes is incorrect in the strictest sense. Calotypes are paper negatives.

There are problems with the process, however, and even in its heyday (1839–1850s), there were those who found it unusable. Although not completely understood at the time, some of the problems may have been the nature of the paper being used, the manner in which it was sized, the type of size used, the impurities in the chemicals used, and so on. Today the process faces additional problems from the peculiarities of modern papers, but these should not prevent anyone from experimenting with the process and working out the difficulties by trial and error.

What You Will Need

Chemicals

- Silver nitrate
- Potassium iodide
- Glacial acetic acid
- Gallic acid, saturated solution
- Sodium thiosulfate (454 g to 1 gallon water, a typical working fixer solution)
- Washing aid, such as Hypo Clear
- Distilled or deionized water

Materials

- Clean plastic tray
- Plastic clips
- Buckle brush or glass rod
- Pencil
- Mixing graduates, 500 cc and 1000 cc
- Blotting paper
- Firm board the size of your paper
- Cotton wool, if you use a buckle brush
- Plastic ruler (not metal)
- Scissors or sharp single-edge razor blade
- 100 cc brown-glass dropper bottles (5)
- UV light source
- Candle wax or beeswax

Safelight

Although the silver iodide–coated paper (the iodized paper) is insensitive to light, the pure silver nitrate may be affected by some forms of artificial lighting, especially fluorescent. Standard red safelights, whether the screw-in bulb type or commercial safelight fixtures, are fine. If you want to be traditional, use a candle; but even that can affect the emulsion over a long period of time. It may seem illogical that the iodized paper is insensitive to light, but nevertheless it is. This may be because of the relative overabundance of iodide compared to the amount of silver.

A glance at a chemical manufacturer's catalog will indicate a variety of silver nitrates with differing trace elements. I cannot say with certainty that there are noticeable differences between the various chemicals I have used; and when compared to the inherent problems with papers, differences in silver nitrate are probably not worth worrying about.

Paper

The historical calotype process was paper-based, and this creates a problem for those who want to make calotypes today. Modern paper is often made with cellulose and can contain chemicals, including hypo, that are detrimental to the process. Talbot's paper was what is loosely termed rag/gelatin; in fact, he had a preference for a particular kind and year of Whatman's paper: Turkey Mill 1840. A number of high-quality non-wood rag papers are on the market today, and experimentation will lead you toward the best paper for your conditions. As with most alternative photographic processes, each person's working environment, conditions, water chemistry, and materials will determine the relative success or failure. This point accepted, when considering papers for calotype negatives, the main considerations beyond the basic content of the paper are the following:

- Good wet strength
- White color
- No laid lines and (if possible) no watermarks
- A good, clean appearance overall, not blotchy, when held up to the light

Only a few modern papers fit these parameters. They include:

- Crane's 3111 writing paper (this has a watermark, so your image will need to be smaller than the sheet)
- Crane's Kid Finish (also has a watermark)
- Twinrocker 100% linen, gelatin sized

In the late 1840s, a special paper appeared—Turner's Patent Talbotype paper—that was ideal for making calotype negatives, although it did, on occasion, contain metallic particles that showed up as black specks in the finished images. A recent analysis of a sheet of this paper showed the following characteristics:

Dimensions: 23.8 cm x 16.8 cm
Type: cream, tub sized, rag wove, no watermark
Machine made
Grammage: approximately 90 gsm
Finish: probably plate glazed
Sizing: tub sized with gelatin
Loading: nil
Rag: 100%. Some cotton; mainly linen, with some lignified material probably derived from flax. Well beaten, and virtually free from aging indications.
Color: cream; no added pigment; probably self-color plus the effect of aging.

Unfortunately, if anyone has an unexposed sheet of this paper today, it will be well past its shelf life and the gelatin will have become brittle. Even more unfortunate is that to try and reproduce this paper today would probably be impossible, and certainly costly. The basic paper could be achieved, but it would be difficult to reproduce the same gelatin content. From my own experiments, it is the gelatin more than anything else that affects image quality.

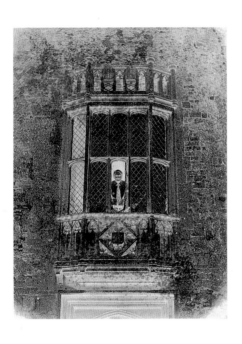

Richard Morris, Portrait of Robert Lassam at Lacock Abbey. *Calotype negative.*

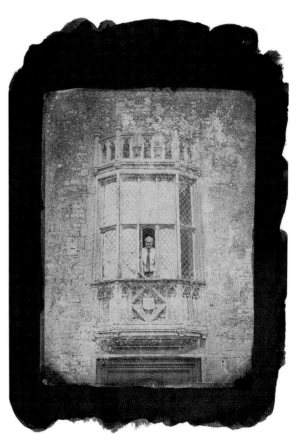

Richard Morris, Portrait of Robert Lassam at Lacock Abbey. *Salt print from the calotype negative at left. This print shows Robert Lassam, former curator at the William Henry Fox Talbot Museum, standing in the window that served as the subject for what is Talbot's oldest existing calotype negative. Talbot's negative was made from the inside, looking out of this window.*

Procedures

Iodizing the Paper

This part of the process involves coating one side of a sheet of paper with a solution of silver nitrate and then immersing it in a solution of potassium iodide. You may do this at any time since the iodized paper will keep almost indefinitely.

Distilled or deionized water should always be used with this process unless otherwise stated.

Preparing the iodizing solutions

1. Add 15 grams silver nitrate to 15 cc distilled water. Mix thoroughly and add more distilled water to make 200 cc of solution. This makes a 7.5% solution.

2. Separately, add 33.6 grams potassium iodide to 400 cc distilled water. Mix thoroughly and add more distilled water to make 600 cc of solution. This amount will accommodate 5 to 10 sheets of 8x10 paper. This makes a 5.6% solution.

Both of these solutions keep well in storage, so large quantities can be made up ahead of time. The silver nitrate solution should be kept in a brown glass bottle.

Coating the paper

1. Cut a sheet of paper to the size your film holder requires and clip it, using nonmetallic clips, to a board fitted with a sheet of clean blotting paper. In one corner, use a pencil to mark the side of the paper facing up from the board with an "X." This will identify which side of the paper has been iodized.

2. Brush the 7.5% silver nitrate solution over the paper with a clean buckle brush (see fig. 1), making sure none gets on the back of the paper. Allow the paper to become matte dry, i.e., with no pools of silver nitrate.

3. Immerse the paper totally in a tray containing the 5.6% potassium iodide solution, removing all air bubbles carefully. Leave at least two to three minutes. The paper will turn a primrose yellow on both sides.

4. Drain the paper and wash it in gently running water for several hours to remove the potassium nitrate, leaving the insoluble silver iodide behind.

5. Drain and hang to dry.

6. To make a negative with more contrast, hang the paper in sunlight for two hours. It is quite insensitive to light at this stage. If the paper shows brown blotches, it was not in the iodide bath long enough. If it does show brown blotches, throw that piece away, because it will be no good.

7. The iodized paper will keep for a long time if kept in an acid-free box or acid-free bags. *Do not* store it in the plastic bags that photographic paper manufacturers sell by the box for bromide paper or sheet films. The card stock from which those boxes are made contains chemicals that will damage the iodized paper and may have contaminated the bags.

Sensitizing the Paper for the Camera

Preparing the sensitizer
Mix stock solutions A, B, and C, and store them in separate bottles. These solutions have a long shelf life, but A and B should be stored in dark brown bottles since the silver nitrate is light-sensitive.

Solution A
Add 11.4 grams silver nitrate to 75 cc distilled water. Mix thoroughly and add more water to make 100 cc. This makes an 11.4% silver nitrate solution.

Solution B
Into 28.4 cc of solution A, add 5.5 cc glacial acetic acid.

Solution C
Into 100 cc of distilled water, add gallic acid and mix thoroughly until no more will go into solution. At this point it is a saturated solution of gallic acid.

Solution D (working solution)
Add three drops B and three drops C to 4 cc distilled water. This amount will cover approximately one sheet of paper about 6½" x 8½" (full-plate size). Mix a fresh batch of working solution for each sheet of paper iodized.

Coating the paper (under red safelight)
1. On a previously iodized (and dry) sheet of paper, mark out the exact dimensions required for your camera format on the side marked with the "X." *Use pencil only.*
2. Using a *fresh* buckle brush (fig. 1), coat the paper with the working sensitizer solution D and let it sit for about two minutes to react with the silver iodide. Note: Always use a fresh piece of cotton wool or cotton ball in the buckle brush for each stage of the process.
3. With a piece of clean blotting paper, blot the sensitized paper firmly and evenly all over. Let the paper dry by itself in the dark. The paper will be slightly moist when put into the camera.
4. Cut the paper to size and load your camera. Turn on the safelight to do this.

Important: When mixing acids with water, the acid should always be added to the water—not the other way around.

Fig. 1. *The buckle brush, named after a certain Mr. Buckle, is a glass or plastic tube with a lump of cotton ball or cotton wool stuffed into one end. The advantage of this is that a fresh brush can be used for each step of the process. This is extremely important in order to avoid contamination. It is best to make up at least three brushes ahead of time to help make the steps go as smoothly as possible.*

Making the Exposure

Use as large a camera format as you have available. Keep in mind that dark slides vary in quality and that some problems may be experienced with damp paper reacting with a metal sheath. If you use a glass plate holder, place a piece of black card behind the paper to avoid contact with the spring. In addition, put a sheet of thin glass or mylar on the top (sensitized) side of the paper, facing the lens. This prevents the dark slide from catching on the paper when it is withdrawn and re-inserted. The glass or mylar may come into direct contact with the damp paper. In fact, early calotypists often sandwiched their paper between two thin sheets of glass to keep it both flat and moist. Note, too, that some glues and linen hinges on old glass plate holders may affect the calotype paper.

Exposure times

On a bright, sunny day, begin with an exposure of two minutes at f/8. Your times will vary according to the sensitivity of your paper and the relative intensity of the light, but this is a good place to begin your experiments.

Developing the Negative (Under Red Safelight)

When it comes from the camera, the paper may either be totally blank or show a faint image. To develop the latent image, you will need the stock chemicals B and C from above that you used to sensitize the paper.

1. Place the exposed negative on a clean sheet of blotting paper with the X side up. Clip it to the firm board as before and make up several clean buckle brushes.

2. Mix equal amounts of solutions B and C—about 5 cc of each for a 6½" x 8½" print—and brush the chemical over the negative. The image will appear almost immediately.

3. Using a separate, clean buckle brush, apply a quantity of solution C. Do not over-wet. Allow the image to develop until it stops increasing in density, then recoat with C in the same way. The negative is fully developed when a good, contrasty image is visible when the print is held up to the red safelight.

4. Wash the negative briefly in plain tap water, then fix it for five minutes in the sodium thiosulfate solution. If the yellow potassium iodide stain is still visible, fix further until it has disappeared.

5. Wash thoroughly in gently running water for 10 minutes if you use a wash aid; at least one hour if you don't.

6. Dry face up on a clean fiberglass screen.

Final Preparation and Printing

Waxing

Waxing the negative makes it more translucent, which allows for faster printing. It also helps to remove the hair-like effect of the paper fibers in the final print. While there are different ways to do this, I find the following method gives good results. Use an iron that is dedicated to this purpose only. Do not attempt to iron your best shirt with this iron once you have waxed a calotype! Do not use a steam iron, or at least remove *all* water from a steam iron if that is all you have.

1. On top of a firm board larger than the negative to facilitate easier handling, place several sheets of clean blotting paper.

2. Place the negative on top of this, *image side down*. Lay another sheet of clean blotting paper on top of the negative.

3. Sprinkle wax chippings, either candle wax or beeswax, on the top sheet of blotting paper, then iron it into the blotting paper until the hot wax soaks evenly into the entire negative.

4. It will be necessary to experiment with the correct heat for each iron. *Do not* apply the iron directly onto the negative; if the wax burns, it will ruin the negative.

Making a print

Calotypists normally used salt (silver chloride) paper (see Chapter 3, Salt Prints) or albumen paper to make their prints. The calotype negative has a very high contrast, and both of these papers are very soft. If you print onto modern bromide papers, you will lose some of the tonal range of the negative. When printing onto either salt or albumen paper, always place a thin sheet of mylar between the negative and the printing paper to avoid one staining or contaminating the other. Calotype negatives can also be printed onto cyanotype paper, or onto any other printing paper that requires a contrasty negative.

Peter Marshall, Paris. Untoned salt print on Waterford NOT paper.

Chapter 3 Salt Prints

Terry King

History

Salt printing, the first method developed for making prints from negatives, evolved from William Henry Fox Talbot's efforts to make drawings using the camera lucida when he was on his honeymoon in 1833. A prism in the camera lucida enables one to perceive the paper and the scene at the same time, so that the scene may be traced onto paper. Although accurate drawings can be made using this instrument, one still needs to have drawing skills to be successful delineating a scene. Talbot did not have those skills.

Perhaps this was fortunate, because in his frustration he eventually invented the positive/negative system of photography as we now know it; we are concerned here with the positive. Talbot wondered if it might be possible to fix the image in a camera obscura, where an image is projected onto a solid surface or ground glass. Talbot was a chemist and a mathematician, and he was a member of the Royal Society, which had been founded 150 years earlier to advance scientific knowledge. He knew of the work of earlier scholars who had experimented with capturing the likenesses of objects using light-sensitive materials such as silver nitrate. When that chemical is exposed to light, the silver nitrate changes to metallic silver, producing a weak, pinkish-brown image.

By 1835, Talbot had photographed the oriel window in the long gallery of Lacock Abbey, his house in Wiltshire. He made some more experiments and distributed the prints to his family, but he did not take the idea further until he heard that Jacques Louis Mandé Daguerre, a French inventor, was about to announce an entirely different way of making photographs. In January, Talbot

put his prints on exhibit in London, and in February he disclosed his method to the Royal Society.

Talbot's experiments established that silver chloride gives a stronger image. The difficulty was that, while silver nitrate is soluble in water, silver chloride is not. Being a chemist, he knew that if he first coated the paper with salt (sodium chloride), allowed it to dry, and then coated it with silver nitrate, the silver would combine with the chloride in the salt. The combination would form insoluble silver chloride that would not wash away in water. The sodium would combine with the nitrogen to form soluble sodium nitrate, which can be washed out of the paper. Chemists call the exchange of chemicals in this way double decomposition.

Talbot's friend Sir John Herschel, who was very good at camera lucida drawing, found other means of making photographs. Most importantly, however, he suggested that since sodium hyposulfate (what we now call fixer) would wash away silver chloride salts that had not been turned to silver by the action of light, it could be used to prevent the paper from darkening completely. Herschel also thought up the name *photography* for this new art.

At this stage, Talbot was making paper negatives and printing them onto paper. He was using what has come to be known as a "printing-out" process, which means he was allowing light to do all the work of changing the silver chloride to silver to make the image, but this meant long exposures. However, if gallic acid was added the silver chloride would be changed into silver more quickly. This meant that exposures could be far shorter, and that the "calotype," as the new system was known, could be used for portraiture. Because it was not as important to have faster paper for the positive prints contact-printed in sunlight as it was for negatives made in the camera, prints continued to be made by the salted-paper method. Such prints are known as "salt prints."

Since the calotype process depended upon paper negatives, the fibers in the paper prevented fine detail from appearing in the prints. The shadows tended to block, and the highlights would burn out. The resulting prints were very painterly and were strong in contrast between light and shade. In painting, this way of presenting a scene is known as *chiaroscuro*, from the Italian for light and shade. Rembrandt used light in this way, and today some portrait photographers set their lights to achieve a similar effect.

Modern Salt Prints

Today's film, of course, has no fibers, which means that prints on modern photographic paper can have a full range of contrast, with detail in the highlights, middle tones, and shadows. The clarity of today's film base means that if

Terry King, Bosham Church. *Untoned salt print.*

we make a salt print using modern film materials for the negative, we have a great advantage over historical practitioners. Salt prints use a solution of silver salts that sinks a little way into the paper; the light-sensitive material thus is not only on the surface, but also beneath the surface. When the paper is exposed through a modern negative, those parts under the thinnest parts of the negative will darken first to act as a mask, slowing down the action of the light on the light-sensitive chemicals under the surface in those areas. The practical effect of this phenomenon is that more time is available for the light to work on the parts of the paper under the densest parts of the negative. This effect is known as "self-masking." Images printed-out on sized watercolor paper can print from negatives with greater contrast range than those on readymade silver gelatin paper.

It used to be said that printing-out papers needed contrasty negatives, but I think of it in the sense that using printing-out papers allows you to obtain a greater range of tone. In fact, a good negative intended for a printing-out process will have twice the tonal range of a standard develop-out negative. This means that if you are printing directly from your camera negative, the brightness range of your subject can be twice as great. Unfortunately, these coated papers are so slow that you would need an immensely powerful enlarger if you were to attempt to expose smaller camera negatives using a projection enlarger. If you do not have a large-format camera, you will thus need to make an enlarged negative (see Chapter 20).

Talbot regarded his work as the beginning of a new art, and, in fact, many of his early prints retain their original beauty after over one hundred and sixty years. A salt print made according to Talbot's method but with modern negative materials may be rivaled in its beauty, but it will not be surpassed.

Pure silver nitrate images do not have much depth of tone, because the darkest color they produce on paper is about that of milky cocoa. Talbot knew, however, that other light-sensitive silver compounds existed that were based on the halogen chemicals bromine, iodine, and chlorine. A silver chloride image can have a warm and deep brown color, with an impressive range of contrast.

When Talbot made his first positive prints, he experimented with a number of methods of stopping the action of the light once his negative and his prints had been exposed sufficiently to produce an image. An excess of sodium chloride worked, but it gave a lilac-colored print. Potassium iodide gave a print with brown darker tones and yellow highlights; potassium bromide a warm brown. Silver chloride gives a burnt umber brown. This brown can be made even richer by adding organic acids such as tartaric acid or citric acid. The additive that has become common is potassium citrate. It is the one I use to make my salt prints.

Terry King, Stoke-by-Nayland Church, Suffolk. *Untoned salt print.*

Talbot often made his prints on a Whatman paper that was sized with gelatin. The gelatin—the "size"—prevents the light-sensitive solution from sinking too far into the paper; it also reacts with the silver to give a richer, warmer color. If the solution sinks too far into the paper, the fibers of the paper get between the image and the viewer. I made a salt-print portrait of Bob Lassam, the first curator of the Fox Talbot Museum, sitting in front of a bust of Talbot. The print was deliberately made on lintless blotting paper in order to demonstrate this effect; both Bob and the bust look as if they are swimming in the mists of time.

Today I use 100% cotton rag watercolor paper for salt prints and other printing-out processes where I coat the paper myself. These papers give a surface texture that adds to the richness of the overall effect, a quality known as tactility.

It is these qualities that, I think, justify my claim that a salt print can be rivaled in its beauty by other types of print—the platinum print, for example—but it cannot be exceeded.

Opposite top: Peter Marshall, Montreuil, France, 1988. Gold-toned salt print on Georgian watercolor paper (20-minute print exposure in hazy sun).

Opposite bottom: Peter Marshall, St. Denis, France, 1988. Gold-toned salt print on Georgian watercolor paper.

What You Will Need

Chemicals

You may also use food gelatin.

- Photographic gelatin—260 Bloom deionized ossein (hard gelatin)
- Silver nitrate
- Potassium citrate
- Ammonium chloride (The pure form of ammonium chloride is cheaper than sodium chloride and does the job as well, if not better. It was the chemical most often used when salt printing was at its height.)
- Sodium thiosulfate
- Deionized or distilled water

Since tap water often contains chlorine, which will react with the silver nitrate, it must not come anywhere near your salt prints or the brushes you use.

Materials

- Three hake (Japanese for brush) brushes with a tied ferule (steel reacts with the silver nitrate)—one for the silver nitrate, one for the salt, and one for the size. Do not use these brushes for anything else!
- A palette (a white tea plate will do).
- A contact printing frame or two sheets of float glass.
- Beakers to mix the materials, for example a 250 cc glass beaker to mix the size and a larger glass beaker or other container to act as a water bath.
- UV light source (because direct sun or fluorescent tubes set close to the work give flat prints, use diffuse light from a high pressure mercury vapor graphic arts lamp or indirect outdoor light on a bright day to get good contrast).

Paper

100% cotton rag paper, either hot or cold pressed

- Fabriano Artistico Watercolor
- Whatman's Watercolor
- Saunders Waterford

Use a body-sized artists' watercolor paper. These allow the solution to sink slightly into the surface to take advantage of the "self-masking" effect. Gelatin sizing enhances this effect and allows softer and more absorbent papers such as Rives BFK to be used. I prefer to use heavier papers (300 gsm) since they are less likely to buckle in the wet processing.

Safelight

Low-level tungsten or red

Negative

With the method and materials I suggest, and taking advantage of self-masking, you should be able to make good salt prints with negatives at least twice as dense as those you would use for silver gelatin printing. A negative for a salt print should have a range of between six and seven stops, with a density range of somewhere between 1.8 and 2.0. A smaller density range will give a shorter range of tones and a flatter final print. This may, of course, suit a particular image. It is a good idea to buy a Stouffer step wedge, which shows these changes in half-stop stages.

If you are lucky enough to own or have access to a large-format camera, you can start to plan your salt print before you push the button. Increase the "normal" exposure to get full details in the shadows, and increase the development time by one third to achieve the necessary contrast range. This method can only be used with a traditional grain structure such as FP4. But if you are starting from a 35mm negative, you should make the best negative you can for silver gelatin paper and then increase the contrast range when you make your interpositive and your enlarged internegative. If either the original or the interpositive is too contrasty, you will lose detail when you try to increase contrast for the next stage.

Procedures

Sizing the Paper

The first task is to size the paper (this stage may not be absolutely necessary, but it will certainly improve the quality of your print).

1. Place 1 g of ossein (gelatin) and 5 cc of distilled water in a small Pyrex beaker (I use glass 200 cc urine-specimen jars) and set it aside for thirty minutes, or until the ossein has soaked up the water.

2. Heat 95 cc distilled water to 100°F, and add it to the swollen ossein. Stir with an inert stirrer, such as a glass rod.

3. Place the beaker containing the ossein in a water bath—a larger container with water at 120°F—and keep the water at that temperature.

4. Stir the ossein mixture from time to time until the ossein has completely dissolved. If when you hold the small beaker against the light, you can see that all the transparent filaments of ossein have dissolved and the solution is completely clear, the size is ready for use.

5. Wash the bristles of the hake brush in distilled water and remove excess water until the bristles are damp. (To identify the brush, write "gelatin sizing brush, distilled water" on the handle in waterproof ink.)

6. Warm the palette or tea plate.

7. Pour sufficient warm ossein onto the warm plate to cover the sheet of paper being sized.

8. With the hake brush, pick up the ossein from the plate and spread it onto the printing paper as quickly as you can. Hold the paper to the light and check to ensure that there are no dry patches left.

9. The ossein must not be allowed to gel at this stage. Place the paper in front of a fan heater immediately so that the temperature of the ossein does not fall below 95°F.

10. Dry the paper until there are no damp patches showing.

11. Place the paper in a confined space that also contains a tray of warm water. This will rehumidify the gelatin so that it does not absorb too much of the sensitizer when you coat the paper.

Ossein is cheap, so only make up enough solution for the day. Do not use poisonous preservatives. It should last one or two days, and it can be allowed to gel and then be heated two or three times for further use. Do not warm it above about 130°F, as there is a danger of the material losing its gelatin characteristics.

Salting the Paper

Salt the paper using the following solution:

- 10 g ammonium chloride
- 10 g potassium citrate
- Mix the two chemicals into enough distilled water to make 500 cc. (The solution is not light sensitive and will keep forever.)

1. Using a different hake brush—one with "salting solution only" written on the handle—apply the solution on a sheet of sized paper lightly and evenly, ensuring that there are no puddles, which will cause darker areas. If you leave gaps, there will be no reaction with the silver nitrate, and the image will be a weak pink in that area.

2. Leave the paper to dry. This need not be in the dark.

3. Mark off the image area to be sensitized; this should include space for a step wedge if necessary.

4. When the paper is dry, in safelight conditions, coat it further with 12% silver nitrate solution (12 grams silver nitrate with distilled water to make up 100 cc). Again, ensure that your coating is light and even, because puddling can lead to uneven coating and black and silver patches in the final print.

5. Dry the sensitized paper in the dark. Make sure that it is dry, because damp patches will print mauve instead of deep brown.

Use silver nitrate with care. Wear gloves when using it. Do not use it if you have open cuts. Light will turn silver nitrate that gets on your skin black, and you will have to wait for the skin's natural replacement process to get rid of it. Store it in a brown bottle marked POISON.

Printing

1. Attach the negative and a step wedge (until you have the experience to omit the step wedge) to the sensitized paper using Magic Tape in such a way that the sandwich will stay in register when you take the print out to see if it is done.

2. Expose in the printing frame or between two sheets of plate glass, using sunlight or an ultraviolet lamp.

3. Expose the print until it is one stop (two steps on a step wedge—see Chapter 19) darker than is intended in the final print. Be sure to keep the negative and paper in register when you check the exposure.

4. Wash the print in running water for two minutes, or until the wash water is clear, to dissolve and wash away the ammonium or sodium nitrate.

5. Fix the print in a 10% solution of pure sodium thiosulfate for 10 minutes. (The print will appear to bleach about a stop below what you want.)

6. Wash the print for at least forty minutes. Since the chemical reactions are now completed, it is safe to use tap water, but some workers still prefer to use distilled water at this stage (it depends on how much chlorine there is in your local water supply).

7. Hang the print up to dry. As it dries, it will darken to about one stop less than it was after exposure.

It is possible to gold tone the final print, but in my view this detracts from the rich umber color of the salt print.

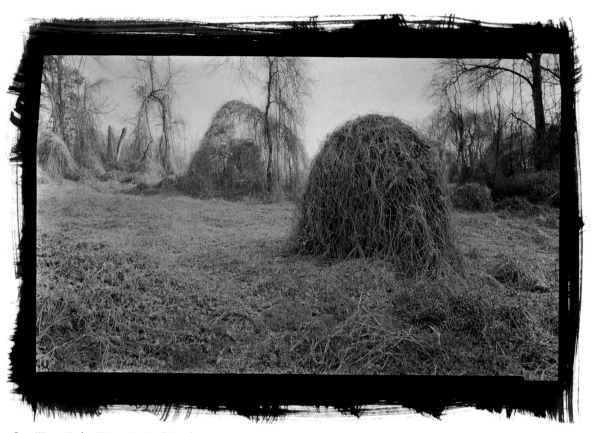

Sam Wang, Kudzu Winter III. Traditional cyanotype.

Chapter 4 Traditional Cyanotype

W. Russell Young III

History

Cyanotype is one of the simplest and most archival photographic processes. Since it uses only two inexpensive chemicals and develops in plain tap water, it is the perfect introduction for those new to alternative photographic processes. Its rich Prussian blue color presents a striking, fully scaled image; cyanotypes can be printed on various papers, and even on some fabrics.

Cyanotype is also one of the first photographic processes. Its procedures were first published by Sir John F. W. Herschel in 1842, in a paper called "On the Action of the Rays of the Solar Spectrum on Vegetable Colours, and on Some New Photographic Processes." Herschel's original album of experiments is in the collection of the Humanities Research Center at the University of Texas at Austin; those cyanotypes from the dawn of photography are as brilliant today as the day they were pasted into the album by Herschel's hand.

While Herschel was a pioneer of early photographic processes, he initially did not envision using the cyanotype for making prints from photographic negatives. Nevertheless, his previous photographic experiments undoubtedly led to his cyanotype discovery. In fact, it was Herschel who enlightened William Henry Fox Talbot, inventor of the first positive/negative photographic process, about the abilities of sodium thiosulfate (what we now call fixer) to make photographic images permanent; it was also Herschel who introduced the term *photography*.

In its early days, the cyanotype was rarely utilized for making photographic prints. Herschel himself intended it as a means for duplicating mathematical tables. However, some artists, such as Henri Le Secq, did make cyanotype

prints from negatives in the 1850s. In addition, the earliest-known photograph-ically illustrated book, made by Anna Atkins in 1843, exclusively used cyan-otype for both the text and the illustrations.

Because of their utter simplicity and speed of processing, photographers have used cyanotypes to make proof prints from negatives while still in the field; in the 1850s, M. J. Diness proofed the collodion wet-plates he made in and around Jerusalem, and early-twentieth-century artists such as Edward S. Curtis and Arthur Wesley Dow routinely used cyanotypes in this manner.

A number of American companies sold presensitized cyanotype paper from the 1870s until around 1930, yet the cyanotype never experienced widespread acceptance. There are two likely reasons for this. First is the misconception that the process yields too short a tonal range to be useful, but perhaps more rele-vant is the fact that the nearly immutable Prussian blue color is unsuitable for many subjects.

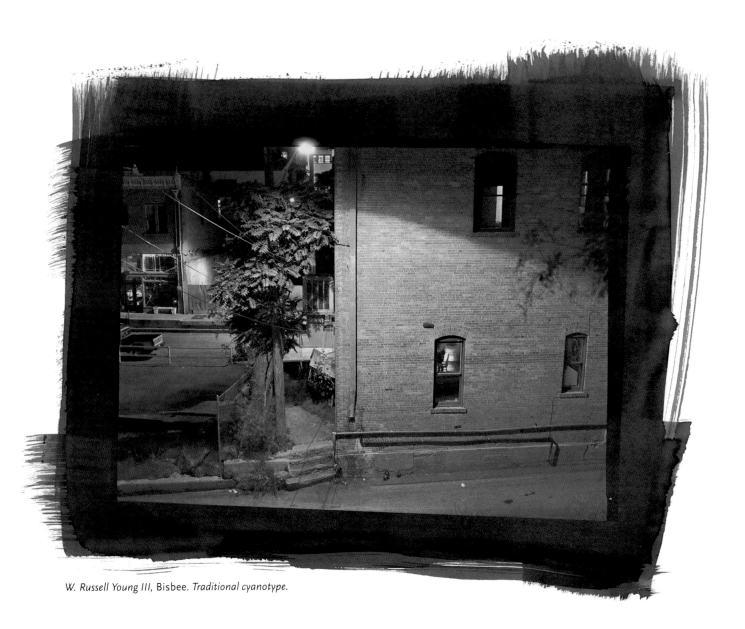

W. Russell Young III, Bisbee. *Traditional cyanotype.*

What You Will Need

Chemicals

- Potassium ferricyanide
- Ferric ammonium citrate
- Sodium borate or lead acetate (optional, for toning)
- Distilled or deionized water

The chemicals needed for cyanotypes are inexpensive. They keep well both dry and in solution, and they are relatively safe to handle, assuming proper care is taken.

Ferric ammonium citrate comes in two forms: a brownish-red scale and a green powder. The latter is more light sensitive and, in my experience, produces a longer tonal range print. I suggest using the powdered form for better results. You must exercise care in purchasing the potassium ferricyanide; there is a very similar compound, potassium ferrocyanide, that will not work for cyanotypes.

Over time, the mixed ferric ammonium citrate solution will grow a fungus that floats on the surface. This does not affect its usefulness, but the fungus should be strained through a paper coffee filter or a piece of cheesecloth before you coat the paper. Once mixed, the potassium ferricyanide breaks down gradually over a period of months. If your prints lack a deep blue tone, try replacing this solution first.

Store both of these solutions in brown glass bottles and keep them out of extended bright light and heat. Brown glass is needed because both chemicals are light-sensitive, albeit at a very low level when in aqueous solution.

Materials

- Foam brush (wooden handle only; the foam on brushes with plastic handles crumbles)
- Adjustable-heat hair dryer
- Ultraviolet light source (sun or artificial)
- Washing tray with running water
- Drying line or screen
- Contact printing frame
- 100 cc brown glass dropper bottles (2)

Paper

Paper selection is especially critical for best results because the cyanotype process is finicky. Suitable papers have substantial wet strength, and they will produce a strong deep blue color and clean whites, with no graininess. (Graininess can be caused by chemical and physical interactions with the paper; it is different from the grain inherent in the negative.)

Use only nonbuffered papers. Buffered papers contain certain alkalies that will bleach the image, either immediately or over time, or interact adversely with the iron-based chemicals of the cyanotype. Good papers with which to begin your experiments include the following:

- Crane's Parchmont Wove
- Crane's Platinotype
- Bienfang 360 Layout paper
- Whatman's Printmaking paper
- Arches Platine

Safelight

Low-level tungsten

Negative

The negative for cyanotype printing should be slightly contrasty when compared to a negative that prints well on silver gelatin paper; it should have a density range between .95 and 1.4. A step wedge test can measure the density best suited to a given paper.

Procedures

Preparing the Sensitizer

Solution A

Potassium ferricyanide	4 g
Distilled or deionized water	50 cc

Solution B

Ferric ammonium citrate (green)	10 g
Distilled or deionized water	50 cc

Mix the two stock solutions separately, and store them in the brown glass bottles. These chemicals both go into solution easily by shaking or stirring at room temperature. It is important to mix them with distilled or deionized water to prevent reaction with iron, either dissolved or as rust flakes, that might be present in your tap water. Any free iron will cause blue streaks when you coat the paper.

Sensitizing the Paper

To optimize the life of your foam brush, wash it with running water, gently squeeze it dry, rinse it in distilled or deionized water, and then squeeze it dry again. A clean brush will last a long time; if it is not cleaned properly, it will contaminate all future prints.

1. Mix the potassium ferricyanide and ferric ammonium citrate solutions together in a 1:1 ratio immediately before use. Mix enough of the combined solution to coat the paper. The chemicals are so inexpensive that you should not be concerned about having a little extra working solution left over. I mix them in an empty, well-washed plastic margarine tub.

2. Dip the foam brush in the combined solution and blot it against the edge of the container the same way you would a paint brush against a paint can. Just how wet the brush needs to be depends upon the paper and how heavy-handed you are in coating it. Coat the paper by brushing first horizontally, then vertically; work the excess solution to a corner of the paper and soak it up with the foam brush.

The number of passes you make with the brush will be determined by the paper; some surfaces only need a single pass in each direction to be evenly coated, while others may require multiple passes. (After a trial print is dry, look for tiny white specks in the image that are symptoms of either inadequate coating or fibers in the paper that will not pick up the chemicals.)

3. The paper should glisten with moisture for a few seconds and then become matte. Lay the sensitized paper on a horizontal screen in the dark to dry. Do not hang it vertically; you do not want the sensitizer to migrate to one corner.

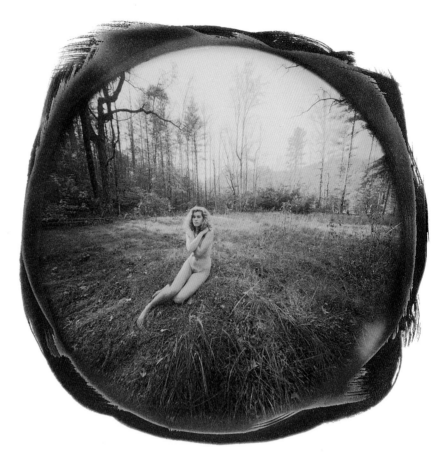

Sam Wang, Figure in Landscape. *Traditional cyanotype.*

Use the coated paper within a few hours to obtain maximum results; just how long it may be stored depends on the ambient humidity of your workspace—the higher the humidity, the shorter the paper's unexposed life. If you must leave the coated and dried paper overnight, it should be put into a desiccated, light-tight box.

4. Air-dry the paper for about an hour or until it is completely dry. Or, about five minutes after coating, blow-dry the paper on both sides using the lowest heat setting on a hair dryer. You must be consistent in drying in order to obtain repeatable results. At this stage, the paper should be a yellow with a tinge of green. Since the cyanotype is a relatively insensitive process, the paper may be coated under low-level tungsten light levels; this makes it much easier to observe your coating quality and remedy any unevenness you may notice.

The coated paper should remain a light yellow color. Any hint of green or blue, either as an overall color or in a particular area, indicates that the paper is chemically fogged and will be incapable of producing a fine print.

5. Repeat the coating process a second time. Make sure the paper is completely dry. On most papers, the additional coat produces an image with a noticeably deeper blue.

Cyanotype on Fabric

Cyanotypes may also be printed on some fabrics that have cotton or linen content. You must wash the material in hot water before using it to remove the sizing chemicals, dust, and lint. The sizing should be removed because you will have no idea what the manufacturer used or whether it is evenly applied. Hot water removes the sizing agent more efficiently, and it may help to preshrink the fabric to make it denser. Iron the fabric smooth after it is dry.

Carol Adelman, The Bedjacket. *Cyanotype on fabric.*

Coat the fabric with a brush in the same way you coat paper, make the exposure, and develop the image in water. If sizing is needed to prevent the cyanotype chemicals from soaking in too deeply, a light coat, or multiple light coats, of spray starch may help. You can also mix a solution of cornstarch and brush it onto the fabric, although it may be difficult to get the coating even and between the threads, especially if the weave is rough.

The higher the fabric's thread count, the sharper the image will be, and often the deeper the blue will be. Pima cotton is a very good choice, as are cotton muslins, simple bed sheets, and some cotton/poly-ester blends. Remember that any cotton fabric may have been treated, and these treatments can make huge differences in how well the material works for cyanotype. Natural fiber content does not guarantee a good cyanotype print; you must experiment on various samples, just as with cyanotype on paper. Art supply stores offer nonprimed cotton and linen canvas by the yard. When testing fabric samples, label each with a waterproof marker or standard laundry marker, since the samples will look very much the same.

Subsequent washing of the finished cyanotype on fabric will weaken the image to some degree, and it is important to use a nondetergent product such as Woolite to minimize any bleaching. Never use a powdered detergent, since it does not dissolve thoroughly or rinse out of the fabric cleanly. Ironing a cyanotype at too hot a temperature may alter the hue slightly, so use the coolest setting possible.

Printing

1. Place the negative emulsion-to-emulsion with the sensitized paper and put them in your contact frame with the negative against the glass. Expose the frame to UV light. The paper must be *bone dry* before exposing a print. If it is not, several problems may occur; the damp area can stain your negative permanently, and even a slightly damp region will solarize. As soon as the sensitized paper is struck by UV light, the colors begin to change. A correctly exposed, full-tonal-range print will turn an olive-drab green in the highlights, the mid-tones will be a dirty blue, and the shadows will usually become a pale blueish-gray. The shadows may also reverse. Since this is a printing-out process and you may monitor the progress, you should have relatively few bad exposures once you gain a little experience. You must overprint the image, although to what degree depends on the particular paper. With my favorite paper, about five steps of density as shown by a step wedge will wash away.

2. Developing, fixing, and washing are all achieved in the same process—rinsing the exposed print in water, nothing more. First, remove the print from the contact printing frame, place it face up in an empty tray, and gently add water. I use a small ¼" hose and gently play the water back and forth across the surface of the print. Although cyanotype is not particularly temperature-sensitive, this procedure should be carried out with normal darkroom water temperatures. A range of 65°F to 75°F will work well; if the temperature is under 65°F, you risk incomplete clearing and washing. At over 75°F, your paper may become dangerously soft and could fall apart in the wash water.

As soon as the water hits the paper, the unexposed part of the image will dissolve and wash away. The lightest areas will also wash away, but some of the uniformly dark tones will begin to show tonal separation. The greenish high-lights will turn blue, and the blue mid-tones will deepen, having already become Prussian blue (ferric ferrocyanide) through exposure to the UV light. The areas that appear light gray, because of their relative overexposure from the UV light, consist mostly of Prussian white (ferrous ferrocyanide). This will oxidize to blue upon contact to oxygen that is either dissolved in the wash water or present in the air during drying. It is important to clear the image in gently running water; this prevents the highlights from becoming stained by the dissolving iron compounds.

3. Dump the wash water four or five times over a period of roughly five minutes. The timing depends on the paper, because some discharge the iron readily and others are slower to do so. Excessive washing will lead to bleached highlights, especially if your water is very alkaline.

A shallow, flat-bottomed Tupperware container makes a great substitute for standard photo trays for cyanotype printing.

If you suspect your tap water is too alkaline—graininess and bleached highlights are the typical symptoms—add ¼ oz. of 28% acetic acid to two liters of water in the initial wash tray. You can also use other photo stop baths, or even a little vinegar if that's all you have.

Spotting out dust and other light-toned flaws in a cyanotype image is quite easy; use a high-quality Prussian blue watercolor. It is an exact color match with the cyanotype.

4. Dry the print face up on a clean fiberglass screen. As the print dries, the darkest areas (D-max) of the image will deepen, although the tonal separations will not change.

Some sources recommend rinsing the developed print in various solutions to intensify the D-max; the experience of many careful printers has been that this has *no* effect on the D-max of the dried print and unnecessarily adds chemicals that may be deleterious to the print.

Toning

My best advice for toning cyanotypes is this: If you want a color other than the Prussian blue natural to the cyanotype process, use some other printing method! There are ways in which to alter the cyanotype's signature color, but none of the formulas that produce reds or browns is stable. The prints will either yellow or fade in a matter of weeks. Subtle variations to basic blue are achievable, however, by using either of the following chemicals as a toner.

- 5% solution of lead acetate. Deeper, more ultramarine blues can be achieved by immersing the print into this solution, *but note that this is an extremely toxic compound.* The print can be immersed in this toner either wet or dry.
- 2.5% solution of sodium borate. Immerse a completely dry print for only a few seconds, as the action is very rapid.

Wash the toned prints thoroughly in running water, or uneven fading may occur over time.

Archival Considerations

Since Sir John Herschel's original cyanotypes are still in mint condition, we know with certainty, and without encountering methodological issues about accelerated aging tests, that the process is inherently stable. The issue, therefore, becomes one of storage. Remember that cyanotypes are extremely sensitive to alkaline environments (pH > 7.5), so the standard rule of thumb for most types of photographic image does not hold here. Never store cyanotypes in an alkaline box, or use alkaline mat board or interleaving tissue. Use only unbuffered rag board; Light Impressions (see Resources) sells such board in both bright white and cream. Silk and wool are also sensitive to alkaline storage conditions, so boxes made for their storage are probably safe for cyanotypes as

well. Any quality mat board is pH rated and labeled as to whether it is buffered. Always check; *nearly all mat board today is buffered, and it will destroy your cyanotype artwork.*

Bibliography

Ware, Mike. *Cyanotype: The History, Science and Art of Photographic Printing in Prussian Blue.* Bradford, England: National Museum of Photography, Film & Television, 1999.

Mike Robinson, Flatiron Building, New York. *Gold-toned albumen print.*

Chapter 5 Albumen

Mike Robinson

History

Albumen printing was by far the most common photographic printing process used in the nineteenth century. It dominated the industry from 1855 until about 1895, when it was gradually replaced by the presensitized and easier-to-use collodion and gelatin printing-out papers. Albumen prints are recognizable by their purplish-brown image color and by varied degrees of yellowing in the highlights. Historically, an albumen print made from a wet-collodion glass negative remains unsurpassed in its capacity to render detail and tone; it represents the highest level of quality attainable with silver-salt imagery.

Albumenized paper was introduced on May 27, 1850, by Louis-Désirée Blanquart-Evrard. The use of albumen, a natural product derived from egg whites, was a tremendous improvement over previous salting methods since the silver image is formed in a separate layer suspended above the surface of paper. This separate binder layer of albumen allows the print to have increased density and brilliance, as well as an improved ability to resolve the details of the negative.

After 1860, the demand for prints spawned an industry in albumen paper manufacture. Factories were built in France and Germany near the sites of paper mills capable of producing paper of the highest quality. At the height of albumen paper production in 1888, one firm in Dresden, Germany, consumed over six million eggs to produce close to nine million sheets of paper. Illustrations in nineteenth-century photographic manuals showing the various steps of the manufacturing process indicate that the paper was hand-coated by floating sheets on albumen in trays, and that the majority of the work was

performed by women. Factories provided albumenized stock in a variety of surface textures, ranging from a diluted albumen matte paper to a double-coated and roll-pressed high-gloss finish. To prepare the paper for printing, the photographer simply floated the albumenized paper on a sensitizing bath of silver nitrate solution.

While the use of albumenized paper continued well into photography's dry-plate era, it ceased to be available as an item of commerce shortly after World War I.

Process Overview

Albumen is prepared by beating the whites of hens' eggs to a froth and dissolving into this liquid a quantity of ammonium or sodium chloride and a trace of acetic acid. The beaten froth then settles back into a clear, homogeneous liquid that, when filtered and aged for a time, provides an ideal solution from which to prepare albumenized paper. A thin paper stock is coated by floating it on a tray of the prepared albumen mixture. The paper may be double-coated to provide a glossier, more evenly coated surface.

To make the albumenized paper light sensitive, it is floated on a silver nitrate solution under safelight conditions. A weak (40 watt or less) tungsten light is safe for the albumen process. The silver nitrate reacts with the chloride in the coating to form light-sensitive silver chloride particles suspended in the albumen above the paper surface. To be light-sensitive, there must be an excess of silver nitrate in relation to the chloride present. Typically, for greatest printing speed and print density, the silver-to-salt ratio should be approximately 4:1 or 5:1.

Albumen printing, like most nineteenth-century techniques, is a printing-out process. The image is printed by ultraviolet light energy alone, without chemical development. Enlarging is thus impractical, and prints must be made in contact with the negative. A typical exposure time can vary from five or ten minutes under direct summer sun to several hours in weak diffuse light. The direct rays of intense sunlight are best for full-scale negatives, since they yield a lower image contrast than does diffuse light. In fact, historical references advise printing weaker (less contrasty) negatives by turning the contact frame

away from the direct rays of the sun. Fortunately for us today, there are many good artificial UV light sources available that provide consistent exposure intensity, night or day.

Variables that affect the appearance and quality of the print are as follows:

- Choice of paper stock
- Single vs. double coating of albumen
- Percentage of chloride content in the albumen
- Strength of the sensitizing solution and duration of flotation
- Quality of the light source during exposure
- Negative density range
- Toning
- Fixing

Early references suggest that some degree of contrast and speed control is possible in the manufacture of albumen paper; however, these controls seem to be achievable only at the expense of optimum print quality. Adding ammonia to the silver bath and/or subjecting the sensitized paper to ammonia fumes were techniques used to increase the contrast and sensitivity of albumenized papers. These measures are unnecessary when the salt/silver quantities outlined here are used with negatives of optimum contrast.

Albumenized paper will show an increase in printing speed with the increase in excess silver nitrate. A weaker silver bath would be beneficial for printing lower-density-range negatives, but at the expense of rich print density. Double-coated paper exhibits a smoother and glossier surface, as well as a greater maximum density. The higher silver chloride–content paper will print the greatest negative density range (2.00 to 2.50). Use the formula (3.0% ammonium chloride, 12% silver nitrate) suggested here as a standard.

What You Will Need

Chemicals

- 28% acetic acid
- 70% isopropyl alcohol
- Ammonium chloride
- Silver nitrate
- Sodium borate (Borax)
- 1% gold chloride solution
- Sodium acetate (for optional acetate toner)
- Sodium thiosulfate, anhydrous or pentahydrate
- Sodium carbonate
- Sodium sulfite
- Sodium thiocyanate (for optional thiocyanate toner)
- Kaolin

Materials

- Two dozen farm-fresh eggs
- Blotting paper
- Cheesecloth or similar filter
- Clothespins
- Nylon string
- Paper towels
- Brown glass bottles (1000 cc) (3)
- Brown glass bottles (500 cc) (2)
- Glass baking dishes, 10.5" x 15" (2 or more)
- Glass beaker (500 cc)
- Glass funnel
- Glass stirring rods (2)
- Litmus paper

The vellum paper is easier to handle for coating, as bubbles can be seen through the back of the paper, but the Strathmore has a nice weight with less tendency to curl when dry. I suggest you practice coating with the vellum and switch to the better paper when you get the hang of it. Double-coating yields glossier prints with more even coating and greater density, but it is more difficult to do.

Paper

- Strathmore 500 single-ply (plate finish or equivalent)
- Clear Print Drafting Vellum (for practice)

Safelight

Low-level tungsten (15 watt)

Negative

Long-scaled, dense negatives print best. 2.0 to 2.5 is a good density range.

Procedures

Preparing the Albumen

1. Get some eggs. To make 500 cc of albumen, which is enough to double-coat about fifty 9" x 12" sheets of paper, you need approximately fifteen extra-large eggs. (If you're clumsy, get two dozen.)

2. Separate the eggs. Do one at a time using a small dish, and be careful not to get any stringy bits into the egg white. If any yolk gets into the dish, discard the entire egg. The yolks are high in sulphur content and would destroy the archival permanence of the finished image. Once you have separated the egg, pick out the debris and pour the egg white into a graduate. Repeat this process until you get to 500 cc of egg whites.

3. Add to the egg whites 2 cc of 28% acetic acid, 15 cc of distilled water, and 15 g ammonium chloride.

4. Stir until the albumen has been converted to a froth. To be historically correct, use a bundle of quill pens. If you have a magnetic stirrer—the kind used in most chemical labs—one hour of stirring is OK. The point is to froth the solution well.

5. Cover the albumen mixture and let it settle in a refrigerator for twenty-four hours; then remove the froth that has collected on top. Filter the albumen through cheesecloth or a plastic scouring pad and let it age in the refrigerator for at least a week. The older it gets the better.

Coating the Paper

Albumen should be stored in the refrigerator and brought to room temperature for use. Be very careful to filter the albumen before use; cheesecloth works well. Try to remove any bubbles and debris from the albumen once it is in the tray. Also before coating the first sheet of paper, drag a piece of paper across the surface to remove any impurities.

Mike Robinson's Coating Tips

The albumen must be *absolutely clean* when poured into the tray. Eliminate all bubbles, dirt, or stringy bits of albumen by filtering it through cheesecloth or a plastic scouring pad. As a tray, I use a glass Pyrex baking dish with a white paper under it so that I can see impurities in the albumen. These should be carefully removed with a glass rod. You can also draw a small piece of paper across the surface to skim off debris before you float the paper.

I use Strathmore Artist Drawing 500, a single-ply plate-finish paper cut to 9" x 12" for 8x10 negatives. The trick I use for floating is to fold up a ¼ inch, 90-degree bend along the entire width on both ends of the paper. Not only do these bends provide "handles," but they prevent the paper from curling in that direction. I keep light pressure on the handles with my fingertips to keep the paper from curling in the other direction.

The floating method that works best for me is to hold the paper over the tray and let it bow in the middle. I then lower the far edge of the bow down to the solution; as it touches, in one smooth motion, I lower the near edge of the bow and then each side. This method seems to drive out any bubbles quite well. I remove the paper from the solution by picking it up in a steady continuous motion from one corner. Jerkiness during this step may show uneven density on the print.

I hang the sheet up horizontally by two corners so that the paper bows with the albumen side out. I continually blot off the drip ridge that forms on the bottom. This is crucial to even sensitizing later.

When the paper is dry, float it for a second time and hang it in the opposite direction as the first time. This should give very even results. I air-dry my albumen paper, which I find does not take very long. It is said that heat drying will provide glossier paper. My double-coated albumen paper has a surface sheen similar to Ilford Multigrade fiber-based (glossy) paper that has been air-dried after processing. Historically, extreme glossiness in the albumen surface was created by burnishing the print with a heated high-pressure roller during mounting. Early albumen paper was very thin, and it was necessary to mount the prints to a thicker paper or card stock. Unmounted albumen prints curled up into a tightly wound tube.

The key to even sensitization is to make sure the albumenized paper is fairly supple and flat. As it dries, the paper curls and becomes quite stiff and hard to manage. If the paper is dry and stiff, it helps to humidify it by suspending it over a tray of hot water. Often it helps to draw the reverse side of the paper back and forth over a rounded edge to shape it and make it more flexible. It is beneficial to store the albumenized paper face to face under weight (an old book press works great). It will remain very flat for easier sensitizing at a later date.

I cut the paper larger than the negative size because the perimeter of the paper will always be irregular in coating and printing density, but this unevenness should not occur in the image area. Also, the borders of the paper provide a good area with which to judge printing exposure. Maximum density is reached when the borders of the print begin to "bronze."

Single coating

1. Pour the albumen through a cheesecloth or plastic scouring pad filter into a glass baking dish. Float the paper on the albumen surface. Don't get any albumen on the back of the paper; the print will have uneven density in that area.

2. Check for air bubbles (break them with a glass rod or plastic toothpick).

3. Once all bubbles are gone, start the timer and float the paper for three minutes. With a smooth and steady motion, pick the paper up out of the tray starting from one corner.

4. Hang the paper with clothespins on the nylon string along the long side. Blot off the excess from the lower edge as it dries to avoid a thicker coating there.

Double coating

1. Follow steps 1 to 4 above; then immerse the dried paper for about 15 seconds in the following bath.

> **Albumen Coagulating Bath**
>
> | Isopropyl alcohol 70% | 1 liter |
> | Ammonium chloride | 30 g |

This hardens the albumen for the second coat. If you don't do this, the first albumen coat will wash off during the second floating.

2. Refloat the paper in the albumen solution a second time for three minutes. Hang it up from the opposite two corners this time to ensure even coating.

3. Blot off the excess along the bottom edge.

An alternative to this is to skip the alcohol bath and use a very short second flotation, approximately 10 to 20 seconds at most.

You may sensitize the coated paper as soon as it is dry, but albumenized paper will keep well if you have to sensitize it later. Store it under a weight or contained in such a way as to prevent it from curling; the flatter the better for sensitizing it on the silver bath. Sensitized paper *cannot* be stored successfully.

Sensitizing the Paper

Under low-level (15-watt) tungsten light:

1. Mix 30 g of silver nitrate with enough distilled water to make 250 cc. (This makes a 12% solution.) Silver nitrate solution is not light-sensitive until it comes into contact with organic material, such as salted albumen or human skin. Wear surgical gloves and eye protection—silver nitrate splashed in the

eyes will cause permanent damage! The bath will blacken with use as organic matter is dissolved into it.

2. Pour the sensitizer into a glass tray. After checking for air bubbles, float the albumenized paper on the solution for three minutes. Do not get any of the silver solution onto the back of the paper.

3. Slowly peel the paper off the surface and hang it to dry.

The silver bath loses strength with each sheet sensitized. To avoid weak prints and uneven sensitization, a defect known as the measles, the silver bath should be replenished regularly using a 24% solution of silver nitrate. Replenish with 15 drops of this double-strength solution per 8x10 print, or add 5 cc after every five 8x10's. Stir the replenisher into the silver bath with a clean glass rod.

If you want to reuse the silver bath in several printing sessions, add 15 g of kaolin per liter when you mix the 12% silver nitrate solution. The kaolin will absorb the organic impurities introduced by the albumen paper and settle to the bottom of the bottle. Replenish the solution in the sensitizing tray as described above. After a day's printing, pour the silver bath into the bottle and shake it; the kaolin will absorb the organic impurities and leave the bath clear for the next sensitizing session. Decant the clear silver bath with a siphon to avoid disturbing the kaolin. This bath will continue to work for months if properly managed.

Printing

Print as soon as the sensitized paper is dry. You can expect to lose about two stops maximum density and speed if you wait until the next day. If you wait longer than that, you can resort to citric acid preservatives and ammonia fuming to restore speed and contrast, but it's not worth the effort.

1. Find some sunshine on a warm day if you can. A high UV light source is needed if you print indoors. Printing albumen in the sun is about twice as fast as with UV fluorescents. Printing in the shade will take hours; also, the longer it takes to expose the print, the greater the tendency for highlight yellowing.

2. Put a suitable negative with a density range of 2.0 to 2.5 in contact with the paper. Use a hinged-back frame so you can check exposure without disturbing registration.

3. Print until the shadows are just staring to "bronze," which means you've reached maximum density. The bronzing is seen as a metallic sheen in the print border or deep shadow area of the image. If the negative is thin, print until the highlights are about 1 to 1.5 stops too dark. Printing times will vary

If your quantity of silver nitrate is limited, an 8x10 sheet of paper can be floated on as little as 100 cc of the 12% solution, which should sensitize five to ten sheets. Use only enough solution in the tray to fill it to a depth of 0.5 cm for easier handling.

Mike Robinson, Central Park, New York. *Gold-toned albumen print.*

depending on the type of light source, the strength of the silver bath sensitizer, and the density of the negative. A thin negative will be fully printed before any bronzing occurs. The print lightens up during processing.

Processing and Toning

Wash the print to remove the excess silver nitrate. The wash water will turn milky when it reacts to the silver. After about ten minutes, the wash water should be clear. Prints that are not washed sufficiently at this point may develop black spots.

Toning is expensive, but it is necessary to improve the final image color and permanence of the print. Untoned albumen prints are reddish in color, but gold-toned prints have a pleasing purple-brown color. An alkaline bath made with sodium borate and gold chloride will yield cool brown to purple tones. A bath of sodium acetate and gold chloride will yield stronger purple tones. The toner temperature should be at least 68°F. Warmer toning baths will tone faster, but toning cannot be done with time alone as a guide. The art of albumen toning is knowing when to stop.

Aside from the difficulty in manipulating the paper during the coating and sensitizing stages, gold toning is perhaps the most challenging and rewarding

part of the albumen process. Knowing exactly when to stop the toning process comes only through experience, since the color of the print when viewed in the toning bath will be different than it is when the print is dry. Attempting to standardize on a time is ineffective, because the toning bath changes with every print toned. Toning thus must be done by inspection.

There are many different gold toning formulas. Here are just a few.

Alkaline gold toners

Borax gold toner

Distilled water to make	1000 cc
Borax Solution	1000 cc of 2% solution (in distilled water)
Gold chloride	20 cc

Borax gold toner is only usable for one half hour after mixing. Replenish mixture with five drops of 1% gold chloride after each 8x10 print.

Sodium acetate gold toner

Distilled water	750 cc
Sodium acetate	20 g
Gold chloride	45 cc of 1% solution
Distilled water to make	1000 cc

Acetate gold toners require at least twenty-four hours to ripen after being compounded. They function best around a pH of 9. If the pH is too high, toning becomes too rapid and does not penetrate into the albumen layer. Much of the image color will be on the surface of the print and will be lost in the fixing bath. When the pH of the toner is too low, the print will not tone, even after several minutes. Monitor the pH of your alkaline baths with litmus paper.

Thiocyanate toner

Distilled water	750 cc
Sodium thiocyanate	35 g
Gold chloride	70 cc of 1% solution
Distilled water to make	1000 cc

This bath will immediately turn red in color when it is mixed, but after a few minutes it will become colorless. It is usable when clear. To maintain the strength of the toning bath, add five drops of 1% gold chloride solution per 8x10 print toned.

The sodium acetate bath can be reused if the gold content is kept up with replenishment. To replenish it, add about five drops of 1% gold chloride solution after each print. The borax and thiocyanate baths are generally one-time-use formulas, since they lose their toning ability after one or two sessions.

Toning procedure

1. After the excess silver nitrate is washed from the print, immerse it in the toning bath.

2. Tone until correct tone is achieved: Upon entering the toner, the print will lighten, and its color will shift toward a reddish tone. Eventually the tones will shift back to a colder brown or purplish hue. Tone until the highlights and midtones show a distinct color shift. The shadows may still be a little reddish. The color will change again toward red in the fixing bath and then back again when it dries. The print's color when dry will be different from any of the colors seen during processing.

3. Rinse.

4. Fix. Add 150 g sodium thiosulfate and 2 g sodium carbonate per liter of distilled water to make a simple, slightly alkaline, fixing bath. Use of two successive fixing baths of four minutes each is highly recommended for complete fixation and image permanence.

Conventional acid fixers should not be used for albumen prints, because these will bleach the print excessively. The carbonate is added to the plain hypo bath to make it slightly alkaline. Modern rapid fixing baths are not suitable.

5. Immerse the print in a 1% sodium sulfite solution. This is a simple washing aid that should be made fresh for each printing session and discarded after treating twenty 8x10 prints. Five minutes with continuous agitation is plenty.

6. Wash for at least thirty minutes.

7. Squeegee the print dry and hang it up or blot it dry under weight. A finished albumen print is very curly and should be mounted according to conservator's procedures. You can store the print in a mylar sleeve with a mat board of the same size for support.

Good luck! Albumen printing is tricky at first, but you soon learn what works and what doesn't. Frustration before success is part of the game.

Mark Osterman, Ross Abbey Transepts, County Galway, Ireland, 1996. 18" x 13". Sulfide-toned silver-gelatin print from a wet-collodion negative.

Chapter 6 Collodion: Wet-Plate Negatives, Ambrotypes, and Tintypes

Mark Osterman and
France Scully Osterman

The collodion wet-plate technique can be used to make images in three distinct classes: collodion negatives; ambrotypes and tintypes, which are positive collodion images viewed by reflected light; and collodion positive transparencies. All involve coating a plate with collodion containing bromides and iodides and then sensitizing the collodionized plate in silver nitrate. Collodion formulas, as well as developer formulas and developing techniques, differ slightly between the classes, as does the choice of fixer.

Collodion Negatives

Collodion negatives are made in-camera by giving the plate full exposure and then extended development with a weak developer containing either ferrous sulfate or pyrogallic acid. Sodium thiosulfate is traditionally used to fix the developed plate. The negatives can be used to make prints on both printing-out and developing-out papers.

Collodion Positives Viewed by Reflected Light

- Ambrotypes—positives on glass.
- Ferrotypes, also known as tintypes—positives on metal plates.

Both ambrotypes and ferrotypes are made in-camera. Unlike modern photographs, the areas of silver in these images are light colored, a property

inherent to the collodion process. Collodion positives require less exposure than negatives, and they are processed with a stronger ferrous sulfate developer for a shorter period of time than for negatives. Potassium cyanide is traditionally used to fix the developed plate.

Collodion Positive Transparencies

Collodion positive transparencies are made by printing a negative onto a collodionized plate. In the days before modern electric enlargers, this was done with a solar enlarger.

History

Nitrated cotton was discovered in 1846 by German chemist Christian Fredrich Schönbein. It was made by introducing cotton fibers into a mixture of sulfuric and nitric acids. The longer the cotton was in contact with the acids, the stronger the final nitration. When the treatment was complete, the cotton was drained and washed with water until no trace of acid was detectable. Once dry, this nitrated cotton was very flammable and was commonly known as "guncotton," although the term is only accurate when applied to cotton with the highest degree of nitration. It was used as an explosive and later in the century became the base for smokeless gun powders. Nitrated cotton was also known as pyroxylin, cellulose nitrate, nitrocellulose, soluble cotton, and positive and negative cotton.

In 1847, John Parker Maynard, a medical student in Boston, discovered that lightly nitrated cottons were soluble in equal parts ether and alcohol. The resulting clear, viscous liquid dried to a thin, tough, flexible skin that made an ideal medical dressing for wounds.

The suggestion to use this material as a binder for silver halides was first made by Gustave Le Gray in 1850, but it was English sculptor Frederick Scott Archer who published the first detailed description of what he called the wet collodion process on glass in the March 1851 issue of *The Chemist*. At the time, there were two imaging systems sparring for popularity, the daguerreotype and the calotype. A few years before, Abel Niépce de Saint-Victor had introduced a method using albumen on glass, but while its resolution far exceeded the calotype, the extremely long exposures required were not practical for portraiture or even some landscape work. Albumen on glass evolved into a technique for making lantern slides that was popular until the late nineteenth century.

In Archer's original formula, potassium iodide was added to a dilute solution of collodion. When a glass plate coated with this "salted" collodion was

introduced into a solution of silver nitrate, a layer of silver iodide formed on, and just under, the surface of the collodion. The sensitized plate was exposed while still wet and developed immediately with pyrogallic acid; it was then fixed in sodium thiosulfate.

In the early 1850s, the introduction of bromides into the collodion helped to increase the sensitivity of the plates and produce negatives with a wider range of tones. Wet-collodion negatives required a slightly longer exposure than did daguerreotypes, but their great advantage was that they could be used to produce multiple prints on salted and albumen paper.

Variants of the wet-collodion process followed soon after its introduction. Photographers were quick to discover that, due to the light color of metallic silver in collodion plates, under-timed negatives appeared as positive images. The effect was enhanced when the plates were developed in ferrous sulfate, fixed in potassium cyanide, and held against a dark background. In America, these one-of-a-kind images on glass were called *ambrotypes*, but the rest of the world called them *collodion positives*. Deluxe ambrotypes were made on deep purple–colored plates called "ruby glass"; original examples can be found made on dark blue and amber as well. The same positive technique applied on asphalted iron plates was used to produce *ferrotypes*, popularly called *tintypes*. Collodion negatives were also printed onto a second collodionized plate and by this technique positive transparencies could be made for magic lantern projection and hand-held stereo viewing.

The introduction of factory-made gelatin dry plates in the late 1870s started the decline of the wet-plate popularity, but the high cost of manufacturing larger-sized dry plates accounted for continuing sales of collodion and wet-plate apparatus well into the late 1880s. Wet-plate tintypes were also made well past the turn of the century, but the dry plate was much more convenient for popular photography and the only choice for millions of amateurs around the world. Wet collodion continued to be used for graphic arts, precise copying, and scientific work well into the 1940s due to its extremely high resolution, but it was eventually replaced by modern technical films. Today, collodion is still manufactured for use as a medical dressing, just as it began in 1847.

France Scully Osterman, Pablo, Rochester, New York, 1997. *10" x 8". Ambrotype.*

Process Overview

Learning how to master the wet-plate method is a difficult and often bewildering process. Two batches of collodion mixed from the same constituents on the same day may give completely different results. A silver bath that worked perfectly for two weeks may refuse to make a flawless image at any time, and for no apparent reason. The entire process, from cleaning the glass to applying the varnish, is technique-dependent, and success can be elusive. But when everything works, the results can be extraordinary.

For students of history, an understanding of wet-plate imagery provides a whole new way to appreciate the work of nineteenth-century photographers. For artists, working with collodion is not only a window back to another time, but an exciting new creative tool. Collodion-coated plates may be exposed in the camera or under an enlarger to produce positive or negative images.

Why would a contemporary photographer choose a method from the 1850s over conventional silver-based photographic processes? The obvious reason is the uniqueness of collodion imagery. No two plates are alike, no matter how

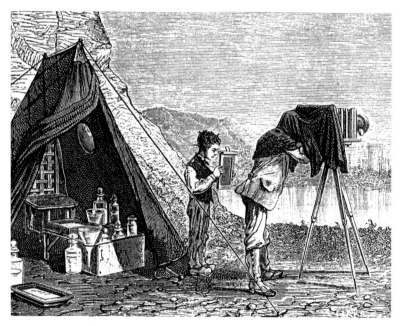 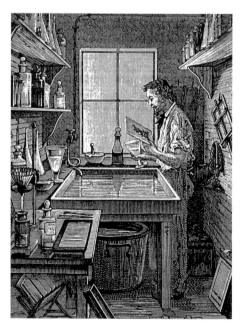

Nineteenth-century wet-plate photographers at work, with a dark tent in the landscape (left), and in a darkroom (right).

hard you try to replicate your results. Aside from the handcrafted look of the finished plates, collodion negatives were the basis for almost all of what are now called alternative printing processes. No other negatives have as wide a tonal scale. Additionally, the collodion process is capable of producing virtually grainless detail, and enlargements of "soft" negatives using conventional developing-out papers can be made from very small plates.

Collodion positives on glass and many other materials have a special quality all their own and, if varnished, represent one of the most archival forms of photography. The wet-plate collodion process is certainly time-tested.

Wet-Plate Collodion Chemistry

Much of the control you have using the wet-plate process is based on skillful troubleshooting. Changes in the silver bath and collodion from age and continued use must be adjusted for. Relative humidity, temperature, and quality of light also affect the approach one must take to get the best possible results. While the formulas in this section are well tested, in actual use they are often modified to fit specific conditions. As you become comfortable with the basic technique and start to understand the effect of specific chemicals, you will want to adjust these formulas to suit the situation.

Unlike modern photography, certain chemicals used for wet-plate work must be "aged" in order to produce the best results. The first of these is the "salted" collodion. Most method books from the wet-plate era give formulas based on making collodion by dissolving nitrated cotton in ether and alcohol. We advise that you do not attempt to make, or even handle, nitrated cotton. It is extremely explosive! For photographic purposes, it is better to purchase fresh "plain" collodion, U.S.P., from a supply house and then dilute and salt the collodion with an iodide and a bromide. Most commercially available plain collodions contain around 6% nitrated cotton, up to 26% alcohol, and the balance ether.

There are several different kinds of iodides and bromides from which to choose, but their basic effect is usually the same. Iodides give greater contrast, and bromides produce more delicate halftones.

What You Will Need

Chemicals

- Silver nitrate crystals
- Nitric acid
- Tincture of iodine
- Plain collodion U.S.P.
- Ethyl ether (anhydrous, reagent grade)
- 190-proof grain alcohol (available at some liquor stores)
- Cadmium bromide
- Potassium iodide
- Potassium bromide
- Potassium nitrate
- Ammonium iodide
- Ferrous sulfate
- Pyrogallic acid
- Acetic acid (glacial)
- Potassium cyanide or sodium thiosulfate
- Gum sandarac
- Oil of lavender
- Chloroform

Equipment and Materials

- Camera, lens with cap, wet-plate back, tripod
- Silver bath with dipper (cover box optional)
- Porcelain developing tray with flat bottom
- Fixing bath with dipper (cover box optional)
- Small and large glass beakers with oz. and ml. measurements (also one with drams)
- Assorted glass bottles (100 cc to 500 cc), both clear and brown glass
- Four funnels for filtering the silver, fixer, developer, and varnish
- Cotton balls
- Photographic plate rack
- Glass cutter, cork-backed steel rule
- Glasswax glass cleaner, or rottenstone and alcohol
- Flannel sheeting, for polishing glass
- Makeup brush
- Small paint brush
- Alcohol lamp

- pH test strips
- Beer or wine hydrometer with tall glass cylinder
- Plastic syringe for measuring small amounts of water when mixing iodides and bromides

Safelight

Bright amber, yellow, or red light—bright enough to read by

Cameras and Lab Equipment

Any view camera can be adapted for wet-plate work by the addition of a wooden film gate with a swing-away ground glass. A special wet-plate holder is then locked into the space that the ground glass occupied when focusing the camera.

Unlike dry-plate holders, wet-plate holders are always loaded from the back. A flat spring on the inside of the door holds the collodion plate against the inside of the holder. Many original plate holders have small glass or ceramic corners to receive the sensitive plate. For ferrotypes it is necessary to back the thin iron plate with a piece of glass to prevent the plate from being pushed out of the focal plane by the leaf spring in the plate holder. The light trap in wet-plate holders was traditionally made by introducing a spring-loaded flap of rosewood where the dark slide enters the holder. Plastic, stainless steel, and sterling silver are all good materials for the light trap.

Many period European wet-plate holders have no spring-loaded light trap, but rather, a dark slide that does not pull completely from the holder. A thin strip of wood at the end of the slide prevents removal and acts as a light block as well.

For experimental work, a temporary wet-plate holder can be made by adapting a modern sheet-film holder (see fig. 1). Both dark slides are removed, and an opening the size of the finished plate is cut into the rigid septum. Two small holes are then drilled into the septum at each corner so that a silver wire may be introduced to intersect the corners of the opening. The sensitized plate is placed into the holder, collodion side down, so that it is supported on each corner by the silver wire. The plate is held firmly against the wires by inserting a flat plastic "spring" cut from a yogurt container as the dark slide is reinstalled. In time, silver nitrate will eventually corrode the modern-style light trap.

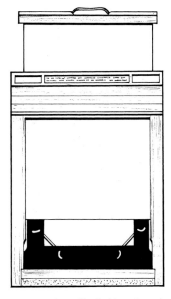

Fig. 1. *Sheet-film holder adapted for wet-plate use.*

Vertical Chemical Baths

Vertical tanks are used at several points of the collodion process to facilitate bathing the glass or metal plates in chemicals (see fig. 2). Separate tanks are needed for the silver bath and for the fixer solution. The tanks can be made from glass or plastic, and should have a dipper to hold the plate.

The size of your vertical bath, which must be large enough for the plates you are using, of course, determines the amount of solution you will need. For 5x7 plates, we use a Plexiglas tank with inner dimensions of 8" long x ¾" wide x 9" deep. It requires about 900 cc of silver solution to cover a vertical 5x7 plate. The vertical tank for the silver bath is traditionally placed inside an outer wooden box with a removable light-proof lid since the silver nitrate solution is light-sensitive (see fig 3). The fixer tank does not need this outer box since the fixing process can be done in daylight.

You can make dippers from Plexiglas. Cut the material in the shape of an upside-down Y. Then heat the Plexiglas and bend two small "feet" up to hold the plate. The whole unit is then tipped back at a 15-degree angle so that the plate will remain on the dipper as it is slowly plunged into the solution (see fig. 9, page 77). Use separate dippers for the silver bath and the fixer.

Fig. 2. *Early drawing of vertical chemical bath.*

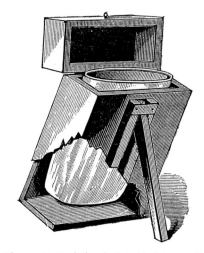

Fig. 3. *Vertical silver bath inside light-proof box.*

Mixing the Chemistry

In a general sense, the wet-plate collodion process is the same as what we are familiar with for modern black-and-white photography—the plate is exposed, developed, fixed, and washed. The difference, of course, is that the collodion plate must be coated and sensitized just before exposure, and the chemicals used for developing are specific to the collodion process. Also, the final plate is varnished to protect the delicate surface of the collodion image. The procedures below describe the process for making collodion negatives and ambrotypes and ferrotypes.

Salting Plain Collodion

There are hundreds of nineteenth-century formulas for negative and positive collodions (positives being ferrotypes and ambrotypes). The following collodion formula has a very good shelf life and is excellent for collodion positives. As with all collodion formulas, you may elect to dilute your plain collodion with a higher proportion of alcohol to ether, up to 1:1 in the total assay. This will result in a collodion that produces more density, is less likely to peel when drying, and is able to stay wet longer during hot and/or dry weather, but it is more fragile when wet.

Warning Be sure to do any mixing of alcohol, ether, and collodion out of doors or in a well-ventilated area. The fumes from these fluids are very flammable; and, in the event of a spill, the slightest spark could result in a dangerous explosion. Make sure that your darkroom has a flameproof ventilating motor. *Do not use in-line fans that have a sparking armature in the path of the vented fumes!*

Mixing part A

1. Add 155 cc ether to a 500 ml bottle containing 236 cc plain collodion. You might see cotton-like swirls appear momentarily while incorporating the two chemicals. Cap and shake the bottle and they should disappear in a few seconds. Set this mixture aside.

2. Put 3 g cadmium bromide into a small glass beaker or test tube and add about 4 cc of distilled water. The bromide will cake up. Break it up with a glass rod, then hold the beaker over an alcohol flame and keep the liquid moving until the cadmium bromide dissolves *completely*.

3. Slowly add the bromide solution to the collodion/ether mixture. This is part A.

Mixing part B

1. Dissolve 4 g potassium iodide in a small amount of water (as you did with the bromide) and add this to 155 cc 190-proof alcohol. This is part B.

Combining parts A and B

1. Slowly add part B to part A, then shake the bottle. The collodion may become very cloudy as the two parts are mixed due to the nonsoluble iodides and bromides in suspension.

2. Set the bottle on a sunny windowsill for a few days; the cloudy precipitate will gradually clear. Be sure to release pressure from the bottle occasionally.

3. After it settles and the collodion is *perfectly clear*, you may add two drops of tincture of iodine or some old red collodion, which will speed up the aging process. The collodion should be usable by the next day. Individual batches made from the same chemicals often differ in their characteristics, and like our nineteenth-century counterparts, we are at a loss for the answer.

Note Once mixed, never shake the collodion bottle after this point, since the collodion is constantly "throwing down" the iodides and bromides, which settle to the bottom. Plates made with shaken collodion will have hundreds of tiny pinholes; these are most evident in negatives. To prevent this from happening, you should decant the collodion from your mixing bottle into smaller bottles (you may use clear or brown glass). This will also make it easier when you pour your plates. If you are careful, you can decant as needed; but if the mixing bottle is shaken, it's best to wait a day before using that collodion.

New collodion is more sensitive to light and can produce beautiful halftones; as it ages, however, it will become less sensitive and will yield images with greater contrast. Salted collodion will turn from a straw color to dark red in time, and you may use this color as an indicator of its relative age. If you keep a large reservoir bottle in a cool, dark place, the cadmium bromide/potassium bromide collodion formula should continue working for up to a year or more.

Other Collodion Formulas

A faster-clearing collodion can be made by substituting potassium bromide for the cadmium bromide in the previous formula. Using ammonium iodide in place of potassium iodide will give a similar result. Don't be afraid to experiment, but be warned that any fast-clearing formula, by its nature, has a very short shelf life. You should not attempt to pre-age such collodions. Both formulas work well for positives and soft negatives.

Negative Collodions

Adding a higher proportion of iodides to bromides (up to 4:1) to your basic diluted plain collodion formula will produce a gain in density for making strong negatives required for nineteenth-century printing-out processes such as albumen and salted paper.

If you see a very thin blue film when you remove the plate from the silver bath, it usually indicates too strong a salting of iodides and bromides for that strength of silver bath. A thick, creamy film is the result of too little salting.

Silver Nitrate Solution

Silver nitrate is a corrosive and, whether in crystals or in solution, it will cause indelible brown-black burns when in contact with anything organic. Silver nitrate in the eyes can cause permanent blindness. Use goggles and either latex or natural rubber gloves whenever you handle it. This solution is also called "silver bath."

Mixing the Silver Bath

Fig. 4. *Hydrometer in glass cylinder.*

1. Add 28 grams of silver nitrate to every 355 cc of distilled water and stir until the chemical is completely dissolved. Make enough solution to fill your vertical silver bath.

2. Pour some of this solution into a tall glass cylinder and slowly lower your hydrometer into the solution (fig. 4). Take note of the level of solution on the calibrated shaft of the hydrometer. This is now your benchmark. If you have any doubt about the strength of your silver bath, you can test it with the hydrometer and add either silver nitrate or distilled water until the silver bath again reaches the benchmark.

For positive images, the silver bath works best if the silver nitrate solution is slightly acid. Test the bath with pH test papers and add drops of nitric acid as needed to bring the solution to between pH 3 and 5. Adding acid usually helps to prevent chemical-based image fog, but at the expense of film speed. The more acid you add to the silver bath, the more exposure you'll need to give your plates. For negatives, many photographers traditionally used their baths nearly neutral, and used acetic acid if any acid was needed. Some collodions, however, work best with very acid baths, while others are best with baths that are nearly neutral.

The silver baths must be iodized before they will work well. In order to do this, a plate should be coated with "salted" collodion and left in the silver solution overnight. After you pour a sample of your mixed silver solution into

the hydrometer cylinder, place the hydrometer into the solution. Make a notation of the level of solution on the shaft of the hydrometer.

As the silver bath is used, the silver content is depleted, and alcohol, ether, acids, and "free iodides" are introduced into the silver solution from the collodion. When problems occur, it is usually the silver bath that is at fault. A remedy is to "sun" the silver bath by pouring the solution into a clear, large-mouthed jar and placing it on a sunny windowsill without a lid. This does two things. First, it allows the ether and alcohol to evaporate. Second, it lets any organic matter settle to the bottom. After sunning, the silver solution should be filtered, measured with a hydrometer, and brought to the proper strength by adding silver nitrate or distilled water. It is important to keep a properly working silver bath away from sunlight exposure.

Excess acid can be removed by adding bicarbonate of soda, although the sudsy reaction will require you to filter the bath several times. The remedies for "free iodides" and other "evils" that plague the silver bath would take several pages (see the list of further reading). The best plan is to mix two baths and alternate between them. This way, if one develops problems, you will have a backup already mixed. Silver solutions will work for years if given proper care.

Mixing the Developers

Positive developer (for ferrotypes and ambrotypes)

Ferrous sulfate	15 g
Distilled water	355 cc
Glacial acetic acid	14 cc
190-proof "grain" alcohol	18 cc

Dissolve the ferrous sulfate in the water, then add the acetic acid and alcohol and mix thoroughly. Store the solution in a brown glass bottle.

Negative developer

Pyrogallic acid	1 g
Distilled water	355 cc
Glacial acetic acid	60 cc
190-proof "grain" alcohol	10 cc

Dissolve the pyrogallic acid in the water, then add the acetic acid and alcohol and mix thoroughly. Store the solution in a brown glass bottle. A few drops of silver solution are usually added to the remainder of this developer and poured onto the plate halfway through the development process.

After 1852, pyrogallic acid was usually reserved for negatives. Plates developed with "pyro" will have more density and a neutral color by transmitted light, but will often require almost two thirds more exposure than plates developed with ferrous sulfate. Ferrous sulfate, however, was used for both positive and negative collodion plates.

Both of these developers are ready for use as soon as the ingredients are dissolved, but they should be filtered before using. Pyrogallic acid is much more hazardous than ferrous sulfate, and you should take precautions to keep from breathing the dust or having the fluid come in contact with your skin.

There are many formulas for developers, but some things are common to all. The acetic acid is added as a restrainer to slow down the development process. Without the acetic acid, the plate would develop so quickly that the process would be uncontrollable. In hot weather, more acetic acid should be added to the developer to prevent fogging in the shadow areas.

The amount of developing agent used in the formula also has an effect on the final image. Traditionally, a stronger developer is used for ambrotypes and ferrotypes than for negatives. If you are making negatives and do not wish to use pyrogallic acid, try reducing the ferrous sulfate in the developer to 11 grams. A slower development will build a stronger deposit of silver.

If you find that the developer beads up on the plate during development, add more alcohol. The less alcohol used the better, but the developer should always flow onto the plate without beading up, or spots will appear on the final image. No alcohol is needed in the developers if the silver bath is newly made or recently sunned.

If you prefer a positive image that has a bright, silvery color, add a drop each of nitric acid and silver solution to every two ounces of developer used. The addition of potassium nitrate to the developer will also result in a brighter image. Start with half again as much potassium nitrate as the amount of ferrous sulfate used in the formula, and adjust this up or down to get a result that appeals to you.

Mixing the Fixer

Two different kinds of fixer can be used for wet-plate work, potassium cyanide and sodium thiosulfate; both were used in the nineteenth century:

- 28 g potassium cyanide dissolved in 946 cc distilled water.
- 142 g sodium thiosulfate dissolved in 887 cc distilled water.

For the fixing bath you will need a glass or plastic vertical bath with a dipper of the same design as the one constructed for the silver bath.

Warning Potassium cyanide is a deadly poison. It should be used under an exhaust hood or out of doors; wear rubber gloves. Cyanide gas will be produced if acids are introduced into the cyanide solution. We keep our cyanide in unbreakable plastic containers. Cyanide leaking through broken glass can be deadly. Make sure that all of your chemical bottles are well labeled.

The advantage of using cyanide over sodium thiosulfate is that cyanide dissolves the unexposed silver faster and more completely, reducing fog.

Also, cyanide produces ferrotypes and ambrotypes with beautiful clear black tones in the shadow areas and lighter deposits of developed silver than sodium thiosulfate. However, because cyanide is deadly, you should probably use sodium thiosulfate unless you have access to an exhaust hood. You can make up for the dulling effect of the sodium thiosulfate by using potassium nitrate and/or nitric acid in the developer, as described above.

Sodium thiosulfate is the best choice for making wet-plate negatives where cyanide, an aggressive fixer, might remove the delicate mid-tone areas of the plate. The sodium thiosulfate bath should be made fresh for each session or day. Cyanide baths also need to be replaced on a regular basis or yellow stains will eventually appear on finished ambrotypes due to the formation of silver cyanide.

Mixing the Varnish

The surface of a collodion plate is very delicate and subject to damage, so a thin coat of varnish is applied to protect it. While the oil of lavender added to this solution gives it a heavenly fragrance, it is actually added for greater flexibility.

1. Add 57 g of gum sandarac to 414 cc of 190-proof "grain" alcohol. Shake the jar until all the gum has dissolved, leaving a residue of dirt, bark, and dead bugs!
2. Add to this 44 cc oil of lavender.
3. Filter several times by pouring the varnish through a funnel filled with cotton balls. It is very important that this varnish is free from any foreign matter. Store the varnish in a glass bottle.

Plates for Ferrotypes and Ambrotypes

Traditionally, pieces of clear or stained glass are used for ambrotypes and soft iron plates are used for ferrotypes. You can use clear glass from the hardware store; however, we prefer to use dark stained glass. If you want to make your own ferrotype plates, soft iron, called "black plate," is still available from the canning industry; japanning—or blackening—the plates for ferrotype use is a difficult procedure, however.

Soft iron plates should be cleaned with lacquer thinner and dipped in asphalt. The asphalt should not contain asbestos. After the excess asphalt is allowed to fall from the surface, place the plates on a photographic plate rack and bake them in an oven with a ventilation tube. Do this outside, and wait for the plates to cool down before you touch them! You are looking for a smooth, glossy black finish. Do not touch the surface of your ferrotype plates; the oils of your skin will prevent proper adhesion. Store them between sheets of paper.

It is easier to use tinned steel or aluminum and to paint the plates, but they will never be as black as the japanned ones. Another option is black anodized aluminum. These black plates require no asphalt coating, and they replicate the old tintype plates in color and thickness. Many people prefer to make ferrotype plates because they do not require the extensive cleaning necessary when making ambrotypes or negatives. They are ready for the collodion after only a simple dusting with a soft sable brush.

Ambrotypes are made on clear or stained glass. After cutting your plates, run a fine sharpening stone along all of the edges to remove the razor-sharp burr. Glass plates for ambrotypes or negatives must be spotlessly clean and dust free. If they are not clean, the collodion will lift off the plate when it is lowered into the silver bath. The old manuals suggest using rottenstone and alcohol to clean the glass, but we have found that Glasswax paste glass cleaner does a great job. This is the same liquid often used on store windows that leaves an opaque white deposit when dry. See figure 5 for an illustration of a nineteenth-century clamp for holding plates while cleaning and polishing.

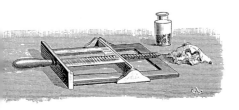

Fig. 5. *Nineteenth-century plate vice used while polishing plates.*

Use a soft flannel cloth to apply the Glasswax and another clean piece to polish the plate before the liquid dries; final cleaning can be done with yet another clean cloth. Be sure to let the cleaned plate air on a rack. We have found that "out gassing" of the solvents in glass wax may cause defects on the image if the plate is used immediately after cleaning. The plate should be dusted with a soft sable brush prior to coating with collodion. Just to make sure, breathe on the plate. If the condensation reveals any rub marks or streaks, the plate is not clean enough. The cleaned plates should be stored in a wooden box with slots designed to keep the plates from touching each other. A tight-fitting lid will keep out the dust.

Making Collodion Plates

Pouring the Collodion

Contrary to most of the recent literature written on the subject of wet-plate photography, pouring the collodion, often called "flowing the plate," may be done in bright daylight. Good ventilation is suggested, since the fumes of the ether might be irritating and explosive! All wet-plate photographers have their own way of pouring collodion. Here is ours.

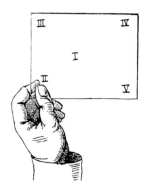

Fig. 6.

Hold glass plates by the lower-left corner, using the thumb and first finger of your left hand. (We hold ferrotypes by balancing the plate from underneath using the thumb and two fingers.) With your right hand, slowly pour a puddle of collodion into the middle of the plate (fig. 6). Tilt the plate so that the collodion goes to the lower left corner, but do not let it touch your thumb. If it does, the collodion will go to the back of the plate and down your arm! Next, tilt the plate so the collodion flows to the upper left corner, then to the upper right corner, and finally to the lower right corner. (Fig. 7 shows this sequence.) Try to prevent areas from being coated twice. Uneven double coating will produce ridges in the final image. When the entire plate is coated, tilt the plate so that the lower right-hand corner actually touches the mouth of the collodion bottle, allowing the excess collodion to go back into the bottle (fig. 8).

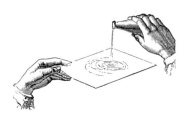

Fig. 7.

While the collodion is slowly draining into the bottle, rock the plate vigorously from side to side to prevent ridges from forming in the direction of the flow. (The whole process of flowing the plate takes a matter of seconds.) Hold the plate nearly horizontal, with the lower right-hand corner lower than the rest, and allow the collodion to set for a few seconds. The plate should have a uniform texture except for the lower right corner and the edges of the plate leading to that corner. These exceptions will have a thicker coating of collodion, a telltale sign of the wet-plate process.

As the ether and alcohol in the collodion evaporates, the plate will feel cold to the touch. You will see the surface of the collodion change texture and it will appear to have a skin form on the surface. The plate should be put into the silver bath at this point. If the plate is sensitized prior to the collodion changing texture, or too long after the change, some areas of the plate will not have an image. Timing is critical, and the variables of temperature, relative humidity, and collodion formula will dictate the time it will take for the skinning-over process to take place.

Fig. 8.

Sensitizing the Plate

Wet-plate work should be done in a room with bright amber, yellow, or red safelight conditions. If you can't read a newspaper in your darkroom, it's too dark; but it must be absolutely free from white daylight or your plates will be exposed.

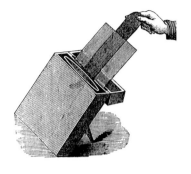

Place your plate on the dipper and, in one motion, slowly plunge the plate into the silver bath without stopping (fig. 9). Cover the bath and check on the plate after three minutes. Check the progress by bringing the plate up from the bath and watching the way the silver solution flows from it. If it runs down the plate in streaks or if it beads up on the surface, you need to leave it in the bath for a few more minutes. In cold weather, this change will take more time. Moving the plate from side to side and gently knocking it against the walls of the tank will actually speed up the process.

Fig. 9.

When the plate is ready, the excess solution will sheet off the surface when the plate is raised. The process of sensitizing will usually take three to five minutes. The ambrotype collodion formula used here should look creamy white under the safelight if it has taken on enough silver. Ferrotype and dark glass plates will look thinner because of the darker support.

France Scully Osterman, Sleeping, Rochester, New York, 1997. *8" x 10".*
Ambrotype. Collection of Howard Greenberg.

Exposing the Plate

1. Keeping the plate in the same orientation as it was when pulled from the silver bath, blot the excess silver from the back and bottom edge of the plate with a piece of paper towel. Failure to blot this excess silver may result in streaks on the image caused by the capillary action of the excess silver solution migrating from the back of the plate to the front during the exposure.

2. Place the plate into the plate holder and keep the holder in an upright position. Silver nitrate will drip from the bottom corners of the plate holder; this is normal.

3. The plate must be exposed and developed before the silver nitrate solution evaporates or the collodion dries. Excessive heat will speed up this process, and temperatures below 40°F cause all sorts of problems. The ideal range is from 60°F to 80°F.

4. Exposure is done by trial. Most period portrait lenses (rated around f/3.5) require stopping down when shooting out-of-doors on a bright day. Ambrotypes can be made with exposures as fast as it takes to remove and replace the lens cap, but we usually stop down the lens as a way to control exposure.

The age of the collodion, the acidity of the silver bath, the amount of bromides used, the color of the subject, and the color of the ambient light will all affect the sensitivity of the plate. Collodion is mostly blue sensitive, and we have never found a light meter useful. When making ambrotypes, most beginners err by overexposing the plate, causing what the old manuals call "fog."

Ambrotypes are, in reality, underexposed negatives. By exposing the plate two to three times longer than the correct time for an ambrotype (or ferrotype) and using a weaker developer, you will produce a negative. Using a "negative" collodion with a higher alcohol content and iodide-to-bromide ratio gives best results.

Developing the Plate

There are two methods for development: by tray, which is easier, or in hand. Regardless of the method chosen, the most important part is covering the plate all at once, without stopping, and with as little developer as possible. Development must be done under safelight conditions.

Tray method

1. Pour enough developer into a flat-bottomed porcelain tray that is larger than the plate being developed to just cover the plate.

2. Tilt the tray so that the developer occupies one end of the tray.

3. Carefully remove the plate from the plate holder without touching the collodion and place it, collodion side up, in the raised part of the tray.

4. In one motion, rock the tray so that the developer flows over the plate as quickly as possible. *Any hesitation or stopping will make a ridge in the image.*

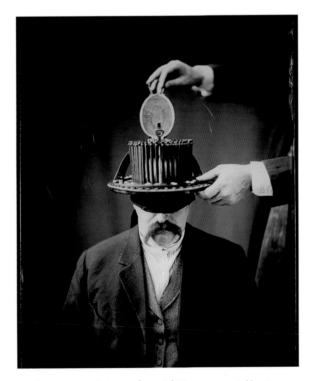

Mark Osterman, A Circumferential Measurement, Newtown, Pennsylvania, 1999. *10" x 8". Tinted ruby glass ambrotype. Collection of Jayne Hinds Bidaut.*

Fig. 10.

In-hand method

1. Holding the plate in one hand, collodion side up, pour a small amount of developer from a pilsner-shaped glass along one edge of the plate with the other hand (fig. 10).

2. Do this in a sweeping motion. This method allows the excess silver solution present on the plate to mix with the developer, thus making a stronger image.

Judging Development

A properly exposed ambrotype will show the highlights in a few seconds, followed by the medium tones and then the shadow areas. Typically, positive collodion images are developed for no longer than fifteen seconds. If the whole image flashes up as soon as the developer meets the collodion, the plate has been overexposed.

Development for ambrotypes and ferrotypes should be stopped before the shadow areas present themselves! The final color of a collodion positive has as much to do with the length of development as it does with the type of collodion, developer, or fixer. The longer the development is pushed, the more neutral the tones. Creamy images are made by proper exposure and a short development.

Negatives should be developed with the same steady progression, but allowed to continue well after the midtones have become evident, and stopped before the point to where the plate starts to cloud over. Negatives should be inspected during the latter part of development by holding them up to the safelight to evaluate the progress.

If a greater deposit of silver—or greater density—is desired, as for negatives used with printing-out papers, redevelop the plate with pyrogallic developer to which a few drops of the silver bath have been added per ounce of solution. Wash the old developer off the plate and add this new developer. This can be done several times to build up your negative to the desired density.

Stopping Development

When development is complete, it is stopped by pouring tap water onto the plate. Areas of the plate can be left to develop longer by avoiding those areas with the wash water. *The plate must be thoroughly washed before fixing.* Failure to do so will result in blue stains. Keep pouring water onto the plate until it flows off the plate in sheets without beading on the surface. Be sure to wash the back of the plate as well.

France Scully Osterman, Belchite at War, Aragon, Spain, 1998. *13" x 18". Sulfide-toned silver-gelatin print from a wet-collodion negative.*

Fixing the Plate

Another myth about wet-plate processing is that the fixing must be done in the darkroom. In fact, once the plate is washed of its developer, it may be brought out into strong daylight without injuring the plate. Fixing ambrotypes on dark glass and ferrotypes is the most amazing part of the process, because within seconds you will see the plate turn from a negative to a positive image.

The plate is placed on the dipper and lowered into the cyanide (or sodium thiosulfate) vertical bath. When using cyanide, the visual change should take no more than a few seconds, but you should keep the plate in the cyanide for about a minute. If your finished plates have brown or yellow stains, it could be an indicator of insufficient fixing. Fixing with sodium thiosulfate will take at least twice as long.

Washing the Plate

Wash the plate for five minutes under a gentle stream of fresh water (tap water will do). We have found that collodion plates do not require excessive washing, but it doesn't hurt to wash them longer than five minutes if you can. The wet image after fixing usually appears similar to what the finished product will look like after the varnishing.

Drying the Plate

Plates may be air-dried in a plate rack (fig. 11) or over the gentle flame of an alcohol lamp. If the lamp method is used, be sure that the plate is kept moving so that the heat is distributed evenly or (in the case of an ambrotype or negative) the glass will break.

Regardless of the drying method used, occasionally some of the collodion may lift from the edge of the plate during drying, though this is more apt to happen if plates are dried on a rack. Keep a small bottle of sandarac varnish and a small watercolor brush handy to quickly "paint" down the areas that lift up. You will notice that the image will brighten significantly as the collodion dries. Don't be alarmed; the varnishing step will bring it back to its original tonality.

Fig. 11.

Varnishing the Plate

A number of antique ambrotypes and ferrotypes are not varnished. The reason for this is that they were probably underexposed. Varnishing would have made the image too dark, so the photographer left it "dry and bright." We suggest that you varnish all of your wet-plate images. The collodion surface is very fragile,

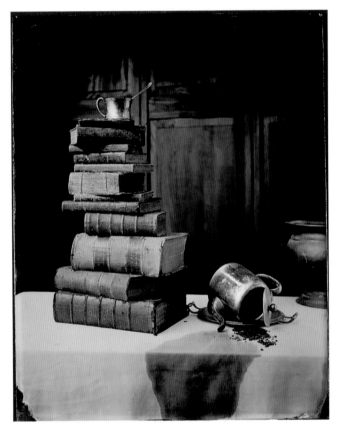

Mark Osterman, The Spilled Tea, *Newtown, Pennsylvania, 1999.*
10" x 8". Tinted ruby glass ambrotype. Private collection.

and, if uncased, it will not survive even light handling if it is left unvarnished. Unvarnished plates will also oxidize, or "tarnish," in time.

The varnish is applied when the plate is warm. It is also helpful to warm the varnish prior to pouring. If the plate is too hot to lay on the back of your hand, it's too hot to varnish. Varnishing can be done as soon as the entire plate is dry. Be sure to check the thick areas of collodion along the edges of the plate. Pour the varnish in exactly the same fashion as you did the collodion. The entire plate must be coated as quickly as possible or lines will appear in the image. The trick is to coat the image before the plate cools down.

When the last drop of varnish has left the lower edge of the plate, keep the plate in a nearly vertical position with that last corner lower than the others. When the varnish appears to have set, hold the plate over an alcohol flame. Keep the plate moving so that the plate has uniform heat and continue until the varnish is dry. Be careful; if the alcohol in the varnish hasn't evaporated enough, the varnish will quickly catch fire with a "Woof!" Place the varnished plate in a plate rack for the finish to cure. If the alcohol solvent in the varnish is stronger than that in the collodion, or if the collodion is too old and has decomposed, the varnish may dissolve the image. While nothing can save the dissolved image, you may be able to prevent further problems by adding a small quantity of water to the varnish and refiltering it. A little chloroform added to the varnish will also help. If these attempts do not correct the problem, throw the varnish away and make a new bath using fresh alcohol, or try a fresh batch of collodion.

Further Reading About Wet-Plate Photography

As you become familiar with the basics of collodion processes, you may want to experiment with different formulas. The process we have described here is essentially the same as that done in the nineteenth century, and many of the early photography manuals and periodicals contain information that can be used by contemporary experimenters. Historically, special collodions were formulated just for large negatives or for use in dry climates. Different developers that work for special applications were also created. Redevelopers and intensifiers are typically used in more advanced collodion techniques. Most importantly, these publications contain early troubleshooting guides, although they often have a disclaimer that states they don't have all the answers!

Philadelphia Photographer and *The Photographic Journal* (British) were the popular photography magazines of the wet-plate era. They include hundreds of formulas, designs for equipment, and illustrations. *Philadelphia Photographer* even included actual tipped-in albumen prints. Original copies show up at photo and book shows, and single issues usually go for around $30. Check the microfilm department of your nearest big city library. Libraries may also have original issues bound in books.

The Silver Sunbeam. This method book, written by John Towler in 1864, was the standard text on the subjects of photography, ambrotypy, stereo photography, and printing processes. It is not easy reading, but it is a wonderful reference book. You'll find that every contemporary wet-plate photographer

has a well-worn copy. The last edition of this book, which is now out of print, was published in 1974 by Morgan & Morgan.

The Collodion Journal by Scully & Osterman. A typical issue of this quarterly journal on all aspects of wet-plate photography will include a technical article, a reprint from a nineteenth-century photographic journal, at least one tipped-in color copy of a contemporary wet-plate image, a question-and-answer section, a classified ad section limited to nineteenth-century photographic equipment and images, and display ads pertaining to nineteenth-century photography. Contact Mark and France Scully Osterman for subscription rates. Scully & Osterman, 186 Rockingham Street, Rochester, NY 14620, sculloster@aol.com.

Sandy King. Untitled. Monochrome carbon print.

Chapter 7 Monochrome Carbon

Sandy King

History

The carbon printing process, which yields highly permanent and richly scaled prints characterized by a distinct image relief, was invented and patented by Englishman Joseph W. Swan in 1864. By 1866, Swan was marketing ready-to-use carbon supplies to photographers, offering material to produce prints in three colors: black, sepia brown, and purple brown. The sepia brown proved to be the most popular because it so closely matched the color of albumen papers of the day. Improvements to the process were introduced by J. R. Johnson in 1868 and by J. R. Sawyer in 1874.

The greatest initial use of the carbon process was to make reproductions of paintings and drawings. In the 1870s, Adolphe Braun, of Alsace, operated a huge carbon printing service with an output of some fifteen hundred prints daily. For the last three decades of the nineteenth century and well into the twentieth century, carbon was the preferred process of the top echelon of commercial photographers, who considered it the aristocrat of all printing options. Carbon continued as a viable commercial process until the early 1950s, at which time most of the major manufacturers of carbon materials disappeared from the market. At the time of this writing, there is no commercial source for carbon tissue, which means that the process can only be practiced by those willing to learn to make their own materials.

Process Overview

Carbon is a contact-printing process in which a negative is placed in contact with a sensitized sheet of carbon "tissue" and exposed with an ultraviolet light source. This results in a tanning (or hardening) of the gelatin on the carbon tissue in proportion to negative densities, with the tissue hardened more in the shadow areas than in highlights. In the carbon process the deepest layers of the gelatin are not reached by the exposing light and remain soft, or unhardened. Since the hardened areas are not in contact with the support, direct development of the tissue would result in complete separation of the gelatin layer. To get around this, the exposed tissue is first soaked for a brief period in cool water, then placed in contact with another support; after a short time the exposed tissue is developed in warm water. In the warm-water development, the unhardened gelatin slowly washes away, leaving a relief image firmly attached to the second support. A carbon print has a long tonal scale and excellent straight-line characteristics; this quality allows the use of fully detailed negatives with long density ranges, resulting in an even distribution of tones from the highest lights to the deepest shadows.

Carbon prints can be made by either the single- or the double-transfer procedure. The single-transfer method, in which the tissue is developed directly on its final support, is easier, but it gives a reversed final image when the negative and tissue are exposed emulsion to emulsion. This can be solved by reversing the negative during printing, i.e., placing the base of the negative in contact with the emulsion of the tissue, but there will be considerable loss of sharpness when exposing with diffuse light sources. Another solution is to make an internegative with the original negative or transparency reversed in the enlarger or the printing frame to assure correct final orientation. However, with original in-camera negatives, the double transfer procedure must be used if correct orientation of the scene is required and a fully sharp image is desired. (There are times, of course, when image reversal does not affect the "reading" of a scene, and the single-transfer method may be used.)

In the double-transfer procedure, the carbon relief is developed on a temporary support and, after it dries, is transferred to a final support. The temporary support must be one that will both provide temporary adhesion and release the image at the time of transfer to the final support. The best temporary carrier is a plastic of the polyvinyl family. These supports can be washed and reused indefinitely.

Carbon prints can be made to look almost indistinguishable from silver prints; unlike many of the historical printing processes, the pigment image formed by the carbon process can be made to appear as sharp as a silver image. Indeed, because of the discernible relief of carbon images, they often have

greater apparent sharpness than silver prints, provided of course that they have been transferred to smooth surfaces. Both the image contrast and the perception of a dimensional quality are enhanced in prints where there is a juxtaposition of glossy shadows and matte highlights. The shadows of carbon are unmatched by any other photographic process; the tonal separation is outstanding, and a print's maximum reflective density, its D-max, can be as great as that of silver bromide papers. There is no "superior" printing process, but in its versatility and range of possibilities, carbon is a superb process. Unlike other processes whose visual characteristics are closely linked to the inherent qualities of the process (i.e., the softness of gum bichromate, the limited color range of platinum, the surface qualities of silver, etc.), carbon has the capability of presenting images with a wide range of characteristics. Prints may be of virtually any color or tone, and on a wide variety of surfaces. In spite of its difficulty to learn, the carbon process is a rather straightforward operation that, once learned, offers a range of possibilities not available with any other photographic system.

One of the most important attributes is that carbon prints can be made in a wide variety of colors. The Autotype Company once supplied carbon tissue in more than thirty-two different colors, not counting duotone and three-color papers. The hand manufacture of carbon tissue described here makes it possible to produce images in any color imaginable.

Collectors should be aware that carbon prints are far less common on the antique market than are silver prints; and because they are capable of the same degree of detail, they are sometimes difficult to identify. Characteristics that help in their identification include unusual colors, visible pigment particles, glossy shadows contrasting with matte highlights, and discernible relief. Gelatin crazing, which resembles the surface cracking of tempera paintings, is sometimes seen in very old carbon prints.

What You Will Need

Chemicals

- Gelatin (100–250 Bloom) or Knox gelatin (from the supermarket)
- Formalin 2–4%
- Ammonium dichromate
- Potassium metabisulfite
- Sodium bisulfite
- Distilled or deionized water
- Sugar
- Chrome alum 5%
- Glycerin
- Acetone or alcohol

Pigments

- Sumi ink
- Tube watercolors
- Creatix pure pigments

Materials and Equipment

- Float glass (plate glass) ¼" thick and 2" larger on all sides than the print
- Rubber roller that is larger than the largest print to be made
- Contact printing frame
- UV light source
- Rubber squeegee that is sturdy and the approximate size of the print
- Sheets of polyvinyl
- Mortar and pestle

Negative

Negatives used for carbon should have a density range of 1.6 to 2.0, similar to those used for cyanotype and platinum-palladium printing.

Paper for Final Support

- Watercolor paper or other artist paper
- Fixed and thoroughly washed photographic paper

Safelight

Yellow bug lights, 15 to 50 watts

Sandy King. Untitled. *Monochrome carbon print.*

Procedures

Hand Manufacture of Carbon Tissue

Preparing the gelatin and pigment

1. Start with 900 cc of distilled water in a wide-mouth glass or plastic container, at about 70°F. Stir 100 g gelatin of Bloom 100-250 into the water and let the mixture stand for at least one hour.

2. After one hour, place the container in warm water at around 100°F to 115°F and allow the solution to completely liquefy.

3. Remove the container of gelatin solution from the warm water, stir in 24 g of plain white sugar, and allow it to dissolve completely.

4. Mix in the pigment. First, pour about 10 cc of glycerin into a pestle, add the required pigments, and mix well. If you are using powdered pigment, grind it with a mortar for a minute or so; otherwise mix the glycerin and pigment thoroughly. Add about 25 cc of the gelatin solution to the mixture and grind again until the solution seems uniform. The pigment must be thoroughly ground and dispersed in the gelatin solution. Aqueous dispersions of pigment (watercolors, Sumi ink, Createx pure pigments, etc.) mix much more readily than powders and are available in a wide range of colors (see note on contrast below).

5. Add the contents of the pestle to the container of gelatin solution. Add water to make 1000 cc of pigment solution and stir vigorously for at least a minute. For maximum dispersion of the pigment, place the coating solution in a blender and allow it to mix at a high speed for about two minutes.

6. Place the container of gelatin-pigment solution in water at about 125°F and leave it for at least two hours. During this time, most of the air bubbles caused by the vigorous stirring will be expelled. After the two hours have elapsed, you may either proceed directly to the coating operation or refrigerate the solution for use at a later time. Blender-mixed coating solutions should be set aside for at least twenty-four hours before coating to allow time for the extra bubbles to dissipate.

Contrast

The amount of pigment added to the gelatin solution affects tissue contrast. You can make a low-contrast tissue by using enough pigment to produce a tissue coating that is just barely opaque. Adding more pigment to the solution results in higher-contrast tissue. Low-contrast tissues produce images with

greater relief because the exposing light can penetrate very deeply into the coating. Tissues that have been coated with a great excess of pigment produce high-contrast images low in relief because they allow only a limited penetration of the exposing light into the tissue. For a cold-black tissue of normal contrast, use 25 g of Sumi ink (18 g for lower-contrast tissue, 35 g for higher contrast).

Coating the Carbon Tissue

The final stage in tissue manufacture is coating a suitable paper or plastic base with the gelatin-pigment solution. The carbon tissue carrier can be either a paper or a thin plastic base. Plastic bases are reusable and make it possible to use automatic registration systems for the assembly of the reliefs in color work. Many of the smooth drawing papers make good carriers, but they are relatively expensive to use. It is not important that the carrier have archival qualities, for it will be discarded after use.

While you are doing the coating, do not wear wool or other clothing that has a tendency to shed lint particles.

Room temperature for the coating operation should be about 70°F. If it is much colder than that, the gelatin will set rapidly and it will be impossible to achieve a smooth coating, especially for larger print sizes; if the room is warmer than 72°F, the solution will take a very long time to set. Coating should be avoided altogether at room temperatures under 65°F or over 75°F. The gelatin-pigment solution should be 100°F to 110°F when poured onto the carrier. Maintain the temperature of the stock coating solution at a constant level throughout the operation. The coating may be done with regular room lighting since the material is not yet light sensitive.

1. Begin preparation for the coating operation by leveling a piece of plate glass several inches larger on all sides than the largest tissue you intend to coat. Leveling can be done quickly using a hand level and a ball of clay placed under each corner of the glass. Press down gently from corner to corner as needed until the glass is perfectly level. I do not advise using Plexiglas for the coating platform because it is less stable dimensionally than glass and may cause uneven coatings.

2. Place a wet paper or plastic carrier on the leveled glass and squeegee off all surface water, then blot it with a clean towel.

3. Very slowly, and without creating any air bubbles, pour the required quantity of gelatin-pigment solution into a small glass or plastic measuring cup (20 cc for a 5x7 tissue, 55 cc for an 8x10, 100 cc for an 11x14, and 205 cc for a 16x20). The pigmented gelatin solution should be free of any foam and bubbles. Burst any air bubbles and remove any particles of lint.

Sandy King, Cathedral at Seville, 1995. *Monochrome carbon print.*

4. With a gentle motion, carefully pour the solution onto the center of the carrier. Working quickly, spread this mixture evenly on the carrier, using either your fingers, a comb, or a coating rod.

5. After you have finished smoothing out the coating, look over the surface carefully and remove air bubbles and any lint, hair, or other foreign particles that may have settled on the gelatin during the coating operation. The coating mixture should harden in ten minutes or less at a temperature of around 70°F. The coating mixture should not flow beyond the edge of the paper; if it does so consistently, you should either increase the percentage of gelatin in the coating solution or lower the temperature of the coating room.

6. Once the gelatin has set, carefully transfer the newly coated tissue to a drying screen and set it aside to dry. Drying will take from fifteen to twenty-four hours, depending on temperature and humidity. It may be accelerated by the use of a fan.

Sensitizing the Carbon Tissue

Carbon tissue is sensitized with a dilute solution of ammonium or potassium dichromate. Tissue may be sensitized by immersing it in a tray containing the sensitizer or by brushing on a solution containing the sensitizer and some fast-drying spirit, such as alcohol or acetone. Tray immersion gives more sensitivity, but the tissue takes longer to dry, anywhere from thirty minutes to two hours depending on the temperature and relative humidity. Tissue sensitized by brushing, though less sensitive, will dry and be ready for printing within fifteen to thirty minutes. Both methods are capable of giving excellent and repeatable results when used properly.

While contrast in carbon printing is affected by the amount of pigment, as described above, it is primarily controlled by the strength of the sensitizer. Only experience will indicate what percent sensitizing solution is needed with a given negative. Carry out initial tests as follows: high-contrast negatives, 5%; medium-contrast negatives, 2–3%; and low-contrast negatives, 1%. For carbon printing, a very high-contrast negative has a density range of 2.0 or over; medium contrast, 1.3 to 1.9; and low contrast, below 1.2.

Tray Sensitizing

1. The sensitizing bath should be between 45° and 60°F. If the tissue has dried out excessively, it will curl. If this happens, place the tissue in a tray of water for a minute or so and allow it to flatten out before proceeding. Squeegee out the excess water before transferring the tissue to the sensitizing bath.

2. Prepare the sensitizing solution as described above. Use enough sensitizer to keep the tissue completely covered. Immerse the tissue in the sensitizer, emulsion side up, taking care to remove any air bubbles that may appear on the emulsion.

3. When the tissue becomes limp, turn it over and break any air bubbles that may have formed on the back; then turn it face up again. Continue turning the paper and checking for air bubbles until the sensitizing period has elapsed. Sensitize for at least two minutes.

4. After two minutes, remove the tissue from the sensitizing solution and allow it to drain for a few seconds. Then place it emulsion side down on a clean plate of glass or Plexiglas, and squeegee it to remove excess sensitizer.

5. After squeegeeing, put the tissue aside in a dark room (or one illuminated only by a yellow bug light) to dry. Drying time will vary considerably depending on a number of factors, including the thickness of tissue, the amount of sensitizer squeegeed from tissue, the temperature and humidity of the drying room, and the strength of the dichromate solution. In my own working conditions, tray-sensitized tissue takes approximately one hour to dry fully.

Since potassium and ammonium dichromate are essentially interchangeable, either chemical may be used. Potassium dichromate is less expensive, but it is also slower. One can achieve identical results by varying the relative concentration of whichever chemical is used.

Carbon tissue should be sensitized under low-level, bug-light illumination.

Brush Sensitizing

Tissue sensitized by a spirit solution will be less sensitive than tray-sensitized tissue, but in most circumstances, the loss of sensitivity (on the order of about 50%) is compensated for by the faster drying time. Spirit-sensitized tissue will be fully dry and begin to curl in fifteen to thirty minutes, depending on drying conditions. Either alcohol or acetone can be used to prepare a spirit sensitizer, but the latter is superior in promoting fast drying and can be used with either ammonium or potassium dichromate. Alcohol, on the other hand, should not be used with potassium dichromate because of the risk of reducing the light-sensitive chemicals to a non-sensitive state.

1. Prepare a dichromate solution of twice the strength that would be necessary for tray sensitizing. Dilute one part of this stock solution of dichromate with one part of acetone (or alcohol). For example, if your negative requires a 2% dichromate solution, dilute a 4% stock solution of potassium dichromate 1:1 with the spirit.

2. Place the carbon tissue on a flat surface, pinning it down at the edges if it curls excessively.

3. Brush the sensitizer on the tissue using a wide foam brush (a one-inch brush for 5x7 and 8x10 tissue, a three-inch brush for 11x14 and 16x20 sizes). Wet the brush, and first apply the sensitizer with parallel strokes on the long dimension. Repeat the process on the short dimension, then brush on the diagonal.

4. Lay the tissue aside for a couple of minutes until it is surface dry, then brush on a second coating following the same procedure. Avoid leaving puddles of sensitizer on the tissue.

5. To coat the surface twice, you will need a minimum of these amounts of sensitizing solution per tissue: 5x7—5 cc per tissue; 8x10—10 cc per tissue; 11x14—20 cc per tissue; 16x20—40 cc per tissue.

6. Drying can be accelerated with a fan, just as for tray-sensitized tissue. The tissue must be completely dry before it is placed in contact with a negative; otherwise the two could stick together, causing serious damage to the latter.

The dichromate sensitizer can be reused, but its light-sensitive properties change with time and it must be renewed periodically. The primary reason for the change is that the tissue leaves minute traces of organic material in the sensitizer, causing a change in the pH of the solution. Filter the bath after use and store it in the refrigerator; this minimizes the accumulation of organic material and retards the consequent changes.

With both methods of sensitizing, beware of the phenomenon called "dark effect." Dark effect is caused by a spontaneous insolubilization of the sensitized (but unexposed) tissue, the practical consequence of which is a gradual gain in

speed and a decrease in contrast of the tissue. The minimum gain in speed occurs when the tissue is left in a cold, dry environment; the maximum gain is in hot, moist conditions.

Exposing the Tissue

Sensitized tissue can be stored in the freezer, where it will keep for many months. Store each sheet of sensitized tissue in a separate vapor-proof container (ziploc bags work well). Avoid condensation problems by allowing the package to reach room temperature before opening.

Before the tissue is placed in contact with a negative to make a print, it should be thoroughly dry, a condition indicated by a slight curling and a feeling of crispness.

1. Place the negative in the printing frame, emulsion side up, masking around the edges with an opaque tape so that a safe edge of about $1/4$" is left all around the negative. Failure to mask the negative will likely result in frilling of the print edge during warm-water development. When printing negatives with large areas of clear shadows along the image edge, use a semi-opaque border (ordinary masking tape works well) instead of the opaque tape; otherwise the dense pigment areas of the shadows are likely to frill during warm-water development.

2. After placing the tissue over the negative, emulsion side to emulsion side, secure the hinged inserts or clamping device of the printing frame so that sufficient pressure is maintained to bring the negative and tissue into firm contact.

3. Exposure times are rather long in carbon printing, varying significantly according to light source and negative density. When exposing with a bank of twelve 24" UV fluorescent tubes placed about 3" from the printing frame, typical exposures will be in the two- to eight-minute range.

The sensitivity of carbon tissue is affected by a number of factors:

- The gelatin used in the manufacture of the pigment tissue.
- The color of the pigment; blue and violet tissues are more sensitive than black, brown, and red ones.
- The strength of the dichromate solution. Strong solutions produce more sensitivity than weak ones.
- The temperature and humidity of the workroom. The tissue is more sensitive in a warm, humid room than in a cool, dry one.
- The age of the pigment tissue. As tissue ages, the gelatin gradually becomes less soluble, causing an apparent increase in sensitivity.

Transferring the Image to the Final Support

Since exposure to light has hardened only the outer layer of gelatin, the image must be adhered to a different support or it will all wash away from the original support. Carbon reliefs can be transferred to any suitably prepared surface.

The final support normally used is either a sheet of fixed-out photographic paper or a watercolor paper. Surfaces such as canvas and glass can also be used. Except for the photographic paper, which already has a gelatin emulsion, surface preparation for use as a final support merely involves coating it with a layer of hardened gelatin. The processing procedures that follow here assume use of a paper support. Methods for preparing alternative supports follow the processing instructions.

1. After exposure, under safelight conditions, separate the carbon tissue from the negative and place it in a tray of cool water, no more than 68°F, for about one and a half minutes. Wipe off any air bubbles that may appear. The tissue must not be left to soak too long; otherwise it will absorb so much water that its adhesive qualities will be impaired, with a greatly increased risk of frilling.

2. Soak the paper support in cool water for about fifteen minutes, then bring it into contact with the tissue underwater (emulsion to emulsion). The support should be somewhat larger than the tissue.

3. Remove the sandwich from the water and allow it to drain for a few seconds. The water in the transfer tray will gradually pick up bits and pieces of tissue and turn more and more yellow as your printing session continues. The yellow color of the water is of no consequence, but the water should be replaced periodically because there is a risk that some of the trash might lodge between the tissue and the support and ruin the image.

4. Place the sandwich on a sheet of plate glass, with the tissue on top. Carefully hold one corner of the tissue with one hand, and squeegee the sandwich, starting in the middle and working toward the sides. Blot up the expelled water with a towel or damp sponge, taking special care to wipe away any drops that accumulate around the edges of the tissue.

5. Place a clean blotting paper over the sandwich, cover it with a sheet of plate glass, and let stand under pressure for ten to twenty minutes.

Warm-Water Development

1. To develop the carbon relief, remove the plate glass and blotting paper, and slide the sandwich into a tray of warm water at around 105°F, with the final support on the bottom. After about two to three minutes, the gelatin will start to ooze at the edges.

2. At this point, lift one corner of the tissue backing and carefully separate it from the support. If there is any resistance to the separation, leave the sandwich to soak another minute or so and try again. After the tissue separates completely, discard it.

3. The image will be hidden under a mass of dissolving pigment. Gently agitate the support with a rocking motion, occasionally lifting the print out of the water to drain. Be very careful not to brush or rub the surface of the image, because it is very delicate. Large prints can be difficult to handle and should be developed clamped to some type of additional support (thin sheets of aluminum work well for this purpose).

4. With the developing water at 105°F, a carbon print should be fully developed, i.e., all of the unhardened gelatin has washed away, in about six minutes, certainly no more than ten.

5. A properly exposed and developed carbon print relief looks somewhat lighter when wet than after it is dry. Development should continue, therefore, until the highlights are somewhat lighter than they should appear in the final print. When the print is fully developed, transfer it to a tray of cool water (50°F to 60°F) and leave for about five minutes to allow the gelatin to set, then hang it up to dry.

6. Before setting the print aside to dry, look carefully at the image to see if the margins of the print are veiled, a likely result when using old carbon tissue. Veiled margins can be cleared by carefully rubbing the edges of the print with a clean sponge.

Temporary to final transfer

If you want your final carbon print to have correct right/left orientation, you must transfer it from the original support to a temporary one. Warm-water development is done on this temporary support, and the developed relief is then transferred to the final support. Plastics of the polyvinyl family make the best temporary supports; they release the image easily, and they can be washed and reused. If the final support requires preparation (see Preparing the Final Support, page 100), do this and let it dry before proceeding.

Once the relief is dry, pour about 25 cc of a 2–3% gelatin solution at about 80°F onto the final support. Next, squeegee into contact the relief on the temporary support with the paper final support and hang the sandwich to dry. When the sandwich is dry, the temporary support will strip from the final, leaving the image on the final support.

Clearing the Print

Prints developed on a final paper support will have an overall yellow stain from the dichromate sensitizer. This can be removed by soaking the dry print in a 3% solution of sodium bisulfite or potassium metabisulfite for five to ten minutes, or until the dichromate stain clears. The dichromate stain should not

Some degree of compensation for under- and overexposure can be accomplished by developing in water at extreme temperature ranges—down to 90°F for underexposure; up to 120°F for overexposure. Another method that allows for some correction of overexposure is the addition of an alkali to the developing water, in the form of 5 to 10 cc of ammonia or 1 to 2 level teaspoons of sodium carbonate per gallon of water. However, if the print has received gross over- or underexposure, it will not be possible to salvage it.

be cleared without first drying the print, because the relief image, which is extremely delicate after warm-water development, would be further softened by these clearing agents and blistering or reticulation is possible. After clearing, transfer the print immediately to a running-water rinse at 60°F to 70°F and wash it for ten minutes. The print is now chemically stable and ready to be mounted for presentation, unless some retouching is required. Carbon reliefs developed on plastic for double transfer do not require clearing.

Retouching and Spotting

Touch-up work can be done with a piece of carbon tissue of the type used to make the relief. Immerse a small piece of the tissue in warm water until the pigment begins to melt, then brush it on the areas needing touching up or spotting. The melted pigment can be diluted with warm water to achieve varying degrees of opacity. When all the retouching is done, allow the print to air dry.

Preparing the Final Support

Photographic paper

Photographic papers must first be placed in a fixing bath for five to ten minutes (under red or OC safelight), then washed thoroughly. This will remove all the photographic chemicals, leaving a clean gelatin emulsion. Generally, any good-quality paper may be used, depending on the desired surface. The appearance of detail will, of course, be greater when the final image is on a smooth, glossy paper, but luster and matte-surface photographic papers are also good for retaining apparent sharpness. Matte papers accentuate the relief characteristics of carbon prints and make excellent final supports. Photographers concerned with ultimate permanence should be aware that fixed-out photographic papers are more likely to discolor over time than all-rag papers, though much depends on the quality of the barium sulfate surface coating on the photographic papers.

Watercolor paper

A medium-weight, hot-press paper with a smooth surface makes an excellent final support. Paper such as 90-lb Fabriano, Arches, and Rives BFK all make attractive final supports. Cold-press papers have textured surfaces that will tend to diminish the apparent sharpness of the image. Watercolor papers must be prepared before being used as a final support.

The Hand of the Artist

Julia Margaret Cameron, Portrait of Sir John Herschel, *1867. Carbon print. Courtesy of the Royal Photographic Society of Great Britain.*

This is an unusual print, since almost no surviving nineteenth-century photographs show the telltale signs of their making—the negative edges, dark borders, and messy carbon gelatin—that this remarkable print exhibits. Information left behind like this tells a lot about this print. Sandy King analyzed it with the following observations.

The original plate used to make the print was masked, which explains the white margins around the rectangle of the photography. The plate was exposed to a piece of carbon tissue larger than the plate itself, and the edges of the tissue beyond the plate received exposure. This explains the dark borders of hardened pigmented gelatin beyond the white image. Normally we would wipe these borders clean but Mrs. Cameron did not seem concerned with doing that, perhaps because she saw this as a secondary quality print and was not concerned with final presentation. Finally, there are definite signs that after warm water development the print was hung to dry before the gelatin had set completely. You can see this from the colored drippings at the top of the print (almost dead center, where there is a dark colored blob that starts in the very dark borders and extends into the image area) dripping from the dark area of the image into the white masked-off areas. Let me give you some further information. In 1867 when Mrs. Cameron made this print there was still considerable experimentation in the transfer procedures. In most probability she followed the steps of Joseph Swan:

1. *tissue coated on paper*
2. *when dry, exposed to light under a negative*
3. *face of the tissue, and face of paper to which the image would be placed coated with an india rubber solution*
4. *warm water development, image adheres to paper, but reversed*
5. *final paper support coated with hardened gelatin, which is then placed in contact under water with the image. After transfer to warm water the image permanently adheres to the paper with the hardened gelatin, resulting in a photograph with correct orientation.*

It should be noted that the Autochrome Company in London made a series of carbon prints for Cameron at this same time, just before she moved to Ceylon. This print may have been from that group, although no direct indication is evident of who the maker was.

The paper is first sized with a gelatin coating. Use the amounts of chemicals given below, and mix them according to the method described for making pigment tissue above. The sized paper must be hardened with a formalin solution and allowed to dry before use.

Coating watercolor papers

1. Prepare 500 cc of a 5% gelatin solution, using a medium-hard gelatin (Bloom of 150–175). Proceed as in the manufacture of the carbon tissue above, first soaking the gelatin in cold water for about an hour, then placing it in a waterbath and raising the temperature to about 110°F to 120°F.

2. Soak the watercolor paper in water at room temperature immediately prior to coating it.

3. Carefully place the wet paper on a leveled glass plate and use a rubber roller and clean towel to remove all excess water.

4. For a 22" x 30" sheet of watercolor paper, use about 100 cc of the warm gelatin solution, spreading it onto the paper with a clean foam brush. For different size papers, adjust the ratio accordingly. It is easier to prepare a large sheet and cut it down to print size later.

5. When the gelatin sets, hang the paper to dry.

6. When completely dry, soak the paper in a 2 to 4% solution of formalin to harden the gelatin.

It is possible to combine the coating and hardening operation in one step. Before coating, add 50 cc of formalin, or 5 cc of a 5% chrome alum solution, to the gelatin solution. Paper hardened with formalin will be ready for use as soon as it is dry; but if the hardening agent is chrome alum, the paper should be set aside for at least one week before use. Avoid using formalin in areas where pigment tissue is stored, because the fumes will harden the gelatin and make the tissue useless. Both chrome alum and formalin are carcinogens, and great care should be taken to avoid skin contact and breathing the vapors of these chemicals.

Troubleshooting

Carbon printing presents a number of problems not faced in silver gelatin printing. There is very little latitude for error in many of the steps of the process, and neglect of detail can be quite unforgiving. Fortunately, most problems can be traced and corrected fairly easily. Some of the most common problems, in the order of operating procedures, are listed here.

Problem The dry sensitized tissue is so stiff and curled that it is impossible to maintain good contact with the negative for exposure.

Cause This results from prolonged drying in conditions of low humidity.

Solution Once the sensitized tissue has dried, seal it in a Ziploc-type bag if it is not to be exposed immediately. This will prevent further drying and curling of the negative.

Problem Negative will not separate from the tissue after exposure.

Cause The tissue was not given sufficient time to dry completely, and when placed in contact with the emulsion of the negative, the two became "glued" together. Local problems of this nature can also be caused by a bit of water splashing either the negative or the tissue just before they are placed in the printing frame.

Solution Do not use the tissue until it is completely dry, and avoid splashing water around the tissue and negative.

Problem Tissue and transfer paper are soaked for the proper time in cool water, but the two will not stick together.

Cause This can occur for one of several reasons. Either the tissue has become insoluble (it is too old, or it shows the result of the dark effect), or the tissue and/or transfer paper have absorbed too much water, or perhaps the transfer paper was not sufficiently sized. The wrong side of the paper may have been placed in contact with the tissue. Insolubilization is usually caused by one of three reasons: 1) over-exposure of the tissue; 2) the tissue dries too long before use; or 3) the tissue is too old. The tissue and transfer paper will not stick together when the gelatin of the transfer paper and/or the gelatin of the tissue become too swollen with water. A common cause for this problem is over-soaking of the tissue and/or pigment before squeegeeing the two together. This problem can also occur in conditions of high humidity and temperature.

Solution Use fresh tissue, process it before the dark effect makes it insoluble, and expose correctly. Make sure the transfer has a good gelatin size, and be sure to use the sized side of the paper. If you must work in conditions of elevated temperatures and high humidity, reduce the soaking time of both tissue and transfer paper to thirty seconds or less.

Problem It is impossible to separate the tissue from the transfer support during warm-water development.

Cause This is caused by gross overexposure of the tissue, which hardens the gelatin all the way to the base of the support. It can also be caused by the use of low-contrast tissue, or tissue with a thin gelatin coating. It can also result from very long exposures.

Solution Expose the tissue correctly. In tissue manufacture, always use enough pigment and gelatin coating to give an opaque coating. Correct your photographic technique to produce negatives suitable for carbon printing.

Problem The gelatin relief washes off the support during warm-water development.

Cause The tissue was underexposed, or perhaps received no exposure at all. Perhaps the developing water was too hot.

Solution Expose the tissue for the proper amount of time. Develop the tissue in water at no more than about 115°F.

Problem The image frills around the edges during development.

Cause 1) moisture around the edges of the tissue was not blotted off after squeegeeing; 2) the tissue and/or transfer paper soaked up too much water; 3) no safe-edge was used around the negative during exposure; or 4) temperature and humidity of working room was too high.

Solution Blot up all excess moisture from around the edges of the tissue; do not soak the tissue and/or transfer paper too long, or use a plastic carrier for transfer and development. Try to maintain a proper working room environment, with the temperature 70°F or less and the humidity 55% or less.

Problem Parts of the image wash away during development.

Cause This can be caused by very vigorous agitation and by using water that is too hot.

Solution Avoid overly vigorous agitation, and do not use development baths over 115°F.

Problem The image is too dark and/or has too much contrast.

Cause The image was overexposed or the sensitizer was diluted too much.

Solution Expose correctly and/or use a stronger sensitizer.

Problem The image is too light and/or flat.

Cause The image was underexposed and/or the sensitizer was too strong.

Solution Expose correctly and/or use a more diluted sensitizer.

Problem Round, irregular blisters on the final image.

Cause This problem results from air bells being trapped between the tissue and its developing support. Upon development, these air bells expand, causing a bubble to develop between the tissue and the support. When the tissue is stripped from the support, this area will show uneven dispersion of the melting pigment. In most cases, the unevenness will disappear during development, though in some cases it may be necessary to extend developing times somewhat.

Solution Prepare the transfer water well in advance to allow the dissipation of air under pressure. Also, try soaking the tissue for a longer period of time before combining with the support.

Problem Shiny specks on the print.

Cause Shiny specks are sometimes seen when using watercolor paper sized with gelatin. Slight irregularities in the surface coating cause some areas to have higher gloss than others.

Solution Apply a thinner gelatin coating, decrease the gelatin percentage in the solution, or add a small amount of starch to the sizing solution to cut the gloss.

Problem The final image has a yellow stain.

Cause The yellow stain is residual dichromate from the sensitizer.

Solution After the carbon print has dried, it should be cleared by soaking it in one of the recommended clearing baths, sodium bisulfite or potassium metabisulfite, followed by a wash of several minutes in running water.

Problem The final image contains streaks.

Cause In home manufacture of tissue, one will find that certain pigments, most notably many varieties of lampblack, can cause streaking on the face of the tissue. If this problem occurs, eliminate the guilty pigment. The problem can also result from inadequate dispersion of the pigments within the gelatin solution.

Solution Disperse the pigment thoroughly in the gelatin solution and eliminate the pigment(s) causing the problem.

Some workers will experience problems that have no history in the literature or that are specific to their working conditions. Such problems can be difficult to correct. In such circumstances, it is of enormous help to keep a good set of records, because the cause of a problem will often suggest itself through an analysis of one's operating procedures.

Archival Considerations

The archival qualities of carbon prints are superior to those of images derived from silver salt papers. When suitable pigments are used, the stability of carbon is limited only by the gelatin carrier and its paper base, making this one of the most stable of all photographic processes. Matting, framing, and other presentation considerations should be similar to those of any fine art print material. Always use acid-free mounting boards, interleaving paper, and storage containers. When framing and matting, always use acid-free linen tape and mounting corners, and never let the print come into extended contact with suspect glues, cardboard, masking tapes, or nonarchival mat boards.

Cy DeCosse, Moscow Cemetery. *Platinum/palladium print from a negative enlarged from a 35mm color negative.*

Chapter 8
Platinum/Palladium

Ted Rice

History

Platinum prints are popularly considered one of the most beautiful photographic printing processes. Platinum images are characterized by rich tonalities, a long tonal scale, and, like many alternative processes, a lusciousness that comes from the relationship between the image and the paper surface on which it is printed.

Palladium, a close chemical cousin of platinum that is also considerably less expensive, is often combined with platinum, or even used by itself, to produce similar but slightly warmer tones than pure platinum prints. Many platinum printers combine the two in various ratios to save money, warm the image, and smooth the tonalities (pure platinum prints can be grainy).

Platinum printing became widely popular in late 1800s and early 1900s with the availability of commercially produced printing paper, although most companies eventually phased out their products. Eastman Kodak discontinued theirs in 1916, and the Platinotype Company in England stopped in the late 1930s. The original patent for a platinum printing process was first granted to Englishman William Willis in 1873. After further refinements, an additional patent was granted in 1880; that process forms the basis for most of the platinum printing formulas in use today.

A modern version of ready-made platinum paper is currently manufactured by the Palladio Company of Cambridge, Massachusetts. Although expensive, the paper may be a good choice for those who have neither the time nor the interest to coat their own paper (see Resources).

What You Will Need

Chemicals

The platinum/palladium process does not require all of the chemicals listed here; the reader should decide on which variations to try and then check which chemicals will be needed.

- Ferric oxalate
- Potassium chlorate
- Potassium chloroplatinite
- Palladium chloride/sodium palladium chloride
- Potassium carbonate
- Citric or hydrochloric acid
- Sodium carbonate
- Ammonium citrate
- Gold chloride
- EDTA tetra sodium
- Mercuric chloride
- Potassium dichromate (*Note*: extremely toxic)
- Oxalic acid
- Potassium oxalate
- Potassium phosphate
- Glycerin
- Ethol LPD, Ilford Bromophen developer, or non-staining developer

Materials

- 2" foam brush
- Small jar
- Dropper bottles, 2 oz (at least 3)
- Hot plate
- Dedicated processing trays and tongs (3 sets)
- Graduated cylinders, 500 cc and 1000 cc
- Print washing tray
- UV light source
- Timer, 60-minute
- Photographic step wedge
- Masking tape
- Cardboard

Negative

The negative for platinum/palladium printing should be similar in contrast and density to one that will print well on a #1 silver paper. Density ranges of 1.8 to 2.2 work very well.

Paper

- Crane's Kid Finish
- Crane's Platinotype
- Arches Platine
- Bienfang 360 Layout (This is extremely thin paper and needs to be handled carefully.)
- Arches 90-lb Watercolor, hot pressed
- Twinrocker White Printmaking
- Twinrocker White All-Purpose
- Twinrocker Calligraphy Cream

Safelight

Low-level tungsten

Procedures

Mixing the Chemistry

Sensitizers

Begin by mixing the basic sensitizer chemicals and storing them in brown glass 100 cc bottles (bottles with dropper caps are a good option). You will need one bottle for each of the following formulas:

If you don't want to mix your own sensitizer, ready-made chemicals are available from Bostick & Sullivan and the Photographers' Formulary.

Sensitizer A

Distilled water (100°F to 125°F)	55 cc
Ferric oxalate	15 g
Oxalic acid	1 g

Sensitizer B

Distilled water—hot	55 cc
Ferric oxalate	15 g
Potassium chlorate	3 g
Oxalic acid	1 g

The ferric oxalate goes into solution more easily if the distilled water is heated to around 125°F. One method is to pour the proper amount of water into the glass bottle, add the ferric oxalate powder, and shake. Place the bottle in a pan of hot water on the stove or hot plate and shake it periodically until the solution is no longer cloudy.

Sensitizer C (Platinum solution)

Distilled water—hot	55 cc
Potassium chloroplatinite	11 g

Sensitizer C (Palladium solution)

Distilled water—hot	55 cc
Palladium chloride	5 g
Sodium chloride	3.5 g

James Henkel, Collection, 1994. *8" x 10". Platinum/palladium print.*

Developers

The standard developer for both platinum and palladium prints is a saturated solution (33%) of potassium oxalate, which is formed by combining potassium carbonate and oxalic acid. This developer may be used anywhere from 70°F to 120°F. As the developer temperature increases, the print color gets warmer, and the image contrast decreases. At 120°F, the print is about one grade softer than at 70°F. If you dilute the cold developer, you can increase the contrast, too. If the developer is less than ½ strength, the effect will be like using too much restrainer.

Another developer I have often used is sodium citrate, which is very easy to make. The components are less toxic than potassium oxalate. The print color from this developer can be very warm on starch or synthetic-sized papers, and the contrast is about ½ grade higher than potassium oxalate. You might have to increase your exposure 10–20% over the prints developed with potassium oxalate.

Ammonium citrate is another developer currently popular among platinum printers. This developer is much colder in tone than the potassium oxalate

developers listed below, and will make a palladium print appear much closer to platinum colors. It does not keep well, however, and smells strongly of ammonia. You will have to double your exposure over that used for the potassium oxalate developer. Also given here is another formula in which potassium phosphate is added. This was popular in the old days for making warm tones on palladium. All of the developers are less active when cold and more active when warm.

Although different developers give different results, beginners need to mix only one. Those just starting this process are advised to start with potassium oxalate developer, since it is the easiest developer with which to work. (Photographers' Formulary and Bostick & Sullivan offer this standard developer as a package in which the dry components are premixed; simply add distilled water.)

Potassium oxalate developer (traditional)

Potassium carbonate	227 g
Oxalic acid	207 g
Distilled water at 110°F	1315 cc

Potassium oxalate developer (variation)

| Potassium oxalate | 330 g |
| Distilled water at 110°F | 1000 cc |

Sodium citrate developer (alternative)

Sodium carbonate	266 g
Citric acid	162 g
Distilled water	1440 cc

Ammonium citrate developer (alternative)

| Ammonium citrate | 500 g |
| Distilled water | 1500 cc |

Warm tone developer (alternative)

Potassium oxalate	180 g
Potassium phosphate monobasic	60 g
Distilled water	1000 cc

Clearing Baths

There are not so many choices for the clearing bath, which is used to remove iron salts after the print has been exposed and developed. My personal favorite is citric acid, which is safe and efficient (although it may burn holes in clothes). Traditionally, hydrochloric acid was used for a clearing bath.

Contrast Control

You can increase the contrast in a print by adding potassium chlorate to the ferric oxalate sensitizer; this acts to restrain the image formation. Unfortunately, if you add too much of this restrainer, you also restrain the metal salts from being reduced. This is called "graining." Your first line of defense is to make a negative of good contrast and density. If you are using an enlarged or duplicate negative and find that it won't print with enough contrast, make another.

There are also other methods that can be employed to control contrast. Traditionally, potassium dichromate was added to the developer. Start with ½ to 2 grams per liter. Pictorial photographer and platinum-printing expert Paul Anderson wrote that this additive would bleach palladium prints, but in my tests printing palladium I had good results with 1 gram of potassium dichromate per liter. There is some exhaustion rate, though this is never specified in any of the old writings.

Another much safer contrast-control additive is hydrogen peroxide. You can start by adding 10 cc of 3% peroxide, the drugstore variety, per liter of developer. You will have to add another 10 cc. after every three to four 8x10 prints. This should give at least ½ grade contrast increase without any graining. An alternate method is to add 1 drop of 3% hydrogen peroxide per cc of combined sensitizer solution just before coating.

Ethylene diamine tetra-acetic acid tetra-sodium salt (EDTA) can also be used as a clearing agent, but this does not work with every paper.

Citric acid clearing bath

Citric acid	30 g
Distilled water	1000 cc

Hydrochloric acid clearing bath

Hydrochloric acid (37%)	16 cc or less (Any ratio from 1:60—acid to water—or weaker can be used with palladium. Strong acid will bleach palladium images.)
Distilled water	1000 cc

Remember to *always add the acid to the water* for safety reasons, and wear eye goggles. This is very dangerous stuff.

EDTA clearing bath

EDTA tetra sodium	3 g
Distilled water	1000 cc

Coating the Paper (under low-level tungsten safelight)

There is as much art as technique involved in learning how to coat the paper. Of all the skills needed to make platinum and palladium prints, this is the most difficult to learn.

1. After selecting the paper to print on, tape it at the corners onto a sheet of cardboard. The cardboard should be at least one or two inches larger than the paper in order to absorb sensitizer solution that goes beyond the paper edge. The tape used to hold down the paper should not be very sticky (try re-use tape or drafting tape), or the corners will be ripped off when the paper is removed from the cardboard.

2. Mix the sensitizer solutions according to the contrast you desire (see Contrast Chart, page 116). A total of 48 drops of combined solutions (A, B, and C) will cover an 8" x 10" image area.

3. Coat the paper using either the brush method or the glass rod method. The instructions here describe the brush method; see the Coating Sensitizer Solutions in the Basics section for details on glass-rod coating. Measure the sensitizer out by drops into a shallow wide-mouth jar or dish wide enough to accommodate your brush. It is helpful to establish a sequence that you always follow when putting the solutions into the jar. This avoids confusion about what has been added and what has not. The order doesn't matter, but consistency helps to avoid mistaken measurements. After the components are in the jar, mix them by rotating the jar gently or stirring with a glass rod.

4. After the chemistry is mixed, place the brush into the jar to soak up the liquid. Gently but efficiently glide the brush in even, parallel lines across the long dimension of the paper. By manipulating the brush speed over the paper surface you can make sure the right amount of chemistry ends up on the paper. Remember that a slow-moving brush puts down chemistry, while a fast-moving brush picks it up.

5. Once the paper has been coated, brush in lines perpendicular to those you first put down. This evens out the surface distribution. Make sure any puddles of sensitizing solution are picked up, or the areas will be of different densities.

6. It is possible to repeat this brushing a few more times, but you must have a very light touch. Many beginners tend to coat their paper as though scouring a pan, which pulls up the fibers and leaves a very ugly surface. When in doubt, err on the side of delicacy.

7. Finally, let gravity do the work. Let the chemistry sink in for several minutes while the paper begins to dry on its own. Don't forget to wash out your

brush. When wet, the platinum solution has a light lemon-yellow color that is sometimes hard to see on the paper. Palladium, which has an oranger color, is easier to see when wet.

Ted Rice, Untitled. *Palladium print.*

Contrast chart

By varying the relative amounts of the three sensitizer solutions, you can gain control over the contrast of your print. The first formula, very soft contrast, for example, could be used both to create a very low-contrast print from a normal negative and to reduce the effective contrast of a high-contrast negative. The amounts below cover an 8" x 10" area. Calculate chemistry amounts for smaller or larger image sizes proportionately.

Very soft contrast

Sensitizer A	22 drops
Sensitizer B	0 drops
Sensitizer C	24 drops

Soft contrast

Sensitizer A	18 drops
Sensitizer B	4 drops
Sensitizer C	24 drops

Normal contrast

Sensitizer A	14 drops
Sensitizer B	8 drops
Sensitizer C	24 drops

Higher contrast

Sensitizer A	10 drops
Sensitizer B	12 drops
Sensitizer C	24 drops

Extreme contrast

Sensitizer A	0 drops
Sensitizer B	22 drops
Sensitizer C	24 drops

Drying the Sensitized Paper

Although many platinum printers use a hair dryer to dry their sensitized paper, I prefer the hot plate method. Let the paper sit to air-dry for a few minutes. When you estimate it is about 75% dry (learned by experience), hold it by opposite corners about six to eight inches above a warmed hot plate set to medium. I dry both the front and back of the paper using a rapid twist of the wrists. It is important to keep the paper moving; if you burn part of it, the paper will become desensitized in that spot. When the paper is properly dry, it makes a crisp sound, like a dry leaf.

If pieces of lint or other objects have fallen onto the surface of the paper, it is best to remove them after the paper is dry, lifting the lint particles with a soft, dry paint brush.

Using Hair Dryers

There are both safety and practical reasons for not using a hair dryer. First, the hair dryer blows particles of palladium and iron salts into the air that may go into your lungs, causing health problems. The hair dryer also can dry the paper unevenly, leaving desensitized areas on the paper surface. If you feel you have a good ventilation system and/or a good dust mask, you can try the hair dryer method of drying the sensitized paper:

1. Begin by slowly passing the hair dryer about 12" to 18" above the surface of the paper. It should be set to its lowest (coolest) setting.

2. Move the hair dryer slowly and evenly along one length of the paper, slowly progressing across its width.

3. Every minute or so, increase the temperature of the hair dryer, repeating the same movements as above.

4. Periodically, lift the paper and dry both the back of the paper and the surface on which the paper is lying.

5. Test the paper for dryness by touching the surface of the sensitized paper gently. Be sure to touch only a section that is outside the image area, or you could leave marks that will show up on the developed image.

Storing Sensitized Paper

You can store sensitized paper for short periods of time, provided the proper precautions are taken. I've used a photo paper box with silica gel placed at the bottom, not touching the paper. The paper will usually remain good for two to three days. After a week, it will lose about one-half grade in contrast (become lower in contrast); after one month, it will lose a full grade and become progressively fogged.

Printing

Exposure

For beginners, the simplest (and cheapest) method of exposure to use is the sun. Of course, your exposure times will vary greatly depending on the time of day, time of year, altitude, level of overcast, and how close or far you are from the equator. Sun exposures are cheap, but they are seldom consistent if you are printing editions of the same image.

1. Under safelight conditions, place the print frame face down on a counter and open the hinged back. Remove any dirt lodged inside the print frame with canned air or negative brush.

2. Place the negative's emulsion (the dull side) against the coated side of the paper. Place the film-and-paper sandwich into the frame, with the negative against the glass and the paper on top, coated side down.

3. Put the hinged back on the frame and close the spring clips. Check the frame from the front to make sure the negative lies on the paper where you want it to be. Also check for any stray pieces of grit, which will show up as tiny indentations on the film. If you find any, open the frame, clean the film and paper, and reposition them back into the frame.

4. Now you are ready to go outside and print. To keep stray light from hitting the paper before I am ready to make the exposure, I usually place a piece of cardboard over the print frame and remove it at the same time I turn on the timer. Time can be kept by wristwatch, stopwatch, wind-up timer, or simply counting out loud. The most consistent time of day for sunlight printing is between 10 A.M. and 2 P.M. If you make test prints, be sure to mark the month and time of day on the print border in pencil.

5. When you think the negative has had enough exposure, open one half of the frame back in subdued light. When you lift the edge of the paper, you should see a faint image of your negative, orange and violet in color, in which the details are just barely visible. If no details are visible, expose the print longer until they do appear. This image will be more visible in a palladium print than in a platinum print.

6. All iron-process prints, including platinum and palladium, dry down darker than they appear when wet. Your exposures will need to be adjusted to allow for this dry-down effect, which varies from paper to paper. I find about $1/2$-stop dry-down with Crane's paper. On Arches Platine, it can be as much as $1^1/_2$ stops.

Developing the print

For beginners it is recommended to use potassium oxalate developer. The temperature should be between 70°F and 120°F.

1. Remove the paper from the frame and put the negative in a safe place where it will not get wet or damaged.

2. Set up a tray to be used for developing; it should be at least one size larger than the print. Pour a small amount of developer into the tray, just enough to wet the bottom.

3. Place the paper in the tray, image up. Pour the developer quickly and evenly over the surface of the print. One liter should be sufficient for an 8x10.

4. Break up any bubbles that form on the print surface with the rubber end of a print tong. If left alone, these bubbles cause undeveloped spots on the print.

5. Gently agitate the print while it is in the developer. After about thirty seconds, the print will have developed. Since this is a completion process, leaving the print in longer will not create more print density. The print should show just a trace of detail in the highlights when development is complete; otherwise it will be too dark when dry. Note that if you don't pour the developer evenly there will be streaks on the print. Some printers use a hake brush to even out the developer ffow.

Clearing the print

Prepare two trays of citric acid clearing bath.

1. With print tongs, gently pick up the print by one corner. Allow the excess developer to drain off the surface into the developer tray, then place the print face up in the first clearing bath.

2. Gently agitate it in the first clearing bath for five minutes. Remove the print from the tray, rinse it brieffy in running water, and place it in the second clearing bath. The water rinse greatly speeds up the clearing process.

3. Gently agitate the print in the second clearing bath for five minutes. The print is now ready for the final wash.

You will notice a profound change in print color as the iron salts migrate out of the paper during the first clearing bath; the color is much less yellow. After the print is placed in the second clearing bath, very little color change will be noted.

Platinum prints can stand very strong acid baths, but these are likely to bleach palladium prints. The clearing bath formulas given here are safe for both.

The temperature of the developer affects both contrast and print color. Potassium oxalate developer may be used from 70°F to 120°F. Above 100°F, it produces warm-tone images. When the developer is used hot, it is very active and will develop the image almost instantly.

This thirty-second development time is given as a general rule. With heavy paper and ammonium citrate developer, it may take a minute or more to complete development. Platinum prints usually take slightly longer to develop completely than palladium prints. Leaving prints in too long, however, can result in staining.

Recently I have discovered that a combination of separate baths of citric acid and EDTA is useful on stubborn paper in which the yellow iron stains won't clear out. As a last resort, the stain can sometimes be removed with a 10% solution of sodium sulfite. This is, however, not a clearing agent. Any stains remaining after this treatment are likely to be permanent.

Washing the print

Two washer types are suitable for platinum and palladium prints: a deep tray with a siphon at the edge or the vertical style with Plexiglas dividers. Most modern drawing papers can be washed vertically; this allows more prints to be washed at a time, although the weight of the paper is sometimes enough to tear it when it is washed on its edge. It is best to test a sheet first. The paper should be fully washed in ten to fifteen minutes. Multi-ply papers can separate when they get wet and come apart in the wash water, so wash them with care.

It is important to remember that wet drawing paper is extremely fragile. When picking up the print corner, do not use any force or the paper will tear. Prints made on extremely fragile paper should be washed in a deep tray, using minimal water flow, and processed only one or two at a time. Some papers are so fragile that they are damaged merely by the flow of water running over the surface.

Drying the print

1. Gently remove the print from the wash water with your hands, picking up the print by the edges. Allow the water to drain from one corner.

2. The preferred drying method is to place the print face up on a plastic screen. In most climates, a print will dry in a few hours. Do not use dirty drying screens used for silver printing or stains will appear on your platinum/palladium prints.

Note Put a clean paper towel under the print to prevent screen marks.

Flattening

The prints can be made quite flat by putting them in a hot dry-mounting press between two archival 100% rag boards. Most prints only require thirty seconds at 225°F. I do not recommend actually dry-mounting platinum or palladium prints, however.

Spotting

You can spot platinum and palladium prints easily, and most of the time you will not be able to tell they have been spotted. Distilled watercolor, in either tube or cake form, is the best medium to use. The cake colors are more concentrated than the liquid. I use Winsor & Newton sepia and lamp black. These two colors can match most colors of both platinum and palladium. Start out with a small amount of dilute paint in the brush; the paint will dry darker than it appears when wet.

Note Silver spotting dyes often change color over time.

M. J. Diness, Dome of the Rock from atop the Golden Gate, 1860. *12" x 14". Platinum/palladium print by John Barnier from the original collodion wet-plate negative.*

Toning for Color Variation

As with silver prints, platinum and palladium prints can be toned to alter the color of the final image. Two toning techniques are described here. The first, mercury toning, is technically an extension of the development process. It has a definite toning effect on platinum images. The second technique, which tones with gold chloride, works with both platinum and palladium prints.

Mercury-toned platinum prints

Perhaps the most beautiful and elusive of all the platinum printing techniques is the mercury-toned print. This is actually a development procedure since the mercury is added to the developer solution rather than being used as a separate bath. It also utilizes an unusual step of re-exposing the processed print to UV light to complete the procedure. This particular variation was popular at the turn of the century. On some papers, the prints can be made to have an intriguing split tone, with cold shadows and peach-colored highlights or a beautiful chocolate brown color on some papers. If you want warm-colored prints, you can make them more easily and consistently using palladium. It will warm up palladium prints, but it won't give any split colors. If you are trying to make an edition of prints, do not use mercury toning. Even with the best controls, there is a great deal of variation from one print to another.

There are actually two methods of toning using this process; however only one works with any consistency. In the first, you add mercuric chloride to the sensitizer. I tried this method, and it made an uneven mess. The best method is to add mercuric chloride to your developer, as I describe here.

When you first add the mercuric chloride to the developer, the prints will be yellow in the highlights. After the developer has aged a day or more, the color will be more peachy and rich looking. Your developer will look like black coffee after the mercuric chloride reacts with it, but don't throw it away! It is still good. Mercuric chloride is extremely toxic, so be very careful with this developer and observe all safety precautions.

The added mercuric chloride will provide some other benefits to your printing, since the paper speed will increase one-half to one stop. The mercuric chloride will also yield a more even reduction of the platinum, give smoother tones in the print, and boost the shadows.

Choosing Paper for Mercury-Toned Prints

The choice of paper makes a big difference with the mercury technique. The best split tones can be made on gelatin-sized paper, and papers with linen fibers are superior. At one time I had a stash of the kind of paper that platinum-printing expert Laura Gilpin used. When it ran out, I had to search for modern substitutes, and many will work. The reason for choosing a linen paper for this technique is that the shadows are much cooler and deeper than with cotton papers. If you try this technique and get weak-looking prints, the paper is probably to blame.

I have been able to examine several old prints that were mercury toned. A few were about one hundred years old, and one was an Alfred Stieglitz portrait from around 1930. Although I had read in the old platinum books that this process is fugitive, I have not been able to find any noticeable deterioration of the image or print color. The Stieglitz print had some mat burn under the edges though, proving that old pulp boards do indeed stain any type of print! I made some mercury-toned prints as early as 1980, and I cannot detect any change in them. It appears that the main component of the image color is a stain caused by the reduction of the mercuric chloride. This coloring can be partly removed with strong acid at the time of processing, but it stabilizes later on. For this reason, use a weak citric acid bath to clear the prints. Make sure your acid is fresh though; otherwise yellow stains will form from the undissolved iron compounds.

Procedure

Reserve a separate set of trays and tongs for this process; otherwise contamination from other chemicals will ruin your prints.

Mercury developer

Mercuric chloride	5 g
Potassium oxalate developer	1000 cc

1. Sensitize and dry the paper as usual. You may have to shorten the exposure time to compensate for the gain in speed the mercury developer/toner gives.

2. In safelight conditions, place the exposed, unprocessed print face up in a tray.

3. Pour the mercury developer over the print slowly and evenly, and gently agitate the print in the tray.

4. The desired color will take from three to five minutes to form. Remove any air bubbles that form on the surface with a soft paint brush.

5. When the developing is complete, lift the print gently by one corner with bamboo print tongs and let it drain.

6. Place the print in a weak citric acid clearing bath, approximately half the normal strength (15 g per 1000 cc). You must be very careful with the clearing stage. Too much clearing will remove the color; not enough clearing will result in stains.

7. Use a second weak bath after the first to make sure the iron has been removed.

8. Wash and dry the print in the usual manner.

9. To complete this procedure, a final re-exposure to UV light is necessary. After the print is dry, place it face up in a hinged contact-printing frame. Take it outside and expose it to direct sunlight for one or two minutes. If the sun is not available, use the UV light source normally used to expose your prints. The print will become about one-half stop darker. No further processing is necessary. There should be no future color or density change in the print; as I mentioned earlier, this print color appears to be permanent.

Toning with gold chloride

Another variation of the platinum/palladium process that may be easily done is to tone prints with gold chloride. This toning may be done on both platinum and palladium prints. There is a cooling effect of the print color if you add the gold chloride to your sensitizer (see sidebar), but if you tone an existing print as described here, the technique produces blue-black colors.

There seems to be a variation in the effectiveness of gold chloride toning depending on the age of the print. The original author of this process, A. W. Dolland, recommended that the print be no longer than ten weeks old. I don't know how he came up with this particular age. One thing is certain, though; as the prints age, the metallic compounds become more inert, and are less susceptible to change.

Procedure

1. Soak an exposed, processed, and dried print for a few minutes in warm water. This will swell the paper fibers and make the gold chloride tone more evenly. Remember that this toner acts in proportion to the amount of it applied to a given area of the print, so it is possible to tone unevenly in creative ways.

Adding Gold Chloride to the Sensitizer

You can add gold chloride to the sensitizer solution when coating your platinum/palladium print. This will cool the tones, especially the highlights, and will give a generally smoother texture to the image. Too much gold will cause pink to purple highlights, however. Both 1% and 5% solutions of gold chloride can be purchased ready-mixed from the Photographers' Formulary or Bostick & Sullivan (see Resources), or you can mix your own. For a 1% solution, add 1 gram gold chloride to enough distilled water to make 100 cc of total solution. For a 5% solution, use 5 grams of gold chloride. When measuring out your sensitizer solutions during coating, simply add the gold chloride by drops to the combined solution. A starting point would be to add 3 drops of 1% gold to 46 drops of sensitizer. This is just a starting point; you will need to experiment for results that suit your own taste.

I use the 1:25 solution of gold for platinum prints (4% solution). For palladium, I recommend a much weaker solution of gold chloride, 1:250 (0.4% solution), as a starting point. If the gold on a palladium print is too strong, you will end up with insoluble purple stains.

2. Place the print face up on a sheet of plate glass that has been coated with glycerin. The size of the glass is not important, but it shouldn't be too large or it will be hard to handle.

3. Using a soft paint brush, coat the surface of the print with glycerin.

4. Mix one gram of gold chloride with 25 cc of distilled water, and put this in a dropper bottle. Be careful opening the gold chloride; it comes sealed in a glass vial that can easily break and leak the chemical. The old literature recommends opening the vial in a tub of water. The gold chloride will stain anything it contacts, and can burn your skin as well. The safest and easiest solution to this problem is simply to buy a bottle of gold chloride ready-mixed to your desired strength from Photographers' Formulary or Bostick & Sullivan.

5. Mix three to five drops of gold chloride solution with about 15 to 20 cc glycerin and brush it on the print. It is best to do this toning under strong daylight.

6. As the gold solution sits on the print, the color will become much cooler, and the density will increase.

7. When you have reached the desired print color, place the print under 68°F running water until all the glycerin is washed out.

8. Immerse the print for one minute in any non-staining paper developer. Ethol LPD and Ilford Bromophen work well. Look for one made of phenidone-hydroquinone. This developer will reduce any leftover gold compounds that might be formed and trapped in the paper or the sizing.

9. Wash the print for fifteen minutes to remove the residual developer.

10. Dry the print as described above.

Troubleshooting Guide for Platinum/Palladium Prints

These are some of the most common problems and their solutions.

Problem White spots on print.
Cause Too much potassium chlorate in sensitizer.
Solution Use a higher-density negative, which will then require little or no chlorate to boost contrast. The added chlorate causes this "graining" effect.
or
Cause Water or sweat spilled on exposed, unprocessed print.
Solution Keep wet side of work room separate; wear a headband.
or
Cause Paper was abraded when coated.
Solution Remember to use a light touch when coating.
or
Cause Dirt on negative.
Solution Blow off negative before using; check the printing frame and negative for grit.

Problem Black spots on print.
Cause Metal shavings from paper cutter or scissors.
Solution Crease and tear the paper, or use a whole sheet.
or
Cause Dirty trays or tongs.
Solution Clean with tray cleaner, or obtain new trays.
or
Cause Bad batch of paper.
Solution Check it against paper known to be good.
or
Cause Undissolved platinum, palladium, or ferric oxalate.
Solution Check chemistry bottles for precipitate; warm the bottles to dissolve chemical particles, or filter their contents.

James Henkel, Pear/Camera, *1996. 8" x 10".*
Platinum/palladium print.

Problem Print is solarized.
Cause Not enough ferric oxalate sensitizer was used.
Solution Add more drops of ferric oxalate sensitizer to the total sensitizer solution.
or
Cause Negative is too dense, necessitating an overly long exposure time.
Solution Use a thinner negative requiring less exposure.
or
Cause Paper was not dry before printing.
Solution Dry over hot plate for a longer time.

Problem Streaks on the print.
Cause Uneven coating.
Solution Use more sensitizer solution, or use a softer brush. Allow to dry more before using hot plate.
or
Cause Paper has too much sizing.
Solution Use a thinner paper, or soak the paper to remove some sizing. (Dry it before use.)

Problem Print density weak.
Cause Not enough ferric oxalate used.
Solution Add more ferric oxalate sensitizer to the sensitizer solution.
or
Cause Not enough exposure.
Solution Give longer exposure time.
or
Cause Negative too weak to produce a good image.
Solution Use a stronger negative.
or
Cause Ferric oxalate is old or heat damaged.
Solution Mix fresh ferric oxalate.

Problem Print too dark when dry.
Cause Not enough sizing in paper.
Solution Use paper with a harder surface.
or
Cause Too much exposure.
Solution Decrease exposure time.
or
Cause Negative is too weak for results wanted.
Solution Use a negative with higher contrast.

Problem Highlights fogged.
Cause Print was exposed to stray UV light.
Solution Keep exposed paper away from printing light or daylight.
or
Cause Not enough potassium chlorate in sensitizer.
Solution Add more solution B to sensitizer.

Problem Out-of-focus print.
Cause Paper was not flat in frame.
Solution Remove tape and other obstructions in frame.
or
Cause Negative or interpositive is not sharp.
Solution Check originals for sharpness.

Problem Light areas on print.
Cause Paper burned on hot plate.
Solution Use less heat.
or
Cause Uneven coating.
Solution Use more cross strokes when brushing.
or
Cause Paper curled at edges.
Solution Tape down more securely.

Problem Stains.
Cause Contamination.
Solution Clean tongs and trays, or use a tong and tray set only for platinum and palladium printing. Check work-area counters for spilled chemistry.
or
Cause Residual chemicals in the print.
Solution Print needs more clearing and/or washing.

W. Russell Young III, Kelley's Robe. Kallitype.

Chapter 9 Kallitype

W. Russell Young III

History

Sir John Herschel's famous 1842 paper, "On the Action of the Rays of the Solar Spectrum on Vegetable Colours, and on Some New Photographic Processes," which disclosed to the world his inventions of the cyanotype and chrysotype, also laid the groundwork for the theory for kallitypes. Herschel noted, "if instead of a solution of gold the nitrate of silver is used..." an image would result. While Herschel was contemplating the chemical possibilities of these processes, the reaction he described here led to the development of what became known as a *kallitype*. In his *Memoirs*, he observed that "if after exposure, the paper [brushed over with ferric oxalate] is washed over with nitrate of silver, a picture of much intensity results." This is clearly a description of the kallitype process.

Englishman W. W. J. Nichol, who is usually credited as its inventor, gave the name *kallitype* to the process he patented in 1889. In his process, the paper was sensitized only with the iron salt. It was then exposed and developed in a solution containing silver nitrate. Using silver nitrate in the developer rather than in the sensitizer was common through the end of the kallitype's popularity in the 1920s. The system Nichol patented had a basic problem because, with every print developed, the amount of silver in the developer decreased; very few workers use this system today. Since the developer could not be replenished accurately, results could not be repeated precisely. The technique did, however, avoid using alkaline developers, which are known to diminish the potential life of the kallitype print.

Nichol applied for two further patents in 1891, and they were granted in 1892; both were substantial revisions of his initial patent. One of these revised patents called for the silver nitrate to become part of the sensitizer, rather than the development bath, thereby remedying one major variable of the process. It also used Rochelle salt as the basis for the developer. The other revised patent created a process that was more theoretical than practical and seems to have been unusable by all who tried it.

American amateurs became involved with kallitypes about 1900, after the publication of an article by Dr. O. P. Bennett in the widely read *Photo Beacon*. This article was followed by numerous others over the next twenty years in *Photo-Miniature*, *Photo Beacon*, *Camera Craft*, and other journals. American workers had articles published in Europe, as well, in the *British Journal of Photography* and *Photographische Mitteilungen*.

The first substantial volume on kallitypes was written by Henry Hall and published in 1903 as an issue of *Photo-Miniature*. The editor of the journal, John Tennant, later noted that the issue sold over five thousand copies that year; this success led to creation and circulation of a postal portfolio of kallitypes. That sales figure is remarkable in the world of photo-technique books even today.

A well-known book of the era, *Ferric and Heliographic Processes* (1899), also included a full chapter on the process. It lays out many of the "modern" adaptations, including adding dichromate to increase contrast and the use of hypo.

There were numerous commercially available papers based on the kallitype. In the United States, Nelson Hawks manufactured Polychrome. In England, Satista was the dominant brand; no less an artist than Alfred Stieglitz used Satista paper! Other American brands included Sensitol, Soline, Similiplatinum, and Platinograph.

A Willis & Clements advertisement in Number 185 of *Photo-Miniature* noted, "Get quality and distinction in your prints and HIGHER PRICES [their emphasis] by using Platinotype, Palladiotype and Satista Papers. Exquisite surfaces. Unequaled tone values. Easy in manipulation." Kallitypes were largely banned from salon competition because of their reputation as faux platinotypes; it seems the judges did not like to be fooled.

James Thompson, who published more than twenty articles in American photo magazines, was certainly the most prolific writer about kallitypes. Despite his wide publication, however, his formulas often leave something to be desired. They are complicated, convoluted, and often were stolen from earlier writers with no credit given. Thompson's articles have been widely cited in the last fifteen years as the basis for modern kallitype improvements, but if

you read that in a contemporary article, it is a warning that the author probably doesn't have much hands-on experience with kallitypes!

As the popularity of hand-coated processes declined after World War I, so did the kallitype. After the late 1920s, mentions of it in print are more for novelty than for practical application; and after World War II, it essentially became unknown.

Serious arguments have been raised throughout its history about how archival kallitypes are. Nichol made a major mistake by not fixing them correctly, but this was remedied before 1899 by other workers. Kallitype prints do seem very resistant to light fading; contemporary Portuguese kallitypist Carlos Gasparino kept one taped to the window of his car for over six months, a very severe test. I made similar tests a decade ago and also found they were unaffected by such torture. (Resin-coated silver prints, by comparison, fall apart in the same test.)

Most recently, the English photochemist Mike Ware has argued that the very nature of the chemicals in the process prevents a long-lasting image, and he invented a variant of the kallitype, the "argyrotype" (see Chapter 16), to surmount that problem. Although his reasoning is accurate, I would add that many kallitypists over the years have produced images with lasting qualities. Ware especially warns against using alkaline developers, such as those with high borax contents. Most of the developers listed in this chapter are acidic, and therefore circumvent that problem.

Process Overview

With the unavailability of commercially produced kallitype papers, contemporary workers must replicate the practices of kallitypists in the early twentieth century. In the procedures presented in this chapter, the paper is sized and coated with a silver nitrate/ferric oxalate solution. After exposure to ultraviolet light, the print is developed in an acidic developer. I've presented a number of possible developers that give a variety of results. Following development, the print is cleared, toned, fixed, and washed.

There are possibilities for subtle tonal and color variations at almost every stage of the kallitype process, making it ideal for workers who wish a great deal of flexibility in fine-tuning their results.

What You Will Need

Chemicals

Basic components
- Silver nitrate
- Ferric oxalate
- Sodium thiosulfate (hypo)
- Tween 20 (optional)
- Distilled or deionized water
- Citric acid or
- Tetrasodium EDTA
- Powdered arrowroot (optional)
- Knox gelatin (optional)
- Alum (optional)

Chemicals for various developers
- Rochelle salts (sodium potassium tartrate)
- Sodium borate (borax)
- Potassium oxalate
- Sodium acetate
- Sodium citrate
- Tartaric acid
- Potassium dichromate
- Ammonium citrate (optional)
- Potassium citrate (optional)

Toners (all optional)
- Kodak Selenium toner
- Potassium chloroplatinite
- Palladium chloride
- Gold chloride
- Mercuric chloride

Materials

- Trays (as many as 9 if you plan to tone your prints)
- 30 cc or 60 cc brown-glass dropper bottles (minimum of 3)
- 1-quart/liter bottles (12)
- Foam brushes (3 to 5)
- Contact printing frame
- UV light source
- Mixing graduates

The main disadvantage of the kallitype process is the sheer number of trays and bottles you will need. Assuming you will tone the print, nine trays will be required for the various baths and the rinses in between, plus an archival washer. The number of bottles for processing is variable. The minimum is three (developer, fix, clearing bath), but in practice, you'll probably need three for each type of developer (plain, plus two with various amounts of potassium dichromate added) and one for each type of toner. You should probably have about a dozen one-quart/liter bottles available at the beginning. If you are meticulous and patient, you may be able to use a single tray, pouring all the solutions in and out of it; I make large prints that way.

You cannot use metal objects anywhere in the process until after the fixing is complete! No metal print tongs, no metal trays, no metal ferrules on the coating brush, etc. Even a paper-cutter edge may leave extremely fine particles of iron on the paper that will show up as stained spots later. Keep your trays and tongs spotless as well.

Always use either distilled or deionized water to mix all solutions—no exceptions. Iron particles and dissolved chlorides, often found in tap water, will cause substantial problems.

Negative

Unlike the cyanotype and printing-out paper, the kallitype is not self-masking. This allows a minimal printing time and yields good results with normal density-range negatives. If a negative prints well on #2 silver gelatin paper, it should be easy to make a good kallitype from it. With a correctly exposed and developed negative, my print exposure times (using a UV fluorescent tube box) run from two to five minutes.

Paper

The choice of papers is extremely critical with kallitypes, as in many other processes in this book, because it sets the limits of tonality and color that can be achieved with any developer. Increasingly, some papers simply won't work because you cannot clear them. Certain papers inherently yield a longer tonal range than others; this is an important way to control contrast besides using chemical additives in the developers. Developers that produce cool blacks on one paper may produce warm browns on another.

If you want to spend time experimenting in the darkroom with the tremendous range of the combinations inherent in kallitypes, paper is the most important variable! It is far better to settle on one or two developers and one or two toners than to spend the rest of your life testing permutations. The paper is more important, and you should test new papers as they become available. Suggested papers are:

- Arches Watercolor
- Gallery 100
- Lanaquarelle Watercolor
- Fabriano Uno

Safelight

Low-level tungsten

Procedures

Sizing the Paper

Sizing allows use of papers that are otherwise not suitable, but which have color or texture you like so much you can't bear not to print on them. It also lets you fine-tune color and contrast range, with an increase in D-max. The sizing agents I'll discuss are gelatin and starch; these are the exclusive sizing agents in vintage papers, yet they are rarely found in contemporary papers. Current papers can produce good prints, but they are substantially different from vintage prints.

Starch sizing

Powdered arrowroot	10 g
Water	1000 cc

1. Stir the arrowroot into a small amount of the room-temperature water, dissolving it and breaking up any lumps.

2. Add the remainder of the water and bring it to a boil. Boil for two or three minutes, removing any "skin" that may form on the surface.

Allow the starch to cool to room temperature before coating the paper. If used hot, the paper may cockle. The starch must not be too thick when brushed on the paper or else it is likely to flake off after the paper has been wet for an extended period. Unlike gelatin, there is no way to harden starch. You can brush on two or three layers, however, if you wait until each one is dry. Do not use spray starch; it is not archival.

Gelatin sizing

Knox gelatin	7 g (one envelope from the package)
Alum	1 g
Water	1000 cc

1. Mix and let the gelatin swell and absorb the water for at least thirty minutes.

2. Add 1 g of alum, then slowly bring the solution to a boil; boil it for three or four minutes.

As with starch sizing, the gelatin solution should be allowed to cool before use. If the paper is really absorbent, use only 500 cc of water when making the sizing. The alum helps to harden the otherwise soft gelatin; the typical hardener is formalin, which I consider too hazardous for use. The alum has some negative implications when it is within paper, but my educated guess is that this very small amount inside the gelatin has no measurable effect on the longevity of the print.

Sizing methods

Paper can be sized in two ways, either by brushing the sizing agent on one side or by floating the paper gently in a tray of the sizing solution.

Brush sizing

Brush sizing is usually done with a foam brush (be certain it has a wooden handle; the plastic-handled kind tends to disintegrate with use). For 5x7 prints, the size I make most often, a 3" foam brush is ideal. The brush strokes should go in all four directions and exert minimal pressure on the paper.

Just how wet the brush should be depends on the paper; here you must experiment. I cannot tell you precisely because it depends on how much pressure you put on the brush, how fast your strokes are, how much overlap there is between strokes, the degree of texture or smoothness of the paper surface, and the sizing. All of these vary with each person or paper; and as a result, a paper that causes one photographer to lose patience and sanity may coat easily for someone else.

Floating

The other classic sizing method is to float the paper on the sizing solution. This produces a more even coating, free of brush strokes and thin spots.

1. Place the sizing solution in a tray at least one format larger than the paper dimensions (i.e., a 5x7 tray for a 4x5 print). Gelatin sizing needs to be warm to flow easily and penetrate the paper. With both starch and gelatin, the warmer the solution, the less the surface tension; this means it penetrates the paper better and the tiny air bells (which will cause no end of grief later) are likely to burst of their own accord. A temperature range of 90°F to 110°F gives good results. Use a metal or Pyrex tray (they conduct heat better than plastic) and float it in a larger tray filled with hot water. Some workers use aquarium heaters to keep the solution warm enough.

2. Take the sheet of paper and fold two diagonally opposite corners at a right angle to the paper surface. These tabs will be your handles, so they should be large enough to be grasped easily by your thumb and forefinger. Pick the sheet up by the handles, one in each hand; let the weight of the sheet bow the paper, and very gently let the bottom of the bow come into contact with the size. Lower the handles so the entire sheet is floating on the surface.

3. Keep the paper in contact with the sizing solution for a measured time period (so each sheet is identically sized), and then lift it off very gently.

4. Draw the paper over the rounded edge of the tray, or a round glass or acrylic rod, to remove the excess sizing.

5. Lay the sheet face up on a fiberglass screen to dry.

The floating technique is easier and more efficient if you deal with a few fairly large sheets of paper rather than a number of small sheets. If you have a tray large enough, it makes sense to float an entire sheet, approximately 24" x 30", then cut it to size afterward.

Home-sized paper lasts indefinitely. You will probably find it more convenient to coat large batches at one time and get it over with; this also ensures consistency rather than batch-to-batch variations. Keep things simple—there are enough other variables left to deal with!

W. Russell Young III, Spring Flood. *Kallitype.*

Coating the Paper

Sensitizer solutions

Part A

Silver nitrate	5 g
Distilled water	50 cc

Part B

Ferric oxalate	10 g
Distilled water	50 cc

The sensitizer formula contains only silver nitrate and ferric oxalate (plus, perhaps, Tween 20). I have used both a commercial brand and homemade ferric oxalate, and there are substantial differences in speed, color, and tonal range. If you are buying the ferric oxalate as a powder and mixing it yourself, *do not add excess oxalic acid* as you might with platinotype sensitizer. It will react with the silver nitrate to form silver oxalate (the combined iron-and-silver solution turns rather pearlescent), which is useless to the process. Ferric oxalate with excess oxalate must have the excess neutralized with ferric nitrate before it is usable for kallitypes.

The shelf life of a mixed ferric oxalate solution is at most three months; this is a good reason to buy Bostick & Sullivan's powder, which seems to last for years. With the mixed solution, the amount of fog in your prints will increase steadily, and the sensitivity will vary. The solution can, however, be converted back to the ferric state by adding hydrogen peroxide. Even the weak 3% hydrogen peroxide from the grocery store will work. Add a few drops to the ferric oxalate solution and shake well, but be sure to leave the cap off since the chemical reaction generates gas. It is better to use the stronger hydrogen peroxide available at hair dressers' supply houses; it doesn't dilute your ferric oxalate as much. One effective approach is to mix just enough from powder for each printing session.

Mixing the working solutions

Immediately before use, combine them in a plastic (I use old margarine tubs) or glass container in a 1:1 ratio. Swirl the container to mix the solutions together well and brush on the paper. Gently air dry in a horizontal position, preferably on something like a drying screen, which allows air circulation on both sides. If you hang it to dry, sensitizer will migrate to the lowest edge of the paper and produce an uneven coating. I prefer to err on the side of safety and coat under subdued tungsten light (not fluorescent, which has a significant UV component) and dry in total darkness. This guarantees no light fog.

When you have coated the paper, immediately wash your brush, using only distilled or deionized water (tap water contains elements which may mix with the silver in your brush and contaminate future prints). Or simply throw the brush away.

Recently, a proprietary wetting agent, Tween 20, has been found to increase the D-max and smoothness of coating with some modern papers used for kallitypes. Tween 20 is the trade name for a specific dilution of polysorbate, a chemical you will see on some food content labels. Other similar chemicals do not seem to work as well. A tiny bit of Tween 20 goes a long way! Dilute it by taking 5 cc of the stock solution and adding it to 100 cc of distilled water. Use one or two drops of this diluted wetting agent in 40 drops of the working sensitizer solution.

Although Tween 20 improves the printing characteristics of some papers, it ruins others. The dilute Tween 20 is good for several weeks before it begins to grow mold.

Sensitizing the paper

1. Working under safelight conditions, sensitize the paper by brushing the working sensitizing solution gently in each direction. The amount of sensitizer needed varies considerably with the paper and type of brush used, so you will have to experiment to determine the correct amount. The amount depends on: paper sizing, paper surface, ambient humidity, and the type of brush used.

2. When you have coated the paper, wash your brush immediately using distilled or deionized water. Tap water contains elements that may react with the silver in your brush and contaminate future prints. The foam will break down sooner or later, so just toss the brush (it's only fifty cents) and grab another. I buy half a dozen at a time from the hardware store.

3. The sensitized paper must be completely dry before printing. Air-dry it partially, then use a stream of cool or slightly warm air from a hair dryer. In order to obtain consistent contrast and speed, the length of time the paper is air-dried before forced-air drying must be identical each time. The drying period is dependent upon the paper, how heavily you coated it, and the ambient humidity in your darkroom. In my arid climate in New Mexico, a three-minute air-dry is enough.

As long as the sensitized paper is kept *very dry* (stored at 10% relative humidity or less), it will last at least a week. There may be some lessening of sensitivity and contrast, but for most purposes it will be acceptable.

Sensitizer additives

Any of several metallic salts may be added to the working sensitizer solution to modify the color and tonal range of the print. The two most common are gold and mercury. Mercury has been a part of the platinotype printer's color-modification palette for nearly a hundred years, and it works on kallitypes as well. Note that too much mercury is not desirable, both for the color changes it causes and because of concerns about archival preservation. Rarely is more than 10% of the volume of the sensitizer made up of the mercury or gold solution. Experiment using different amounts of the formulas below to find a result that pleases you.

Gold sensitizer additive

1% gold chloride stock solution

Gold chloride	1 g
Distilled water	100 cc

Mix 1 g of gold chloride in 100 cc of distilled water, stirring until it is dissolved completely.

Gold chloride working solution

1% gold solution	5 cc
Distilled water	20 cc

Mix the gold chloride stock solution and the distilled water well. Gold chloride yields a warm olive tone in the image, similar, but not identical, to that achieved with the mercury additive.

Mercury sensitizer additive

Mercuric chloride	1 g
Distilled water	30 cc

Dissolve the mercuric chloride completely in the distilled water. With most papers, one drop of this mercury solution in 20 drops of sensitizer brings about a very lovely soft olive tone, but in some cases it produces a reddish brown. When the drop hits the mixed sensitizer, the liquid becomes cloudy, but it does not seem to precipitate silver. Use a special brush dedicated only to the mercury sensitizer—it seems impossible to wash all of it out. Increasingly with modern papers, the mercury may react adversely with the sizing agent, causing staining or difficulty in clearing. Mercuric chloride is a *very hazardous* chemical; handle it carefully.

Gold chloride is sold in sealed-glass, one-gram vials because it absorbs atmospheric moisture so quickly. Break each vial under water with needle-nose pliers. The gold chloride is extremely acidic and will burn through your skin very rapidly in the crystalline form. Gold toner is also available already mixed.

Exposure

Before making an exposure, be certain the paper is bone dry! Residual dampness will exacerbate the difficulty of the shadow areas solarizing. Although many people use a hair dryer to dry the sensitized paper, there are now some questions as to whether you are blowing fine metallic particles in the air to inhale. A safer technique is to use a hot plate and gently move the print about 10 inches above the surface.

1. Place the sensitized and dry paper in a contact printing frame, emulsion to emulsion with your negative.

2. Expose the paper and negative to UV light. Normal negatives print in sunlight in the one to six minute range, depending on the time of year, time of day, and weather conditions.

Obtaining a correct exposure is a little tricky. Like the platinotype, only a vague kallitype image showing just the darkest areas (i.e., deep shadows) should be visible after exposure; the developer will make the remaining areas appear instantly. Since different developers have varying efficiency levels, you will have to determine different exposure times for each developer you use. The sodium acetate and potassium oxalate developers require the least exposure time; they are nearly a full f/stop faster than most others.

Development

During development, the minimal image produced by exposing the print emerges with a full tonal range. The developer formulas below yield a range of image colors. Since the exact color depends on the sensitizer formula used, you will have to experiment to find the sensitizer/developer combination that produces the results you want.

Developer formulas

Black tones (after Hall, *Photo-Miniature*, 1903)

Sodium acetate	150 g
Tartaric acid	1.5 g
Distilled water	1000 cc

This is perhaps the best, most reliable all-around developer; it is also one of the fastest.

Brown-black tones

Borax	50 g
Rochelle salts	40 g
Distilled water	1000 cc

This is my next-favorite developer; it yields lovely tones and split-tones easily.

Brown tones (after Thompson, *Photo-Miniature*, 1922)

Rochelle salts	40 g
Distilled water	1000 cc

This produces nice colors, but it does not have much capacity.

Black (after Palmer, *Camera Craft*, 1908)

Potassium oxalate	30 g
Distilled water	1000 cc

I have always obtained very warm tones, nearly reddish with gelatin sizing, from this developer despite the designation William Palmer gave it. The developer produces the coolest colors on Strathmore papers. It is very fast, and if the sensitizer coating is uneven, it yields extremely pronounced effects; it is tricky to use well.

Warm brown (after Young)

Sodium citrate (see note at left)	200 g
Distilled water	1000 cc

Although not widely available, sodium citrate is easy and inexpensive to make at home. It is formed by neutralizing a solution of citric acid with sodium carbonate (this will also produce a large amount of carbon dioxide). Sodium carbonate is available cheaply as Arm & Hammer brand "super washing soda" in the detergent section of grocery and other retail stores; citric acid is also inexpensive and is available from chemical suppliers.

W. Russell Young III, Aspens. Kallitype.

The formulas that include Rochelle salts and borax approach being saturated solutions; they will dissolve more easily if you use water at about 100°F. I suspect that the amount of dry chemical in these formulas is excessive since in 1900 both of them were likely only available in a hydrated form. Borax is now available as a decahydrate form, which weighs about 30% less than the water-laden hydrate. I have successfully used developers with 40% less chemical than given here (except for the potassium oxalate developer) with identical results; the more saturated bath may have a greater print capacity, however.

1. Develop the print by placing it into an empty tray and pouring the developer over it.

It is important that the developer cover the image all at once, or else a line of demarcation may result. Pouring the developer over the print in an empty tray reduces this problem; it also helps prevent the formation of air bells which, if not removed immediately, will permanently mark the image.

2. Agitate the print constantly for at least two minutes. Full development is *critical* to the archival life of the print.

The purpose of the developer is to reduce the ferric salt struck by light to ferrous salt. It is critical, both to the beauty of the image and to archival stability, to give full development. This requires at least two minutes in the developer with continuous agitation. The agitation provides fresh developer to the print

surface and sweeps away ferric salts dissolving in the denser image areas that can stain the print. There is no such thing as overdevelopment. If you find that a particular paper/developer combination does not clear well, try keeping it in the developer for six to ten minutes.

After full development, the image should look too dark; no matter how much you may like the color at this stage, it will change. Both the color and the density are affected by iron and silver compounds still in the paper that were not struck by light; these particles will be removed by subsequent steps. You cannot judge the color until the print has been through all the baths and has totally dried.

3. Rinse in a gently running water bath for a minute. This will discharge excess chemicals from the paper's fibers.

Different developers have quite different useful capacities. Some, especially the 100% Rochelle salt developer, can only process four to six 8x10s per liter. Others, such as the potassium oxalate developer, can develop as many as twenty-five prints. This is a very critical issue for archival stability! An exhausted developer will still bring the image to full intensity, but it does not reduce the iron salts adequately. As a result, the print does not clear fully, and excess iron remains in the paper to yellow. In the potassium oxalate developer, the iron will settle and the "good" developer can be decanted.

Contrast control

The contrast of the print may be increased at the development stage simply by adding a dichromate salt to the developer. Some workers keep several containers of developer on hand, each with a different amount of dichromate, to produce varying contrasts.

Mix a stock solution of potassium dichromate by dissolving 10 g in 100 cc of distilled water. Each 1 cc of this solution added to one liter of your developer will yield approximately a half-grade gain in contrast. The maximum effective amount varies with the paper and sizing, but I have used up to 96 drops per liter! Be aware that the exact effect varies with the developer as well. You may substitute ammonium or sodium dichromate for the potassium salt.

An alternative approach is to add the dichromate salt to the developer when it is mixed. Since we are using a 10% dichromate solution, adding 10 cc of the solution adds 1 g of the salt; for each 1 cc of the 10% solution desired, you can substitute 0.1 g of the dry salt and add it when you mix the developer. This method makes creating higher concentrations easier, but you have to pull out the scale every time.

The dichromate depletes with use, so it is difficult to get exact replication. You can work out a replenishment schedule based on the surface area of prints which have been developed by making step-wedge tests.

Clearing the Print

The unexposed ferrous salts may be removed by using any of three chemicals: hydrochloric acid, tetrasodium EDTA, or citric acid. Hydrochloric acid is the traditional clearing agent for the robust platinum or palladium prints, and historically some authors recommended it for the more fragile kallitype; I think it too dangerous and too harsh.

Tetrasodium EDTA is widely touted in some circles, but I have reservations about its effectiveness. It is certainly safe for both the user and the print, however. Try mixing one tablespoon per liter of water.

My choice is citric acid; it dissolves easily, and it is safe to handle, safe for the print, effective, and inexpensive. Two tablespoons dissolved in a liter of water clears kallitypes well on nearly all papers with nearly all sizing agents. One liter is enough to clear four 8x10s safely. Change this frequently! Some workers combine the EDTA and the citric acid in one clearing bath.

1. Clear the print by immersing it into a bath of two tablespoons citric acid or EDTA to one liter of water with constant agitation for two minutes.

2. Rinse the print in running water for one minute.

The color of the bath will change as the excess iron, which is yellow in color, is removed from the print. You want to be absolutely certain the iron is removed. I have seen modern kallitypes and a few platinotypes that have developed brown stains only a few years after printing because of residual iron compounds that were left in the paper by inadequate clearing.

Toning the Print

Toning is an important option in the kallitype process. It not only alters the image color, but the noble-metal toners add considerably to the archival life of the print. Although the metals used are relatively expensive, the solutions require small amounts and tone a lot of prints; hence, they are very economical. In addition, with most papers, the toner will reverse the solarized shadows and transform them to maximum density. I feel that, because of archival issues, all kallitypes should be toned for stability.

Please note that in my processing sequence, toning takes place before fixing. It may also be performed after the print has been completely processed and dried, but the effect is quite different. Toning before fixing usually yields a print far richer in both color and density. Again, you will have to experiment with the formulas below to find the one you like best.

Toner formulas

Palladium toner (after Wynne, 1982)

Palladium chloride	0.5 g
Distilled water	1000 cc
Sodium chloride	5 g
Citric acid	5 g

Dissolve the palladium chloride in the water completely, then add the sodium chloride and citric acid and mix thoroughly.

Platinum toner (after Wynne, 1982)

Potassium chloroplatinite	0.5 g
Distilled water	1000 cc
Sodium chloride	5 g
Citric acid	5 g

Dissolve the potassium chloroplatinite in the water completely before adding the other chemicals. Mix thoroughly. I have used an even more dilute toner with only 0.25 gram of the platinum with fine results. This toner produces slightly different colors at different dilutions.

Selenium toner (after Wynne, 1982)

Kodak Rapid Selenium toner	5 cc
Distilled water	500 cc

This is a very simple toner that yields fine colors with almost any developer/paper/sizing combination. If you want to keep just one toner in your kallitype darkroom, this is my recommendation.

1. Tone the print by immersing it in a tray of toner solution and agitating it constantly. Times will vary according to the desired result, but a range of fifteen to sixty seconds is normal.

2. Rinse in running water for two minutes.

Times for the platinum, palladium, and selenium toners range from as little as fifteen seconds to a minute or so, depending on the sizing and the degree to which you wish to modify the color. Sometimes even ten seconds is enough for a subtle toning of the colors, or to allow for split tones. Split-toning is possible with some paper/developer combinations, but not at all with others; you must experiment! Selenium and gold toners are the most likely to allow this phenomenon. If the image mottles or decreases in density, try a more dilute toner, or use a different paper and sizing.

W. Russell Young III, Adobe Shadows. *Kallitype.*

Fixing the Print

Part of the archival problem with the early versions of the kallitype was due to ineffective fixing agents, which did not remove the unexposed silver completely. The consensus today is that the standard photographer's fixer, sodium thiosulfate, at a rate of fifty-five grams in a liter of water, does the job thoroughly. (Some current workers believe this solution may be stronger than necessary and feel that two grams per liter is adequate.)

1. Fix the rinsed, toned print in the sodium thiosulfate solution for at least one minute; two is better. Be careful not to leave it in the fixer too long, or the image will fade.

2. Rinse in running water for one to two minutes.

An untoned print may bleach with extended fixing, but a minimum of one minute is required. Agitate the print constantly. Unlike modern silver gelatin papers, there is no supercoat layer for the fixer to penetrate; thus the action begins almost immediately. Change this bath after four 8x10s or the equivalent have gone through it.

Washing aid

Removing the fixer is a crucial step that ensures a long life for the print, so a commercial washing aid is a necessity. Kodak, Ilford, Heico, and other manufacturers sell stock solutions that work very well. Follow the instructions on the brand of your choice, but do not eliminate this step! Agitate the print in the washing aid for at least one minute.

Final wash

3. After the washing-aid, a ten-minute wash in running water at 68°F to 75°F will suffice to remove the residual fixer in light- and medium-weight papers. If the paper is heavy, a fifteen- to twenty-minute wash is best.

A longer wash is better than a shorter one, but some paper cannot withstand prolonged immersion and may fall apart. In some cases, the image may fade. (Toning will prevent this.)

4. Air dry the prints face up on fiberglass screens.

Bibliography

Brooke, W. J. "Kallitypie." *Photographische Mitteilungen* 36 (1899): 160–164.

Brown, George E. *Ferric and Heliographic Processes, a Handbook for Photographers, Draughtsmen, and Sun Printers.* London: Photogram, Ltd., 1899. The second edition has some revisions and further information.

Hall, Henry. "The Kallitype Process." *Photo-Miniature*, 4, no. 47 (February 1903): 513–552.

Palmer, J. Will. "The Kallitype Process." *Camera Craft* (May 1908): 165–169.

Stevens, Richard. *Making Kallitypes, a Definitive Guide.* Boston: Focal Press, 1993.

Thomson, James. "Kallitype and Allied Processes." *Photo-Miniature* (January 1922): 209–245.

———. "Kallitype to date, Supplementing the information given in The Photo-Miniature Nos. 47 and 69." *Photo-Miniature* (September 1907): 421–428.

———. "Postscript to No. 47." *Photo-Miniature* (December 1904): 507–516.

Ware, Mike. "The Argyrotype." *British Journal of Photography* (13 June 1991): 17–19.

Wynne, Thomas A. *The Kallitype.* California: New Pictorialist Society, 1982.

Linda Connor, Farmer Washing Spinach, 1993. *Gold-toned POP.*

Chapter 10 Printing-Out Paper

John Barnier

History

Printing-out papers—those whose images emerge as they are exposed to light, without the need of liquid developing solutions—have been around since the beginning of photography. As early as 1835, William Henry Fox Talbot, inventor of the first negative-positive process, utilized a silver chloride paper that printed-out during exposure. Talbot's initial prints, which he called "photogenic drawings," were the beginning of a long continuum of papers produced during the first century of photography that utilized a certain characteristic of silver chloride: when regular table salt (sodium chloride) is applied to an environment of excess silver nitrate, the resulting silver chloride becomes much more sensitive to light than either silver nitrate or silver chloride alone. These papers (salted paper, albumen paper, gelatin printing-out paper, and collodion printing-out paper) offered photographers a wide choice of surface textures, image colors, and background tints. By the late 1900s, however, only Kodak's Studio Proof (a silver gelatin printing-out paper) remained, and in 1987 even that paper was discontinued.

Silver gelatin printing-out paper (POP) was immediately reintroduced in 1988 by other manufacturers because so many photographers were using it; it was clear that a demand existed. Today the major manufacturer of silver gelatin POP is Kentmere, Ltd., in England, which produces Centennial POP on contract for the Chicago Albumen Works, located in Housatonic, Massachusetts. It is distributed worldwide by both the Chicago Albumen Works and by its affiliate, the Nationaal FotoRestauratie-Atelier in Rotterdam. Centennial POP is available directly from the distributors and from dealers in many countries,

including the United Kingdon, France, Japan, and Germany. In the United States, it is also available from Bostick & Sullivan.

Centennial is double-weight fiber paper that comes in a variety of standard sizes. It can also be custom cut and ordered in rolls up to 40 inches by 100 feet.

Characteristics

Printing-out paper has several important qualities that separate it from other modern silver gelatin papers. Besides the ease of judging correct exposure by simple visual inspection, it also has a unique characteristic curve that produces relatively high shadow contrast, while at the same time producing lower highlight contrast. The effect produces prints with smooth and gentle highlight tonalities and strong, open shadow details. Another creative advantage of POP is its broad range of toning possibilities, achieved with either gold chloride- or platinum-based toners. A dramatic range of colors can be produced—from bright orange-reds to deep mahogany-browns to cool blue-blacks—by choosing one toner or another, as well as by varying the ratios of the various components of each. This rich color palette offers photo-artists an opportunity to give their work a unique look.

It should be noted that there are many more gold/alkaline toning formulas than could be listed. The ones here are included because their ingredients are inexpensive and readily available. They serve as a good starting point from which to understand the potential of POP toning. While POP yields prints with specific characteristics, my greatest interest is in the range of image color that can be achieved by toning the prints. Specific instructions for contact printing and initial processing prior to toning are given in the description for gold toning below.

For an additional list of gold toning formulas, see the instruction sheet enclosed with each box of Centennial POP. Thanks to Doug Munson of the Chicago Albumen Works for the gold-toning formulas. For the initial procedures for platinum-toned POP, thanks to Ted Rice for his original research in this area. The addition of lithium palladium is based on research by the author.

What You Will Need

Chemicals

For gold toning
- Ammonium thiocyanate
- Gold chloride (.20% solution)
- Sodium thiosulfate (15%)
- Borax
- Sodium bicarbonate (baking soda)

For platinum/palladium toning
- 20% platinum solution (potassium chloroplatinate)
- Lithium palladium solution (available through Bostick & Sullivan; see Resources)
- Cesium palladium solution (available through Bostick & Sullivan)
- Sodium chloride (table salt)
- Alum (aluminum ammonium sulfate)
- Sodium thiosulfate

Materials

- Centennial POP (printing-out paper)
- UV light source
- Contact printing frame
- Four clean trays
- Eyedropper
- Two measuring graduates; 500 cc, plastic or metal
- Distilled water

Safelight

Red, low-level tungsten, or yellow bug lights

Procedures

Mixing the Chemistry

Listed below are a number of formulas for gold and platinum toning solutions that work well with POP, along with formulas for other processing solutions. You need not mix all of these variations—select one to start with and explore other possibilities once you have reasonable success with it.

Gold toners

The traditional toner for POP is gold chloride combined with ammonium thiocyanate, and the Chicago Albumen Works offers gold-toning kits that are very easy to mix and use. These kits are perfect for beginning experiments. The colors possible with POP can be enhanced even further with the addition of alkaline-based chemicals to the basic gold chloride solution.

Gold/thiocyanate solutions

Either use the Chicago Albumen Works kit, or mix the following:

Stock solution A

Ammonium thiocyanate	10 g
Distilled water	500 cc

(Allow this solution to sit overnight or eight to ten hours before using.)

Stock solution B

Gold chloride	1 g
Distilled water	500 cc

Working solution

Tap water (around 70°F)	900 cc
Stock solution A	50 cc
Stock solution B	50 cc

Gold/alkaline solutions

For a working solution add *either* 4 g of Borax or 1 g of sodium bicarbonate to 900 cc water (tap water is fine). To this solution, add 30 cc of 0.2% gold chloride (stock solution B from above). Add tap water to make 1000 cc and mix completely. It is ready to use in about five minutes, after it loses its yellow color.

The alkaline elements can also be combined to achieve additional color variations. For a working solution, add *both* 1.5 g Borax and 3 g sodium bicar-

If you have a 1% solution of gold chloride already available (it is sometimes used as an additive in platinum/palladium printing), you can use that as well. Dilute 100 cc of 1% gold chloride solution with 400 cc of distilled water. Mix well; this will be your stock solution B.

John Barnier, Skull. Platinum-toned POP.

500 cc each of the stock chemical solutions (stock A and B) will tone approximately fifty 8x10 prints. They will keep indefinitely as long as they are not mixed together.

bonate to 900 cc water. Then add the gold chloride and additional water as instructed above.

You can vary these ratios to get even more color possibilities. Gold/alkaline formulas tend to produce prints with more contrast than do the gold/thiocyanate formulas.

Gold toners can be replenished, making the gold method more economical than usually assumed. For each 8x10 print (or every 80 square inches of paper toned) do the following:

- Gold/thiocyanate solution: Add approximately 8 cc *each of stock solutions A and B.*
- Gold/alkaline solution: Add 5 cc of the 0.2% gold chloride (solution B) only.

Higher replenishments may be required with prints that have large black borders.

Platinum toner

Although gold is the traditional toner for POP, it may also be toned using a stock 20% platinum solution—the same used in making platinum prints—instead of the gold. Not only can the images be assumed to be better preserved with platinum, but they are also capable of a wide range of final print colors. Platinum toning is also less expensive than gold toning.

Solutions

Stock solution A

Sodium chloride (table salt)	7 g
Alum	3 g
Water (tap water is fine)	500 cc

Stock solution B

Platinum solution 20%	25 cc

Stock solution C

Lithium palladium solution	25 cc

Although these solutions can be replenished, they do not keep well over time. Discard the used toner after each printing session.

Fixer

Fixer (with hardener)

Sodium thiosulfate	150 grams
Kodak liquid hardener	70 cc
Tap water	1000 cc

or

Kodak fixer (powder)

Mix this according to the packaged instructions; it already has hardener in it.

POP emulsion is rich in silver nitrate, which can ruin your negative's emulsion over time—even long after it has been retired from use. One solution is to place a sheet of clear Mylar between the negative and the paper. Although common sense would indicate that inserting any material would cause unsharp images, the truth is that as long as you are using a thin enough material—0.5 to 0.7 mm—the image will indeed be sharp.

Toning Procedures

Gold toning

1. Set up four trays: a running-water wash, an empty tray for the toner, and two fixer baths with 500 cc of fixer in each. Always use trays that are about one size larger than the paper on which you are printing: an 11x14 tray for an 8x10 print, for example.

2. Under safelight conditions, open the back of the contact-printing frame and place the negative in the frame *away* from the glass. Place the *emulsion side* of the printing-out paper against the negative and close the back. Flip the frame over and check for any pieces of grit or other foreign matter that may have dropped between the negative and paper. If there are any, a slight impression in the negative will be visible. Take out the negative, blow or brush it clean, and reposition it against the paper.

3. Make the initial exposure. Times will vary according to your negative's density and the nature of your light source; but since this is a printing-out process, you can monitor the print's progress with only a little initial guesswork. As long as you are using a split-back contact-printing frame, you can check the print's progress by lifting one half of the back (the other half will hold the negative and paper in register) and inspecting the print visually (with the light source off). The print is fully exposed when it looks *much darker* than the final print is supposed to look. In Zone System terms, this is about two zones darker, but experience will relatively quickly guide you toward judging the look of a correctly exposed print.

4. Remove the paper from the contact frame and immerse it in a tray of running water at about 70°F, being careful to slide it into the water with an even motion. Wash for at least two minutes.

5. Place the print in the empty toning tray and pour the working toning solution over the print; agitate constantly but gently by lifting one corner of the tray, then another. Continue this agitation procedure, alternating corners, for two to ten minutes, depending upon the color desired. Be sure to remove any air bubbles that may appear on the surface of the print.

6. Lift the paper and drain it for a few seconds, then immerse it in the first fixer tray (sodium thiosulfate solution). Do not rinse between the toner and the fixer.

7. Fix the print for five minutes, then lift and drain it and place it in the second fixer tray. Fix five minutes more, for a total of ten minutes.

8. Remove the print from the fixer, and wash it for thirty minutes. Air-dry the print, *face up*, on fiberglass drying screens. Drying face down may leave the pattern of your drying screen in the surface of the paper, which is very soft while wet.

If you use tape to hold the negative to the paper, small deposits of adhesive will invariably collect on its surface. Photographic film cleaner dabbed onto a lint-free cloth will clean the negative surface, and at the same time give it an antistatic coating, helping to prevent the attraction of dust.

While each formula produces different color variations, a general rule of thumb is that shorter toning times produce warmer/redder tones, while longer times produce more neutral or even cold tones. This effect will vary according to the toner used.

a

b

c

d

e

f

g

h

Platinum toning

1. Follow steps 1 through 4 above.

2. Add between two and ten drops of stock solution B or a combination of stock solutions B and C to the 500 cc of stock solution A.

3. Place the print face up in the tray and pour the toner over it, agitating constantly as described above. Remove any air bubbles on the surface of the print.

4. Tone for two to twelve minutes, depending on the color desired.

5. Fix, wash, and dry the print as instructed above.

The number of drops will affect the final color of the toned image, as will the variation in quantities of solutions A and B. Experiment with different proportions until you find one that suits you.

Color Variations

By varying the toning times and the ratios of the various chemicals, one can control the color range of POP in almost endless ways. As an example, varying the ratio of salt to alum in the platinum toner stock solution A shifts the color dramatically from reddish-orange to neutral black. The examples shown here are meant as starting points from which you can begin your own experiments.

All of the following test prints were exposed and fixed the same way. Exposure time with my light unit was eleven minutes. After processing, the prints were rinsed in running tap water for two minutes, toned for seven minutes regardless of toner, fixed for ten minutes (five minutes in each of two baths), and washed.

The images at left demonstrate the wide range of colors that can be achieved through various toner combinations:

a POP print exposed, not yet toned

b Gold/thiocyanate

c Gold/borax

d Gold/sodium bicarbonate

e Gold with borax and sodium bicarbonate

f Gold with borax and extra sodium bicarbonate

g 7 drops standard platinum solution

h 3 drops platinum and 3 drops lithium palladium

Terry King, Bridge, Birmingham, Warwickshire, England. Gum print from one enlarged negative. Original image was made on 35mm Kodachrome film. Terry's explanation: "Three coats, the first Davey's grey, the second in burnt sienna, and the third in a mixture of burnt umber and neutral tint on 300 gsm Fabriano Artistico Satinata hot-pressed paper with an acrylic medium size."

Chapter 11 Gum Bichromate

Terry King

History

One of the biggest challenges facing the early pioneers of photography was the unfortunate tendency of their silver-based photographs to fade. Obviously there was great concern over this, and by the mid-1850s, formal committees were set up in London and Paris to find ways of making permanent photographs. It was ultimately found that the reason the silver prints faded was that they had not been fixed properly or washed long enough, but the experiments that were undertaken in early attempts at a solution led to a number of what we have come to call alternative photographic processes.

In 1839, Scotsman Mungo Ponton demonstrated in Edinburgh that if paper coated with a solution of potassium bichromate was exposed to light under a "negative" (using objects to make shadowgrams) an image was formed by the hardening effect of the bichromate on the size within the paper. This produced an image on a brown background; he then fixed the image—made it permanent—by simply washing out the still-soluble bichromate.

Taking this idea another step forward, both Alphonse Louis Poitevin and John Pouncy found that they were able to produce permanent, full-tonal-scale prints by adding color pigments to their dichromate mixtures. One can see from the John Pouncy print in the Royal Photographic Society collection at Bath that his method produced prints that were stunning in their detail, contrast, gradation, and freshness; even though it is one hundred and forty years old, it still retains those qualities.

Although gum prints were more "archival," to use the current jargon, in the mid-1850s it was easier and cheaper to make silver prints using the new wet

Bichromate *is the old word for what chemists now call* dichromate; *photographers, however, conventionally use the older term when talking about gum printing.*

collodion plates and albumen papers, and the gum process never achieved widespread popular appeal.

The great period for gum printing followed the introduction in the 1880s of the Kodak camera, which removed photography from the exclusive control of professionals and rich amateurs. In the same period, there also was a reaction against the technological approach to photography, which claimed that just because a photograph could provide an accurate record, it had to. In England, Peter Henry Emerson had sown the seed for a different approach with his use of differential focus and his promotion of "naturalistic" photography. There was also a strong movement towards "art photography" in Europe and the United States, but it was the Frenchman Robert Demachy who brought gum printing to the attention of the world of art photography.

One day, when buying some hydroquinone (a black-and-white silver-developing chemical that had just been discovered), Demachy complained that silver bromide was not producing the rich blacks he sought in his prints. He was told to try Poitevin's process, which at the time was being sold as a means of reproducing engravings. That process was essentially the gum bichromate process as we know it today. The results were so good that, in 1894, Demachy's gum prints were displayed at the London Salon of Photography, regarded as the leading art photography exhibition of the time, with work by photographers from Austria, Germany, France, Great Britain, and the United States.

Poitevin's process was attractive to art photographers for many reasons. The image could be developed using a brush; the photographer could choose colors and textures and papers; it gave far greater creative freedom than adjustments in focus or montage techniques; and, in the right hands, it could produce prints of great subtlety, strength, and beauty. It was these qualities that led to its adoption by other leading art photographers of the time, including Alvin Langdon Coburn, Edward Steichen, and Alfred Stieglitz. Unfortunately, this greater control could easily be abused by unfeeling practitioners who thought that manipulation alone would allow them to transcend mediocrity.

Process Overview

Most of the photographic images we have seen over the last one hundred and seventy years have been produced using one of three effects of exposure to light:

- Light reduces silver salts to silver.
- Light causes light-sensitive iron salts to reduce other metallic salts to metal.
- Light causes dichromate salts to make gum arabic or other colloids become insoluble in water.

Terry King, St. Margaret's on Thames. *Multi-color gum print from one enlarged negative.*

Processes using the insolubilization effect were among the earliest explored. Joseph Nicéphore Niepce depended upon an insolubilization effect in his experiments as early as the 1820s. He used bitumen of Judea and developed the print in oil of lavender, which dissolved away those parts of the image that had not been insolubilized.

The basic principle of gum printing is that when light, which is a form of energy, falls on a molecule of a chrome salt, atoms knocked off the salt by the light join together with the long chain molecules in gum. This has the effect of stiffening them, which in turn makes the gum insoluble in water.

If you mix a solid pigment with dichromated gum, which is porous, the pigment is trapped when the gum becomes insoluble. Since the degree of insolubilization is proportional to the amount of light striking the gum, if a negative is placed between the light and the pigmented, dichromated gum and the print is exposed for the right amount of time, the softer bits can be washed away, leaving a picture. This picture can be as archival as those made by any other process, and the gradation and tonal range of the final image can rival that of platinum.

What You Will Need

Chemicals

- Ammonium dichromate or potassium dichromate, saturated solution (see note on dichromates, below)
- Gum arabic
- Sodium metabisulfite
- Gelatin Bloom 260

Note on dichromates

Use saturated solutions of either ammonium dichromate or potassium dichromate. A saturated solution is one in which the water will not dissolve any more chemical. For the potassium salt, a saturated solution is around 11%; for the ammonium salt, 30%. The ammonium is more light-sensitive than the potassium since there is more of it to the cubic centimeter. Wear protective gloves and a dust mask when you mix these salts. Do not breathe in the dust, because it eats away the mucous membranes. Dichromates can also be absorbed through the skin. As with all chemicals, treat the dichromates with respect.

Materials

- Protective gloves
- Tray
- UV light source
- Brush
- Dust mask
- Plastic measuring spoon
- Contact printing frame
- 100 cc brown glass dropper bottle for storing the dichromate solution
- White tea plate or similar non-metal plate; used as a palette
- Palette knife

Pigments

Start out with artist's watercolors in tubes. I stick with Winsor & Newton because they are consistent and the colors look like what the label says they are. Look for strong colors and permanent colors, since you will be exposing them to UV light and you do not want your pictures to fade. The following colors have given me good results:

Reds: Permanent Rose, Alizarin Crimson (process red)
Greens: Permanent Sap Green, Viridian, Terre Vert
Yellows: New Gamboge, Cadmium Yellow Deep (process yellow)
Blues: Cobalt Blue, French Ultramarine, Winsor Blue (red shade; process blue), Indigo
Browns: Raw and Burnt Umber, Burnt Sienna
Toners: Yellow Ochre, Davy's Grey, Neutral Tint (which can be used for black)

Do not use black in gum printing. Lamp black is kerosene soot, which can work its way into the fibers of the paper. Neutral tint acts as black and gives subtler and purer shades in the shadow detail. If you must have black, use pure pigment in sparing amounts for really deep specks of shadow.

UV Light Source

For my own work I use high-pressure, mercury-vapor graphic-arts lamps that are designed to give light at a number of wavelengths suitable for other processes. With these lamps, a single bulb gives even light over a four-foot circle at four feet from the bulb. A distance of eighteen inches is suitable for a 16x12 print. I also use UV tubes in a sun bed at six inches, but these give flat prints for other processes. Keep the light source enclosed or surrounded by yellow film. Do not look at the UV tubes or bulbs when they are on, and keep out of their direct light as much as you can.

Negative

The ideal negative will have the same density as one intended for silver gelatin printing, which is a density range of around 1.0, but a density of well over 2.0 can also be used. It is possible to get a gum print with subtle gradation from a single exposure if the negative has a density range of about 0.7, but I find it more satisfying to work from a negative with a wider tonal range because one can obtain subtleties of color and tone in the print by applying different colors and amounts of pigments for the shadows, middle tones, and highlights. Normal negatives for silver gelatin work well.

When I started, I used paper negatives. To make one, just put a transparency in the negative carrier of your enlarger and expose onto single-weight paper. In order to cut down on the length of exposure using paper negatives, you will need to make different negatives for the highlights, middle tones, and shadow detail. For those familiar with the Zone System, this translates into zones of about seven, five, and three, respectively.

If you are using a continuous-tone film negative, all the exposures can be made from the one negative. You can also use lith or line film, such as Kodak Kodalith type 3, and develop it to continuous tone by using a weak paper developer, 1:20 rather than 1:9 as an example, and giving a long exposure and short development time.

Paper

I recommend these papers to those starting gum printing, because they served me well when I was a beginner:

- Fabriano 5, which is called Fabriano Classico in the United States
- Bockingford

Neither of these papers needs initial sizing, although they do require sizing between subsequent exposures. I also suggest using heavier papers (300 gsm) since they are more stable. Other papers can be used if you want to stretch them or size them first with gelatin and a hardener. Although I do not usually use hardeners, there are a number of different methods of making hard sizes that will protect softer, but often beautiful papers such as Fabriano Artistico or Saunders Waterford. These papers can suffer from strong pigments and repeated developments that will wash away the original size.

Procedures

Sizing the Paper

I use a 2% photographic gelatin size for gum known as deionized limed ossein 260 Bloom, which can also be used for silver and platinum printing. Dry the coated paper in front of a stream of hot air; use either a hair dryer or a heater/fan. Once it is dry, place the paper in a bath of 0.5% chrome alum solution for two minutes and then rinse and dry. The gelatin is available from Bostick & Sullivan in the U.S. and Silverprint in the U.K. (see Resources).

Another sizing method is to brush on equal amounts of gum arabic and saturated dichromate solution. Dry this in the dark, expose it to your light source for not more than a minute, and wash it thoroughly until the stain is removed. If a slight gray cast remains on your paper after using the

gum/dichromate mixture, the exposure to UV light was too long. To clear the gray stain, immerse the paper in a weak solution of sodium metabisulfite and water—two hefty tablespoons to 1000 cc—and the color will disappear. Wash for five minutes, and dry the paper before proceeding.

Printing

While a gum print can be made in just one step using a single color for all tonal ranges, the process I use allows greater control over the different density areas of the final image as well as the colors of those areas. The amounts of chemicals given below are enough for a print between 8" x 10" and 10" x 12".

The gum should be about the consistency of corn syrup (a specific gravity of 17 degrees Baume). Although it is expensive, begin with a high-quality gum from Winsor & Newton or Daniel Smith. If you have a source for etchers' powdered gum arabic use that; mix it 1:1 with cold water and leave it to dissolve. I use a PVA gum called Gloy, which is available in the U.K., but is not sold in the U.S. market.

In theory, you should not use metal palette knives, but in practical terms it does not make any difference. I use polyethylene palette knives.

1. Decide on the color for the highlights of the print, squeeze a very small amount of the color from the tube onto the palette plate, and mix it into 5 cc of gum. Check to see if this is the tone and hue that you intend for your highlights (a light tone with good highlight details; about zone 7 for those familiar with the Zone System). If not, add more color. Do not try reducing the color by adding more gum; you will just finish up with more than you can use, and you may be tempted to apply too thick a coating to the paper. If you do, the gum will fall off the paper. Some people keep jars of ready-mixed colors of different consistencies. To my mind, this is an unnecessary complication, and it inhibits creative judgments.

2. Under low-level tungsten light, add 5 cc of dichromate solution to the palette plate and mix. The color will change, but you wash the orange out at the end.

3. Brush the mixture onto the paper with smooth but firm strokes. Do not scrub at it. Since you are spreading gum arabic, which is used as a lacquer for watercolors, it seems reasonable to use a watercolor lacquer brush for spreading our dichromated gum. That is what I used for years; I have only recently switched over to hake brushes.

4. Allow the paper to dry in the dark.

5. Register the negative using pins and tape. Put the pins through one side of the print and the clear edge of the negative, then tape the negative to the paper with 3M Magic Tape or something similar with low tack. Remove the pins before proceeding.

6. Place the registered negative and paper into your print frame or between two sheets of glass. If you have a sturdy printing frame use it. I sandwich my prints between two sheets of 6 mm float glass (plate glass), which will transmit the "near UV light" you will be using. Put the frame under the lamp, and expose it until the only parts that wash away completely are those you wish to be white in the final print. It is a good idea to make a full-size test print first for each coat, essentially using it as a large test strip. Determining the correct exposure time is a matter of trial and error initially. Try three or four minutes as a starting point, but remember that your final times may vary significantly.

7. Wash the print in cold water. The initial development is in cold water as the gum will develop (dissolve) more slowly. Warmer water will soften and thus develop the gum more quickly. Slowly increase the water temperature as needed. Use very soft brushes or water from a hose to provide extra control. You can also float the print face down in a tray of water until the soft bits fall off, but this gives you no control. By starting with cold water, one can judge to what extent brushes, sponges, or jets of warm or even hot water can or need to be used to remove the unhardened gum, and thus control the rate of development either locally or over the entire image.

8. Dry the print with a stream of warm air, as from a hair dryer set to low.

9. Use a brush to apply a warm coat of 2% size and dry the print in the warm air again. This step will not be necessary if you have put down an initial coat of hardened gelatin or gum.

10. Repeat steps 1 through 9, but use a stronger or different color for your middle tones (darkest about Zone 4, or equal to a dark gray) and give about a third less exposure. Remember to coat the entire print with the second and subsequent colors.

11. Repeat steps 1 through 8 using a stronger or different color for the shadows, and again give it a third less exposure. Experience will allow you to make your own judgments in these reduced exposure times.

12. After drying the print, give it a short exposure to UV light to fix it. Since you have already washed off the unhardened gum you do not want, any residual dichromate will fix the gum that is left behind. This exposure should not be more than a few seconds or the gum will fog.

13. To clear the dichromate, wash the print face down, with coins on the back to keep it under water, for six hours in a tray with a dribble of water, or soak it for six hours, changing the water every hour.

14. Dry by hanging, or by laying the print face up on a clean fiberglass screen.

Basic Principles

The more dichromate you use, the less the contrast. If you put in too much dichromate, the gum hardens too quickly, so the contrast is reduced.

The less dichromate, the greater the contrast. If you put in too little dichromate, only the shadows will be affected by the light and the areas under the denser parts of the negative will be washed away.

The more pigment you use, the greater the contrast. If you put in too much pigment, the light will not be able to act as effectively on the chrome salts. So use strong pigments.

The longer the exposure, the less the contrast. Too long an exposure gives reduced contrast since more of the gum becomes insoluble.

The less the exposure, the greater the contrast. Too short an exposure gives increased contrast, because too much of the gum and the pigment can be washed away.

You can use all these variables to vary the color and the contrast to your advantage. For example, use a little pigment and a long exposure for the highlights, a lot of pigment and a short exposure for the shadows, and somewhere in between for the mid-tones.

Using the gum printing method described here, you should get subtle gradation and a good range of tone with colors of your choice from only three coats. This is how I have made my most successful prints, but I am the kind of dinosaur who often aims to use a craft as a means of producing things of beauty.

This method is simple and uncomplicated, and it works. It is designed for those whose prime interest is to produce pictures. I would not, therefore, recommend this method to those who find the process more important than the picture.

Terry King, Untitled. *Platinum over gum print. "This is a gum/platinum print. The gum print was pink and yellow ochre for the upper half, blended into blue and Davey's grey for the bottom half. A platinum print was then made over the top of the gum print using the same negative. No base size, but there is an intermediate gelatin size."*

John Barnier, Pecos Monument. *8" x 8". Rawlins oil print.*

Chapter 12 Rawlins Oil

John Barnier

History

A Rawlins oil print begins photographically but the result is more like a lithograph or monoprint. While the actual image-forming effect is based upon the mutual opposition of oil and water, the final image is ink.

The earliest form of the Rawlins oil process was an ink and gelatin procedure invented by Alphonse Louis Poitevin in the mid-1850s, at about the same time the gum bichromate process was developed. The process was seldom practiced until 1904, however, when its namesake, G. E. H. Rawlins, perfected it into a more predictable and controllable procedure. Because of their dreamlike look and hand-worked nature, Rawlins oil prints largely appealed to photographers from the pictorialist movement, most notably the French photographer and gum-bichromate printer Robert Demachy, who fully exploited the expressive, hand-worked nature of the process.

Process Overview

In the Rawlins oil process, also known simply as the oil process, gelatin-coated paper is sensitized with ammonium dichromate and, after thorough drying, is exposed to UV light in contact with a negative. Since this process is a contact process only, you will need a negative the size of the print you wish to make (see Chapter 20).

After the paper is washed, an image appears, not in shades of light and dark, but in a shallow three-dimensional relief. While the paper is damp, greasy oil-based ink is applied with a brush. The ink takes to the relatively dry

areas that received light through the negative (the dark tones), but not to the water-swollen areas where light did not strike it (the light tones). The process is completely continuous tone; the ink adheres in varying degrees relative to the amount of light that struck the paper through the negative.

A Rawlins oil print is sometimes characterized as looking like a charcoal drawing or an etching because of the way the inked image sits on the paper surface. If the ink is allowed to dry at this stage, the Rawlins oil print can be considered finished. However, in an extension of the basic process, the oil print can quite literally become a monoprint if the inked paper is sandwiched with fine artist paper and run through an etching press. The still-wet ink transfers from the gelatin surface to the artist paper. Many of Robert Demachy's Rawlins oil prints are transfers done in this manner.

The procedures for preparing, coating, and exposing a Rawlins process print are given below. Since the technique for inking is identical to that used for bromoil prints, consult the following chapter for those procedures, beginning on page 188. Readers making Rawlins oil prints should also read the sections on brushes and brayers on pages 183–84 of the next chapter. For a complete description of the transfer technique, read David W. Lewis's book *The Art of Bromoil and Transfer* (see Resources).

The Rawlins process is the predecessor to the bromoil process, and like its cousin, it is a temperamental and finicky process to master. However, as with all other processes in this book, if you keep careful notes on all your steps—and if you persevere—the prints will be well worth the effort. The hand of the artist is clearly evident in this process, and as such makes the Rawlins oil process one of the most expressive in the entire repertoire of alternative photographic processes.

What You Will Need

Chemicals

- Ammonium dichromate
- Potassium metabisulfite
- Methyl ethyl ketone
- Alum (aluminum ammonium sulfate); optional, for hardening

John Barnier, Chambered Nautilus. *4" x 5". Rawlins oil print.*

Materials

- Gelatin, 250 Bloom
- Ink
- Bromoil stag-foot brushes
- Foam rollers
- 10" x 10" sheet of glass or ceramic tile
- High-quality leather chamois
- Photo trays (2), one size larger than your print
- Print tong
- Acid-free blotter paper
- Hot plate or stove near your work area
- 2-quart sauce pan (never to be used in cooking)
- Wide, flat watercolor brush, 2" or wider
- Glass coating rod, the type used in coating sensitizers in this book
- Micro Mixer, large size
- Drafting tape or other tape with low tack
- Glass beaker, 500 cc
- Protective latex gloves
- Wide, shallow glass dish (at least as wide as your coating brush)

Negative

Normal contrast, suitable for printing on #2 contrast silver paper

Paper

The main concern is to use a paper that can withstand many soakings in water without fluffing and discarding its fibers. Some suggestions are:
- Twinrocker printmaking paper
- Twinrocker watercolor paper
- Arches Platine
- Arches watercolor paper

Procedures

Coating the Paper with Gelatin

Coating method 1

1. Mix 9 g gelatin into 150 cc distilled water in the glass beaker.
2. Let this mixture stand for twenty minutes.
3. Place the beaker in a pan of water on the hot plate or stove and turn to medium heat.
4. Heat this mixture until it becomes clear.
5. Tape down each corner of the paper to your work surface.
6. Pour a small amount of hot gelatin into a shallow, wide dish.
7. Dip the watercolor brush into the hot gelatin and brush a thin coat over the paper, making sure to make the strokes smooth and regular. Avoid streaks, ridges, and uneven deposits as much as possible.
8. Hang up the paper by one corner or lay it face up on a clean fiberglass screen dedicated to this procedure only, since gelatin will dry on the screen and be impossible to remove. Dry at least one hour.
9. In the meantime pour the remaining gelatin back into the beaker of hot water. You can turn off the heat at this point. The gelatin will remain liquid for more than an hour.
10. When the paper is dry, reheat the gelatin, tape down the paper again, and repeat the coating procedure. Do this for a total of three coats. *Be sure that the paper is completely dry between coats.*

Coating method 2

Have the glass coating rod and the Micro Mixer handy. The Micro Mixer is a plastic syringe with a length of tubing that is used for holding, measuring, and distributing quantities of solution. It works extremely well for applying sensitizers used for processes throughout this book, and it is ideal for the gelatin used in this process. It comes in sizes ranging from 6 cc to 60 cc.

1. Follow steps 1 through 5 above.
2. Insert the Micro Mixer into the hot gelatin and draw up about 15 cc.
3. Run a steady and continuous stream of the gelatin across the longest edge of the paper's coating area.
4. With a steady motion of the coating rod, draw the ribbon of gelatin down the paper without stopping. At the end of the first pass, gently lift the rod, place it behind the remaining gelatin ribbon, and push it back in the other direction.
5. Using the Micro Mixer, suck up any remaining gelatin and squirt it back into the gelatin container.

To keep neat edges within the coating area, tape the area with drafting tape. Do not use masking tape; it will tear the paper when removed.

John Barnier, Skull. 7" x 9". Rawlins oil print.

It is best to apply *more* gelatin than necessary than to have too little. If you don't start with enough to coat the paper, the gelatin will coat very unevenly because it will cool and dry somewhat while you try to gather up more hot gelatin and reapply it. It's not worth the aggravation.

6. Dry the paper as above, and repeat this procedure for a total of three coats. *Be sure the gelatin is completely dry between coats.*

Coating method 3

If you have sheets larger than 11x14 to coat, you will need to alter the glass rod coating technique; otherwise you will have too much puddled at the beginning of the procedure, making coating very difficult.

1. Follow steps 1 through 5 of Method 1. Pour a puddle of gelatin directly onto the paper.

2. Using a wide, flat hake brush, brush the gelatin quickly and evenly across the paper. You don't need to worry about evenness at this point.

3. Using the coating rod, gently and continuously draw the rod across the surface of the gelatin to smooth it out. Do this two or three times until the gelatin is completely smooth.

4. Continue with steps 8 through 10 in Method 1.

Hardening the Gelatin

Although not necessary with a gelatin with a high enough Bloom rating (250 or higher), you may need to harden the gelatin if you notice the brush abrading the surface during inking.

1. After all three coats of gelatin have been applied and are thoroughly dried, soak the paper in room-temperature tap water for one half hour.

2. Dissolve 5 g alum in 1000 cc distilled water (room temperature) thoroughly.

3. Soak the gelatin-coated paper in the alum solution for about two minutes.

4. Rinse the paper lightly and hang to dry.

Sensitizing the Paper

Note that dichromate solutions look invitingly like orange drink and may be a tragic temptation for small children. This is no joke; keep all children away from this solution, because dichromates are extremely toxic.

The Rawlins sensitizing bath can vary from a 1% to 5% potassium dichromate solution. A 1% solution produces the most contrast, but is slower to print; 5% gives the least contrast, but is faster to print. The following yields a 3% solution.

1. Mark an X in a bottom corner of the sheet to be coated. Otherwise you may not know which side of the paper has been sensitized after it dries.

2. Under safelight conditions, mix 30 g ammonium dichromate into 1000 cc distilled water at room temperature. Mix this solution until all the crystals are dissolved.

3. Pour this into a photographic tray one size larger than your coated paper (for example, an 11" x 14" tray for an 8x10 print).

4. Slide the gelatin-coated and completely dry paper into the sensitizer and gently rock the tray so that sensitizer flows over the paper. Dislodge any air bubbles on the paper with your finger (wearing a protective latex glove) or with the action of the solution washing over the paper's surface.

The paper is not light-sensitive while wet; it becomes light-sensitive as it dries. The sensitized paper should be exposed soon after drying, otherwise the "dark effect" of the dichromate will harden the gelatin, even without exposure to light, rendering the paper useless.

5. Agitate the paper every fifteen to thirty seconds for a total of three minutes. Between agitations, be sure the paper is completely covered with sensitizer.

6. After three minutes, lift the paper out of the sensitizer by one corner with the print tong and let it drip-drain for a few seconds.

7. Hang it to dry by the opposite corner, dabbing the bottom drips with a wadded-up paper towel to remove excess sensitizer.

8. Leave the paper hanging in the dark to air-dry. Do not use a hair dryer or it will fog the paper. The paper will be bright orange.

9. The paper is ready for printing after it is completely dry. Check the edges for dryness.

Exposing the Paper

Test strips

For workers new to the Rawlins process, it is a good idea to make a series of test exposures to judge proper exposure and soaking times. Having these tests at hand will help greatly in learning to master the process. I use a 4x5 negative, and cut enough dry, sensitized paper to give me five strips at least 2" x 6". Use a negative of at least 4" x 5" so you will have test strips large enough for an accurate assessment. Strips wider than 2" are even better.

To get the most accurate test, always place the paper against the same area of the negative for each exposure.

1. Using pencil on the back side (the side with no gelatin), mark one strip five minutes; mark another ten minutes; mark the next three strips fifteen, twenty, and twenty-five minutes.

2. Place your negative against the five-minute strip emulsion to emulsion: the negative's emulsion (the duller side) against the gelatin-coated side of the paper.

3. Put them into your contact frame with the negative against the glass, and expose for five minutes. Remove the strip and begin washing it in running water to remove the orange dichromate stain.

4. Place the same negative against the ten-minute strip, put it into the contact frame, expose for ten minutes, and then wash the strip.

5. Do the same for the remaining strips, making sure your exposure times match those written on the back of each strip.

6. Wash all strips until the orange stain is completely removed.

7. Hang the strips to dry, weighted down with clothespins or film clips so they don't curl.

8. Dry completely; at least two hours.

You now have five strips with progressive amounts of a faint image. The best way to gauge the correct exposure is to ink up the test strips, the way you would a final print. Since those procedures are identical to those done in the bromoil process, refer to the next chapter, Bromoil, for a complete explanation of soaking and inking. The Rawlins procedures begin again with the instructions for Drying and Superdrying (page 187).

John Barnier, Arroyo Tree. *9" x 11". Bromoil.*

Chapter 13 Bromoil

John Barnier

History

The bromoil process, perfected in 1907 by Englishman C. Wellbourne Piper, is a variation of the Rawlins oil process described in the previous chapter. Like the Rawlins, the bromoil process produces beautifully impressionistic images in ink. The advantage is that bromoil produces its image on standard silver bromide enlarging paper, making the need for enlarged negatives unnecessary. Theoretically, bromoil prints of any size can be made from any size original negative. In practice, however, smaller original camera negatives yield larger grain in the image, and this film grain can compete with the stippled ink impression produced by the bromoil brush. It is also more difficult to achieve good results with a larger image until one becomes quite experienced (similar to Rawlins). On the other hand, small bromoil prints—just a few inches square—have a striking presence to them; the ink is physically raised above the print's surface, and as with the Rawlins process, there is great freedom to manipulate the ink and brush. The hand of the artist can be evident in every part of the image.

During the first half of the twentieth century, when the process was popular and there was a ready market for bromoil products, several photographic paper manufacturers produced papers, brushes, and other materials specifically designed for bromoil. The papers came in a variety of surface textures and base tones, but by the late 1960s all had been discontinued. Unfortunately, most modern enlarging papers do not work for the bromoil process because their surfaces are supercoated. For their normally intended purposes, this gives the prints extra protection against abrasions and scratching, but it also prevents the

gelatin from swelling, which is absolutely necessary in a bromoil. A few modern papers do work well, however. With the renewed interest in alternative photo processes, a few bromoil-specific papers are once again available.

Process Overview

In the bromoil process, a gelatin-bromide photographic print is bathed in a dichromate solution that both bleaches out the silver and creates a low-relief image corresponding to the amount of exposed silver that was in the original image. After this relief image is hardened, it is inked using special brush techniques that give the bromoil print its unique character.

The instructions below follow the bromoil process through steps for exposing the print, bleaching the image, and inking it. As with Rawlins oil prints, the bromoil image can also be transferred to a different surface by running the bromoil print and artist paper in contact through an etching press. For details on this transfer technique, see the book *The Art of Bromoil and Transfer* by David W. Lewis.

What You Will Need

Chemicals

- Paper developer: Ethol LPD, Kodak Dektol, or Kodak Ektaflo Type 2. These developers have been tested with good results; however, these may not be the only developers that will work. Experiment if you wish to use another developer.
- Acetic acid or indicator stop bath
- Sodium thiosulfate
- Copper sulfate
- Potassium bromide
- Potassium dichromate
- Sulfuric acid
- Methyl ethyl ketone

Materials

- Ink
- Medium, for softening ink mixtures
- Two ceramic tiles, plastic picnic plates, or 8" x 8" sheets of glass (or any combination)
- Leather chamois
- Acid-free blotters, larger than your prints
- Paper towels
- Palette knife
- Latex gloves
- Glass jar for brush cleanup

Brushes

The traditional brush for bromoil (and for Rawlins oil prints) is a stag-footed bristle brush (fig. 1), although many different (and less expensive) brushes also do an excellent job.

If you want a fine, high-quality brush that has been designed exactly like the classic stag-foot brushes used by early master bromoilists, use those manufactured by David W. Lewis. I prefer these for their superior bounce, balance, and general feel on the paper. I use a hog-hair brush for the initial inking, and I finish with a softer fitch-hair brush. Although the Lewis brushes are expensive, they are of exceptional quality and will last for many years with proper cleaning and storage. They come in various sizes.

If your budget demands less expensive brushes, you have several options. Some bromoilists use soft-bristle shaving brushes (the five-dollar synthetic variety found in pharmacies). Other brushes that work well are faux decorating finish brushes, stencil brushes, varnishing brushes, and Isabey Decor Elephant Brushes, which come in dome or round shapes. Any of these can be hand trimmed to the classic stag-foot shape or simply left as is. For soft and smooth effects, I like the chubby makeup brush with very soft bristles I found in my wife's makeup drawer (taken with her permission, of course). In addition to David W. Lewis, Bostick & Sullivan has a fine selection of brushes and other materials dedicated to bromoil.

Fig. 1. *Stag-foot brushes.*

Brayers

These are used to spread the ink on the palette before brushing it onto the print. Either of the following will work.

- Soft rubber ink-brayers, the kind typically used for block printing. Get these at art supply stores.
- Soft foam paint rollers, the denser the foam the better; the type used for paint finishing and edging. Get these at hardware or paint stores.

Safelight

Standard red or OC safelight. This is used only during the printing of the bromide print. All other procedures can be carried out in any type or intensity of room or natural light.

Paper

Bromoil-specific papers:
- David W. Lewis
- Caswell Finesse
- Bergger
- Kentmere

Non-bromoil-specific papers:
- Agfa MCC 118
- Forte Bromofort Fiber Base, semi-matte
- Ilford MCiii and IV, matte surface
- Luminos Charcoal, Grade N
- Luminos Tapestry, Grade N

These papers have some supercoating, but they work very well for bromoil.

Ink

Ink has been somewhat troublesome for bromoilists since the original bromoil inks were discontinued many years ago. One line of inks that has worked is that from the Graphic Chemical & Ink Co. (see Resources). David W. Lewis has also developed a line of excellent inks that come in different colors and consistencies.

Procedures

Mixing the Chemistry

Mix the developer in a diluted solution. I use Kodak Ektaflo Type 2 paper developer at a dilution of 1:18 and the stop bath at normal strength. Mix the fixer in a 10% solution: 100 g sodium thiosulfate crystals to enough water to make 1000 cc at about 70°F.

Exposing the Bromide Print

A print properly exposed to be used as a bromoil matrix should look somewhat flat and definitely be darker than a normally printed image.

1. In safelight conditions, expose and develop a series of test strips to determine the correct exposure for the final image. Develop them fully for four minutes at about 70°F.
2. Immerse the print in the stop bath and agitate for thirty seconds. Lift the print and drain it for fifteen to twenty seconds.
3. Immerse the print in the fixer and agitate it for three to five minutes.
4. Wash for thirty minutes in gently running water.
5. Dry the print face up on fiberglass screen.

John Barnier, Untitled. 4" x 5". Bromoil.

Bleaching the Print

The bleached and tanned print is known as the matrix.

From this point on all steps can be conducted under any lighting situation, even daylight.

Mixing the bleaching and tanning chemicals

Note These formulas don't make exact percent as described in the Basics section, but work perfectly for these procedures.

- Add 10 g copper sulfate to 100 cc distilled water. This is the 10% copper sulfate solution.
- Add 10 g potassium bromide to 100 cc distilled water. This is the 10% potassium bromide solution.
- Add 1 g potassium dichromate to 100 cc distilled water. This is the 1% potassium dichromate solution.

1. To 1000 cc of distilled water, add 70 cc of the 10% copper sulfate solution. Mix well.

2. Add 70 cc of the 10% potassium bromide solution to this and mix well.

3. Add 30 cc of the 1% potassium dichromate solution to this and mix well.

This is the final bleach/tanning solution. The quantity above will bleach and tan ten to twelve 5x7 prints.

Bleaching and tanning procedures

Set up two trays: one with water for initial soaking and the other with the bleach solution, both at room temperature.

1. Immerse the bromide print into the tray of water for five to ten minutes. Watch the print to be sure it stays beneath the surface or you will get uneven soaking.

2. Drain the print for a few seconds and immerse it into the tray containing the bleach solution.

3. Gently agitate the print in the bleach/tanning solution for eight to twelve minutes. The highlights will fade first, followed by the middle tones and then the low values. I find that my prints need to go to the full twelve-minute mark, when a faint light-brownish image remains in the lowest tones of the image.

4. Wash the matrix for about twenty minutes in gently running water at about 70°F.

5. Place the matrix in a bath of 10% sodium thiosulfate. Agitate for five minutes.

6. Wash the matrix in gently running water for thirty minutes.

7. Place the matrix in a solution of 2% sulfuric acid at room temperature. This will make the gelatin more responsive to swelling and inking. (Do this only for bromoil—*not Rawlins oil prints.*)

8. Wash the matrix in running water for about twenty minutes and then dry it by either hanging it by one corner on a line, or by laying it *face up* on a clean fiberglass screen.

Drying and Superdrying

Note The following procedures apply to both bromoil and Rawlins oil prints.

For both bromoil prints and Rawlins oil prints, the ink takes to the matrix more easily if the matrix has been superdried before initial inking. While this involves nothing more than drying the matrix one last time, it effectively facilitates easier inking. Use a hair dryer, a stovetop burner, or a hot plate.

With a stove or hot plate, set the burner to medium, hold the matrix above it, and move the matrix over the heat. With a hair dryer, apply a stream of hot air directly onto the matrix. After about thirty seconds of this superdrying, the matrix is ready for soaking and inking.

Soaking the Matrix

Before inking—but after superdrying—the matrix must be soaked in water to swell the gelatin. Different papers, as well as matrices exposed with varying times, require different soaking times and different soaking temperatures. Other factors such as the relative hardness of your water supply will also affect soaking. The David W. Lewis bromoil paper has a recommended soak time of fifteen minutes at 68°F. I find that the Caswell Finesse paper works best (under my conditions) with a one-hour soak and a beginning temperature of 100°F. The water cools down over that hour, but there is no need to keep the temperature up. For soaking, use a print tray just larger than your prints. Keep the soaking tray nearby as you will need it for subsequent soakings throughout the inking stage.

For Rawlins prints gelatin-coated according to the method in the previous chapter, I soak the matrix for 1½ hours at 100°F.

Judging soaking times and temperatures

Because the characteristics of different makes of paper vary so greatly, the best way to gauge a paper's soaking parameters under your specific conditions is by experimentation. When trying a new paper, make several matrices, or make at least one that can be cut into several strips. Test the matrices or strips by soaking them at different times and temperatures and then inking them. After a

few attempts, you will be able to fine-tune your variables and determine a precise set of procedures that are geared to your personal working methods and provide consistent results.

Inking the Matrix

First lay out the following:

- Two ceramic tiles or plastic picnic plates
- Palette knife
- Brushes and/or rollers
- Damp chamois
- Glass working surface (larger than your matrices)

Apply a pea-sized dab of ink onto the first ceramic tile or plate with the palette knife. Work the ink into a softer consistency by scraping up the dab, laying it down, smoothing it out with the palette knife, and repeating. Do this for a minute or two until you have a thin layer of ink about 3" in diameter.

There are three basic brush techniques used to ink a bromoil or Rawlins oil print: walking, stippling, and hopping. The techniques are normally employed in this order, although with experience, you may use all three—or just one or two, depending on the effect you wish to achieve.

Before beginning the first brush technique, remove the matrix from the soaking tray and gently wipe it clear of all water with the dampened chamois (folded over a couple of times to make it thick and soft). It is important that enough water be removed to leave a damp, but not wet, surface. Note, too, that this is the only time the matrix will actually be wiped. After this it will be *dabbed*.

Walking

This is the initial brush technique when inking a matrix. Many bromoilists use a stiffer brush for this initial inking stage, although it is not necessary. Any brush will work—each produces its own particular effect.

1. Dab the brush in the ink of the first tile a couple of times to charge it.

2. Remove the excess ink by gently dabbing the brush on the second tile or plate three or four times.

3. Holding the brush in a vertical position loosely between your fingers—about halfway up the handle if you are using a stag-foot bromoil brush—begin inking in the top left corner of the matrix (top right corner works well for me as I am left-handed).

Always squeeze the chamois to expel the excess water. Never twist it or ring it out or you will damage the chamois.

You can also can use a soft rubber brayer or foam roller to ink the matrix. These tools give less of a hand-worked look to the image, but they produce a finer surface texture, with less of the grainy effect common to the brush method.

4. Walk the brush down the print by lightly dabbing the brush on the matrix while at the same time slowly moving it in a downward direction. Leave the brush in contact with the matrix while walking it down, lifting it only to recharge the brush with fresh ink. Never pound the brush into the ink or onto the matrix. In fact, if you are using a stag-foot brush, the heel of the brush should never actually come into contact with either the ink or the matrix. The brush is designed to use only the springy front end.

5. Repeat this action top to bottom, left to right, until you have covered the whole image; then rotate the matrix 90° and repeat the procedure. Do this a total of four times, until the entire matrix shows a light gray image. Do not try to ink the entire image to full tonalities at this point. This process requires a careful building up of the image.

Stippling

The stippling brush action lays down most of the image's ink, but it can also be used to remove ink.

1. While the initial ink image is applied, the matrix will dry somewhat. Soak the matrix for about twenty minutes in the tray of water that you used for the initial soak.

2. Recharge the brush and dab it to remove the excess ink.

3. For the stippling technique, hold the brush upright and somewhat loose in your fingers.

4. From a height of about 2 to 3 inches, drop the brush onto the matrix, allowing it to bounce slightly, and lift it off the surface. This may require a little getting used to, but after a short time it will become very intuitive.

5. Slower dabbing actions, during which the brush comes into contact with the matrix the longest, will add the most ink to the image. Quicker dabbing adds less, and very quick dabbing removes ink.

6. Continue to build up the image this way, constantly overlapping previous areas to keep the image as smooth as possible.

Hopping

The hopping brush action is similar to the stippling action, except that the brush is not charged with ink at all. The main purpose is to smooth out areas of excess ink, but it can also be used to remove ink (by stippling quickly) in areas that you feel need extra lightening.

1. A fresh, uncharged soft brush is best for this. If you have only one brush, simply dab off as much ink as you can.

2. With a more vigorous motion than the stippling action—but not pounding—dab around the print to redistribute ink where you would like. If you wish to remove ink entirely, dab it quickly, with a slight lifting forward movement of

Working the Ink

As you ink your image you will find that, depending upon the amount of swelling and the relative density of the matrix exposure, you may need inks of varying hardness. A matrix that has been soaked longer or received a light exposure will require a softer ink; a matrix that has not soaked very long or received a longer exposure may require a harder ink. A soft ink will take more easily to various tones than a hard ink, which is especially noticeable in the highlights, and can produce a lower-contrast image. A hard ink will not take to the highlights as well and will give you a more contrasty appearance.

I prefer to start with a relatively hard ink and see how it takes to the image. If it is too hard, not depositing enough ink in the highlights and midtones, I will add a drop of medium to the ink, mix it well with the palette knife, and then continue inking. Be sure to use *only* a small drop of medium, or you may over-soften your ink. If you do, you will have to clean your inking tiles and start over.

the brush. This is an excellent means of finishing a print, adding the final touches.

Resoaking

Most bromoil matrices will need resoaking to maintain the necessary amount of swelling in the gelatin. I have made several good-quality bromoils with only one initial soaking, but the images were small and were inked with a foam roller, which is much faster than brushes. You will know you need resoaking when the highlights begin to take on too much ink and are hard to clear with the quick stippling brush action.

1. To resoak, place the matrix back into the tray of room-temperature water and leave it for twenty minutes.

2. Remove the matrix and let most of the surface water drip off.

3. Lay the matrix onto a sheet of blotter that has been dampened with water.

4. *Gently dab* the surface of the matrix with a damp, folded chamois. Do this extremely gently so you do not remove or mar the ink, although a certain amount of ink will come off the matrix and onto the chamois.

5. Look at the surface of the matrix against a lamp or other light source to see if there is any remaining water on the surface. If there is, you will see a sheen or sparkle in those areas.

6. Go over those areas again with the chamois until all surface moisture is removed.

7. Place the matrix back onto the inking surface and continue inking.

Soaking times will vary according to the condition of the gelatin, how hard it is, how humid or dry your immediate environment is, and the hardness of your water. If, after a twenty-minute resoak, you notice that the highlights are still taking too much ink, soak it again. The next time, try a thirty- or even a forty-minute soak. With a little experience, you will soon get an idea of correct soaking times under various conditions.

Cleaning Up Edges

As you build up your image you will also build up excess ink beyond the perimeter of the image. If you want clean white borders around your image do this:

1. Gently place the print under water (using the same water tray you use for soaking between inkings).

2. With a firm-bristle brush, like those used in oil or acrylic painting, gently brush the ink away from the edge of the image. The ink is very soft at this stage and usually comes off easily, although sometimes it doesn't. To avoid this, I usually clean the borders several times throughout inking just in case.

What to Look For

Bromoil and Rawlins oil printing can be frustrating for those new to the process, regardless of how much experience the worker may have in other alt-photo processes. Judging correct matrix exposures, soaking times, inking techniques, etc. takes time and patience to master. The results are well worth the effort, but it isn't always easy getting there.

It is particularly difficult, especially if you've never seen the procedures demonstrated, to know if what you're seeing at different stages is right or not. Keep in mind that if you follow the three inking techniques stated above, the image will build up *slowly*. Your initial walking steps down the print will produce only the faintest of images, and may require several resoakings and walkings to produce a good basic image.

My very first bromoil image (at left) took somewhere between two and three hours to produce, which seemed like forever—inking, resoaking, adding

John Barnier, Untitled. 2¹/₄" x 3¹/₄". *Bromoil.*

medium, and changing brushes—before it started to look like a real print. But once it did, my sense of control built rapidly. That first stage is slow, but it is crucial for adequately judging the quality of your image.

That said, I should also point out that this careful, methodical way of working is only one way of making bromoil and Rawlins oil prints. Part of the beauty of these processes is their range of expressiveness, which allows images produced in this classical bromoil manner as well as more expressionistic, bold treatment using a brayer or other brush-and-ink combination. The possibilities are endless.

Drying the Print

The image surface is extremely soft, and it is easily damaged until the ink has dried completely. It usually takes between one and three weeks to dry, depending upon the initial hardness of the ink and how much medium may have been added during the inking stage. The softer the ink and the more medium added, the slower the drying time. Keep the print away from dust during this time, since any particles of lint or dust can become imbedded in the ink and dry into the image.

Cleanup of Equipment

Warning Clean your materials outside or in a *well ventilated* area.

Always clean your brushes, palette knife, and ceramic tiles soon after you are finished inking. I use methyl ethyl ketone, also known as MEK, which is sold in paint stores. Assemble the following before starting:

- MEK or other cleaner mentioned in the chemical section.
- Ample quantity of paper towels, ten to twelve sheets of a good *absorbent* brand.
- Small jar or deep glass dish. I use an old pasta sauce jar that is deep enough that, when I shake the solvent-laden brush around inside the jar, nothing spills out.
- Everything to be cleaned: brushes, palette knife, tiles, etc.
- Latex gloves.

Cleaning procedure
1. Put on the latex gloves.
2. Pour about 1" of MEK into the glass jar.
3. Insert the brush into the cleaner and move it around in a dabbing and swirling motion. The cleaner will turn black immediately, but keep moving the brush around for about one minute.

4. Remove the brush, dab it on a paper towel, and lay it on a hard, clean surface. Do not allow the brush's bristles to get dirty.

5. If you used a second brush, insert it into the cleaner and clean it for another minute. Dab it on another sheet of paper towel.

6. Discard the cleaner in an appropriate container. You will need to learn how to discard such materials in your area.

7. Pour 1" of MEK into the jar.

8. Insert the first brush and repeat the cleaning motion for one minute. Remove it, dab it on a paper towel, and lay it down. Do the same with the second brush.

9. Inspect the towel for any residual traces of ink. If ink still comes off either brush, return it to the jar and clean it longer.

10. When no further ink comes off the brushes, set them aside.

11. Insert the palette knife into the cleaner and wipe with a paper towel. Set it aside.

12. To clean the tiles (no need to clean the picnic plates, just toss them), soak a paper towel in cleaner and wipe the tiles. You will need to do this several times before the tile is clean.

13. After everything is cleaned and the cleaner is tightly capped and put away, wash the brushes, knife, and tiles in warm, soapy water.

14. If you use stag-foot brushes, be sure to pat the bristles back into their original shape before you set them out to dry. Squeeze out as much water as you can first, then gently shape the hairs back into place and set them out to dry. I usually hang my brushes, but I've never had trouble setting them upright to dry.

Peter Charles Fredrick, Untitled. Fredrick temperaprint.

Chapter 14 Fredrick Temperaprint

Peter Charles Fredrick

Process Overview

During the 1980s, I spent a considerable amount of time trying to evolve an efficient tricolor system of alternative printmaking based on the gum dichromate method. This process has a lot to offer since it is a highly flexible technique; but while my efforts were partially rewarded, the progress was just too slow and erratic. I also encountered a number of problems.

First, the classic process uses rag paper as a base. This material provides a very beautiful support for an image, but it poses problems of dimensional stability and pigment staining that require time-consuming stretching and sizing procedures. If a nonabsorbent support such as Synteape (a plastic "paper") or primed canvas is employed, these problems are alleviated. The gum still caused trouble, however. It was inconsistent from batch to batch and was unsympathetic to nonabsorbent bases. I tried a number of other colloids, such as casein, fish glue, and some of the new soluble polyvinyl acetate mediums; but each had problems that seemed equal to, though different from, those with the gum.

Then I stumbled across egg as a possible substitute. Egg tempera has been around for many centuries, having been used by neolithic man, the Egyptians, and Renaissance painters. I started a series of experiments using egg white, egg yolk, and whole eggs; the latter proved to be the most useful.

The results of these tests were astonishing. The tempera emulsion coated smoothly and evenly and processed very cleanly, with none of the messiness associated with gum printing. The image itself was much sharper, and once it

dried the surface took on a lovely sheen typical of classic tempera painting. I was hooked!

The Fredrick temperaprint process is extremely simple. It is far more robust in nature than traditional gum printing, producing prints with much more saturated colors; and it allows multicolored work of great saturation and purity to be made. In these respects, it is far superior to the classic gum bichromate. I would not deny that some of the sensitivity of the previous method is lost, but I feel that is a small price to pay for the positive advantages gained. I see this process as complementary to gum and not a rival, rather like the difference between an orange and a lemon—both are citrus fruits, but what a difference in flavor.

The basis of the temperaprint process is similar to gum in that it depends on the action of UV light to harden those areas struck by the light through a negative. When washed or scrubbed, the image appears in proportion to the amount of UV light that struck the sensitized paper: those areas that received little or no UV light are removed; those areas that received UV light remain in proportion to the amount that struck them. The result is a continuous-tone image that can be rendered in any monochrome color, or even in full realistic color when printed with color separation negatives.

Peter Charles Fredrick, Untitled. *Fredrick temperaprint.*

What You Will Need

Chemicals

- Ammonium dichromate
- Sodium metabisulfite
- Ilford liquid acid hardener or sulfuric acid for clearing
- Distilled water

Materials

- Foam paint roller (preferably the width of your image's shortest dimension)
- Flat paint pad, the flat bristly type sold in paint and hardware stores for painting trim
- Glass jars with leak-proof lids (2). Jam jars work well. Be positive the lids do not leak, or you risk spilling ammonium dichromate.
- Mortar and pestle (for dry pigments)
- Children's art brushes
- Eggs
- Sheet of glass twice the area of your paper

Pigments

A wide range of pigments may be used including:

- Acrylic paints, such as those made by Liquatex, that are available in tubes or jars.
- Raw pigments. These require grinding in a mortar and pestle, or with a muller.

Negative

Another good source for negatives is a high-quality ink jet printer. Many printers are capable of achieving very fine resolutions in the 700 to 1400 dpi range.

Negatives of a contrast that prints well on grade #2 silver-gelatin paper are best for the temperaprint process. Good-quality negatives may also be made on line film or lith film by exposing them in contact with a glossy resin-coated Multigrade print. These film stocks are orthochromatic and normally of high contrast, but they can be made to resemble conventional photographic film by developing them in any conventional print developer at double dilution in conjunction with a warm-water presoak of about three minutes. For softer results still, use ID11 or D23 as a substitute for the dilute print developer.

Paper

The Fredrick temperaprint process requires a special paper support.

- Synteape paper (FGP300), marketed by Arjo Wiggins in the U.K.
- Kimdura (USA), available through the Paper Warehouse in Minneapolis. This remarkable material is highly inert and enables a sharp image to be produced. It dries extremely quickly, and marks may be removed by a pencil eraser. For best results, use the heaviest grade, which is 300 gsm.
- Kwik Print base support material, marketed by Light Impressions.

Procedures

Mixing the Chemistry

Dichromate sensitizer

1. Fill a jam jar or other leak-proof jar three quarters full of distilled water.
2. Add ammonium dichromate, a spoonful at a time, until the powder no longer dissolves. Shake the lidded jar after each additional spoonful.
3. Add two extra spoonfuls, shake the jar, and allow the solution to settle. This is a saturated solution. It will keep well if stored in a dark container. Top off this solution with distilled water and ammonium dichromate from time to time as you use it, but make sure there is always a residue of dichromate at the bottom of the jar.

Standard temperaprint emulsion

1. Take another jam jar with a tight-fitting lid and into it break two standard hen eggs. Whisk lightly to mix.
2. Add 50 cc of the sensitizer, close the lid tightly, and shake the jar five to ten times.
3. Filter this mixture, using a stainless steel tea strainer or other stainless or plastic strainer, to remove the yolk sack, specks, etc. This emulsion should be bright orange in color.

Make up only enough standard emulsion for one printmaking session, since this emulsion will spoil over time due to dark reaction effects. Discard any remaining at the end of each day.

Mixing the Pigment with the Emulsion

If you are using liquid acrylic paint, mix level spoonfuls of the standard emulsion with the paint using a large artist's brush in a clean vessel. I use plastic microwave pots with tight-fitting lids and a child's paint brush for each pot. It helps to color-code the brushes. The proportions may be altered considerably, but the following chart provides a guide to quantities. Use one level teaspoonful (or about 5 cc) of liquid acrylic as a standard unit of measure.

Saturation	Spoons of emulsion	Spoons of pigment
Strong	3	1
Medium	5	1
Thin	8	1
Glaze	12	1

If you are using powdered pigment, try mixing one level spoon of pigment to ten spoons of emulsion for a medium coat. Acrylic tube color can also be used; substitute one inch of tube color for the liquid acrylic. If in doubt, make the mixture thinner.

Coating the Emulsion

1. Attach a sheet of synthetic paper support to the glass with masking tape applied to diagonal corners.

2. Paint a puddle of the pigmented emulsion roughly a quarter of the size of the Synteape.

3. Roll the foam roller into this puddle backwards and forwards until the color is distributed evenly; two or three passes in each direction should suffice.

4. If the surface seems full of bubbles, the roller is probably too wet. Roll it out onto a piece of scrap paper or clean newsprint to expel the excess sensitizer, then reroll until the Synteape surface becomes smooth and even.

5. Remove the coated paper support from the glass and dry it with a warm hair dryer. This takes only a few minutes. Do not overdry, or heat fogging will spoil the print.

6. At this stage the paper will appear weak in color, with a sheen to the surface.

Clean the support glass thoroughly after each coating session. It should be squeaky clean and completely clear of any residual coating mixture to avoid color adulteration. Keep a separate foam roller insert for each color used. Wash and dry each insert thoroughly before reusing it.

Peter Charles Fredrick, Untitled. *Fredrick temperaprint.*

Printing

Registering the negative and print

While it is possible to make a Fredrick temperaprint in a single pass using only one color, the process lends itself well to multiple coatings. In fact, producing prints in full realistic color is possible. For multiple-coated images, the print is given the first coat, exposed, developed (washed), and dried. It is then ready to receive the next coat and the cycle is repeated. In this way, many different layers can be built up, allowing you more creative control over the construction of the image.

Some form of mechanical registration is necessary to do multiple coatings so that the negative and print are in perfect alignment for each layer and the colors are applied accurately. A reliable and cost-effective system can easily be constructed using a standard two-hole office paper punch. First punch two holes in one edge of the negative, preferably near its center. Punch the coated support in a similar manner. Do not punch the negative in the image area, however. Each new print will have to be punched before starting.

The Lite Star Pin-Register Frame incorporates a built-in pin registration system. The punched paper is placed face upwards on the integral pins; the negative is then placed face down on the same pins; the frame is then assembled and the exposure made.

The Lite Star Pin-Register Frame is available from Silverprint (see Resources).

Exposure

The Fredrick temperaprint is a contact printing process that requires a high-output UV lightsource. Place your negative in a printing frame in contact with the coated support, using a registration system if you are planning multiple coatings.

Direct sunlight produces good exposures in the range of thirty seconds to three minutes; under UV bulbs, around two minutes. Your results will probably vary somewhat, so use these times as starting points.

After the print has been exposed, the image should be slightly darker than the surrounding color/tone.

Developing the image

1. Immerse the print in a flat-bottomed tray with a flow of plain tap water at around 70°F.

2. Gently stroke off the unhardened emulsion with the paint pad, using a consistent circular motion.

3. After use, clean the pad in warm water and set it aside to dry. After it is dry, place it in a dust-free environment.

Clearing the dichromate stain

Once the image is developed, the dichromate stain must be removed. This step is optional for monochrome prints, but it is essential for three-color printing because any residual dichromate will affect the subsequent coating and exposure.

When mixing acid and water always add the acid to the water.

1. Gently agitate the print in one of the following: a 5% solution of sodium metabisulfite, a 5% solution of Ilford Liquid Acid Hardener, or, better still, a 1% solution of sulfuric acid, until the stain is gone.

2. Wash the paper in running water for five minutes to remove the clearing bath. An alternative method is to let the print soak overnight in slowly running water.

Drying the print

Dry the paper with a hot hair dryer. This takes only a few minutes.

John Barnier, Venice. 10" x 13" from an enlarged negative. New cyanotype.

Chapter 15 New Cyanotype

John Barnier

History

The new cyanotype process, formulated by the English chemist and photographer Michael Ware, is a variation on the traditional cyanotype formula developed by Sir John Herschel in 1842 (see Chapter 4). Many workers produce perfectly rich and smooth cyanotypes using the traditional method and have no reason to change their procedures, but for those who have problems with the traditional method, this variation offers significant advantages.

The problems many photographers encounter with the traditional formula include its relatively slow printing speed; poor absorption of the sensitizer into the fibers of the paper; stained highlights due to sensitizer running off the paper in development, and excessive graininess. The new cyanotype formula addresses these issues, and in doing so provides many workers with a better method of producing a cyanotype image. It should be pointed out, however, that the new cyanotype formula is more difficult to prepare and more toxic to handle.

What You Will Need

Chemicals

- Ferric ammonium oxalate
- Potassium ferricyanide
- Ammonium dichromate (25% solution; optional, this is used only as a preservative)
- Distilled water
- Tween 20

Materials

- UV lightsource
- Coating rod or brush
- Mortar and pestle
- 100 cc brown glass bottle with cap
- Contact printing frame
- Hot plate
- Old sauce pan
- Mixing graduates (three 16 oz., plastic)
- Eyedropper (glass or plastic)
- Paper coffee filters (either cone or basket type)
- Drafting tape or another tape with low tack for masking paper edges. (Other tapes, especially masking tape, will tear the paper when removed.)
- Litho tape for masking negative edges
- Protective mask or respirator
- Glass beaker that fits into sauce pan

Negative

Negatives used for the new cyanotype process should have a long density range, similar to those for platinum-palladium printing; i.e., extending from a base+fog of 0.2 to a D-max of 2 or more. This can be achieved by the usual methods: overexposing the negatives by one to two stops, or overdeveloping the negatives by about 70% to 80%. I usually expose at half the rated ASA and then develop 25% more than normal.

Ferric ammonium oxalate, ammonium dichromate, and potassium ferricyanide are all poisonous. They should be kept away from children and require appropriate handling, storage, and disposal measures. Wear protective gloves and a mask when weighing, preparing, and mixing.

John Barnier, Notre Dame. 11" x 13" from an enlarged negative. New cyanotype.

Paper

- Crane's Parchmont Wove
- Crane's Platinotype
- Bienfang 360 Layout
- Twinrocker Whitefeather deckle
- Twinrocker White Printmaking
- Buxton (U.K.)
- Atlantis Silversafe (U.K.)

Safelight

Low-level tungsten

Procedures

Preparing the Sensitizer

For a sensitizer with a faster printing speed, make the solution more dilute, up to a total volume of 200 cc. Although the resulting image will print faster, it will also have a weaker blue color.

1. Under safelight conditions, heat 30 cc of distilled water in the glass beaker to about 120°F and dissolve in it 30 g of ferric ammonium oxalate.

2. Add 0.5 cc of the 25% ammonium dichromate solution and mix thoroughly. The ammonium dichromate gives the sensitizer longer shelf life, inhibiting decomposition during storage. It is optional since omitting it does not affect image quality.

3. Add 10 g potassium ferricyanide (keeping the solution hot), and stir thoroughly until no red crystals remain. I prefer to crush the crystals into a powder with a mortar and pestle, although this is not necessary; the ferric ammonium oxalate solution is dark green, and I find it difficult to determine if the crystals have thoroughly dissolved. If you do not crush the crystals, I recommend leaving the solution to dissolve at least ten minutes, shaking or stirring it periodically. Once dissolved, set the solution aside to cool for about one hour in the dark.

4. Filter the solution and discard the remaining sludge.

5. Add distilled water to make a total volume of 100 cc.

6. Store the sensitizer solution in a tightly capped brown bottle. Shelf life should be more than one year if stored properly in a relatively dark environment.

Aging the sensitizer

There seems to be an aging or curing effect associated with the new cyanotype sensitizer. If a print is made several days after mixing the chemistry, it tends to have smoother texture and loses little or no blue into the developing water. On the other hand, if a print is made immediately after mixing the sensitizer, it tends to wash off slightly in the water and to exhibit a slightly grainy texture upon drying. The sensitizer also has a slight yellow-green color right after mixing, but turns a purer yellow after a couple of days. The formula's dichromate is the reason for the solution turning to a pure yellow color, and may account for the sensitizer's improved performance after a few days' time.

Note A key to success in achieving a high-quality image in any hand-coated alternative photo process is getting the paper fibers to absorb the correct amount of sensitizer. One method of achieving this is to add Tween 20 (polyoxyethylenesorbitan monolaurate) to the sensitizing solution. This is a wetting agent similar to, but chemically different from, Kodak's Photo Flo. Add one or two drops of a 25% solution of Tween 20 per 10 cc of sensitizer. The absorption of the Tween 20 into the fibers of the paper is evident by the pronounced spreading effect at the edges of the sensitizer borders. Using this wetting agent, you may find a somewhat flatter contrast, but smoother tonalities. For most papers, however, the addition of a wetting agent is usually unnecessary.

Making the Print

1. Coat the paper with either a coating rod or a brush. Gently brush off the surface of the paper to remove any dust or grit particles; otherwise small dark flecks will appear on the paper after it dries. Coating with a rod requires about 2.0 cc of sensitizer per 8x10; brush coating uses about twice as much. Regardless of the coating method, try to avoid applying excess sensitizer, which can pool on the surface and crystallize. If you are using the rod method, be sure the rod is free of grit and dried chemistry before coating.

If you are using a brush, it is best to use one without a metal ferule. The metal will contaminate the sensitizer if it comes into contact with the solution. Clear nail polish works well to cover the metal ferule.

2. It is simplest to let the sensitized paper dry at room temperature in the dark for about one hour; however there should be no effect if you prefer to dry it with a hair dryer. Expose the paper within a few hours of coating, if possible; otherwise store it in a cool, desiccated enclosure. The coated side of the paper should remain yellow or yellow-green; if it turns a full shade of green or blue, reject it because the highlights will be fogged.

The issue of double-coating is bantered about by alt-photo workers everywhere, regardless of process. Some say it is the only way to get full D-max; others maintain their methods don't require it. The old cyanotype formula may require double coating to achieve full D-max, but this shouldn't be the case with the new cyanotype formula. One sensitizer coat, fully exposed with a good negative, is plenty for a full-tone print with near-black D-max. Assuming correct paper choice or preparation (by adding Tween 20 to those papers that need it), the shadows won't be muddy, the highlights will show definite detail separation, and no unexposed blue sensitizer will be washed off in the developing water.

The addition of a dilute solution of citric acid to the sensitizer solution just before coating will significantly speed up clearing of the New Cyanotype image. First, make up a 40% solution of citric acid (see Basics, page xviii), and then add one drop (0.05 cc) to each 2 cc of sensitizer solution for each print. This will shorten the shelf life of the sensitizer, so add it just before use.

3. Exposure times (to the sun or a UV light source) are considerably shorter than with traditional cyanotype formulas. A correctly exposed print will have a solarized look to it: Deep shadow areas should be reversed to a pale gray-blue, highlights will appear green, the mid-tones a light blue.

4. Develop the print in an initial bath of 2% citric acid for five minutes. This should be replaced after a few prints have passed through it; typically, 100 cc will process ten 8x10 prints. The yellow stain of the sensitizer should clear completely from the unexposed areas. If not, use a second citric acid bath.

5. Wash in gently running tap water for about twenty minutes. Unlike prints made by the traditional method, there should be very little loss of image substance. If reversed tones do not regain their full values during wet processing, they will do so after they have dried for about twenty-four hours. To see the final result immediately, immerse the print in a dilute bath of hydrogen peroxide—about 25 cc per liter of tap water—for no more than half a minute. It is not known, however, if such a bath will degrade the image over time.

Archival Considerations

The new cyanotype process, as well as the traditional cyanotype formula, are two of the most archivally stable processes in photography, yet they both require a chemically neutral environment for storage or they lose their archival integrity. Avoid buffered papers and boards for both coating and mounting, as well as buffered interleaving tissues and long-term storage containers. If a buffered material comes into contact with a cyanotype image, the cyanotype will likely fade. However, if a cyanotype image has faded, it may be rescued by placing it in a dark container—away from any buffering agents—for any time between a couple of days to two weeks. If the image is not faded too badly, it may return to its original deep blue color, although it may be slightly degraded and grainy.

John Barnier, Henry's Truck. *Argyrotype.*

Chapter 16 Argyrotype

John Barnier

History

The argyrotype (pronounced ar-'jir-o-type) printing process is yet another of Michael Ware's improvements to classic historical photographic processes.

Based on Sir John Herschel's argentotype, which was invented in 1842, the argyrotype process is an iron-silver process similar to two other well-known processes: kallitype (see Chapter 9) and vandyke. While retaining the advantages of those processes, it also exhibits few of their disadvantages.

With the exception of the kallitype process, which produces beautiful, long-scaled, and relatively permanent images, the other iron-silver processes suffer from a typical iron-silver problem: deterioration of the silver image by residual ferric iron. The argyrotype process eliminates many of the deterioration problems, and at the same time makes production of a silver-iron image with a beautiful and rich tonal scale easier. It does this by replacing silver nitrate with silver sulphamate, which although not available ready-made, is easily produced by following the formula given here.

Argyrotype prints can be produced in a variety of colors, from rich chocolate brown to reddish brown. Their color can be altered by several toners, and they can even be split-toned. Argyrotypes have a long tonal scale with rich details in both the shadows and the highlights. While the paper used must have certain characteristics, argyrotype prints are less finicky and more permanent than those made by many other iron-silver processes.

What You Will Need

Chemicals

- Sulphamic acid
- Ferric ammonium citrate
- Fixer: A 2% solution of sodium thiosulfate
- Silver oxide (powder)
- Tween 20
- Distilled or deionized water

Materials

- Protective mask or respirator
- Old sauce pan
- Paper coffee filters
- Coating rod or brush
- Paper for final prints
- UV lightsource
- Hot plate
- Glass beaker that fits into the sauce pan
- Mixing graduates (two plastic, 500 cc)
- Eyedropper
- Drafting tape (for masking the image area)
- Contact printing frame

Negative

The ideal negative for this process has a contrast range of between 1.8 and 2.0, or one that prints on silver gelatin paper with a contrast grade of about zero.

Paper

Critical to the success of the argyrotype process, even more so than with other alternative photo processes, is the paper onto which the chemicals will be coated. Only a few papers meet the basic requirement of the process, which is internal sizing with Aquapel or another alkyletene dimer sizing agent. The following papers are recommended:

- Whatman's printmaking paper
- Whatman's watercolor paper

- Atlantis Silversafe (U.K.)
- Buxton (U.K.)
- Crane's Parchmont Wove

Two other papers that work well, although their light weight requires careful handling, are:

- Crane's 3111 writing paper
- Crane's Kid Finish

Safelight

Low-level tungsten

Procedures

Preparing the Sensitizer

1. Under normal room lighting, heat 70 cc of distilled water in the glass beaker to about 130°F. Dissolve 7 g of sulphamic acid in it.

2. To this hot solution, add 7 g of silver oxide, stirring in small amounts at a time and mixing thoroughly.

3. To this, add 22 g of ferric ammonium citrate. Stir in small amounts at a time and mix thoroughly.

4. Allow to cool to room temperature.

5. Add about ten drops of 50% Tween 20 and mix well. Note that the amount of Tween 20 is variable depending on the paper used; for Whatman's, Buxton, and Crane's papers, ten drops is adequate. Harder-surfaced papers may need more; softer, more absorbent papers may need less, or even none at all. Experiment with various ratios of Tween 20 and sensitizer until the solution soaks well enough into the paper that it doesn't pool on top. Look also for strong blacks and smooth tonal gradations in your final prints.

6. Add distilled water at around 70°F to make up a final volume of sensitizer of 100 cc. Allow it to sit for about one hour.

7. Filter the solution and store it in a brown glass bottle. If kept in a cool and dark location, the sensitizer should last for a year or more. The color of the solution should be a deep olive-green. If a black precipitate settles at the bottom of the bottle during storage, however, simply filter it before use, or be sure to draw only the clear olive-green sensitizer at the top of the bottle.

Coating the Paper

This description uses a glass rod for coating instead of a brush, which wastes sensitizer since much of it migrates into the brush. If you only have a brush, first dip it into water, dab it mostly dry, and use *twice* the amount of sensitizer needed for the rod method.

You can give your image a clean straight border by outlining the image area with drafting tape. This will also retain a standardized amount of solution within a given coating area, which is important for repeatability. If standardization is not a concern, you can dispense with the tape and produce a much looser edge to your coating area. Use drafting tape or other tape with a low tack only. If you use masking tape or other kinds that have too much adhesion, you will tear the paper surface when removing it.

1. Under safelight conditions, mark off with pencil the boundaries of the area of the paper to be coated, and tape the paper to a board, piece of plate glass, or counter top using drafting tape or other low-tack tape.

2. Measure out the sensitizer into a small glass container (a shot glass works well). About fifteen drops from an eyedropper will coat an area of 5" x 6". Different eyedroppers may give varying amounts.

3. Draw the sensitizer back into the eyedropper, then release it in a uniform stream along the top long edge of the coating area (the top 6" side of a 5" x 6" coating area, for example.

4. Holding the coating rod just behind the line of sensitizer, gently place it against the paper and draw it forward in an even, steady motion. When you reach the bottom of the coating area, *slowly* lift the rod off the paper, place it behind the puddle, and push it back up the paper. If the sensitizer hasn't soaked into the paper completely after these first two motions, wait a few seconds and repeat the process until it has. Lift the rod off the paper *slowly*, or small specks of sensitizer will flick onto the paper and leave black spots on the paper upon development.

5. Set the coated paper aside in the dark for an hour or so until it is completely dry. A hair dryer set to low can speed up the drying, but the paper should sit for about twenty minutes first to allow the sensitizer to soak into the paper fibers adequately.

6. Dried paper can sit for a few hours (in the dark) before exposure if necessary; however a desiccated box should be used for longer storage.

Printing

1. Under a low-level tungsten safelight, place the negative inside the contact printing frame against the glass, emulsion side up.

2. Place the coated and dry paper against the negative, coated side down.

3. Attach the back of the contact frame, turn it over, and inspect for any dust or pieces of grit that may have lodged against the negative. A small indentation on the negative means there is grit. If so, remove the negative, blow or wipe the dust away, and place it back into the contact frame.

4. Place the contact frame under your UV light source and expose. Exposure times can vary anywhere from three to twenty minutes (or even longer), depending upon negative density and light source. My times hover

around eight minutes with a negative with a contrast range of 2.0 and a small light source that uses six 15-watt UV bulbs. The negative is about two inches away from the lights.

5. This is a "printing-out" process, so the image will appear as it exposes. Test strips are almost unnecessary since visual inspection will lead to a perfectly exposed print once you learn the basic characteristics of the process. A split-back contact frame is needed for this; it lets you hold the negative and paper in perfect register on one side of the back while lifting the other side to see the print's progress.

6. Expose until the print reaches a density about one zone lighter than you want in the final image. There should be just a hint of detail in the highlight areas, which will be yellow at this stage.

7. Remove the print from the contact frame and immerse it in a gently running water rinse. Wash it until the yellow stain is gone.

8. Immerse the print in the fixer bath for five minutes with gentle agitation.

9. Wash at around 70°F for twenty minutes. Unlike cyanotype and some other processes described in this book, the argyrotype image does not reduce or fade with extended washing.

10. Air-dry, face up, on a clean fiberglass screen.

The color and highlight details of the print can be enhanced by humidifying it either before or after exposure. A purple-gray color can be achieved by humidifying the sensitized paper for thirty minutes before exposure. Significantly more highlight detail can be achieved by humidifying the print for ten minutes after exposure but before the water rinse.

To humidify, place the sensitized paper or exposed print over a tray of water on a fiberglass screen that is enclosed under a cardboard box, similar-sized tray, or other enclosure. Maintain safelight conditions throughout this procedure. Breathing on the print will add enough localized humidity to bring out subtle highlight details in small areas.

If you find that your negatives require a more contrasty sensitizer solution, add 1 g of sulphamic acid to the sensitizer formula. With two solutions on hand—one of normal contrast and one of higher contrast—you can fine-tune your image contrast by combining the solutions in various ratios. Note, however, that the extra sulphamic acid can add a grainy texture to your prints.

John Barnier, Untitled. Argyrotype, from a negative made with a pinhole camera.

John Barnier, Untitled. Toned argyrotype, from the same negative.

Toning

Argyrotype prints can be toned in various ways, using many of the same formulas used to tone gelatin silver printing-out paper. Gold chloride combined with ammonium thiocyanate is a traditional toner for POP, and it works very well for argyrotypes. The colors can be enhanced even further with the addition of alkaline-based chemicals to the basic gold chloride solution. Refer to Chapter 10 for the gold/thiocyanate and gold/alkaline formulas, and use the same stock solution and working solution mixtures listed there to tone argyrotype prints. The information on handling, replenishing, and storing gold toners found there applies to argyrotype printing as well. Note, however, that the fixer used for argyrotypes—a 2% solution of sodium thiosulfate—is much weaker than that used for POP and does not include hardener. Once you have mixed the chemicals, follow the procedures below for toning your argyrotypes.

Another toner that works well for argyrotypes is selenium, and by combining the humidification techniques described above with selenium toning, a wide range of colors can be achieved.

As with POP, both toning methods require that the print be toned before it is fixed. Follow the printing instructions above through step 7, and place the exposed and processed print into the toning bath after you have removed it from the rinse that washes out the yellow stain.

Gold toning procedure

1. Follow printing steps 1 through 7 on pages 212 and 213.

2. Place the print in the empty toning tray and pour the working toning solution over the print. Agitate it constantly but gently by lifting one corner of the tray, then another. Continue this agitation, alternating corners, for two to ten minutes, depending upon the color desired. Be sure to remove any air bubbles that may appear on the surface of the print.

3. Lift the paper and drain it for a few seconds, then immerse it in the tray of fixer.

4. Fix the print for a total of ten minutes. Do not rinse between the toner and fixer.

5. Remove the print from the toning tray and wash it for thirty minutes. Air-dry the paper, face up, on fiberglass drying screens. Drying face down may leave the pattern of your drying screen in the surface of the paper, which is very soft while wet.

Selenium toning procedure

This process uses a very weak 1% solution of selenium toner for a very brief time.

1. Add 5 cc Kodak Rapid Selenium Toner to 500 cc distilled or deionized water.

2. Expose and process the print through printing step 7 on page 213.

3. Place the exposed print in the selenium toning tray and pour the selenium solution over it.

4. Gently agitate the print, making sure to dislodge any air bubbles on its surface.

5. Leave the print in the selenium solution for thirty seconds to one minute. You will need to experiment with exact times, but if it is left too long the image will fade.

6. Wash and dry as above.

Charles H. Palmer, Spray of White Orchids, 1996. *Ziatype.*

Chapter 17 Digital Negatives for Alternative Processes

Charles H. Palmer

Process Overview

Over the past decade, digital methods have transformed photography. Electronic imaging offers freedom of expression and control over materials that are inconceivable with traditional photographic tools. Because alternative printing techniques are so heavily based in historical methods, there may be considerable resistance to adapting these older processes to the computer. However, due to the extraordinary nature of these digital tools, it is inevitable that computerized methods will be incorporated into alternative photographic processes.

Since 1989, I have confined my work to platinum and palladium printing. In 1994, I began using digital methods exclusively to make negatives for contact printing. You can adapt the methods I describe in this chapter to any process that uses black-and-white negatives for contact printing.

I explain here the advantages of digital methods for alternative photographic processes, the hardware and software required, the steps involved in making a digital black-and-white print, and a method to adapt digital output devices to a photographer's needs. This chapter is not intended as a comprehensive step-by-step guide for adapting digital methods to alternative photographic processes; in the short space of a chapter, I can give only a brief overview of the subject. There are several important areas, such as monitor calibration and sharpening techniques, that I will not discuss. Instead, I will concentrate on the areas that have presented the biggest challenges to me and emphasize problems that are peculiar to black-and-white photography and contact-printing processes.

There is little in print today to guide the photographer in learning digital techniques for black-and-white photography. One book you may find helpful is *Making Digital Negatives for Contact Printing* by Dan Burkholder.

As rapidly as computer technology changes, anything in a book is out of date by the time it is published; so keep in mind that, by the time that you read this, both hardware and software will likely be better and cheaper than they are now.

Why Use Digital Techniques for Alternative Processes?

Digital methods offer you several advantages for alternative printing processes. One of the most obvious benefits is the ease with which you can enlarge negatives. You can make digital black-and-white negatives with an imagesetter (described later in this chapter) in any size up to about 20x24. The conventional techniques for negative enlargement (direct-positive film or an enlarged film interpositive and new negative) are at best difficult and present several problems; these include dust spots, loss of information in translation through two generations of film images, and difficulty in controlling the contrast and density range of the final negative. In my case, before converting to digital techniques, I used an 8x10 camera to get 8x10 negatives; the nuisance of using a large camera was preferable to the difficulties involved in enlarging smaller negatives. I now use a 6x7 cm SLR for original negatives, since negative enlargement becomes a trivial problem with the computer.

With digital methods, you can tailor the density and D/LogE curve of the negative to the needs and peculiarities of any black-and-white printing method. For example, the characteristic curve of a platinum print has a long, gently sloping toe and shoulder. Because of this, it is often difficult to obtain good separation of tones in shadows and highlights. With digital negatives, I can compensate for this by specifically steepening the extremities of the D/LogE curve in the final negative. I can also specify the D-min and D-max of the negative precisely, so that the negative is very easy to print, with little if any need for the usual contrast-enhancing chemical agents that can lead to grain and loss of D-max in a platinum print.

Even if you have no interest in altering images in radical ways that are obviously "computerized," the extraordinary control digital methods give you over the photograph far surpass traditional darkroom techniques for negative and print manipulation. You can burn and dodge at the pixel-by-pixel level and optimize contrast and density for individual areas of the image. Negatives that I had filed away as unprintable because of technical problems such as excessive contrast, dust on the film, and uneven development became easy to print once I had converted to digital methodology.

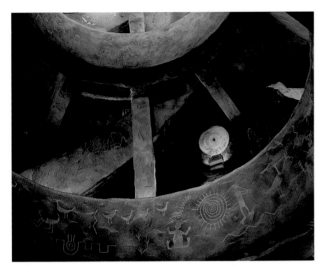

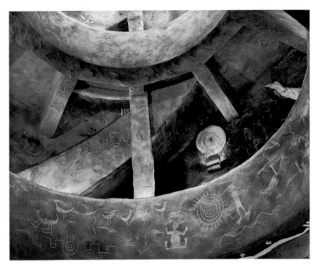

Charles H. Palmer, Watchtower, South Rim of the Grand Canyon. *Palladium print. No curve applied.*

Charles H. Palmer, Watchtower, South Rim of the Grand Canyon. *Palladium print. Curve applied. (Notice the increased details in both the shadows and the highlights.)*

Making an Alternative Process Print with Digital Methods

Making Digital Images

Digital image processing can be divided into three phases: input, image manipulation, and output.

Input
Since digital cameras with resolution comparable even to 35mm film are still prohibitively expensive, most photographers using digital techniques still rely on conventional film for capturing the original image. Once you have the image on film, it must be scanned to produce a digital file the computer can use. You can either scan the film yourself with a personal desktop scanner or have it done for you at a service bureau.

Image manipulation
I will say little here about the actual process of manipulating the image in the computer. With Photoshop, there are essentially no limits to what you can do with a photographic image.

Output

Once you've finished manipulating the image on your computer screen, you must translate that image into a black-and-white negative for contact printing. This translation is currently the biggest obstacle in applying digital methods to alternative photographic processes. Most black-and-white photographers doing digital work use an imagesetter at a service bureau to create their digital negatives. Other output devices include desktop laser and inkjet printers, ordinary computer monitors, and film recorders.

Service bureaus

A service bureau is a shop filled with very expensive hardware, including scanners, imagesetters, film recorders, and other professional input and output equipment. Since it is geared to the needs of the color-printing trade, its staff often knows little about the needs of the black-and-white photography, to say nothing of the requirements of alternative processes.

If you do much work in digital black-and-white photography, you will use a service bureau to make your final digital monochrome negatives; you may also use one to do your scans. The service bureau is in a difficult position here. You will be asking for custom work that will require considerable effort by the bureau's personnel to adapt machinery for alternative process work. The bureau, however, must get work through the shop as fast as possible to cover the cost of a million dollars worth of hardware that is depreciating at an alarming rate.

It has been my experience that, unless you know exactly what you want or have a sympathetic friend working in the shop, scans and negatives from most service bureaus will be less than satisfactory. At least in your initial forays into the digital world, you will probably be better off using one of the handful of bureaus that have done a lot of black-and-white work for photographers. These should become easier to find as more and more serious photographers turn to digitally produced negatives, but initially you may have to search for one that understands what you are after. I use Command-P in San Antonio, Texas, which has several years' experience in digital photography and has worked with Dan Burkholder to develop the methods described in his book. Another source of advice regarding service bureaus and digital methods for alternative processes is the Internet alt-photo-process list, where several digital photographers are active participants.

Hardware requirements

The price of computer hardware drops almost daily. A few years ago, a personal computer system adequate for digital black-and-white work cost about $10,000. That price has now dropped more than 60 percent. Following is a brief summary of a system that would be adequate for beginning to work in this area. Some of the factors to be considered in a computer system for digital imaging, such as the operating system, random access memory (RAM), hard drive, and monitor, are relevant to any home computer. Items such as transportable media, scanners, and digitizing pads have more specific applications in digital imaging.

Operating system

Your first decision will be to choose between the Macintosh OS and Microsoft Windows operating systems. The Macintosh remains the industry standard for graphics work and has an operating system that is somewhat easier to use than Windows. However, all the software you will need is available for Windows systems, and most service bureaus now will accept either Macintosh or Windows files. In either case, you will need a machine with one of the latest microprocessors: the PowerPC chip for the Macintosh OS, or the Pentium for a Windows system.

For digital imaging, the Macintosh OS offers two major advantages over Windows. First, it supports the simultaneous use of two monitors. On my Macintosh, I have a 15" color monitor and a 20" grayscale monitor. I keep all the Photoshop menus open on the smaller monitor, leaving the entire 20" screen for the image I'm working on. Second, despite the claims of "plug-and-play" compatibility with the newer Windows computers, it is much easier to install and use external peripheral devices on a Macintosh system. This is not a small consideration, because the home digital imaging system usually has several external devices (scanner, printer, hard drive with transportable media, tape or disk drive to back up the primary hard drive, digitizing pad, etc.).

Random access memory (RAM)

Photoshop uses enormous amounts of RAM. In addition to the memory needed to run your operating system and Photoshop, for black-and-white work you will need at least 400 KB of RAM per square inch of final image size. For example, you will need a minimum of 40 MB of RAM if your final image size is 8x10 (at least 8 MB for the operating system and Photoshop; 32 MB for the image). The more RAM you have, the faster your system will run.

Hard disk

You will need a large hard drive, since digital image files are huge: a file for a single 8x10 black-and-white image can range in size from 7 to 30 MB. I would consider a 2-gigabyte hard disk as the minimum; 3 or 4 GB is better.

Computer monitors

The situation with monitors is the same as with RAM and hard disks: larger is better. If your graphics work is limited to black-and-white images, consider a 20" or 21" grayscale monitor. Grayscale monitors are much sharper than color monitors of similar size; since they have only a single electron gun rather than three, there is no loss of sharpness due to imperfect convergence. They are also much cheaper than comparable color displays.

Transportable media

To send your files to a service bureau, you will need some sort of transportable storage medium. Most workers use a removable hard disk, such as a SyQuest, ZIP, or Jaz drive. Before purchasing a drive, check with the service bureau you will be using to see what removable media they accept. The prices of transportable media have dropped considerably; for example, a ZIP drive now costs about $100 and individual disks can be found for less than $10.

Scanner

You should consider purchasing a scanner rather than having a service bureau do your scans for you. As I'll discuss later, good scans are a critical part of the digital imaging process, and sooner or later you will want to have direct control of the scanning process. A scanner adequate for black-and-white photographic work costs about $1,500.

Digitizing pad

The mouse is the tool you'll use for guiding the cursor over the image in Photoshop; but if you do a lot of work, you should consider buying a digitizing pad, in which the mouse function is replaced by a pencil-like stylus. For drawing on the computer screen, a stylus has a more natural feel than a mouse. Pads range in cost from $150 to $500, depending on the size of the pad surface.

A final note about hardware costs

If you have extra money to spend, put it into additional RAM and a larger monitor. There is no such thing as running Photoshop on a system with too much RAM; a large monitor will make all aspects of image editing easier and more pleasant.

Software

While there are other digital imaging products on the market, Photoshop remains the industry standard and is the benchmark by which all other image-processing software is measured. It can be criticized for minor shortcomings, but it is an extraordinary program and will do anything you could conceivably want in your alternative process work.

Scanning

The importance of a good scan cannot be overestimated, and there is an art to making one. A good scan has the same importance a perfect in-camera negative has for traditional printing methods. If you have a service bureau do custom scans for you, it will not be cheap. It has been my experience that service bureau personnel do an excellent job with color scans (that is, after all, their main business), but they know little about the technical requirements of black-and-white scans. If you know someone at your service bureau and can work side-by-side with the scanner operator as he or she makes your scans, you can get good results. If not, your scans will probably be mediocre and often unacceptable.

Sooner or later, you will probably want to buy a scanner. Obviously, most of us cannot afford a $100,000 drum scanner like those used by service bureaus, so the problem becomes one of adapting a less-expensive scanner (in the $1,500 to $2,000 range) to your requirements.

You will need scans that have about 300 pixels per inch (ppi) resolution at your final negative size. For 35mm film, you will need a scanner that can resolve about 2500 to 3000 ppi in order to get a final image size of 8x10. For an 8x10 image from a 6x6 cm negative, the scanner must resolve about 1400 ppi. A 4x5 negative requires 600 ppi resolution, while an 8x10 negative needs only 300 ppi. Because of this wide range in required resolutions, the choice of a scanner for personal use is dependent on the size of your original negative. The choices and methods for 35mm and large-format negatives are relatively straightforward. Medium-format negatives present some problems.

If your work is limited to 35mm, you can buy a good desktop scanner for about $1,500. You should realize, however, that 35mm scanners cannot be adapted to scan larger film sizes. The output of these scanners is good enough for a final image size of no larger than 8x10.

For larger film sizes, you will need a flatbed scanner with a transparency adapter. For about $1,500, you can get a scanner that has an optical resolution of 600 ppi, has 30- or 36-bit color, and will accept transparencies (positive or negative) up to 8x10. Pay no attention to advertising claims about interpolated resolutions; interpolation gives empty magnification, and the only number that

matters is the actual optical resolution. I have a Microtek Scanmaker III flatbed scanner that has worked well for my large-format negatives. At 600 ppi, it will scan my 4x5 negatives for a final image size of 8x10; I can achieve a final image size of 16x20 with my 8x10 negatives.

At the present time, a scanner with sufficient resolution to scan a 6x6 cm negative directly at 1400 ppi costs over $5,000, which is too expensive for most of us. This means you must somehow adapt a 600-ppi flatbed scanner for medium-format work if you want to scan medium-format material yourself. I use an inelegant but effective method for scanning 35mm and medium-format negatives with my 600-ppi flatbed scanner: I make an 8x10 interpositive on sheet film and scan the interpositive. This sounds like a lot of trouble, but it really isn't. Also, as long as the D-max of the interpositive is under about 2.0, the contrast range and density of the interpositive are not critical; Photoshop and the scanner software will compensate for these variations in density and contrast.

I use Kodak TMax 100 8x10 sheet film to make my interpositives since it is relatively inexpensive. It has the advantage of being panchromatic, so I can make interpositives from color film without losing information in the red portion of the spectrum, as I would if I used an orthochromatic process film. Another advantage of TMax is its availability. With the advent of digital methods, film manufacturers are discontinuing many process films in sheet-film sizes; you can be fairly sure that TMax will be around for many years to come.

There is one more advantage to having your own scanner that is seldom mentioned in discussions on the merits of service-bureau scans versus desktop scanners—you can use a desktop scanner as both a transmittance and a reflectance densitometer. You can scan a step tablet (transparency or print) as a benchmark and make a curve comparing the optical densities of that reference material with the Photoshop electronic densities. You can then scan the transparency or print you wish to evaluate and use the curve to determine the density of any area in the image. Relatively inexpensive scanners can be used in this manner for transmission densities up to about 2.2. While the results are not as accurate as those obtained with a conventional densitometer, they are adequate for most needs of alternative printing methods.

Making Digital Negatives

Once you have scanned in your image and completed whatever enhancements or "retouching" you want to do in Photoshop, you must somehow translate what is on your monitor to a piece of transparent material that can serve as a negative. The output devices you can use, listed in ascending order of their usefulness for alternative process work, are desktop laser or inkjet printers, home computer monitors, film recorders, and imagesetters.

Desktop laser and inkjet printers

With inexpensive laser and inkjet printers, you can substitute clear transparency material for paper as a substrate and use the output as a negative. There is one limiting factor, however, that makes use of these printers for high-quality negatives impractical: their resolution is too low to produce a continuous-tone image with no trace of grain or halftone dots, especially in the tonal range of white to

Charles H. Palmer, Goosenecks of the San Juan River, Utah. *3³/₄" x 4³/₄". Palladium print.*

light gray. Consequently, at least with the current level of printer technology, I do not feel that these are useful tools for making high-quality negatives for alternative processes. I suspect, though, that the next generation of inexpensive printers may well have enough resolution to allow their use for serious photographic applications.

Home computer monitors

For 4x5 negatives or smaller, your computer monitor can be used as a film recorder to make negatives for contact printing. You can photograph a positive image directly off your computer screen and use the negative to make prints. The method works best with a grayscale rather than a color monitor because of its greater sharpness.

Several alternative printing processes, such as platinum/palladium, cyanotype, kallitype, and gum, are inherently unsharp, since the image is composed of a tangle of paper fibers impregnated with an opaque insoluble product rather than pigment particles suspended in a homogeneous substrate such as gelatin. For these "fuzzy" printing processes, a 200-ppi negative provides enough resolution to make a contact print that looks very sharp and has no trace of its digital origin, provided that there is no clear or empty space between the dots on the negative.

The 20" monitor on a Macintosh has 1062 x 850 pixels of resolution at 4x5 proportions, and this provides a bit more than 200 ppi of resolution for a 3.75" x 4.75" image on a sheet of 4x5 film. A 15" monitor set at 800 x 600-pixel resolution, which is a standard Macintosh and Windows setting, gives an image size of 3" x 4" with 200 dots per inch (dpi). If you don't mind your prints being a little less than really sharp, you might be able to get by with a 4x5 negative from a 15" monitor.

If you are using a color monitor, you should send a single-color image (red, blue, or green) to the monitor via controls in Photoshop. This eliminates any loss of sharpness due to imperfect convergence of the electron guns in the CRT.

There are a few disadvantages to generating negatives with this procedure. Since most monitor screens are not flat, straight lines near the edges of the image are a bit bowed. This is a problem for architecture, but it shouldn't be noticeable for most other subjects. The image on your screen should be slightly larger than the image on the film, so that 100% of the area on the film is filled. Finally, you must expose the film in a dark room to eliminate reflections and glare off the screen.

I have made 4x5 palladiotypes and cyanotypes with negatives generated using a 20" grayscale monitor with excellent results; they are the equal of

The terms dpi (dots per inch) and ppi (pixels per inch) are often used interchangeably, although they do have slightly different meanings. In simple terms, dpi is a term used by the printing industry to measure resolution in a printed image. In this method, tiny dots of ink are printed onto a page in varying sizes and patterns of distribution, which then form the photographic image. The number of dots per linear inch is the dpi of that image. Ppi is strictly a digital term, signifying how many pixels (the smallest unit of a digital image) there are in one linear inch of image area. In a greatly magnified digital image, the pixels would appear as small square blocks of color and tones.

prints I make with digital negatives from a high-end imagesetter at a service bureau. Even with a loupe, there is nothing in the prints to give a hint of their digital origin. Even if your goal is to make prints larger than 4x5, this is an inexpensive way to experiment with digital photographic techniques and avoid the problems and expenses involved with imagesetters and service bureaus.

Film recorders

A film recorder is simply a very high-resolution black-and-white monitor with a built-in camera that records the image on the screen. In contrast to a computer monitor, which will have at most about 1100 pixels in a single horizontal line, a film recorder has many thousands of pixels per line, resulting in very high-resolution images. They are used to make high-quality color film transparencies, recording three images photographed sequentially through red, blue, and green filters. The usual output from a high-end recorder is a sheet of 4x5 film, which can then be used to make enlargements up to 16x20 or more. These are expensive machines: the typical high-resolution film recorder at a service bureau can cost as much as $150,000.

The film recorder offers two advantages over other output devices. First, in contrast to the imagesetter, the film recorder does not require a radical correction curve in order to get acceptable results for black-and-white printing; this reflects the fact that it is designed to output photographic film. Second, once you have a high-resolution 4x5 film positive, you can make an enlarged negative of any contrast range and size you want. This is an advantage for photographers working with different printing processes having different contrast requirements.

There are at least two disadvantages of film recorders for alternative processes. First, their output is expensive: a service bureau typically charges about $75 for a single 4x5 film image. Second, unless you are making small prints, you must use conventional techniques to enlarge the 4x5 film positive to your final negative size. Since this negates many of the advantages that digital techniques offer for producing large negatives for contact printing, film recorders have seen little use in alternative processes.

Prices of film recorders have dropped sharply recently. For example, Polaroid recently introduced an 8,000-line film recorder with a 4x5 back that sells for under $15,000. If the price/performance ratio of these devices continues to improve, film recorders may become an attractive alternative to imagesetters.

Imagesetters

The imagesetter can be thought of as a very high-resolution laser printer that outputs to photosensitive film. In contrast to the 600 dots per inch of the typical laser printer, imagesetters have a maximal resolution of up to 5,000 dpi. The output of the imagesetter laser is binary; that is, it is either on or off when it exposes the film. The film used in imagesetters is a high-contrast, high-resolution Kodalith-like material with a very high D-max (4.0 or greater). The image on the film is thus made up of closely spaced dots of very high optical density.

The image is constructed by the imagesetter in one of two ways. In the first, groups of dots are used to make halftone cells. In order to get 255 shades of gray, the maximum number of halftone cells per inch that can be produced with a 5,000-dpi imagesetter is about 300. This frequency is traditionally stated in lines per inch (lpi). Platinum prints made from 300-lpi digital negatives have a very smooth appearance, with virtually no visual clues as to their digital origin.

Alternatively, the imagesetter can generate a seemingly random distribution of dots, a method that has been termed *stochastic screening*. (The "diffusion dither bitmap" method described in Dan Burkholder's book is another method for producing negatives with random dot distribution.) Stochastic screening eliminates the regular, mathematical array of dots that characterizes the conventional halftone screen; but, in my experience, even with 5,000-dpi imagesetters, the resulting prints sometimes have a rather grainy appearance that does not occur in prints made from halftone digital negatives.

Of all the currently available output devices, the imagesetter produces the best results and is the choice of most workers using digital methods for alternative processes. It has several advantages over other output devices. Imagesetter negatives can be quite large, up to 20x24 or more. The negative is made of silver on a film base; consequently, its archival properties are identical to those of traditional silver negatives. The material can easily achieve the relatively high densities needed for many alternative processes.

The price of digital negatives varies widely among service bureaus. The best prices I have found are $20 for an 8x10 negative and $30 for a 16x20. I usually put several images onto a single 16x20 negative (four 8x10s, sixteen 4x5s, etc.), which makes the cost per individual image quite reasonable.

The imagesetter has one significant drawback, however, and this has made its adaptation to photographic printing quite difficult: its output is designed for the needs of the printing industry, not the photographer. The characteristic curve of a negative optimized for a printing press is very different from that of a negative for black-and-white photographic materials.

Fig. 1. *Photoshop electronic density of original positive image vs. optical density of digital negative.*

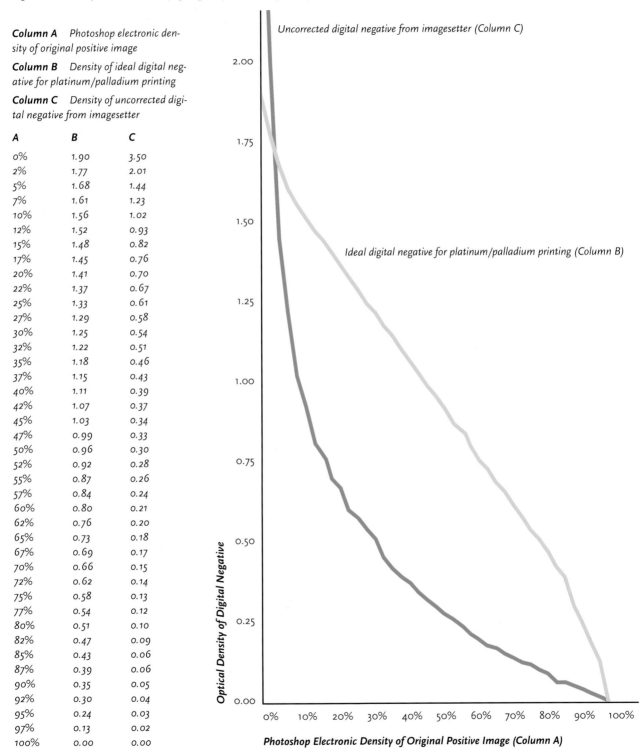

Column A *Photoshop electronic density of original positive image*

Column B *Density of ideal digital negative for platinum/palladium printing*

Column C *Density of uncorrected digital negative from imagesetter*

A	B	C
0%	1.90	3.50
2%	1.77	2.01
5%	1.68	1.44
7%	1.61	1.23
10%	1.56	1.02
12%	1.52	0.93
15%	1.48	0.82
17%	1.45	0.76
20%	1.41	0.70
22%	1.37	0.67
25%	1.33	0.61
27%	1.29	0.58
30%	1.25	0.54
32%	1.22	0.51
35%	1.18	0.46
37%	1.15	0.43
40%	1.11	0.39
42%	1.07	0.37
45%	1.03	0.34
47%	0.99	0.33
50%	0.96	0.30
52%	0.92	0.28
55%	0.87	0.26
57%	0.84	0.24
60%	0.80	0.21
62%	0.76	0.20
65%	0.73	0.18
67%	0.69	0.17
70%	0.66	0.15
72%	0.62	0.14
75%	0.58	0.13
77%	0.54	0.12
80%	0.51	0.10
82%	0.47	0.09
85%	0.43	0.06
87%	0.39	0.06
90%	0.35	0.05
92%	0.30	0.04
95%	0.24	0.03
97%	0.13	0.02
100%	0.00	0.00

Uncorrected digital negative from imagesetter (Column C)

Ideal digital negative for platinum/palladium printing (Column B)

Optical Density of Digital Negative

Photoshop Electronic Density of Original Positive Image (Column A)

In order to understand this, you must know how Photoshop deals with density. Built into Photoshop is a digital electronic densitometer that reads from 0% to 100%. Pure white in a Photoshop positive screen image has a Photoshop density of 0%, while pure black has 100% density. When you place the computer cursor on a Photoshop image, the program automatically reports a density value for the point under the cursor. The D-max of a good digital negative, which corresponds to 0% density in the highlight areas of a positive image on the screen, should equal or exceed the density required by your printing material to print a pure white. In addition, the optical density of the negative should decrease in a roughly linear manner between the extremes of 0% and 100% on the Photoshop densitometer.

The problem with imagesetters is that their output deviates greatly from the optimal curve needed for photographic materials. The yellow curve shown in figure 1 is the optical density of an ideal digital negative for platinum/palladium printing compared to the Photoshop electronic density of a positive image on the computer screen. As you can see, the ideal negative is for the most part linear; I have made the curve a bit steeper in the 0–10% and 90–100% areas to compensate for the rather flat shoulder and toe of the D/LogE curve. The red curve is the optical density of an uncorrected digital negative from an imagesetter, again compared to the Photoshop density of the image on the screen. The curve for the imagesetter negative deviates from the ideal. Figure 2 is a step tablet of a palladium print made from an uncorrected imagesetter negative. In general, the digital negative was too thin; consequently, the step tablet has little if any separation of values in the darker portions of the image, with dark gray to black tones in areas with an original Photoshop density of more than about 40%. In contrast, at the opposite end of the tonal spectrum, in the range of 0% to 20%, there is too much separation because the curve of the digital negative is so steep in that region.

The D/LogE curve of the negative deviates to some degree from the ideal with all output devices for digital negatives. However, the situation is far worse for imagesetters than with other devices, to the point that imagesetter digital negatives are unusable unless strong corrective measures are taken.

0 5 10 15 20 25 30 35 40 45 50 55 60 65 70 75 80 85 90 95 100

Fig. 2.

Adjusting Digital Negatives to Fit Your Needs

What can be done to remedy this situation? Using Photoshop, you can apply a curve to the image that will compensate for the inaccuracies of the imagesetter (or any other output device) and match the requirements of your chosen alternative printing process. With the Curves command, you can create a correction curve that will map any brightness value in an image to any other brightness value. After you've finished creating an image to your satisfaction on the screen, you simply apply the correction curve to the image just before sending it to the service bureau. If all goes well, the resulting digital negative will have a range of optical densities that will give proper tonal values in your contact print.

There are two ways to construct such an adjustment curve. First, using the Image > Adjust > Curves (Command-M) command, you can make a correction curve by using the cursor to drag the curve to fit the values you want. A more precise method is to use the Transfer Function. Use the File > Page Setup > Transfer Button to get to the Transfer Function dialog box. There, you will be presented with a curve identical to the one you had in the Adjust Curves box. However, the dialog box also has spaces for entering specific numerical values for thirteen points on the curve. After you've entered values for a curve, you can save the curve in a file on your hard disk.

Testing the Curves

There are two methods you can use for making and testing correction curves. With the first, you use several experimental correction curves to make digital test negatives, make contact prints from these negatives, and evaluate your curves on the basis of the test prints. In the second method, you evaluate test negatives with a transmission densitometer and construct correction curves on the basis of the densitometer readings, with no intervening test prints.

I have oriented the descriptions of these methods to the unique problems presented by imagesetters. However, the methods can be used to optimize negatives from any digital output device for black-and-white contact printing.

Using test prints to evaluate correction curves

You will get the best results if you do all of your tests with digital step tablets. For my test work, I use a digital step tablet with three segments (fig. 3). The first is a 21-step tablet with densities ranging from 0% to 100% in 5% increments. There are two additional 21-step segments, one having a single step

Test Curve # 1
0 5 10 15 20 25 30 35 40 45 50 55 60 65 70 75 80 85 90 95 100
0 1 2 3 4 5 6 7 8 9 10 11 12 13 14 15 16 17 18 19 20
80 81 82 83 84 85 86 87 88 89 90 91 92 93 94 95 96 97 98 99 100

Fig. 3.

for each of the values in the 0%–20% range and the other values in the 80%–100% range. The tablet measures 1.33" x 5", so twelve of them will fit on a single 8x10 negative, or forty-eight on a 16x20 sheet of film. Using the tools in Photoshop, you can construct a digital step tablet for your own use.

How do you begin plotting correction curves for imagesetter digital negatives? Figure 4 is a chart of numerical values for fourteen test correction curves. These curves are a good starting point for optimizing imagesetter negatives for black-and-white printing, and the right correction curve for your process probably lies somewhere among them.

With 300-lpi digital negatives made by an imagesetter, these curves will each result in a negative with a D/LogE curve similar in shape to the ideal curve illustrated in figure 1. They differ only in the slope of the curve and the D-max of the negative. As indicated by the names of the curves (1.6, 1.8, etc.), they will produce negatives with a D-max ranging from 0.5 to 1.8, in increments of 0.1. The D-min of all the curves is identical, at 0.03 to 0.05.

For your first 8x10 test negative, put twelve of the 1.33" x 5" digital step tablets in a single 8x10 image on your computer screen. With the resulting negative, you will be testing twelve of the curves in the series, excluding the two that are farthest from the D-max required by your printing process. On your computer screen, apply one of the correction curves in figure 4 to each step tablet; use the Photoshop's Marquee tool to select a tablet, then use the Adjust > Curves (Command-M) command to load the file of a test curve that you have entered and saved earlier in the transfer box and apply it to the selected area.

Once all twelve test curves have been inserted, send your test image to a service bureau and have a digital 8x10 negative made. Before you begin preparing your test images, you should work with the service bureau to be sure that the parameters you are seeking fit with the capabilities of the bureau's equipment. For example, when I work with Command-P in San Antonio, I make sure they know the following information:

- File format: Photoshop 3.0 grayscale file, 625 ppi at the final negative size.
- File is sent as a positive image.

Fig. 4. *Test correction curves for imagesetter digital black-and-white negatives.*

D-max 0.5	D-max 0.6	D-max 0.7	D-max 0.8	D-max 0.9
0%: 31	0%: 25	0%: 19.2	0%: 15	0%: 11.5
5%: 36	5%: 27.5	5%: 22.7	5%: 18.5	5%: 14.5
10%: 39	10%: 32	10%: 26.3	10%: 21.7	10%: 17.5
20%: 44	20%: 36.3	20%: 29.3	20%: 25	20%: 20
30%: 49	30%: 40	30%: 35	30%: 28.6	30%: 25
40%: 52.5	40%: 46	40%: 41	40%: 34	40%: 29.9
50%: 57.5	50%: 51	50%: 46	50%: 40.8	50%: 35.5
60%: 63.4	60%: 57.5	60%: 51	60%: 47.2	60%: 41.6
70%: 68.4	70%: 63.4	70%: 58.7	70%: 54.4	70%: 50.2
80%: 73.4	80%: 69.9	80%: 64.7	80%: 60	80%: 56.2
90%: 80.6	90%: 76.5	90%: 73.4	90%: 68.1	90%: 67
95%: 89.9	95%: 84	95%: 82	95%: 80	95%: 78
100%: 100	100%: 100	100%: 100	100%: 100	100%: 100

D-max 1.0	D-max 1.1	D-max 1.2	D-max 1.3	D-max 1.4
0%: 9	0%: 7.2	0%: 5.9	0%: 4.6	0%: 3.6
5%: 11.7	5%: 10	5%: 8	5%: 6.3	5%: 5.2
10%: 14	10%: 11.5	10%: 10	10%: 8.2	10%: 6.8
20%: 17.5	20%: 14.5	20%: 12	20%: 10.1	20%: 8.5
30%: 22.1	30%: 18.2	30%: 15.4	30%: 13.4	30%: 11
40%: 24.8	40%: 22.3	40%: 19.2	40%: 17	40%: 14.7
50%: 31.2	50%: 27.4	50%: 24.7	50%: 22.3	50%: 20
60%: 37.1	60%: 33.5	60%: 31	60%: 27.8	60%: 24.7
70%: 45.6	70%: 41.3	70%: 38.6	70%: 36	70%: 32
80%: 53.8	80%: 50.4	80%: 47.4	80%: 45	80%: 41
90%: 66	90%: 61.7	90%: 59.4	90%: 56	90%: 54.8
95%: 76	95%: 76	95%: 72	95%: 71	95%: 70
100%: 100	100%: 100	100%: 100	100%: 100	100%: 100

D-max 1.5	D-max 1.6	D-max 1.7	D-max 1.8
0%: 2.9	0%: 2.1	0%: 1.9	0%: 1
5%: 4.3	5%: 3.2	5%: 2.7	5%: 2.1
10%: 5.3	10%: 4.7	10%: 3.9	10%: 3.1
20%: 7	20%: 6.1	20%: 5.4	20%: 4.4
30%: 9.5	30%: 8.5	30%: 7	30%: 6
40%: 12.8	40%: 11.3	40%: 9.4	40%: 8.3
50%: 17.5	50%: 15.5	50%: 13	50%: 12
60%: 23.4	60%: 20.8	60%: 18.9	60%: 16.9
70%: 30.4	70%: 27.2	70%: 25.6	70%: 24
80%: 39	80%: 35	80%: 33.8	80%: 32.5
90%: 52.4	90%: 50	90%: 47.5	90%: 45
95%: 68	95%: 66	95%: 62	95%: 62
100%: 100	100%: 100	100%: 100	100%: 100

- Specify stochastic screening or 300-lpi linescreen. (Command-P does not do diffusion dither bitmap screening.)
- Output film requested as a negative with emulsion down.
- Confirm they can read your type of removable disk (SyQuest, Jaz, ZIP, etc.).

When you get the test negative with all twelve step scales on the one 8x10 negative, make a test print of it. You should standardize your printing with a single combination of paper, coating material, developer, contrast agent, etc., *because the curve you develop will be optimal for this single combination of materials only.* Determine the minimum exposure time to produce a pure black with the 100% step. Each test print should be exposed for this minimum time, and no longer.

I cannot emphasize enough the importance of standardizing your printing methods and minimizing the number of variables in your test system. There are enough variables in Photoshop and service bureau equipment to make this testing procedure very complex under the best of circumstances. Don't complicate matters further by fiddling with your printing methods halfway through the tests!

Evaluating your test prints of the digital step tablets
Look first at the 21-step tablet in your test print with 5% increments. Visually, there should be even gradation through all the steps. In particular, there should be good separation between the steps at the extremes of the tablet (0–5–10% and 90–95–100%). The tone of 0% should be absolutely white; compare it against uncoated paper to make sure that the step is white rather than light gray. The 50% step should be a neutral gray.

After you identify an acceptable 21-step tablet with 5% increments, inspect the negative that corresponds to that step scale. The extremities of the curve should be your main concern. Make sure that each individual step in the 0–20% and 80–100% 21-step tablets is different from its neighbors. You are looking for evidence of posterization, in which a few (or several) adjacent steps have identical density. Posterization usually isn't a problem in the 80–100% range but often occurs in 0–20% values when one of the more extreme correction curves has been used. If you have access to a densitometer, it can be quite helpful in confirming there is separation among values that may appear very similar by visual inspection. Posterization in an occasional pair of adjacent values probably won't be apparent with most negatives of real images, but any more than one or two pairs or triplets of adjacent steps with the same density will make a curve unacceptable for many processes.

You will notice that the highest D-max of the family of curves in figure 4 is 1.8. I realize that you may want a denser negative for some alternative processes;

Fine Tuning

You can consolidate values from several curves into a new test curve. For example, if the 0–20% range from one curve looks good, the 25–75% range from another is ideal, and the 80–100% from yet another is best for your process, you can construct a new curve using the optimal segments of each. In the Transfer Function box of Photoshop, simply use the numerical values for the preferred segment of each individual test curve (refer to the table in figure 4 for these values) and build your new test curve. After you've patched together these segments, visually inspect the new curve in the Transfer Function box to make sure that it is smooth, with no abrupt transitions; you may have to make minor adjustments to some of the thirteen data points to insure that the new curve is smooth.

If you have a flatbed scanner, scan the print of your ideal step tablet to use for reference in future testing. Comparing the electronic densities from scans of your test step tablet prints with those of your benchmark step tablet print takes much of the "judgment" and guesswork out of the testing procedure.

however, in my experience with imagesetters, posterization in the 0–20% range becomes a significant problem with D-maxes of 1.9 and higher if the DLog/E curve is relatively linear, like the ideal curve in figure 1. If possible, you should limit your D-max to 1.8 or less and use contrast-enhancing agents with your printing process to decrease the optical density you need in the negative.

If the print of the step tablet with 5% increments is visually satisfying and there is separation of most steps in the 0–20% and 80–100% negatives, you probably don't have to worry too much about the 25–75% range. As long as the extremities of the tonal range are satisfactory, the intermediate tones are usually acceptable.

Using the transmission densitometer to evaluate correction curves

If you know in advance the desired D/LogE curve of your digital negative (such as I have given for platinum/palladium in figure 1) and have access to a transmission densitometer, there is another method you can use to evaluate the test curves that is quicker and more precise than the method just described. I used this approach to develop the family of curves in figure 4. It is rather complex to explain, but is quite simple to do in practice.

- Make a digital step tablet with 101 segments, one for each Photoshop density value from 0–100%. Have your service bureau make a negative of this step tablet, with no correction curve applied.

- With a transmission densitometer, determine the optical density of each of the 101 steps in your digital negative, and make a table of these values similar to the one of the uncorrected imagesetter negative in figure 1, but use all 101 values, rather than just the forty-one given in the figure.
- Make another table giving the desired density of your negative at each of the thirteen set points in the Transfer Function box. For an example, refer to the ideal curve for platinum/palladium printing table in figure 1.
- Construct a new test correction curve based on a comparison of these two tables: For each of the thirteen set points in the new curve, find the density in the uncorrected curve that most closely matches the desired new value. For example, in figure 1, the ideal density for 30% is 1.25; the closest match in the uncorrected imagesetter curve is 1.23, at a Photoshop density of 7%. In the Transfer Function dialog box, use 7% as the new value for 30% in your new correction curve. Determine values for the other twelve set points in the same manner.

The slope of the uncorrected D/LogE curve is very steep in the 0–15% range, resulting in large changes in optical density for each 1% change in Photoshop density. Consequently, you may have to do some interpolation and guesswork to get the correct value for the densest areas in your new negative. In making interpolations, you can use decimal percentages (10.7%, etc.) in the Transfer Function dialog box.

- Apply your new correction curve to the standard step tablet (fig. 3), and have a digital negative made. With the transmission densitometer, measure the density at the thirteen set points to see how close you came to your desired curve. As I discussed above, make sure that there is only minimal posterization in the 0–20% and 80–100% segments of your test curves. You may have to make another generation or two of curves to fine-tune your correction curve.

I have given only a brief description of these calibration processes here. You can consult Dan Burkholder's book, one of the many Photoshop books, or your service bureau for more information about transfer functions, curves, and image-setters.

Making Digital Negatives Without Calibration Tests

I will be the first to admit that this curve construction and densitometry is a formidable task, and that many photographers want to minimize that sort of work. If you wish to go straight to making imagesetter negatives and bypass most of the calibration, here is how to do it:

1. Determine the appropriate D-max needed for negatives for your printing process. This is most easily done by making test prints using a conventional analog step tablet as your negative.

2. To test the Photoshop correction curves, choose an image that has good detail in both highlights and shadows. From figure 4, select the appropriate

curve for your optimum D-max and apply it to your test image. Then make additional images using four or five adjacent correction curves. Have digital negatives made for this set of images.

3. Make test prints of all these digital negatives to see which has the best contrast for your particular combination of paper and chemistry.

Conclusion

If you are just beginning to use computerized imaging, the learning curve is steep. I would compare the effort required to learn digital techniques to the task of mastering your chosen alternative process in the first place. For anyone who has a technical bent, which includes most of us working with alternative processes, learning digital techniques shouldn't be a problem. The biggest difficulty is the lack of information regarding the use of Photoshop with black-and-white materials; the Adobe manuals and the aftermarket books leave much to be desired. It is true that, with a little help, you can pick up the Photoshop basics pretty quickly; but the subtleties and tricks take a while to learn, especially if you're working by yourself.

Skeptics of the procedures I have detailed here point to the technical problems and high costs of digital methods, the necessities for software updates, planned obsolescence, and the like. At least for now, we are pushing the limits of the imagesetter to make good negatives for alternative processes, forcing the machine to do a task it was not designed to do; but no powerful and complex method is without its difficulties. I have had all sorts of technical snags with my digital work, but they are no worse than the troubles I have making platinum/palladium printing work in a consistent manner. Take, for example, the problems created by paper manufacturers. Talk about planned obsolescence! Just when you think you've found the perfect paper, they change it without telling you, and you are once again looking for a new one.

Despite the acknowledged difficulties in applying digital methods to alternative processes, is it worth the trouble? Absolutely! When everything is working, my digital platinum/palladium prints are indistinguishable from conventional platinum/palladium prints. Most importantly, we should not forget what attracted us to computerized imagery in the first place: digital techniques provide control and freedom that are simply unimaginable with conventional methods.

Sam Wang, Kudzu Window, 1995. *Gum/cyanotype print from digital negatives.*

Chapter 18 Three-Color Gum Prints Using Digital Negatives

Sam Wang

Process Overview

This process varies from the traditional method of three-color gum printing in two significant ways:

- The cyan image is formed not by the gum process but by cyanotype.
- Digitally generated separation negatives are used for printing instead of continuous-tone silver separations.

This method has several significant advantages when compared to the traditional method. The image has more apparent sharpness, fewer printings are required to produce a final image, registration can be done by eye, and exposures are much more forgiving with digital negatives than with continuous-tone negatives. Three-color gum/cyanotype printing is a process rife with potential for new and expressive ways to render an image.

Very early texts on color printing contain many references to the use of cyanotype for the cyan layer in three-color subtractive printing. See, for example, E. J. Wallis's *The History of Three-Color Photography*. I don't know when cyanotype was first used in combination with yellow and magenta gum printing to make full-color images, but I am fairly certain that I am not the first to have done it. I am, however, to the best of my knowledge, the first to have produced an extensive body of artistic work with three-color gum/cyanotype, and the first to have used the process in combination with digitally produced separations.

Although the basic method of gum printing is relatively simple and straightforward, traditional tri-color gum is a rather daunting process that

requires a balanced set of color-separation negatives made in-camera or under the enlarger. With the digital revolution, much has changed. Since the middle of the 1980s, personal computers have become increasingly powerful and less expensive, and digital imaging has begun to take over much of the role of traditional photography. Digitally produced negatives are rapidly replacing traditional negatives, although their widespread use is slowed by the shortage of reasonably priced, high-resolution output devices. Some of the advantages of using digital negatives are these:

- Original images may be made with relatively small cameras. This frees the photographer from carrying large and heavy equipment, thereby allowing the capture of images with greater spontaneity.
- Mistakes can be corrected; no more dust spots or scratches.
- Portions of images can be darkened, lightened, blurred, or sharpened where needed. This is not unlike the dodging and burning one does in the traditional darkroom, but there is far greater flexibility and power.
- Negative density range can be tailor-made to the specific requirement of the printing process.
- Because of their extremely clear film base, digital negatives require very short printing times and are more tolerant of exposure errors. Details do not block up as easily with overexposure.

In alternative processes we search for ways to retain a certain degree of photographic realism while flaunting a spontaneous semi-controlled hand-made freshness. The cyanotype/gum print made with digital separation negatives allows us to achieve this particularly well, due to the flexibility of the digital process and the high definition of the cyanotype base.

What You Will Need

Chemicals

- Ferric ammonium citrate (green)
- Potassium ferricyanide
- Gum arabic
- Ammonium or potassium dichromate
- Pigments
- Thymol
- Rubbing alcohol (91%)

Materials

- Contact printing frame
- Trays for developing
- Brush (hake)

Paper

Rives Heavy Weight works well for the cyanotype/gum combination; it was used in all the example images shown in this chapter. It has a fairly smooth surface and is well sized, allowing it to withstand several soakings. Preshrink the paper by soaking it in hot ($120°$F–$135°$F) water for at least twenty minutes, then hang it up to dry before use.

Safelight

Low-level tungsten

Digital Negatives

There are four main categories of digitally produced negatives available for photographic processes:

- High-resolution film output from an imagesetter
- Extremely high-resolution output from a film recorder
- Output from a high-resolution inkjet printer (Iris printer, for example)
- Output from a low-resolution laser or inkjet printer

The resolution of the first three categories of printers is fine enough to be nearly continuous-tone, while the consumer-quality laser and inkjet outputs give very grainy dot structure, which may be a desirable quality in some cases. Procedures for producing digital negatives are described in the previous chapter, Digital Negatives for Alternative Processes.

Source Images

One can input images for digital manipulations from many sources. Direct capture of images with digital cameras is a real possibility, although such cameras capable of 35mm film quality are not yet available at a reasonable cost. Snapshot-quality digital cameras are readily available, however. Flatbed and slide scanners can be used to produce very good-quality scans from color prints and 35mm slides. Even better quality is obtained from images scanned by professional drum scanners. Short of that, the Kodak PhotoCD and the PRO

PhotoCD are the best overall ways to obtain high-quality scans at reasonable prices. Kodak PhotoCDs and Pro PhotoCDs are merely CDs onto which digitized images have been copied. These can be produced from negatives and transparencies, varying in size from 35mm to 4x5. The service is widely available through large photofinishing services and photographic laboratories.

The Service Bureau

If output is to be done through an imagesetter, it is necessary to work with the service bureau from the beginning: find out about file formats, resolution of the imagesetter, and submission procedures (see Chapter 17).

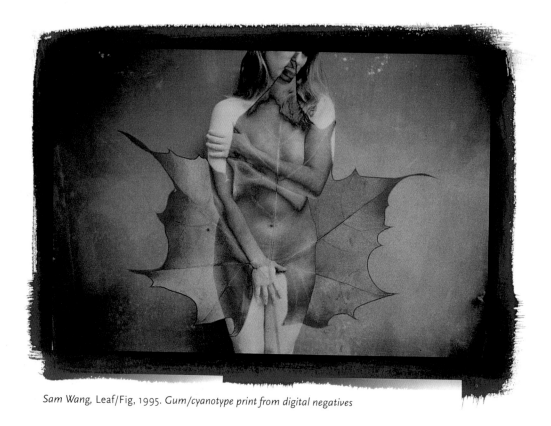

Sam Wang, Leaf/Fig, 1995. *Gum/cyanotype print from digital negatives*

The Computer and Software

Most color-capable computers today are adequate for manipulating images for digital output. For artists, Apple Macintosh computers have always served as the best graphics workhorse, with Adobe Photoshop the principal image-editing software. Today, Photoshop runs just as well on a Windows-based machine. The speed of the computer is less important than its memory. A minimum configuration would include 32 MB RAM, a 1 GB hard drive, and a monitor capable of 16- or 24-bit color. Some type of removable, high-capacity storage device, such as an Iomega ZIP drive, is essential to transport files to a service bureau for output. However, more and more service bureaus make use of electronic connections, with which one can easily send files by direct modem connection, or the Internet, using File Transfer Protocol (FTP). Either technique eliminates the need for the removable storage devices for transporting files.

Calibration

Although tri-color gum printing is far from a science, it is nevertheless helpful to lock down some key variables. One of these is the calibration of the computer monitor. Uncalibrated, monitors vary greatly in terms of color and brightness. Before doing any serious image editing, you should calibrate the monitor for your working environment using the Gamma Control Panel Device that comes with Adobe Photoshop. The various procedures for image preparation are based on the presumption that the reader has a working knowledge of Photoshop. If you do not, the Photoshop manual will explain the specifics of the program. What is presented in this chapter is a refined method for calibrating and using Photoshop to prepare appropriate separation negatives for three-color cyanotype/gum image making.

Image Preparation

Color images are edited as RGB files. In all likelihood, the density and contrast of the image will need adjustment. Called Gamma Correction, this is best carried out using the Levels tool. Place the extremes of the image's density at optimal levels, and move the mid-range tones to appropriate values.

The next step is to color-correct the image using the Color Balance tool. First, check the balance of the three primary colors with the Get Info sampling tool, because tints on the monitor are often not discernible to the untrained eye.

In addition to balancing the colors, it is sometimes advisable to make them slightly more saturated than they normally appear, since the gum process often subdues the saturation. This is done with the Hue/Saturation tool (Image > Adjust > Hue/Saturation). After you've decided which colors need emphasis, adjusting their saturation is easy.

With the computer, you can go far beyond simple corrections and make all kinds of alterations, from increasing the intensity of the blue sky to taking a few pounds off somebody's waist. This capability introduces ethical issues, which will be covered here only with the remark that gum is not a process for objective portrayal; it is much too poetic a medium. What determines appropriate action, then, is the printmaker's taste.

Once the image looks good on the screen, the next step is to check for size. Go to Image Size and examine the size and resolution settings. The two are interrelated. In general, resolution will be decreased if the size is increased. However, Photoshop does some smoothing of details when image sizes are increased. The size of the final image is obviously limited by the sizes available to the output device you are using. With imagesetters, size is usually limited to 22" wide by any length. With most consumer-grade laser and inkjet printers, the only way to go beyond letter size (8½" x 11") is to tile the sheets. Resolutions higher than 300 dpi are usually not necessary for gum negatives, and will only slow down the computer.

Separations

After you prepare the image, you need to separate it into the RBG channels. Open the Channels window, click on the Options arrow in the upper-right corner, and select Split Channels. Photoshop will automatically separate the image into grayscale versions of the R, G, and B channels; the original image window will close.

All that is necessary at this point is to invert the image from positive to negative and flip it horizontally. You are then ready to output your negatives by any of the following methods.

Output of the Negatives

Inkjet Printer

Print each of the channels separately on appropriate inkjet transparency material. Make certain that the printing is done at the heavier inking position—at the Transparency or Best Quality setting—or the density may be too low. These become your separation negatives:

- The R channel will be used to print the cyanotype layer.
- The G channel will be used to print the red color emulsion.
- The B channel will be used to print the yellow color emulsion.

Regardless of the method you use to output your separation negatives, you should always print your negatives according to the above relationships—assuming you want realistic color renditions. Of course, these rules—and many of the rules in this book—can be bent or broken entirely with interesting results, and the reader is encouraged to do so.

Laser Printer

Most laser printers use PostScript to translate the gray scale into halftones. However, the lpi (lines per inch) will be unacceptably low, and the halftone will resemble coarse newspaper printing. Since the printer's dpi (dots per inch) is at least 300, the basic dot is small enough to be used to form bitmap dots.

To prepare the image for output to a laser printer using a random dot pattern, first adjust the curves. With a 300-dpi laser printer, the dots are spaced at 300 to an inch; but since each dot is larger than 1/300 of an inch, the extra size needs to be compensated for. This compensation for dot gain is done by moving the middle of the curve to get a lighter printout in the mid-tones. After adjustment, each separate channel is converted to Diffusion Dither under the Mode change to Bitmap. Since it may not be possible to print 300 dpi dots smoothly on transparency material on a 300-dpi laser printer, try halving the printer's resolution: use 150 dpi dots on a 300-dpi printer, for example. Output these to transparency material tailored for laser printers. The age of the printer has a lot to do with how cleanly it can print on a transparency.

Film Recorder

The highest film resolution—that offering virtually pixel-free images output on traditional black-and-white film—is possible only from a film recorder. Negatives output this way can be enlarged to very high magnifications, but the

cost is extremely high. A typical 4x5 Tmax 100 output from a 20 MB file can run anywhere from $35 to $95, depending on the service bureau used. Most service bureaus also have extra charges for files over 20 MB.

Considering that the gum process, and in fact nearly all the processes in this book, are contact processes and the finished image is only as big as the negative used to print it, a small 4x5 negative at these prices is a waste of money. Besides, imagesetter negatives, although technically not as high a resolution, are virtually indistinguishable from film recorder negatives when contact printed.

Imagesetter

Imagesetters are high-resolution machines that produce camera-ready paper prints or plate-ready film negatives. The resolution runs from 1200 dpi to 4800 dpi. They generate halftones from grayscale sources in one of two ways, by amplitude modulation (AM) or frequency modulation (FM).

AM is the conventional, highly regular way of forming halftones, with the frequency of dot clumps specified as lpi (lines per inch). FM (frequency modulation), also called stochastic screening, can be generated from within Photoshop (Diffusion Dither) or by the service bureau. The patterns are formed by random dots, which appear less mechanical and do not produce regular-looking clumps when different colors are printed on top of one another. Before preparing your files for output, consult your service bureau to see if they offer stochastic screening, and make use of it if they do.

The procedure to create your own Photoshop-generated FM screened files for imagesetter output is similar to that for laser output, but it is not as necessary to adjust for dot gain. It is, however, necessary to adjust the curves for a density range that fits the gum process. Below is a chart of curve-adjustment settings that give good results in gum printing, a reversed S-curve with a straight center portion. You can produce it by entering in the key points and using the smoothing function of Photoshop to iron out the irregularities.

Input	4	11	88	94
Output	11	18	81	87

Split the channels of the image, and for each channel change the Image Mode to Bitmap, using Diffusion Dither, with output resolution placed at 635 ppi (pixels per inch). This is exactly half of the lowest imagesetter resolution, 1270 dpi; it is fine enough to appear smooth in the image, with the file size small enough for easy handling.

Teresa Van Hatten, Longitude. *Gum/cyanotype print from digital negatives.*

When you deliver your files to the service bureau, include these instructions:

- Exact size output to film
- Positive emulsion side up
- No crop marks
- Do not halftone

Printing

Traditional tri-color gum prints are made with multiple coatings of gum arabic solution with primary color pigments added. The solution is sensitized by the addition of ammonium or potassium dichromate. The first layer of emulsion is

applied by brush on gelatin-sized paper and dried; the image is then exposed, developed, and dried before another coat is applied. With this method, it is not unusual to build up the density with dozens of coatings, with the results resembling varnished oil paintings. My method utilizes cyanotype for the blue and blue-black, and plain paper without additional sizing. My motto: life is short; why add sizing unless you must? Cyanotype gives a very sharp and defined image, and this makes it easy to register by eye for successive printings. The use of a cyanotype layer also helps to keep the overall thickness of the gum down to a minimum, giving the final image a fresher, more watercolor-like feel.

Mixing the Gum Solution

Gum 14, used by the graphic arts industry, is suitable for use. However, I prefer making a thicker stock solution by dissolving one part gum acacia granules to two parts water (essentially producing gum arabic), and adding one drop of 100% thymol/alcohol per 5 ounces of gum solution to preserve it.

To make a 100% thymol/alcohol solution, dissolve 10 grams thymol into 10 cc of 91% rubbing alcohol.

Pigment

High-grade watercolors in yellow and red work fine. Pure pigments in aqueous dispersions from other sources can also be used, as can powder pigments.

Printing the Cyanotype Layer

Solution A (ferric ammonium citrate) sometimes forms a layer of mold during storage. This is not harmful to the process; simply filter before use with a paper coffee filter or piece of cheesecloth.

1. Dissolve 50 g of ferric ammonium citrate (green powder) into 250 cc of distilled water, and mix thoroughly. This is solution A.

2. Dissolve 25 g of potassium ferricyanide into 250 cc distilled water, and mix thoroughly. This is solution B.

3. Mix equal amounts of the A and B cyanotype solutions together. Fifteen cc of each makes enough solution to coat four or five prints with an image area of about 8x10.

4. Spread the cyanotype mixture rapidly over the paper. I use a 3" hake brush. These vary a great deal in quality and hair type. The best brush for coating the cyanotype solution is one with springy hair that does not soak up the solution too readily. Cheap foam brushes are prone to abrade the paper surface, and I do not recommend their use. Also avoid too thick a coating and prolonged brushing. Carry out the coating operation in subdued daylight or under weak tungsten lighting.

5. Hang the coated paper to dry in the dark. Use of a warm hair dryer to blow dry the paper is usually not necessary, and in my experience it may contribute to unevenness. Coated cyanotype paper does not keep well and needs to be printed within several hours.

6. Place the paper in contact with the cyan printer (the R channel negative) and expose. Exposure with a NUARC N750 Mercury Printer takes between two and four minutes. If you are not using a contact printing frame, a sheet of glass will ensure contact.

7. Place the exposed paper in a tray of water for clearing. Clearing is carried out by soaking the paper in three successive trays of water, for about five minutes each. Trays of water are preferred over a running-water bath in order to monitor the pH (acidity) of the water. Running water, which can be extremely alkaline, can bleach cyanotype. The addition of a few drops of 28% acetic acid to the clearing water baths will insure against its becoming too alkaline.

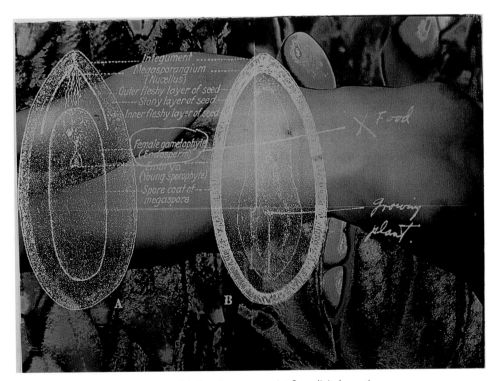

Teresa Van Hatten, Nature/Nurture IV. *Gum/cyanotype print from digital negatives.*

8. At the end of the last soak, rinse the print gently with running water and hang it up to dry.

Printing the Yellow and Magenta Gum Layers

After the print with the cyanotype image is thoroughly dry, it is ready to be printed with the gum colors. I prefer to print yellow first, then the magenta.

1. Measure a small amount of stock solution gum and dilute it with an equal amount of water.

2. Stir in a small amount of yellow pigment.

3. Test brush this onto a scrap piece of Rives paper. Add more pigment as needed until the color is about as deep as the primary-color strips on the edges of newspapers.

4. Stir in ammonium dichromate, at the rate of .25 g to 10 cc of gum/pigment mixture. Measuring such a small quantity of dry chemical can be difficult. Here is my method: make your own measuring instrument by drilling a 1/4" hole in a small piece of 1/4"-thick acrylic; adhere a thin piece of acrylic sheet backing to one side, and you have a homemade spoon that measures approximately .25 g of dichromate.

5. The coating and drying processes are similar to that of the cyanotype. Do all coating in subdued daylight or low-level tungsten light; dry each sheet in the dark.

6. Register the paper and B channel negative visually by aligning the negative with the blue image.

7. Working in subdued daylight or under tungsten lighting, expose the print with a UV light source. Typical exposures with a NUARC N750 Mercury Printer will range from one to five minutes depending on negative density.

Printing a digital negative is different from printing a conventional one. The digital negative is very forgiving in exposure in terms of showing details; however, the amount of exposure will determine the thickness of the emulsion that is hardened on the print.

8. Develop the image by floating the print facedown in three successive trays of water at room temperature for ten minutes each. Then hang it up to dry.

9. Repeat the previous procedure using red pigment and the B channel negative.

After the magenta image is printed you have a color-balanced print, provided all went well. Most likely, however, one of the colors will be too light, and that will necessitate a reprint of that color. Also, the blue from the cyan-

otype can become too dark when it comes in contact with the dichromate, so another printing in gum with the magenta or yellow pigment may be necessary to achieve better color balance and richness.

Tri-color gum printing is neither an exact science nor a way to obtain precise and highly realistic details. Many mishaps can occur along the way, and not all of them are necessarily happy accidents. The nice thing is that, once in a while, you get a print that sings in ways that go beyond description. That is the high that keeps a gum printer going, in spite of the wastebasket full of failures one frequently gets. The digital negative simply increases one's control somewhat and allows the process to become a useful tool, not a constant struggle. What a print has to have in order to be more than just another colorful rendition, however, is not based so much on technical finesse but on the poetic and artistic power of suggestion that resides therein.

Storage

Completed cyanotype/gum prints may be displayed in bright lights for extended periods of time. The pigment used is very resistant to light-fading; however, the cyanotype blue may fade a little with prolonged exposure. This effect can be reversed by storing the print in the dark, although there is no definitive information at this time about whether the color is completely restored. The more serious concern is the fact that cyanotype can be bleached when stored in a highly buffered, or strongly alkaline, environment. Prints should therefore be matted with unbuffered boards.

John Barnier, Bowl of Pumpkins. *Argyrotype.*

Chapter 19 Using Step Scales

John Barnier

Process Overview

A step scale—interchangeably known as a step tablet, step guide, exposure guide, transmission step guide, or step wedge—is an invaluable tool with most alternative photo processes. Some processes in this book, such as daguerreotype, collodion negatives, calotype negatives, tintypes, and ambrotypes, produce camera-direct images and thus do not rely on negatives in the usual manner. Step scales are therefore irrelevant for them.

A step scale is a piece of film that is marked off in twenty-one equal steps of increasing density, each step representing about one-half stop of density. By learning a few basic techniques for using a step scale, you will be able to:

- Establish standard printing times for each process in which you work.
- Gauge minimum printing times for each negative from which you wish to print.
- Judge the suitability of each paper you wish to use.
- Judge the quality of your chemistry and determine if it is old, oxidized, or otherwise no good.
- Judge the contrast range of various negatives.
- Determine the effects of various toning combinations.
- Determine the contrast range of various papers with different processes.
- Determine the contrast of sensitizers.
- Judge exposure and development variables with the internegative/interpositive method of making enlarged negatives.
- Resolve such other matters as assessing the need for double-coating or additives and making other subtle adjustments to chemistry or procedures.

This chapter focuses on two of these uses for step scales, establishing standard printing times and using a step scale in making enlarged negatives. Suggestions are also made as to how some of the other uses above apply to alternative photographic processes. With experience, you may be able to discover other adaptations that will make your work easier.

I recommend that you buy at least two step scales: one 4" x 5" and one ½" x 5" strip, each with twenty-one steps. If you make enlarged negatives using the internegative/interpositive method, you may want a 2¼" x 2¼" scale as well. All these step scales can be purchased inexpensively (see figs. 1 and 2).

Establishing a Standard Minimum Printing Time

Remember: *These tests work only if you use a consistent combination of materials.* In other words, if you use more than one process, or different variables within a process, such as different papers or different contrast additives, you will have to make a separate test for *each* combination.

First, establish a standard minimum printing time for each set of variables you will use. Do this by printing a 4" x 5" step scale for the minimum amount of time it takes to get a full black in the second clearest part of the step scale—step 2. In other words, you want the exposure to render steps 1 and 2 full black, but step 3 should be slightly lighter than step 2. Step 2 is used as the benchmark because without having another step to compare it to (step 1), you wouldn't know if it was *completely* black. By keeping the full-black areas as low on the scale as possible—the minimum exposure time necessary—you will have the optimum number of steps on the scale available for accurate assessments. With some long-scale processes, like argyrotype and platinum/palladium, you will need as many steps as possible to gauge their complete range accurately.

Fig. 1. *Stouffer step scales, ½" x 5" and 2¼" square. See fig. 2 for the 4" x 5" version.*

Procedures

The instructions below outline the general procedure for establishing the minimum printing time for any alternative photographic process. However, to illustrate the importance of controlling the variables while determining this exposure time, I am giving the specific steps I follow to determine the printing time for argyrotype prints. One standard set of variables I use is to make the prints on Whatman's printmaking paper, using fifteen drops of sensitizer for a taped-off 4x5 image, air-dried (relative humidity at about 65%) with no extra humidification or toning. The sensitized paper is then printed in a contact frame made by Doug Kennedy, using my small Palladio Company UV light source. My other contact printing frames require different times because of the specific glass or Plexiglas in the frame.

Making the first test print

1. Coat the paper with fifteen drops of standard argyrotype sensitizer, in an area taped off with drafting tape to a perfect 4x5 space. Using tape restricts the sensitizer to a constant area.

2. Air-dry for two hours.

3. Tape the 4" x 5" step scale against the sensitized and dry area of the paper (emulsion to emulsion). Place a black card against the step scale, covering all but about 1", perpendicular to the steps on the scale. Lay this sandwich into the contact frame, card against the glass, and close the frame.

4. Expose for two minutes.

5. Open the frame, move the card down to reveal an additional 1", close the frame, and expose for another two minutes.

6. Repeat this sequence until the entire step scale has been exposed.

7. Process and dry this test strip normally. It is important to dry the print completely—you can use a hair dryer if you want—otherwise the test won't be valid. Each make and type of paper dries down—gets darker—to different degrees, so even if a print looks perfect while wet, it will look completely different after it has dried down.

When I performed this test, I determined that I reached maximum black in six minutes. I inspected the test strips and found the one in which step 1 was. Step 1 was completely black, and 2 was also completely black. Step 3 was slightly lighter than step 2. Since this step received a six-minute exposure, that is the benchmark from which I made the next print.

Remember, these times will vary with your materials, under your conditions. You may need to expose your strips for one minute, five minutes, or even ten minutes.

The reason for doing the second print is that this first print will give you a good idea of what your minimum printing time will be, but it may not be the perfect time. Because you are turning your light source on and off, there may be a startup factor involved that has an effect on accurate time assessments. One four-minute exposure will probably be different from four one-minute exposures, depending on how quickly your light source comes to full power each time it's turned on.

Making the second test print

1. Sensitize and dry the paper as above, and insert the step scale and sensitized paper into the contact frame. Do not include the black card.
2. Expose for six minutes (the benchmark time from above).
3. Process and dry the print completely.
4. Again examine the print to see if steps 1 and 2 are completely black, and that step 3 is slightly lighter than step 2 (see fig. 2). If it is, six minutes is the correct minimum standard printing time with the variables listed above. If not, a third print is necessary to fine-tune the time.

Making the third test print

If your second test print is either darker or lighter than the benchmark print, simply adjust the exposure for the third print accordingly. If it was too light, add a minute or two to the exposure; if it was too dark, reduce it by a minute or two. This third print will usually need only a one- or two-minute difference in exposure; from my experience, you will usually need to reduce your time.

Analyzing Test Results

By fine-tuning your materials in this way, you will save a lot in subsequent time and materials. In addition, by looking at the final print of your step scale, you can assess a number of the image characteristics the variables you have selected yield in your chosen process. Of course, if this inspection leads to significant changes in your variables, you will need to repeat the test for minimum exposure time.

The basic suitability of the paper for the given process
- Is it mottled or unevenly coated?
- Does it show dark spots or other marks?
- Does the surface have little white specks or other areas that seem to have fallen away?
- Does the surface seem grainy or generally not smooth?
- Are translucent spots showing in the lighter steps?
- Is there any other evidence of the sensitizer sloughing off—like staining around the edges?

Quality of the sensitizer
- Is the image smooth or grainy?
- Does it fully achieve a deep black, or does it seem weak?
- In the case of cyanotype, is the blue color rich and deep where it should be?
- Is the image too flat or needing extraordinarily long exposure times?

Contrast of the sensitizer
By counting the number of visible steps, you can gauge contrast: the more steps visible, the lower the contrast (or the longer the scale); the fewer steps visible, the higher the contrast (or the shorter the scale).

Contrast of the paper
Different papers render images with different contrast. One process may have a longer scale on one paper, but a shorter scale on another, all other variables being equal. Also, what may be a short-scale paper for one process may be the opposite for another.

Contrast range of your negatives
By using a set of white cards and a light table (see White Cards, page 258), and comparing steps on the scale with areas on your negatives, you can determine the contrast range of those negatives.

Exposure time for various negatives
By comparing certain steps on your step scale to areas within your negatives (see White Cards, page 258), you will know how long to print for those values in the future, assuming you maintain similar conditions to those in your test.

Fig. 2. *A Stouffer 4" x 5" step scale printed to the minimum time needed to reach maximum black (this scale includes a ¹/₂" x 5" version as well). The final time was six minutes. The first step to show detail before processing was step #14. After processing and thorough drying, the step scale revealed, for one thing, that I get a 16-step range—or 8-stop range—of contrast with argyrotype on Whatman's Fineprint paper, with a printing time of six minutes. Note that the tonal details are quite delicate in the actual print, and showing this range in a reproduction is nearly impossible.*

White Cards

Having a densitometer to calibrate the exact density values of your negatives is nice, but not necessary. In fact, you can establish very accurate negative densities with nothing more than a light table, two white 4" x 5" cards, a step scale, and a hand-held office punch. In this procedure, you will compare densities between your step scale and your negatives to gauge the following:

- Contrast ranges of your negatives
- Whether or not your negatives have too little or too much contrast for a given process
- Particular densities within your negatives
- Specific areas of your negatives in which you want to render a certain tone

Although you might assume this method to be too crude to be accurate, quite the opposite is true. The human eye has a remarkable ability to distinguish many more subtle shades of gray than any film can record. After using the cards a few times, you will be in control of your procedures in a confident and informed way.

Procedure

1. Punch a hole in the middle of a long edge of each card (see fig. 3).
2. On the light table, place one of the white cards over the first step on the scale that produced true black in your test print. For the sake of this example, let's say that was step 2. Although not absolutely necessary, I also suggest that you have pieces of black card or black paper on hand to place around the cards to block flare from the light table.
3. Place one of your negatives on the light table next to the step scale, and move the hole in the other white card over the negative until you can match a similar tone to the one that produced true black in the test. Make a note that this area is step 2.
4. Do this over various areas of your negative, noting which areas match which steps. *Make sure to include both the highest and the lowest densities in your measurements.*

Remember, each step on the step scale is roughly equivalent to ½ stop of exposure.

Fig. 3. *Using punched white cards to compare negative and step-scale densities on a light table.*

Analyzing the relationship

I already know, based on my earlier tests, that with my minimum printing time for argyrotype prints of six minutes, I will have a sixteen-step (or eight-*stop*) range of tones, with highlights showing details as high as step 14 after processing (assuming I keep all variables equal to the tests), and step 16 after processing and dry down. Now, knowing how the steps in the step scale render under those variables, and before ever making a print, I can match similar densities in any of my negatives and be reasonably confident that they will print with similar tones. Comparing my negatives to the step scale also gives me invaluable information on whether I need to adjust my current film exposure or development procedures. When analyzing your own tests, remember the old saying: "Expose for the shadows, develop for the highlights." In other words, if the shadows print too dark in the test, give more exposure to the film when making the exposures; if the highlights print too dark, develop the film longer. This fine-tuning of your materials will give you much more reliable negatives.

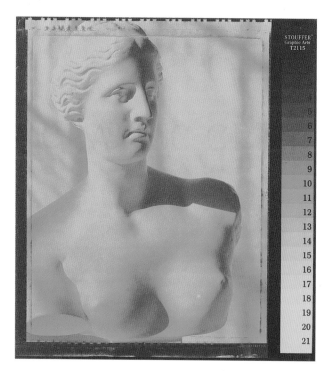 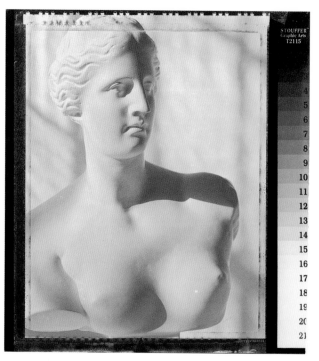

Fig. 4. *Argyrotype print after exposure (left) and after processing and drying (right) showing increase in highlight density due to dry-down effect.*

Making a Print

At this point, all the real work is done. You should be able to make a good print, easily within range of your target, with just one exposure. This assumes, of course, that your variables when printing are exactly the same as your tests.

In the example in figure 4, I learned with the white-card procedure that the highlights on the shoulder of the plaster cast were equivalent to step 16 on my step scale. I also know that, using argyrotype under these parameters, I can expect the final image to dry down darker by two steps on the step scale. Therefore I expose the scale until I get hints of detail in step 16 (fig. 4, left) knowing it will dry down to step 14 (fig. 4, right) .

Step Scales for Enlarged Negatives

If you make enlarged negatives with the interpositive/internegative method, a step scale can be a handy tool. If you know what density range works best for a given process, you can use the step scale to expose and develop your film to reach that density range for both the interpositive and the internegative.

(See Chapter 20, Enlarged Negatives, for particular procedures in the interpositive/internegative method.) Then, using those procedures as a guide, simply insert a step scale in your enlarger in place of a camera negative to establish the correct contrast range for each step.

Your goal is an enlarged step scale image that prints as closely as possible to the contrast and depth of the original step scale from which it is enlarged. Knowing the parameters that led to that successful print, and using the white card technique of gauging film densities, you can calibrate camera negatives to the same results. Note that you will have to do these procedures for every process you print.

Procedure

1. Make a correctly exposed and developed sheet of interpositive film in your normal manner, except instead of exposing the film through a camera negative, expose it through a step scale. Use whatever size step scale you normally use for your camera negative, i.e., 35mm scale if you usually make enlarged negatives from 35mm camera negatives; 4x5 scale if you usually make enlarged negatives from 4x5 camera negatives, etc.

2. Place the finished interpositive step scale into the enlarger and make the corresponding enlarged negative, using your usual developing methods. Adjust your exposure and development if necessary until your enlarged negative step densities match as closely as possible the steps in the original scale.

3. Once the parameters for correctly exposed and developed interpositives/internegatives using a step scale have been established, compare the densities of the step scale to those negatives you wish to enlarge and make careful note of them. Knowing how certain densities in the step scale translate to the final print will help you determine how those densities in the negative will print.

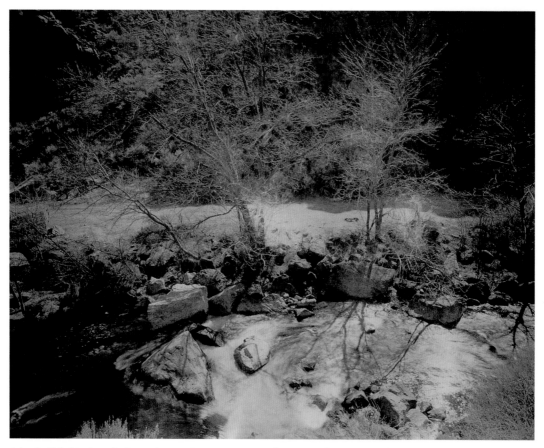

John Rudiak, Rio Grande Gorge Stream, Taos, NM, 1992. *Platinum/palladium print from an enlarged negative.*

Chapter 20 Enlarged Negatives

John Rudiak

Process Overview

The vast majority of historical and/or alternative photographic printing processes are contact printing processes, which means that the negative must be as large as the print we wish to make. The emulsions and sensitizers used are very slow compared to normal silver gelatin developing-out printing papers. They are also usually insensitive to visible light and must be exposed to sources rich in ultraviolet radiation, so conventional enlarging is impractical.

Alternative processes have different requirements for the optimal negative used. Since it is rare to have one negative work for a number of different print-making processes, becoming a skilled negative maker is essential. Since print qualities are dictated by the qualities of the negative, the importance of making the best negative possible cannot be overlooked.

Although there are several methods for making enlarged negatives (direct duplicating film, rephotographing a print with a larger camera, reversal processing of negative film, etc.), the method that affords us the most control is to make a film interpositive first and to use that to generate the enlarged negative. This gives us two opportunities to choose film, to adjust contrast and density, and to dodge, burn, and retouch while getting to the final negative. It can be argued that, with this method, we are working with a second-generation copy with the attendant loss of information; but by generating either the positive or negative through contact, the losses are significantly minimized.

Normally, the interpositive is made in contact with the camera negative and then enlarged to make the final negative. There are some situations, however, where using a film interpositive the same size as the final negative is

advantageous. If the original negative is smaller than 4x5, generating the positive by contact (to avoid going through two enlargements with attendant loss of quality) to arrive at the final negative will result in grain from the positive influencing quality of the negative due to the degree of enlargement. To make an 8x10 or larger negative from a 35mm original, it is better to make an 8x10 or larger positive and contact that to make the negative. Another situation would be if the original negative were larger than 8x10.

What You Will Need

Chemicals

- Kodak HC-110 film developer
- Kodak D-19 film developer
- Kodak D-11 film developer
- Kodak D-8 film developer
- Ilford Ilfotech film developer
- Standard acid stop bath (glacial acetic, indicator, Sprint, etc.)
- Standard fixer, regular or rapid
- Washing aid, such as Kodak Hypo Clear
- Kodak Photo Flo

Materials

In addition to the standard equipment found in any darkroom, it is a good idea to have the following:

- Jobo drum processor, BTZS tube processing system or equivalent
- Electronic enlarging timer
- Voltage stabilizer

Optional

- New coccine
- Retouching pencils
- Kodak Abrasive Reducer
- Opaqueing fluid

Film

- Ilford Commercial Ortho Plus
- Kodak 4125 Professional Copy
- Kodak TMAX 100
- Photo Warehouse Fine Grained Positive
- Photo Warehouse 125 Pan film

Safelight

Preferably none; otherwise dark red, light red, or OC, depending upon the film used.

John Rudiak, Skulls, Llano Quemado, NM, 1991.
Platinum/palladium print from an enlarged negative.

Basic Procedures

The technique for making an enlarged negative is straightforward, but care must be taken throughout for best results, beginning with producing the original camera negative. A long-scaled negative, with full detail in both the shadows and the highlights, is the least troublesome negative from which to begin. The interpositive is first made from the camera negative, and the final enlarged negative is generated from the interpositive. Be sure to follow careful and complete film processing procedures at each stage.

Enlarger and Darkroom Preparation

The equipment and laboratory needed to generate enlarged negatives are the same as those used for conventional silver printing, but the degree of precision must be elevated. Since the materials used are much more sensitive than store-bought photo paper, modifications have to be made to the working environment. As a bonus, these changes will only improve the efficiency of the lab for all photo work. Because you will be using film materials, the darkroom becomes analogous to the inside of a camera with you walking around in it, and stray light that we would not notice under bright safelights poses a very real threat of fogging.

If the darkroom is light-tight enough to load fast film without fogging it, you can turn your attention to the enlarger. Every enlarger I have seen leaks enough light to fog film, so you need to plug up these leaks before exposing any film. Put a lens cap on the enlarging lens, insert a negative carrier, turn out the room lights, and wait a few minutes for your eyes to adjust; then turn on the enlarger. All that light hitting the walls, ceiling, and you is non–image forming, light that will fog and must be eliminated. Velcro and strips of black cloth are very helpful here. Once the enlarger's light leaks are plugged up, put a piece of white paper in the easel, take off the lens cap, open the lens, darken the room, and turn on the enlarger. The light now illuminating the walls, ceiling, and you is caused by bounce from the easel, and it will fall back onto the film and fog it. Paint the walls and ceiling around the enlarger a very dark gray (black seems too depressing) and wear a black shirt when enlarging negatives. Some of the films you use may not have an antihalation backing on them, so paint your easel flat black.

There are some other situations in your lab that need attention to make the transition from silver printing to negative making. Consistency is essential if you want to reproduce results, or make changes to contrast and density in a predictable manner. A voltage stabilizer to control the current going to the timer and enlarger is well worth the investment. Even if your lab is on a separate circuit from the fuse box so that the refrigerator in the next room kicking on during an exposure doesn't affect the light output, there is enough normal line fluctuation from the electric company to affect exposures noticeably. Electronic timers are much more consistent than their mechanical counterparts, so their use is highly recommended. Sometimes it is desirable to make changes in exposure of fractions of a second, and this is not possible with a mechanical timer. A light integrator like the Metrolux, which controls exposure by measuring the total amount of light falling on the print, represents the utmost in consistency.

Enlarging Lens

While on the subject of the enlarger, let's turn our attention to the lens. The films you will be using are much faster than enlarging paper, so exposure times are naturally shorter and the light intensity will have to be reduced. Simply stopping down the lens to f/22 or smaller is not the answer since high-quality enlarging lenses are sharper at wider apertures due to the effects of diffraction. You can check this by putting a negative in the enlarger and examining the grain with a high-quality grain magnifier (focusing aid). Start with the lens wide open and notice how crisp the edges of the grain appear. Slowly stop down the lens and watch what happens to the crispness of the grain; at about f/11 you should begin to notice a loss of sharpness. You should not stop down any more if you desire maximum sharpness. If you want to cut down the amount of light beyond this, use a neutral density filter.

Film Processing

For a number of reasons, you should not process sheet film like you do paper, in trays. Consistency is not possible in trays. Film developers are not designed to have the surface exposure to air they have in trays, and they will oxidize in short order. Processing the first test strip in a tray weakens the solution to the extent that the next sheet processed will receive less development than the test. Using a processor like a Jobo is a wonderful luxury, and it has changed my life in the darkroom; but there was life before the Jobo. For many years, I processed sheet film in color print processing drums that were rolled on a motor base. There are many of these devices in the used photo-equipment market with drums that can handle film sizes up to 16x20.

Safelight

This is definitely a case where less is better. All the films used in enlarging negatives have recommended safelight requirements, either dark red or light red for orthochromatic (blue sensitive) films, or none for panchromatic emulsions. No matter what the safelight, if films are exposed to these lights long enough they will fog. Another danger is that the safelight can cause a sub-threshold exposure on the film. This is an exposure that is not sufficient to initiate a development reaction but still causes electrochemical changes to the emulsion relative to its ability to react with the developer. If such film is then exposed and developed, areas that would normally remain clear will show some density. This will not show up with traditional fog tests. *The best safelight for film is no safelight.* With this in mind, it is wise to take a look at the LED displays used on digital timers, especially since they are in close proximity to the enlarging easel. If the timer has a dimmer switch, turn it down so that it is barely visible and aim it away from the easel. If there is no dimmer, several layers of lithographer's tape (the clear red stuff) is good insurance.

Making an Interpositive

Now that your lab is in shape for negative making, let's take a look at the films that have suitable characteristics for the job at hand, starting with making the interpositive. This film should be fine-grained, capable of lower-than-normal contrast, and have a long straight section on its HD curve with minimal toe and shoulder. The correct positive should look like a flat print when viewed on the light box, with no areas of clear film (some density in all non-specular highlights) and no shadow areas near the D-max of the film. This places all the printable information from your original negative on the straight portion of the film curve, insuring good tonal separation. One film with these characteristics is Ilford's Commercial Ortho Plus, a graphic arts film that I have been using successfully for the past five years. Another alternative would be T-Max 100, which is not a graphic arts film but has characteristics that make it suitable for many aspects of photography, including copying, masking, color separations, and normal picture taking. These films are readily available in sizes up to 8x10. Should larger-size film be required, the film stock referred to as Fine Grained Positive supplied by Photo Warehouse (not the same as Kodak Fine Grain Positive) is available in sizes up to 20 inches. It acts much like Ilford Commercial Ortho. All the above films respond favorably to processing in Kodak's HC110 or Ilford's Ifotech developers.

John Rudiak, Slim Perkins and Mocha. *Platinum/palladium print from an enlarged negative.*

Making an Enlarged Negative

And now to the final negative. This is the phase where most of the controls, such as contrast adjustment, dodging and burning, and retouching, are applied. One film ideally suited for this application is Kodak's Professional Copy Film, number 4125. Specifically designed for generating copy negatives, it has a uniquely shaped shoulder on its film curve that enhances highlight separation to counteract the highlight compaction that usually occurs when making copies. It is also unique in that contrast is influenced not only by development time but exposure as well—increased exposure results in increased contrast. It is retouchable on both sides, and is available in sizes up to 20x24. The disadvantages are that it is very expensive and that supplies, especially in the larger sizes, are limited. It seems that Kodak only makes this film once a year and supplies are exhausted before the next run. While I wholeheartedly recommend this film for enlarged negatives (I have been using it for fifteen years), I believe its future as an available product is limited. As

digitally produced negatives for reproduction occupy an ever increasing share of the market, the future of specialty films like Pro Copy is uncertain, at best. An alternative must be found, and camera-oriented films promise the best availability. Fortunately, some of the new-generation films have very gentle shoulders and are adaptable for use in generating enlarged negatives. The aforementioned T-Max 100 would be a good choice, but it is unavailable in sizes larger than 8x10, except through special order, which is cost prohibitive. Photo Warehouse markets an ISO 125 Pan film for camera use, available in sizes up to 20x24, that I have been using for enlarged negatives with great success. Selenium toning the final negative mimics the highlight characteristics of the Pro Copy, and the film responds favorably to increased development, which is necessary to achieve the higher-than-normal contrast required for most alt-process negatives.

Developers

Because you need to work from a positive that is lower in contrast than a normal negative designed for printing, and you need to generate a final negative that is higher in contrast than a negative for normal printing, conventional film developers are often incapable of generating sufficient contrast before general fogging sets in, lowering contrast. The solution to this problem is to use developers more capable of generating higher-contrast negatives than are normal film developers. For instance:

- If we develop a negative in HC-110 for ten minutes and it is not contrasty enough for its intended use, increasing the development time will likely result in chemical fog rather than increased contrast. The next developer to try is D-19, which is capable of generating a higher-contrast negative than HC-110.
- If ten minutes in D-19 isn't contrasty enough, D-11 can make a contrastier negative than D-19.
- In the unlikely event that D-11 isn't contrasty enough, you can use D-8, an extremely contrasty developer.

With these four developers, you should be able to handle any situation. They are all commercially available Kodak developers; and since the formulas are published, they can also be mixed from scratch.

Other controls

Once the final negative is generated, there are other modifications you can employ to get closer to the perfect negative that affect either local areas or the entire negative.

- Selenium toning the negative will result in a contrast increase, with more effect to the highlights.
- Selenium toner can be applied locally with a brush to increase density in certain areas.
- Detail can be enhanced by retouching with a soft lead retouching pencil.
- The entire negative can be chromium intensified, or bleached and redeveloped in a pyro-based developer.
- New coccine (a red water-soluble dye) can be applied to the film to lighten areas in the resulting print.

 These controls will be discussed in more detail later.

A Sample Enlarged Negative

The theoretical considerations discussed above are all relevant to one degree or another depending on the alternative photographic process you are undertaking. As you are planning how best to produce an enlarged negative, you should think through how the specific negative needs of that process can be met using controls while making the negative from which you will print. In the following section, I will take you through the process of making a 16x20 negative from a 4x5 original that will be used for platinum printing.

The Contact Positive

The negative, shot on 4x5 Tri-X on an overcast day, was developed to print on grade two paper with a condenser enlarger (fig. 1, left). This is large enough to make a contact-generated positive. Adjust the enlarger so that one foot-candle of light falls on the baseboard (this is equivalent to EV 1 at EI 50). Using a standard level of illumination for generating negatives simplifies procedures and makes comparisons meaningful. Make a test strip on Ilford Commercial Ortho Plus of two-second intervals and process for six minutes in HC-110 dilution B at constant agitation. Choose the exposure that first shows density in all the highlight values, which in this case was six seconds. Also check the density of the deepest shadows and notice that they are noticeably less than the film D-max, indicating that the development time is acceptable. Now expose and process a sheet at six seconds and develop for six minutes (fig. 1, right). Generating the positive is pretty straightforward, and some exposure and contrast latitude is permissible as long as there is some density in the highlights and the shadows are less than D-max.

The Enlarged Negative

1. Put the positive in the enlarger and position the head to make a 16" x 20" enlargement.

2. Take out the negative and adjust the illumination on the baseboard to one foot-candle. In this instance we get one foot-candle at f/22.

Fig. 1. *Camera negative (left) and positive transparency made from camera negative (right).*

3. Place a two-stop neutral-density filter in the filter drawer so you can work at f/11, the smallest aperture on this lens before diffraction starts to degrade the image.

4. Make a test strip on the negative film (in this case the Photo Warehouse ISO 125 Pan Film) in two-second intervals and process in HC-110, dilution B, for seven minutes.

5. Choose the exposure that just starts to show density in the shadow areas that you want to print black. This places the printable information above the toe of the film curve and will provide good shadow separation. In this case it is the four-second exposure. Because this negative doesn't need any dodging or burning, you can use the four-second exposure. If the negative needs such adjustments, increase the time to sixteen seconds by putting another two-stop neutral-density filter in the filter drawer to give enough time for dodging and burning.

6. After exposure, process, wash, and dry the enlarged negative in the normal manner (fig. 2).

Fig. 2. *Final enlarged negative.*

John Rudiak. Final platinum/palladium print.

Evaluation and Contrast Adjustment

Look at the highlights to check the negative's contrast. I like to make my platinum negatives so they have a density range of 1.9. If a densitometer is available, this is easy to check. If you already have a negative that printed well in platinum, compare the test to that. If this is your first negative for platinum, make a print of the test adjusting the exposure so the shadows in the four-second segment look right.

Now check the highlights. If they are too dark, which they are in our test, more contrast is needed. The maximum amount of development available is different for each film/developer combination, but a safe assumption would be a ten-minute limit for full-strength developers. Since this test negative was developed at six minutes and the print highlights are noticeably too dark, it is unlikely that a ten-minute developing time would achieve sufficient density. A densitometer would corroborate this, but if you don't have one available, you must use a more circuitous method to arrive at the developer that will yield the proper printing contrast. Once you have established this, however, you can compare the density and contrast of this negative with those of future negatives. D-19 developer is only moderately more contrasty than HC-110, and in the case of this test process for platinum printing, it is unlikely that it would provide enough contrast.

The next-contrastier developer in the series is D-11. Expose a strip of film for four seconds and develop it for seven minutes. A test print of this strip shows that it is very close to the correct contrast for the platinum process, but is still a tiny bit flat. Expose a 16x20 sheet of film for four seconds, but this time develop it for eight minutes to raise the contrast slightly. Once this large negative is dry, make a test print from a part of the image containing highlight values. If the resulting print looks good, but would be magnificent with a little more sparkle in the high values, you could do another test and increase the development time to ten minutes. This would require another large, expensive piece of film, however. An alternative approach is to tone the negative you have just made in selenium toner diluted 1:3 (one part toner to three parts water) for ten minutes. This will give a half-grade contrast boost in the high and middle tones.

Fine-Tuning Local Contrast

The next step is to make a full-size print to see if any post-processing enhancements are needed. In this case none are required. Because the original subject was a low-contrast scene and the print shows good shadow and highlight separation without blocking, all we have to do is sign it. Were it necessary, there

are a number of methods available to control density locally. If you have slight shadow information that barely prints and you would like these areas to have more presence in the print, building up density on the emulsion side of the negative with a retouching pencil is very effective. This technique works on the near highlights and midtones also. If broad areas need to be lightened, a solution of new coccine (a red, water-soluble dye) can be painted onto the negative. Start thin (a pinkish solution of the dye) and build up layers until the desired effect is obtained. Because new coccine is water-soluble and does not sink into the gelatin, it is removable by washing. Another effective way to increase density locally in irregularly shaped areas of the print is to "spot" them with concentrated selenium toner (1:1). This is permanent and more effective in the denser negative areas. Of course, wash the negative after this procedure. If negative density needs to be removed, the area can be gently rubbed with Kodak Abrasive Reducer, which seems to be a pumice-based paste, to darken respective areas of the print. Should you have pinholes or dust holes in the negative, opaque them out so you can spot them later on the print.

Your enlarged negative should be as good a negative as you can make. It is well worth putting the effort into this stage of the printmaking process, because the print you make can't be any better than the negative it comes from. The better the negative, the easier it is to print, and the less stressful the darkroom becomes. Printmaking should be a joy, not a struggle.

William Robert Baker, Rialto Bridge, 1858. *Modern salt print from a calotype negative by Michael Gray.*

Chapter 21 Paper

W. Russell Young III

Process Overview

Perhaps no other variable determines the look of a print made using an alternative photographic process as much as the paper. The surface can be smooth, nearly glossy, or rough and deeply textured; the tone can be brilliant white, dull white, off-white, beige, or even colored. The edges can be crisp and straight or deckled. The image can be sharp and resting near the surface, or soft, the details literally soaked into the fibers.

Only hand-coated processes offer the artist this variety of aesthetic choices concerning papers; but ironically, of all the variables in most processes, the paper is the one most out of the photographer's control. Papers vary from batch to batch simply because of the manufacturing process; worse yet, the maker can change the entire procedure, or just one part of it, and produce a paper with the same name that, for the purpose of alternative photographic printing processes, is a totally different item. Very few papers are—or ever have been—made just for photographers; nearly all have some other primary purpose. The paper mill may improve a paper dramatically for its designed purpose and totally ruin it for photographic use. Today, the only papers *designed* for alternative photographic processes are Buxton, a fine handmade English paper, and Arches Platine.

Pulp Content

Western papers are manufactured from either of two basic materials: wood derivatives or natural fibers such as cotton or, less often, linen or esparto. Papers from Asia are typically made of "bast," the inner fibers of plants as

diverse as hemp and hibiscus. Cotton is widely used in western papers because the plant produces the purest cellulose known. The portion of the plant actually used is the short fibers, called "linters," from the filaments. Almost no papers are actually made of recycled rags today; even those labeled "rag" are instead made of cotton linters.

Wood derivatives are, far and away, the most common ingredients in machine-made papers. At the low end of the scale, wood pulp papers contain lignin and other undesirable materials that cause it to yellow quickly in light and prevent it from having much strength. Newsprint is an example. At the other end of the scale, the pulp can be chemically purified so that it contains little lignin or miscellaneous woody matter and may be of neutral pH (also referred to as "acid free"). "High alpha" wood-based paper has, in theory, the same potential life as a "rag" paper. Because wood fibers are inherently different from cotton fibers, however, the papers will have differing character, especially wet strength (cotton is superior). Some fine papers, such as Fabriano 5 Classico, are a mix of cotton and high-alpha pulps. Wood-based paper may also be termed "sulfite" or "sulfate."

Manufacture

Papers are either made by hand or by one of two types of machine. Always expect to pay more for a handcrafted sheet. It is labor-intensive to make paper by hand; but after decades of decline, there has recently been a major resurgence of small companies that make fine arts papers by hand, offering more choices than at any time since World War I.

Handmade papers have been made in essentially the same manner for centuries, although the exact technology isn't relevant here. Paper mills use high-tech mechanical devices and produce either mold-made or machine-made papers, which are quite different from each other. Mold-made paper, produced on the cylinder mold machine, makes paper in a long roll; it can closely resemble a handmade paper. Machine-made paper is produced by the Fourdrinier machine.

The method of manufacture helps to determine paper characteristics such as grain, deckle, and wet strength. Mold-made paper begins its life like handmade paper until the steps where the pulp becomes a sheet; then a machine performs the work of a human. The result is usually a more uniform product, something generally desirable for our uses. Mold-made paper has two deckle edges (although it may have two more false deckles) and has a grain direction; by comparison, handmade paper has four deckles and has no grain direction. Because of the way the paper rolls off the cylinder, the watermarks nearly

always run along the outside (deckled) edges and are sometimes continuous along the length of the paper. It takes less time to make than handmade but far more than a machine-made paper.

While mold-made paper manufacture is faster than handmade, machine-made (Fourdrinier) papers are even faster. They are generally products of huge mills and are made with the printing and publishing industries in mind. In order to enhance the surface for mechanical printing, these papers often have a "filler," frequently made of clay, that helps fill in the pores of the paper and cause it to be smoother and brighter. In many alternative processes, when the paper is wet, these fillers may fall out of the paper surface and pinhole your coating.

Machine-made papers come in a bewildering array of colors and a fair selection of weights, but they are rarely designed with archival considerations in mind; the colors are notoriously fast-fading in bright light. These papers often have a more drastic grain direction and may have less stability when exposed to changing environments (especially humidity fluctuations). They are more limited in weight than mold-made or handmade papers, rarely going above 90 lb, whereas handmade watercolor papers might be as much as 300 lb. Of course, because of the technology involved and their speed of manufacture, they are the least expensive papers.

Paper Specifications

In general, most papers can be described by certain industry-wide specifications. As an example, here are the specifications for Fabriano Artistico, a heavily textured paper often used by watercolorists.

Purpose: Watercolor
Manufacture: Mold-made
Content: 100% cotton
Sizing: Tub, heavily sized
Surface: C.P. (cold press)
Size: 22" x 30"
Weight: 140 lb
Edges: Two deckles
Watermark: Yes
Color: Off-white
Buffering: None

Even these descriptions don't tell an alternative photo process printer enough, nor do all paper mills or distributors give all of those specifications. Some important details you can determine for yourself, such as wet strength, but others, such as pH, are difficult to determine at home.

Name

The name is usually composed of the mill name and the paper name, e.g., Arches Aquarelle. The mill name is critical, because the same paper name produced by different mills may be very different in character. A mill may also change its production technique at any time, usually without notice. A mill may resurrect an old paper name which may have a different character from the original. Distributors may also have specific varieties of paper made exclusively for them.

Sizing

Size is a material added to the paper to increase its water repellency. It can be added while the paper is still pulp ("internal") or after the sheet has been formed ("vat," "surface," or "tub" sized). Some papers, especially watercolor papers, are both internally and tub sized. A "waterleaf" paper has no sizing and sucks up moisture like a blotter.

Traditional sizing was gelatin or starch (less commonly casein) but now most large mills use synthetics such as Aquapel, which are both less expensive and faster to produce. Cheaper papers are sized with an alum–rosin mixture which shortens the life of the paper considerably, and the residual aluminum sulfate may interact with your chemicals. Papers which are vat sized with gelatin will always be somewhat off-white, and with time external gelatin sizing may craze or crackle.

The more sizing, the more the image stays on the surface of the paper, and the greater the brilliancy and contrast. If the sizing is inadequate for your purpose, starch or gelatin may be added in the home darkroom. Too much sizing may cause your chemicals to slide off during processing; too little causes the chemicals to soak too deeply into the fibers and make them difficult to clear or cause the image to be flat or lacking in contrast.

Surface

Surface describes the appearance of the paper in terms of texture. Many papers are available in more than one surface; Fabriano Uno can be found in four surfaces. The common surfaces are:

- Hot-pressed (H.P.): smoothest surface available, calendered by running between polished rollers or plates, thus also called "plate" surface.
- Cold-pressed (C.P.): a mildly textured paper, between hot-press and rough, also called "not."
- Rough: a heavily textured paper, often for watercolorists.

Hot-pressed papers are often difficult to coat because the liquid does not absorb readily into the paper. Almost all papers are more textured after being wet and then drying; with some papers, the hot-pressed and cold-pressed surfaces cannot be differentiated after both have been thoroughly wet.

Most handmade and mold-made papers have different front and back surfaces; one side is the wire side, the other is the felt side. The wire side is more porous and has a more pronounced grain. If you look at the watermark and it reads correctly, you are looking at the front side of the paper and the one intended for use. Please note, however, that sometimes (usually discovered through trial and error), the back side could be more suitable. As a rule, the back side is not as smooth as the front. Papers bound into blocks, as many watercolor papers are, have the felt side (front) up.

Additionally, the appearance of a paper is described as "wove" or "laid." Wove papers, which comprise most now made, have a uniform, smooth surface reminiscent of the warp and weft of a fabric. This pattern may be distinct or almost nonexistent. "Laid" paper has a distinct pattern of fine parallel lines (chains), with fewer lines running at right angles. Laid lines may or may not be visible on the surface of the paper unless held up to a light. All papers made before 1757 were laid papers. Some machine-made papers have imitation laid lines.

Sheet Sizes

Although there is no international standard size for a paper, something near 22" x 30" (known in England as "Imperial" size) approximates the most common dimensions available. England, the United States, France, Italy, and Germany all have different standard sizes. Because they are made in blocks as well as sheets, watercolor papers may be available in a large number of sizes. Measurements vary with deckled paper because some makers measure from the inside of the deckle, others from the outside; this can amount to between $1/2$" and $3/8$" difference on the same sheet.

The largest standard size for most papers is 30" x 40", although a few papers are available in long rolls if you need to make a really large image. Paper mills will make any size you want, as long as the order is large enough.

Weight

Weight is a very confusing issue because there are two separate systems. The weight given in pounds expresses how many pounds 500 sheets would weigh. Thus, a 140-lb paper is far thicker than a 60-lb paper if they are the same size, but this can be misleading because it varies with different-sized papers. The metric system for paper weight makes far more sense: it is the weight in grams of a sheet one meter on a side. A 140-lb Imperial-size paper thus is equivalent to a 285 to 300 gram per square meter ("gsm") paper.

Color

Designations of color are a little more direct. There are numerous fine divisions of the color white that are caused by sizing, bleaching (chemical or sunlight), water conditions, age, and other factors. Brilliant white papers may either have been bleached (which eventually causes the paper to become brittle and yellow) or contain optical brightening agents (that will yellow in time). Brighteners may also react with chemicals in alt-photo processes or dissolve out into the solution, contaminating it. As the brighteners dissolve, the paper appearance will change toward dull.

Many papers are available as white and buff. Rising Stonehenge is found in white, warm white, cream, natural, gray, and tan. I have made lovely cyanotypes of certain subjects on Rives BFK Heavyweight Tan, where the cyan forms the cold shadows and the warm tan forms the highlights of the subject.

Grain Direction

Grain direction, inherent in mold-made and machine-made papers, is caused by the linear production of the paper. It is more prominent in machine papers than mold-made, and does not exist in handmade papers. This is important to you for three reasons:

- It determines in which direction the paper tears readily (for when you reduce a large sheet into smaller pieces).
- When damp or wet, the paper expands more across the width of the fibers, in the direction of the width. This can have major implications when a

paper needs to be totally wetted or when repeated wetting is required (such as for gum printing).

- If you are making pages for a book, or an image to be tipped in, the book spine should be parallel to the grain so that the page bends along the grain rather than breaking across it.

Archival Quality and pH

Archival is a much abused term. Basically, it means the paper should last well, without much change over time. Technically it means (in the United States) that it complies with ANSI Z39 standard meaning and that it has the following:

- A pH of 7.5 or more (alkaline)
- An alkaline buffer
- Either "rag" fiber or high-alpha cellulose pulp
- A number of miscellaneous factors having more to do with the life of books than the needs of alternative-process prints

Please note that a paper that meets the ANSI standard may not fulfill the criteria for certain photo processes. For instance, a heavily buffered paper will bleach a cyanotype. The buffering agent, often calcium carbonate or magnesium carbonate in the water used by maker or as an additive, may react chemically with the photographic chemicals. The source of the carbonate may be in the water used by the maker or may be an added compound. Using a high-pH paper may make certain processes more difficult to work with successfully.

pH is a measure of acidity or alkalinity on a scale from 1 to 14, where 1 is most acid and 14 is most alkaline. A pH of 7 is exactly neutral, although in practice the range from 6.5 to 7.5 is considered neutral. The pH does *not* necessarily influence the life of the paper. Many historic papers were acidic when produced and are still in fine condition. Conversely, a neutral paper may become acidic with time because of its manufacturing technique or the environment in which it is stored. A buffering agent may be added to the paper during manufacture to help stabilize the pH over time.

Archival stability considerations are compounded by the chemicals that we coat on papers or submerge them into. Many are not good for the paper fibers; it is known, for example, that using a hydrochloric acid–clear for a platinum print severely compromises the paper fibers. The image, made of platinum, may be permanent, but the point is moot if the paper support disintegrates. I have seen several Frederick Evans platinum prints of English cathedrals that are in an advanced state of decay, probably due to too strong an acid clearing bath; they were yellow-brown, and the paper was incredibly fragile due to brittleness.

Notes on Coating Paper

There are three favorite tools used by photographers to coat paper: foam brush, hake brush, and glass (or lucite) rod. These are by no means the only ways— airbrush, homemade Blanchard brush, floating, and spin coating are also used.

What We Can Learn from Lithographers and Other Printmakers

Changes in humidity can affect paper noticeably. When the humidity increases, the paper swells; as humidity drops, the paper shrinks. All paper should be "matured" in a stable atmosphere before use. That is, when you are doing alternative photographic processes, coating and processing the paper should be done in an environment controlled for temperature and humidity. The paper should be allowed to stabilize at those conditions in your workspace before you use it. This will alleviate the aggravating problems that occur in several processes and allow for far greater repeatability generally.

The tool you use can easily damage the surface of the paper, particularly a hot-press surface.

Working too wet, or making too many passes across the paper, or being heavy-handed can all work up the surface, which usually leads to problems. I've watched two excellent students working at the same time use the same brush, chemicals, and different halves of the same sheet of paper obtain varying contrast and speed with kallitypes; the variable was the physical act of coating. A light hand is definitely desirable, regardless of the tool. A good worker can coat a fragile paper such as Japanese Goyu with ease using the correct tool, hand pressure, and moisture, whereas an inexperienced person can ruin a sheet of heavily sized 140-lb paper.

Due to differences in surface and sizing, different brands of paper will need more or less sensitizer solution to coat them well. A super-smooth plate surface needs the least, while a rough sheet may need far more liquid. There will be corresponding differences in the brush technique as well. If the liquid pools or the paper buckles or cockles, either you have too much moisture or the paper needs to be sized more heavily. The addition of a wetting agent (also called a surfactant), especially Tween 20, can make some otherwise unmanageable papers coat smoothly; don't use it unless you know the paper requires it.

Some papers shed loose fibers; this is called "picking." There really isn't much you can do to solve this unless extra sizing takes care of it. The problem

with the loose fibers is that when they wash off in development, a white area will be left behind that usually needs to be spotted out.

Handling Paper

Keep your paper flat and clean when it is stored. If it had to be rolled for shipment, lay it flat as soon as possible. Be careful what it lies on, especially if you are concerned about a long life for the paper. Handle it carefully; use cotton gloves to avoid fingerprints, and use both hands on opposite sides of the sheet when you pick it up. Fingerprints may not only resist the coating you want to apply, but may encourage mold and bug damage. Ideal storage is around 60–68°F and between 30 and 70% relative humidity; with too little humidity and too much heat, the paper may become fragile. With too much humidity, mold is a threat, especially with organic sizing agents. Don't stack papers so deeply that the bottom ones are being crushed. It is imperative to keep the paper free of dust, lint, paint fragments, and darkroom contaminants; always keep it covered.

If you need smaller sheets, be careful how the paper is cut. Tiny metal fragments from a rotary cutter or a standard guillotine cutter can cause black spots on the image later, especially in the iron-based processes. Instead of cutting, consider tearing it. Fold the paper, then burnish the edge of the fold with a celluloid, bone, or ivory burnisher; fold it back the other direction and burnish again. Open the fold and pull the two sides away from each other; this should leave a nice feather-edged tear along the fold. Another way to tear it is to lay the paper face down with a metal straight edge where you want the tear, and pull the edge up and toward the center of the sheet (you need to be careful not to kink hard papers). To make a number of standard-sized sheets, make a Plexiglas template and cut around the edges with a hand-held rotary trimmer (found in fabric stores). Before coating the paper, lay it on a light table and carefully scan it by transmitted light for uneven sizing, tears, kinks, and "contraries," an English term for objects imbedded in the paper during manufacture. Five minutes doing this can save major headaches a day later when unexpected black spots appear on your drying print.

Conversion Chart

The procedures in this book rely primarily on the metric system for measurement of dry and liquid chemicals and other materials, as do most photographic procedures. When calculating measurements for the processes in this book it will be helpful to refer to these tables. A laminated photocopy of these pages, or similar easy-to-read reproduction, posted in your darkroom area will save time and aggravation when mixing solutions.

Measurement in Area

Centimeters to Inches
cm x 0.3937 = inches

Inches to Centimeters
inches x 2.5400 = cm

Examples: *35 centimeters = 13.778 inches*
 12 square inches = 30.48 square centimeters
 8" x 10" = 20.32 cm x 25.4 cm

Avoirdupois to Metric Weight Conversions

One pound = 16 ounces
 = 7000 grains
 = 453.6 grams
 = 0.4536 kilogram

One ounce = 0.625 pound
 = 437.5 grains
 = 28.35 grams
 = 0.02835 kilogram

One grain = 0.0648 gram

One gram = 0.03527 ounce
 = 15.43 grains
 = 0.001 kilogram

One kilogram = 2.205 pounds
 = 35.27 ounces
 = 15,430 grains
 = 1000 grams

U.S. Liquid to Metric Volume Conversions

One gallon = 4 quarts
 = 128 fluid ounces
 = 1024 fluid drams
 = 3785 cubic centimeters
 = 3.785 liters

One quart = 0.25 gallons
 = 32 fluid ounces
 = 256 fluid drams
 = 946.3 cubic centimeters
 = 0.9463 liter

One fluid ounce = 8 drams
 = 29.57 cubic centimeters
 = 0.02957 liter

One fluid dram = 0.125 fluid ounce
 = 3.697 cubic centimeters
 = 0.00397 liter

One cubic centimeter = 0.03381 fluid ounce
 = 0.2705 fluid dram
 = 0.001 liter

One liter = 0.2642 gallon
 = 1.057 quarts
 = 33.81 fluid ounces
 = 270.5 fluid drams
 = 1000 cubic centimeters

Converting Between Celsius and Fahrenheit

Converting Fahrenheit into Celsius:

1. Subtract 32 from the Fahrenheit number.
2. Divide the answer by 9.
3. Multiply that number by 5.

Example: If the Fahrenheit temperature is 78°, what is the corresponding Celsius temperature?

- 78 − 32 = 46
- 46 ÷ by 9 = 5.1
- 5.1 × 5 = 25.5

Answer: 78°F = 25.5°C

Converting Celsius into Fahrenheit:

1. Multiply the Celsius temperature by 9.
2. Divide the answer by 5.
3. Add 32.

Example: If the Celsius temperature is 16°, what is the corresponding Fahrenheit temperature?

- 16 × 9 = 144
- 144 ÷ by 5 = 28.8
- 28.8 + 32 = 60.8

Answer: 16°C = 60.8°F

Resources

Many companies and individuals offer materials, hardware, and support for alternative photographic processes. The following is a listing of many such resources.

Archival Materials

Light Impressions
www.lightimpressionsdirect.com
P.O. Box 940
Rochester, NY 14603
800-828-6216
Good general selection of archival materials.

University Products
1799 Howell Road
Hagerstown, MD 21740
800-628-1912
More serious selection of archival products catering primarily to art museums and the art conservation market.

Art Supplies and Paper

Daniel Smith
www.danielsmith.com
4150 First Avenue South
Seattle, WA 98134
800-426-6740
A large art material supply company with a wide selection of art materials and informative catalogs.

New York Central Artist Materials
www.nycentralart.com
62 3rd Avenue
New York, NY 10003
800-950-6111
Excellent source of papers including Twinrocker and Whatman.

Pearl Paint
www.pearlpaint.com
308 Canal Street
New York, NY 10013
800-451-PEARL
New York–based art materials supplier for more than sixty years.

Utrecht Manufacturing
www.utrechtart.com
800-223-9132
A nationwide chain with an extensive, easy-to-use Web site.

Chemicals and Lab Equipment

Artcraft Chemicals
800-682-1730
A small catalog and phone order operation offering personalized attention.

Bryant Labs
www.sirius.com/~dry_lab
1101 5th Street
Berkeley, CA 94710
800-367-3141
A small company specializing in chemical ingredients.

First Reaction
37 Depot Road
Hampton Falls, NH 03844
603-929-3583
A resource for precious metals materials used in photographic processes.

Fisher Scientific
www.fisherscientific.com
3970 John's Creek Court #500
Suwanee, GA 30024
800-766-7000
A large company with a wide selection of materials.

Supplies, Chemicals, and Kits

Bostick & Sullivan, Inc.
www.bostick-sullivan.com
P.O. Box 16639
Santa Fe, NM 87506
505-474-0890
Complete line of kits and chemicals; plus contact frames, light sources, and bromoil paper. The best source of ferric oxalate—and the only source of chemicals for ziatype.

Chicago Albumen Works
www.albumenworks.com
Front Street
Housatonic, MA 01236
413-274-6901
A source for Centennial™ printing-out paper, and the best source for duplicating and enlarged negative services anywhere. Custom printing in various historical processes.

David W. Lewis
P.O. Box 254
Callender, Ontario
Canada POH 1H0
705-752-3029
Custom-designed brushes, inks, and paper for bromoil. David Lewis is also the author of the book The Art of Bromoil and Transfer.

Graphic Chemical & Ink Co.
www.graphicchemical.com
P.O. Box 7027
Villa Park, IL 60181
800-465-7382
Inks for bromoil and Rawlins oil.

LorAnn Oils, Inc.
www.lorannoils.com
4518 Aurelius Road
Lansing, MI 48909
800-4-LORANN
A source of oil of lavender for collodion process.

Palladio Company
800-628-9618
Ready-coated palladium paper, light units, and vacuum frames. Primarily phone and catalog orders.

Photographers' Formulary
www.photoformulary.com
P.O. Box 950
Condon, MT 59826
800-922-5255
Complete line of kits and chemicals for nearly all alt-photo processes, plus an excellent source of custom-formulated chemistry for traditional photography.

P. L. Thomas & Co., Inc.
P.O. Box 612
Morristown, NJ 07963
973-984-0900
A source of gum sandarac for collodion process.

Silverprint
www.silverprint.co.uk
12 Valentine Place
London, England SE1 8QH
011-44-0171-620-0844
Offers a range of photographic materials, including the Day Star Pin-Register frame made by Peter Charles Fredrick.

Stouffer Graphic Arts Equipment Co.
www.stouffer.net
Stouffer Industries, Inc.
1801 Commerce Drive
South Bend, IN 46628
219-234-5023
The best source of step scales in all sizes.

Theta Plate
thetaplate@worldnet.att.net
3330 Princeton Drive NE
Albuquerque, NM 87107
505-880-1856
A source for precious-metals plating on small objects, as used with daguerreotypes.

Contributor Biographies

John Barnier is a senior photographer for Dayton-Marshall Fields advertising and a fellow of the Royal Photographic Society of Great Britain; former contributing editor for *View Camera* magazine; and owner of Archival Services, which archives, restores, and prints photographic collections. He lives near Minneapolis, Minnesota.

Peter Charles Fredrick, inventor of the Fredrick temperaprint process, is the former head of photographic studies and retired senior lecturer in visual communication at South East Essex College of Art and Technology and has taught at Salisbury College of Art and the London College of Printing. He is the author of *Creative Screenprinting* and lives in England.

Sandy King is a photohistorian and author of *The Photographic Impressionists of Spain: A History of the Aesthetics and Techniques of Pictorial Photography*. He is head of the foreign languages department and a professor of Spanish at Clemson University in South Carolina.

Terry King gained his fellowship in the Royal Photographic Society through his work in and improvements on the gum printing process. He has curated and participated in many exhibitions and is the organizer of the Alternative Processes International Symposium, held in Bath, England, in 1997 and October 2000. He lives in Twickenham in southwest London.

Gerard Meegan is a photo conservator and the first photographer to put the Becquerel theory of daguerreotype development into practice as an actual process. He lives in Minneapolis, Minnesota.

Richard Morris has conducted calotype workshops in Britain and Germany and has published in *History of Photography, The Daguerrian Annual, PhotoHistorian,*

and the *Journal* of the Historical Group of the Royal Photographic Society. He lives in Chalfont St. Peter, England.

France Scully Osterman is a guest scholar at the George Eastman House International Museum of Photography in Rochester, New York. France publishes *The Collodion Journal* with her husband, Mark, and teaches the collodion process at the Scully and Osterman Studio in Rochester, New York.

Mark Osterman is the photographic process historian at the George Eastman House International Museum of Photography in Rochester, New York, and is a former faculty member at the George School in Newtown, Pennsylvania, where he taught fine art photography for twenty years. Mark and France live in Rochester, New York.

Charles H. Palmer has worked with large-format black-and-white photography for twenty-eight years and has worked and experimented exclusively in the platinum/palladium printing process for the past ten. A surgical pathologist, he lives in Albuquerque, New Mexico.

Ted Rice is a graduate of the California College of Arts and Crafts and author of *Palladium Printing Made Easy*. His work can be found in many collections including the Amon Carter Museum, the Center for Creative Photography, and the Corcoran Gallery of Art. He lives in Santa Fe, New Mexico.

Mike Robinson is a faculty member of the George Eastman House International Museum of Photography in Rochester, New York, where he teaches workshops in albumen printing. He is also a part-time faculty member of the Photographic Arts Department at Ryerson Polytechnic University in Toronto, Canada. He lives in Toronto.

John Rudiak teaches photography and antique photographic processes at the University of New Mexico, Taos. A former faculty member of the photography department at the Rhode Island School of Design and a former contributing editor for *View Camera* magazine, he lives in Taos, New Mexico.

Sam Wang, born in China, received his M.F.A. in photography and painting from the University of Iowa and has taught photography and art at Clemson University in South Carolina for more than thirty years.

W. Russell Young III has curated national and international exhibitions of alternative-process photography and has taught photography at the University of Texas and at Ohio Wesleyan University. He lives in Santa Fe, New Mexico.

Index

Text Credits

Introduction, Basics, Printing-Out Paper, Rawlins Oil, Bromoil, New Cyanotype, Argyrotype, and Using Step Scales copyright © 2000 by John Barnier. Fredrick Temperaprint copyright © 2000 by Peter Charles Fredrick. Monochrome Carbon copyright © 2000 by Sandy King. Salt Prints and Gum Bichromate copyright © 2000 by Terry King. Becquerel-Developed Daguerreotypes copyright © 2000 by Gerard Meegan. Calotype Negatives copyright © 2000 by Richard Morris. Collodion: Wet-Plate Negatives, Ambrotypes, and Tintypes copyright © 1998 by Mark Osterman and France Scully Osterman. Digital Negatives for Alternative Processes copyright © 1997 by Charles H. Palmer. Platinum/Palladium copyright © 2000 by Ted Rice. Albumen copyright © 1997 by Mike Robinson. Enlarged Negatives copyright © 2000 by John Rudiak. Three-Color Gum Prints Using Digital Negatives copyright © 2000 by Sam Wang. Traditional Cyanotype, Kallitype, and Paper copyright © 2000 by W. Russell Young III.

Additional Photo Credits

Page 44 copyright © by Carol Adelman. Used with permission of Carol Adelman. Cover, pages ii, xxiv, 157, 160 (all), 172, 175, 177, 180, 185, 191, 202, 204, 208, 214 (left and right), and 252 copyright © by John Barnier. Page 152 copyright © by Linda Connor. Used with permission of Linda Connor. Page 106 copyright © by Cy DeCosse. Used with permission of Cy DeCosse. Pages 194, 196, and 199 copyright © by Peter Charles Fredrick. Page 3 copyright © by Barbara Galasso. Used with permission of Barbara Galasso. Pages 111 and 127 copyright © by James Henkel. Used with permission of James Henkel. Pages 86, 91, and 94 copyright © by Sandy King. Pages 28, 29, 162, 165, and 171 copyright © by Terry King. Pages 26 and 31 (top and bottom) copyright © by Peter Marshall. Used with permission of Peter Marshall. Pages 11 and 14 copyright © by Gerard Meegan. Page 21 (left and right) copyright © by Richard Morris. Pages 60, 79, and 83 copyright © by Mark Osterman. Pages 63, 77, and 81 copyright © by France Scully Osterman. Pages 216, 219 (left and right), and 225 copyright © by Charles H. Palmer. Page 115 copyright © by Ted Rice. Pages 48 and 57 copyright © by Mike Robinson. Pages 262, 265, 269, and 273 (right) copyright © by John Rudiak. Pages 247 and 249 copyright © by Teresa Van Hatten. Used with permission of Teresa Van Hatten. Pages 36, 43, 238, and 242 copyright © by Sam Wang. Pages 39, 130, 139, 145, and 149 copyright © by W. Russell Young III.

THE USBORNE BOOK OF
ASTRONOMY & SPACE

Acknowledgements

Additional editorial and design by Kirsteen Rogers, Karen Webb and Phil Clarke

Photo credits:

Stuart Atkinson (78, 79); Luke Dodd (59); ESA (14-15); ESA/PLI (22-23); Calvin J. Hamilton (33); Jerry Lodriguss (4);
Larry Landolfi/Science Photo Library (Cover: bottom); NASA (6, 9, 11, 14, 20, 20-21, 24, 24-25, 27, 28, 29, 30, 31,
33, 34, 34-35, 37, 42, 43, 46-47, 50, 51, 52, 53, 81); NASA/ESA (55); NASA Landsat Pathfinder Humid Tropical
Forest Project (22); NOAA (23 – top); Pekka Parviainen (15); Detlev van Ravenswaay/Science Photo Library
(Cover: top); Royal Observatory, Edinburgh (1, 2-3); Rev. Ronald Royer (16-17); Robin Scagell (19);
Tom Van Sant/Geosphere Project, Santa Monica (23 – middle left); Frank Zullo (45).

THE USBORNE BOOK OF
ASTRONOMY & SPACE

Lisa Miles and Alastair Smith

Edited by Judy Tatchell

Designed by Laura Fearn, Karen Tomlins and Ruth Russell

Cover design by Karen Tomlins

Illustrated by Gary Bines and Peter Bull

Consultants: Stuart Atkinson and Cheryl Power

CONTENTS

Usborne Quicklinks

The Usborne Quicklinks Website is packed with links to all the best websites on the internet. For links to the recommended websites for this book, go to:

www.usborne-quicklinks.com
and enter the keyword "astronomy".

You can:

- Keep up with the latest space news.
- Print out star charts and constellation guides.
- See incredible images from deep space.
- Take a virtual trip through the Solar System.

Internet safety

When using the internet, make sure you follow the internet safety guidelines displayed on the Usborne Quicklinks Website.

The recommended websites are regularly reviewed and updated, but Usborne Publishing is not responsible and does not accept liability for the availability or content of any website other than its own, or for any exposure to harmful, offensive, or inaccurate material which may appear on the Web. We recommend that children are supervised while on the internet.

THE UNIVERSE

Images of stars among clouds of gas and dust in space.

THE UNIVERSE

The universe is the name that we use to describe the collection of all the things that exist in space. The universe is so huge that its size is hard to imagine. It is made of millions of stars and planets, and enormous clouds of gas, separated by gigantic empty spaces.

Light years

Distances in space are huge. They are usually measured in "light years". One light year is the distance that light travels in a year, approximately 9.46 trillion km (5.88 trillion miles). Light travels at a speed of 300,000km (186,000 miles) per second.

Galaxies

Stars group together in huge collections called galaxies. Galaxies are so big that it can take a ray of light thousands of years to travel across one. Planet Earth is in the Milky Way galaxy. This galaxy is about 100,000 light years across. Distances between galaxies are much greater.

The smudgy little shapes in this photo are some of the most distant galaxies ever seen.

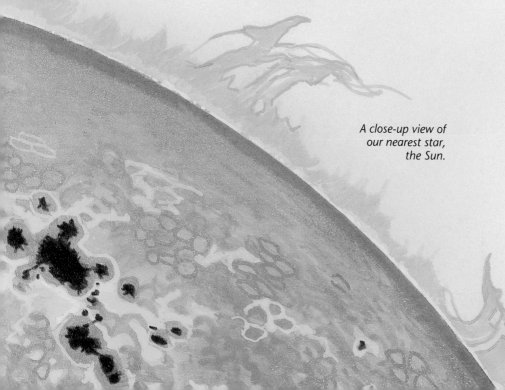

A close-up view of our nearest star, the Sun.

How big?

Nobody knows how big the universe is. It contains millions and millions of galaxies. As astronomers develop new, more powerful telescopes, they discover even more galaxies. So far, astronomers have spotted galaxies that are up to 13 billion light years away.

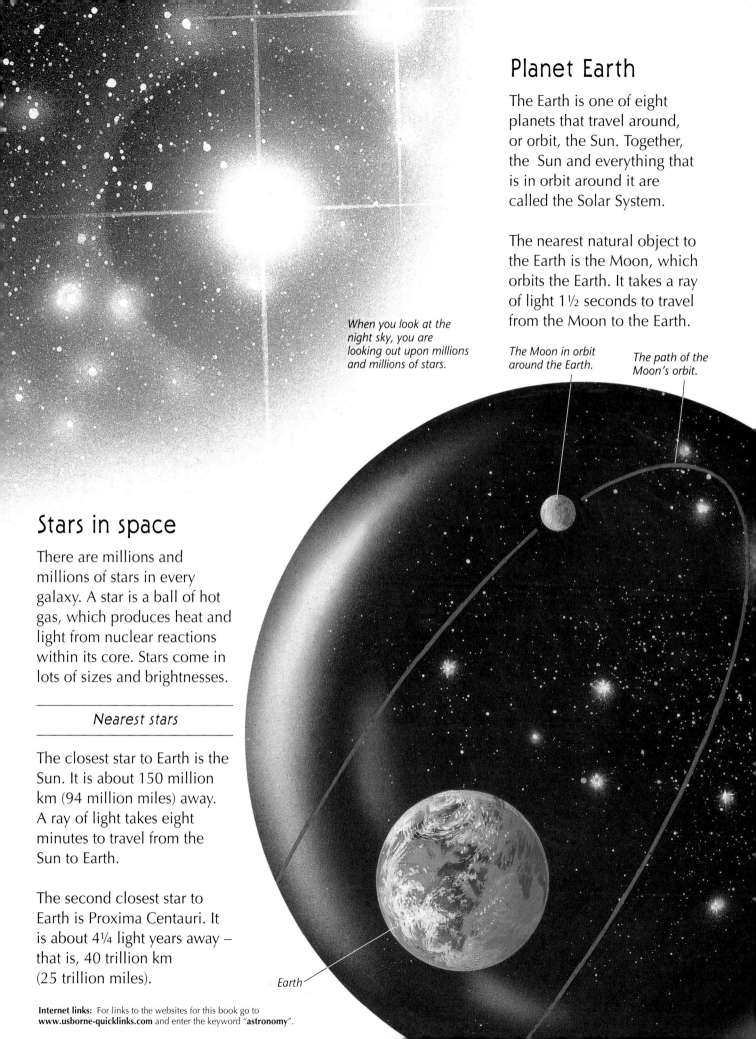

Planet Earth

The Earth is one of eight planets that travel around, or orbit, the Sun. Together, the Sun and everything that is in orbit around it are called the Solar System.

The nearest natural object to the Earth is the Moon, which orbits the Earth. It takes a ray of light 1½ seconds to travel from the Moon to the Earth.

When you look at the night sky, you are looking out upon millions and millions of stars.

The Moon in orbit around the Earth.

The path of the Moon's orbit.

Stars in space

There are millions and millions of stars in every galaxy. A star is a ball of hot gas, which produces heat and light from nuclear reactions within its core. Stars come in lots of sizes and brightnesses.

Nearest stars

The closest star to Earth is the Sun. It is about 150 million km (94 million miles) away. A ray of light takes eight minutes to travel from the Sun to Earth.

The second closest star to Earth is Proxima Centauri. It is about 4¼ light years away – that is, 40 trillion km (25 trillion miles).

Earth

Internet links: For links to the websites for this book go to **www.usborne-quicklinks.com** and enter the keyword "astronomy".

THE STORY OF THE UNIVERSE

The story of how the universe was created is not fully understood. Most scientists believe that it began with a huge explosion. They call this idea the Big Bang theory.

The fireball spreads out and the universe starts to expand.

Big Bang theory

According to the Big Bang theory, the universe was formed in an unimaginably violent explosion, called the Big Bang.

Scientists think that the explosion happened over 15 billion years ago and that nothing existed before this event. Time itself began with the Big Bang.

After the Big Bang

The Big Bang created a huge fireball, which cooled and formed into tiny particles. Everything in the universe is made up of these particles, called matter. The cooling fireball spread out and the universe began to expand.

A dark universe

Over time, the particles formed into thick clouds of gases. The gases then collected into dense clumps. The universe was so dense that light could not travel far within it, so it was very dark.

Galaxies form

The temperature of the universe continued to fall but it was still unimaginably hot. After thousands of years, the temperature fell to a few thousand degrees. The fog cleared and light could travel farther. Galaxies formed from the dense clumps of matter.

Our Solar System

About 10 billion years after the Big Bang, the Sun, Earth and the other planets of our Solar System were formed near the edge of the Milky Way galaxy. Even today, parts of the universe are still forming.

Thick clouds of gases collect into vast clumps of dense matter.

Stars and galaxies begin to form and the universe becomes see-through.

Almost 10 billion years after the Big Bang, the Solar System forms.

Evidence for...

One reason why most scientists think that the Big Bang theory is correct is that a weak signal, like an echo, has been detected from space by powerful radio telescopes. It could be that this echo is from the energy in the early fireball, which spread out into space after the Big Bang.

The energy from the Big Bang explosion spread out into space, creating an echo.

...and against

There is a problem, though. Astronomers have calculated that if the universe contains only the matter that we know about, it would have expanded too quickly after the Big Bang for galaxies to form.

For the Big Bang theory to be true, the universe must hold a lot more matter than we know about. Much more matter must be discovered before we can account for all of the missing matter, known as "dark matter", that should exist.

Dark matter

We may only know about 15% of the universe. The rest is still to be found.

How will it all end?

In 1998, astronomers studying some dying stars measured them to be farther away than expected. This showed that the universe is expanding at an increasing rate. Space scientists think this is caused by "dark energy", a mysterious force that may be the key to the fate of the universe. Below are some of their theories about it.

Big Freeze theory

If dark energy is stronger than a pulling force, called gravity, the universe could expand forever. Old stars would die and galaxies would stop making new stars. Eventually, the universe would just fade away into a mist of cold particles.

The universe could slow down and then simply fade away.

Space detectives

We don't yet know enough to say for sure how the universe works. Astronomers are like space investigators, using powerful equipment, such as the radio telescope on the right, to unravel the mysteries of the universe.

Big Crunch theory

Some scientists think that dark energy may eventually change the way it behaves and start to slow down the expansion of the universe. It will pull everything back until the galaxies collide. There could then be a Big Crunch, like the Big Bang in reverse.

The galaxies could collide in a Big Crunch.

Oscillating Universe theory

Some scientists think that the universe works like a heart, beating in rhythm. They believe that it expands, then it shrinks, then it expands again, and so on. So a Big Bang is followed by a Big Crunch, in a repeating cycle.

Big Bang Big Crunch Big Bang

The Arecibo dish in Puerto Rico. This is the largest radio telescope in the world.

FINDING OUT ABOUT SPACE

Here are some examples of the ways in which astronomers find out about the universe, and the techniques and equipment that they use.

Optical telescopes

Telescopes which use light to magnify objects are called optical telescopes. Astronomers use powerful optical telescopes to look deep into space. Many are built high up on mountains, so that they are above much of the Earth's hazy, polluted atmosphere.

This is a radio telescope.

Radio telescopes

Radio telescopes use very large dishes, or antennas, that collect the faint signals given out by objects in space. They enable astronomers to detect things that are simply too dark or too far away to see, even through the most powerful optical telescope.

The largest radio telescope is the Arecibo dish in Puerto Rico (see page 9). Its 305m (1,000ft) wide dish is built into a natural valley. The picture below shows part of the Very Large Array radio telescope, in New Mexico, USA.

Telescopes in space

Telescopes in outer space can see deeper into space than telescopes on Earth, because they don't have to peer through Earth's atmosphere. The largest telescope to have been placed in space so far is the Hubble Space Telescope, an optical telescope launched by NASA* in 1990.

Space stations

Space stations are bases orbiting the Earth. Scientists and astronauts on board use them to do experiments and to find out how the human body reacts in space. A large International Space Station (ISS) is being built up in orbit right now. It is a joint project involving 17 countries.

Space probes

Unmanned space probes are sent to investigate deep space and transmit their findings back to Earth. Many carry cameras, which take detailed photographs of distant worlds. They beam the photos back to Earth, where they are studied by space scientists.

In 1996, the Pioneer 10 probe became the first man-made object to leave our Solar System. It is now over 15.4 billion km (9.6 billion miles) away from Earth.

Part of the Very Large Array radio telescope. It consists of 27 radio telescopes lying along the arms of a huge "Y". Each single telescope is 25m (27yd) wide.

*The National Aeronautics and Space Administration of the USA.

OUR SOLAR SYSTEM

Shown from the top: Mercury, Venus, Earth and Moon, Mars, Jupiter, Saturn, Uranus and Neptune, taken by various space probes.

OUR SOLAR SYSTEM

The Solar System is made up of the Sun and all the objects that spin around it, from planets and moons, to chunks of rock and huge amounts of dust. The word *solar* means "of the Sun".

The Sun

The Sun is a star; that is, a massive ball of exploding gases. It applies a pulling force, called gravity, to everything within a range of around 6 billion km (3.75 billion miles), locking them into orbit around it.

The planets

The largest things that spin around the Sun are the planets. At the moment, scientists know of eight of them but there may be more that haven't been discovered yet. They travel around the Sun in near-circular paths, called orbits. The four planets closest to the Sun, called the inner planets, are small, rocky and compact. These are Mercury, Venus, Earth and Mars.

This picture shows the planets in orbit around the Sun.

The Sun is bigger than everything else in the Solar System put together.

Mars

Asteroid Belt

Venus

Earth

Mercury

The outer planets

The planets farther away from the Sun are called
the outer planets. These are Jupiter, Saturn,
Uranus and Neptune. They are all made
of ice, gas and liquids, and are
also known as the
gas giants.

Pluto

Neptune

Uranus

Jupiter

Saturn

Asteroids

Asteroids are large chunks of rock, or rock
and metal, that orbit the Sun. They formed
at the same time as the rest of the Solar
System. Most asteroids lie between Mars
and Jupiter in a band called the Asteroid Belt.

Comets

Comets are like huge, dirty icebergs orbiting
the Sun. Their paths take them far away, and
they only come near the Sun for a short time.
They are mostly named after who discovered
them. For example, Halley's Comet is named
after the astronomer Edmund Halley.

The dwarf planets

A new class of astronomical objects, called "dwarf
planets", was created in 2006. Pluto, Ceres, Eris,
Makemake and Haumea are now members. More
objects are being considered. You can find out
more about dwarf planets on page 37.

Moons

Many planets have moons in orbit around
them, just as our Moon orbits the Earth.
Some planets have many moons; for
example, Jupiter has at least 63. There
are different types of moon. Some are
rocky; others contain ice and liquid
as well as rock. Many, like our
Moon, have mountains, valleys
and craters. Others have still to
be photographed in detail.

Meteoroids

Small pieces of debris floating around in the
Solar System are called meteoroids. When
they fall into the Earth's atmosphere, they
burn up, in a bright streak across the sky.
Falling meteoroids seen in the night sky are
called meteors. Some meteors survive long
enough in the atmosphere to hit the Earth's
surface. These are called meteorites.

THE SUN

Like all stars, the Sun is a massive ball of exploding gas. Inside, tiny particles, called atoms, of hydrogen gas join together to form another gas called helium. This joining process is called nuclear fusion and gives off huge amounts of heat and light. This is sunshine. Without it, life could not exist on Earth.

How big?

The Sun measures about 1.4 million km (around 875,000 miles) across. Inside, it could hold more than a million planets the size of the Earth. But compared with the size of some of the other stars in the universe, the Sun is not all that big. This picture shows the size of the Sun compared with one of the biggest stars – Betelgeuse.

Sun ·

Betelgeuse

The structure of the Sun

Core. The Sun's core is twenty-seven times the diameter of the Earth. Its temperature is over 15 million °C (27 million °F).

Radiative zone. Heat produced in the core spreads through this part in waves.

Convective zone. This carries the Sun's energy up to the surface. The arrows show its churning motion.

The photosphere is the Sun's surface. It is made of churning gases.

The corona is the outer part of the Sun's atmosphere. It extends for a vast distance, but is very faint and cannot be seen unless the Sun is blocked out, for instance, by the Moon during an eclipse (see pages 16-17).

14

A sunspot, photographed from Earth using special photographic equipment.

The Sun's surface is sometimes marked with small, dark patches, called sunspots. They are areas of the Sun's surface that are slightly cooler than their surroundings. Occasionally, sunspots form in groups that can become enormous. The largest group yet seen covered an area of 18.13 billion square km (7 billion square miles).

Glowing gases

Clouds of glowing gases often surround sunspots, hovering just above the Sun's surface. These are called faculae. Huge loops of gas, called prominences, rise up from the surface at speeds of up to 600km (375 miles) per second. Explosions of radiation (waves of energy produced by the Sun), called solar flares, are even more violent and spectacular.

The solar wind

WARNING!

Never, ever look directly at the Sun through binoculars, a telescope or with the naked eye. Its strong light can easily blind you. Do not even look at it through smoked glass or sun filters, as they do not block out all the dangerous rays.

You can, however, look at the Sun indirectly. Point a pair of binoculars at the Sun with a piece of white cardboard behind them. Move the binoculars around until a bright circle appears. Focus them until the image is sharp.

Keep cover on this lens.

Sun's image

Light enters here.

An aurora is an eerily beautiful display of moving light, caused by the solar wind. It is visible from areas in the far north and the far south of the Earth.

The Sun blows a constant stream of invisible particles out into space, in all directions. This is called the solar wind. Solar wind hits the Earth all the time, but you don't feel it, because the Earth's magnetic forces deflect and soak up its energy.

When particles become trapped near the Earth's north and south poles, they create a beautiful light display, called an aurora. In the north, this is called the aurora borealis, or the northern lights. In the south, it is called the aurora australis, or the southern lights.

This photo shows the Sun's endlessly churning surface.

ECLIPSES

As the Earth and Moon move in space, they sometimes block each other from the Sun's light. This is known as an eclipse. Every now and then you can see an eclipse. It is an exciting event and often makes the news. There are two different types – a lunar eclipse and a solar eclipse.

Lunar eclipses

A lunar eclipse happens when the Earth passes between the Sun and the Moon. The Moon moves into Earth's shadow.

A lunar eclipse can be seen from the side of the Earth that is in darkness. The Moon looks dim in the sky. It often glows a reddish shade.

There is usually one eclipse every year. They can be seen with the naked eye, but look better through binoculars.

A total lunar eclipse

Like any shadow, the Earth's shadow is lighter at the edges and darker in the middle. If the Moon passes into the darker part, called the umbra, a total eclipse takes place. The Moon looks very dark.

A total lunar eclipse. The Moon is in the Earth's shadow.

A partial lunar eclipse

The Moon passes into the Earth's shadow.

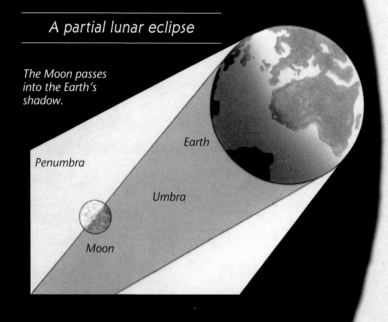

Penumbra

Earth

Umbra

Moon

A partial eclipse happens when part of the Moon stays in the lighter part of the shadow, the penumbra. The Moon turns less dark than during a total eclipse.

A partial eclipse also occurs if the Moon misses the umbra completely and only goes through the penumbra. It is much less noticeable, though.

The big photograph on this page shows a total eclipse of the Sun (a solar eclipse – see opposite). The Sun is blocked out completely by the Moon's shadow. The bright glow of light around the dark shadow is the corona, the outer part of the Sun's atmosphere.

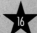

Solar eclipses

A solar eclipse happens when the Moon passes between the Sun and the Earth, blotting out sunlight to part of our planet. Solar eclipses only happen about once every three to four years and usually only last for two to three minutes.

During a total solar eclipse, the corona is visible to the naked eye. You can look at the total eclipse but you mustn't look at the Sun's rays that appear before or after it. An annular eclipse occurs when the Moon passes directly in front of the Sun but has a ring of sunlight visible around it. Some eclipses can look either total or annular depending where they are seen from. These are called hybrid eclipses.

1.The Moon approaches the Sun.

2. The Moon slides over the face of the Sun.

Seeing the eclipse

A solar eclipse can only be seen from the places on Earth which are covered by the Moon's shadow. It only covers a small part of the Earth's surface.

The series of pictures on the right shows what happens during an eclipse.

3. The Sun's light is partly blocked out. This is a partial eclipse.

4. In a total eclipse, the Sun is blocked out. Only the corona can be seen.

A total solar eclipse can be seen from places in the umbra.

A partial eclipse can be seen from places in the penumbra.

LOOKING SAFELY
The best way to see a solar eclipse is to project an image of it (see page 15). DO NOT look straight at the eclipse, or view it through smoked glass, or look at it through binoculars or a telescope. The rays from the Sun may blind you.

The diamond ring effect

This is a dazzling effect that sometimes happens during a solar eclipse. Immediately before and after the eclipse, a big ray of sunlight may shine out, which looks like a diamond.

Diamond ring

Gases of the corona

Solar flares

MERCURY

Of all the planets in our Solar System, Mercury is the closest to the Sun. It orbits at a distance from the Sun of about 58 million km (around 36 million miles).

Since Mercury is the planet nearest the Sun, it orbits the Sun in a shorter time than any other planet.

Mercury

Sun (not shown to scale)

Heat and cold

Mercury is so near the Sun that daytime temperatures can reach 427°C (800°F). This is over four times as hot as boiling water.

Mercury's desolate, cratered surface.

But at night, the temperature can fall to -183°C (-300°F). Some of the craters on Mercury are so deep that the sunlight never reaches the bottom to warm them up. They stay extremely cold.

Tiny planet

Mercury is the smallest planet in the Solar System. Only the dwarf planets are smaller. Mercury's diameter is 4,880km (3,032 miles). The Earth's diameter is nearly three times greater.

Earth

Moon *Mercury*

Mercury drawn to scale with the Earth and Moon.

Years and days

Mercury's year (the time it takes to orbit the Sun) takes 88 Earth days. So a year on Mercury is less than a quarter of a year on Earth.

Mercury spins slowly. Each day (the time it takes to spin around once) is equal to 59 Earth days. There are fewer than two days in the Mercury year. The long periods facing away from the Sun explain why it gets so cold at night.

Seeing Mercury

You can sometimes see Mercury in the sky just after sunset or just before sunrise. Look for it low in the sky. It will look like a white star, shining steadily.

At its brightest, you can see Mercury with the naked eye, but it is best to view it using a telescope or binoculars.

The bright spot in the middle of this photograph is Mercury.

WARNING!
You should only look for Mercury after the Sun has fully set or before it has begun to rise. You might blind yourself if you even glimpse the Sun's rays through a telescope or binoculars.

Mercury's phases

Mercury's brightness and shape appear to change as it goes around the Sun. The changes are called phases. It is possible to see Mercury's different phases, but only through a powerful telescope.

When Mercury is nearer to the other side of the Sun, it looks small and faint because it is so far away. More of it looks lit up, though. (See gibbous and full phases below.)

As it comes around the Sun, Mercury appears bright and relatively large because it is closer to us. Less of its surface looks lit up, though. (See crescent phases below.)

Full phase
(entirely visible)
Gibbous
Sun
Gibbous
Half phase
Half phase
Crescent
New phase
(invisible)
Crescent

Mariner 10, the first space probe to visit Mercury.

Space probes

The first mission to Mercury was the unmanned US space probe Mariner 10, launched in 1973. It discovered a rocky surface covered with sharp-edged craters, but no water or atmosphere, showing that no life could exist there.

In 2008, NASA's MESSENGER probe reached Mercury. During fly-bys, it's taken thousands of images, mapped features such as lava plains, and found evidence that Mercury used to have volcanoes.

A Mariner 10 photograph of Mercury's surface.

VENUS

This planet is a similar size to the Earth. It orbits the Sun at a distance of about 108 million km (67 million miles). From its mostly flat surface rise several areas that resemble the continents of the Earth.

Sunlight

Mercury *Venus*

These planets, and the distances between them, are not shown to scale.

Venus's thick atmosphere reflects most of the sunlight that hits it.

Heavy atmosphere

Venus's atmosphere is very thick. It is mainly made of carbon dioxide gas and is so dense that it presses down on the planet's surface like a great weight. Venus also has clouds made of sulphuric acid. These cause rains that would burn any living thing on the surface.

Morning and evening star

At some times of the year, you can easily see Venus with the naked eye, just before sunrise, or just after sunset. Many astronomers call it the morning star or the evening star, depending on what time of the day it appears. After the Sun and Moon, Venus is the brightest thing in the sky.

This image shows mountains on Venus. It was taken by the Magellan space probe.

Venus's atmosphere reflects the Sun's light like a huge mirror. This is why Venus appears so bright in the sky.

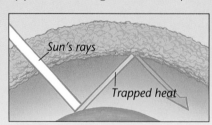

Sun's rays

Trapped heat

Heat from the Sun which does get through the clouds is trapped. On the surface, the temperature can rise to around 480°C (about 900°F).

Slow backspin

Earth's spin *Venus's spin*

Venus spins in the opposite direction to the Earth and most other planets.

It takes longer for Venus to rotate once than it does for it to orbit the Sun. This means that on Venus, a day is longer than a year.

Probing Venus

Nobody knew what the surface of Venus looked like until 1975, when two space probes named Venera were sent by the Soviet Union.

Using radar to see through the clouds, the Venera probes mapped the planet's surface. A robot sent to the surface found that it was covered in sharp rocks and looked like a gloomy, orange-brown desert.

The US space probe Magellan studied Venus in great detail in the 1980s and '90s.

It found that its surface is covered mostly by areas of solidified lava, which has flowed out of the many volcanoes that occur on Venus.

Magellan also found strange cracks and lines, like spiders' webs. Called arachnoids, these are only found on Venus, and are thought to have formed when lava cracked its surface.

In 2006, the European Space Agency probe Venus Express arrived. Since then it has studied Venus's swirling acid clouds.

Venus and the Magellan space probe

Craters

Like Mercury and Mars, Venus has craters, but they are shallower. Venus's thick atmosphere slows down objects which pass through it, so they hit the surface with less force, creating shallower craters.

This dark splodge on Venus was created when an incoming object exploded. The splodge was caused by shock waves from the explosion.

These small craters were formed when shattered pieces of an object fell onto Venus's surface.

WARNING!
Always make absolutely sure that the Sun has fully set (in the evening) or has not begun to rise (in the morning) before you look for Venus. You might blind yourself if you glimpse the Sun accidentally through a telescope or binoculars.

This mountain peak is called Gula Mons.

THE EARTH

The Earth orbits the Sun at a speed of about 110,000kph (almost 70,000mph). It is about 150 million km (around 94 million miles) away from the Sun. Planet Earth takes exactly 365.256 days (one Earth year) to orbit the Sun once.

Mercury Venus Earth

These planets, and the distances between them, are not shown to scale.

Life on Earth

The Earth's distance from the Sun causes it to have the right temperature for water to exist as a liquid, rather than just as ice or water vapour. Earth also has a breathable atmosphere. Animals and plants need both these things in order to live.

A satellite image of Earth, which has been coloured using a computer. In blue, you can see the water, which supports life on Earth. Areas of forest are shown in red. Areas of forest which have been cut down are shown in green.

The atmosphere

The Earth's atmosphere is a mixture of gases that surrounds the planet. It has different layers. Oxygen, which living things use to breathe, makes up about 20% of the atmosphere.

Exosphere. Weather satellites orbit here. It has almost no gases.

Thermosphere. The aurorae (see page 15) are seen in this layer.

Mesosphere. Meteors burn up here.

Stratosphere. Jet planes fly here. It contains the ozone layer, which blocks the Sun's harmful rays.

Troposphere. The weather happens here.

Inside the Earth

Like Mercury, Venus and Mars, the Earth has a rocky crust and a solid metal core. In between the two are different layers.

Crust. This layer is rocky and is a maximum of 50km (31 miles) deep.

Mantle. This layer is partly liquid. It contains 67% of the Earth's mass.

Outer core. This layer is liquid and constantly moving.

Inner core. This layer is solid and made mostly of iron.

The Earth's crust is made up of separate pieces, called plates, which rub against one another. They are always moving, sometimes causing earthquakes at the points where they meet.

Looking back at Earth from space

Today, we are learning more and more about our planet from information sent back by satellites and space stations.

Weather forecasters use information collected by satellites to predict weather patterns. They can use this information to warn people of severe weather conditions.

Information from satellites is also used to find out about the Earth's surface. Areas that are normally hard to see, such as the ocean floor, can now be seen in detail.

This satellite picture shows hurricane clouds approaching the east coast of the USA.

This satellite image shows the ridges on the ocean floor between South America and Africa.

Earth in danger

As the world's population grows, we use up more land, and our vehicles and industries cause more pollution. This damages the whole environment: the land, oceans and atmosphere.

The biggest problem is caused by carbon dioxide gas trapping heat in the atmosphere – a milder form of what happens on Venus (see page 20). Scientists think that unless we cut down this pollution, Earth will grow too hot, causing sea ice to melt and oceans to rise.

The picture across the bottom of these pages is a satellite image of Earth, showing Europe, from Portugal across to the borders of Russia.

THE MOON

The Moon orbits the Earth. It is about 384,000km (239,000 miles) away. Most moons are very small compared with the planets that they orbit, but our Moon is large compared with the size of the Earth. It is about a quarter of the Earth's size.

This is what the Earth looks like when seen from the Moon.

The Earth's effect

Earth's gravity makes the Moon spin. It takes the same time for the Moon to spin around once as it does for it to orbit Earth. This means that the same side of the Moon is always facing us.

The Moon spins as it orbits Earth.

In 1969, the US Apollo 11 space mission landed people on the Moon for the first time in history.

An Apollo astronaut exploring the Moon.

Massive craters

The photograph above shows Copernicus, one of the Moon's craters. It is so large that a city the size of London could fit inside it.

The Moon's craters were made by meteorites hitting it. On a clear night, when the Moon is full, you can see big craters such as Copernicus with the naked eye.

Many of the Moon's craters are surrounded by pale lines, called rays. They were made by dust that was thrown out when the meteorites landed.

Seas on the Moon?

There are lots of dark patches on the Moon's surface. These are flat areas of lava which has cooled and become solid. The lava originally poured out of volcanoes.

From the Earth, these flat areas look like seas. Early astronomers called them *mares* (pronounced *mar-ays*), which means "seas" in Latin.

The dark patches on the Moon's surface are the seas.

Mountains

The Moon's surface is very mountainous. The highest mountain range is called the Apennines. One of its peaks is nearly as high as Mount Everest, the highest mountain on Earth.

This picture shows the side of the Moon that always faces away from Earth.

Temperatures

On Earth, the atmosphere works like a roof. It stops the Sun from making things too hot during the day. At night, it prevents heat from escaping.

The Moon has no atmosphere to protect it. The Sun's rays can make the temperature rise to 123°C (253°F), which is hotter than boiling water.

When the Sun is not shining on the Moon, the temperature can fall to -123°C (-189°F). This is colder than anywhere on Earth.

Phases of the Moon

The Moon does not make its own light, but it reflects the Sun's rays. It can look very bright in the night sky.

The shape of the Moon seems to change from night to night. This is because, as the Moon orbits the Earth, different amounts of its sunlit side are visible. The different shapes are called the phases of the Moon.

It takes 28 days for the Moon to orbit the Earth once. The diagram on the right shows how the Moon's phases occur.

Direction of sunlight — *Moon* — *Earth*

The pictures below show what the Moon looks like from Earth when it is in each of the numbered positions shown above.

 1. New moon
 2. Crescent
 3. Half moon
 4. Waxing

 5. Full moon
 6. Waning
 7. Half moon
 8. Crescent

Internet links: For links to the websites for this book go to
www.usborne-quicklinks.com and enter the keyword "**astronomy**".

MARS

Mars is the fourth planet from the Sun, orbiting at about 228 million km (142 million miles). Mars takes nearly 687 days to orbit the Sun. This is almost twice as long as it takes Earth to do the same.

Mars is only about half the size of Earth.

Mercury Venus Earth Mars

These planets, and the distances between them, are not shown to scale.

Looking at Mars

Mars is visible with the naked eye. It looks like a bright, orange-red star. To see any features on its surface, you need to use a powerful telescope.

Two moons

Mars's moons, Phobos and Deimos, are both dark, dusty and irregular in shape. Phobos orbits Mars at just 6,000km (3,730 miles). Deimos orbits at 20,000km (12,500 miles).

Deimos, Mars's smaller moon, is about 15km (9 miles) across at its widest.

Many scientists think that the oddly-shaped moons are really asteroids that became trapped in orbit around Mars millions of years ago.

Phobos is 28km (17 miles) across at its widest. It has a large crater on it, called Stickney. The crater is about 5km (around 3 miles) across.

The surface of Mars. It is cold, dusty and marked with many craters and canyons.

On the surface

Mars is extremely dusty. The soil contains large amounts of iron, which gives the planet a rusty look. Up close, the landscape looks like bleak orange sand dunes, scattered with thousands of rocks.

Water for life?

Early space probes took photographs of deep channels on Mars, suggesting that water once flowed there, possibly even in the form of rivers and oceans. Water is essential for plants and animals to live. So if there was water on Mars, then living things may have been able to exist there.

Pictures taken recently by the Mars Global Surveyor probe suggest that liquid water may still exist beneath the surface of Mars. If so, there might still be life on the Red Planet.

This sunset on Mars was taken during the Mars Pathfinder mission in the late 1990s.

This dry channel on Mars may once have been a flowing river.

Martian meteorite

In 1984, a meteorite landed on Earth. The meteorite was analysed by scientists in 1996. They decided that it almost certainly originated from Mars, due to the chemical nature of the rock.

These scientists claim that the meteorite contains fossils of microscopic bacteria-like creatures that lived millions of years ago. If true, this would prove that there were once some simple forms of life on Mars.

Mariner 4

Other scientists, however, doubt this theory. Instead, they claim that the remains are not of living things, but of other chemical material.

Investigating Mars

In 1965, NASA's Mariner 4 probe sent back the first photos of Mars's surface. In the 1970s, the Viking probes sent back pictures with greater detail.

When the 2007 Mars Pathfinder probe landed, it dropped off Sojourner, a remote-controlled rover which roamed the planet, photographing rocks.

Since 2004, Opportunity and Spirit, a pair of robotic rovers, have been driving on Mars. They've sent back thousands of detailed photos of mountains, craters, dust storms and sunsets – even Earth in the Martian sky.

Sojourner, the first surface rover on Mars

JUPITER

Jupiter is the largest planet in the Solar System. It orbits the Sun at a distance of 778 million km (483 million miles). It is so large that over 1,000 planets the size of Earth could fit into it. Astronomers have counted 63 moons orbiting Jupiter, but there may well be more.

Mercury Venus Earth Mars Jupiter

These planets, and the distances between them, are not shown to scale.

Great balls of gas

Jupiter is one of four planets that are made mostly of gas. The others are Saturn, Uranus and Neptune. Together, they are called the gas giants.

Jupiter is so vast that it exerts an enormous gravitational pull on things around it. Asteroids and meteoroids that come near it are sucked into its atmosphere. Jupiter is like a giant vacuum cleaner in space, sucking up pieces of space debris.

Looking at Jupiter

After the Sun, Moon and Venus, Jupiter is the brightest object in the sky. You can see it easily with the naked eye as a bright star. Using a good telescope, you can see its tinted cloud bands and the famous Great Red Spot.

The Galileo space probe made a detailed study of Jupiter.

The Great Red Spot

The Great Red Spot is a huge storm 8km (5 miles) high, 40,000km (25,000 miles) long and 14,000km (8,700 miles) wide. Its winds blow at about 500kph (310mph).

As the spot moves around, it swallows up other storms. But it is shrinking. It is only half as big as it was 100 years ago.

Jupiter's Great Red Spot

Probing Jupiter

Several space probes have been sent to Jupiter.

Pioneer 10

The first, Pioneer 10, was sent by the USA in 1972. It reached Jupiter in 1973 and beamed amazing pictures of Jupiter's clouds back to Earth.

Voyagers

In 1979, the Voyager probes discovered that Jupiter has three very faint rings, too fine to be seen from Earth.

Galileo

This is a Galileo image of Jupiter's faint outer ring, known as the gossamer ring.

The Galileo probe reached Jupiter in 1995 and spent eight years studying the planet and its moons before burning up in its atmosphere. In 2000, the Cassini probe flew past and took amazingly detailed images. The New Horizons probe passed Jupiter in 2007 and saw new volcanoes erupting on its moon Io.

This picture shows what scientists think Jupiter's structure may be.

① The atmosphere's top layer is broken by high winds into vast clouds. It forms a beautiful blend of red, brown, orange and yellow.

② The dark bands are gaps in the clouds. You can see through them to deeper, hotter layers of the planet's churning atmosphere.

③ This layer is 17,000km (10,565 miles) thick. Made of hydrogen gas, it is so compressed that it behaves like liquid.

④ This layer is also made of hydrogen. It is even more compressed and behaves like a solid. It is so heavy that it makes up over 77% of Jupiter's mass.

⑤ The core is solid and rocky. It is slightly larger than Earth.

Many moons

Astronomers know of at least 63 moons in orbit around Jupiter. The four largest (shown here*) are called the Galilean Moons after the Italian scientist Galileo, who discovered them in 1610. You can see these moons with binoculars.

Jupiter's other moons are much smaller, and some may be just asteroids, or debris from a moon that was destroyed.

Europa. A deep ocean beneath the icy crust may hold simple life forms. Many scientists think that there is a greater chance of finding life on Jupiter's moons than anywhere else in the Solar System.

Callisto. This moon is basically a ball of dusty ice. It is scarred with hundreds of craters that make it look similar to Earth's moon.

Io (below) is covered with volcanoes that pour sulphur onto the surface.

Ganymede is the largest moon in the Solar System. It is even larger than the planet Mercury.

Europa's icy surface, shown here in blue.

*The Galilean Moons are not shown to

SATURN

S aturn is the second largest planet in the Solar System. It is often called the ringed planet because it is surrounded by distinctive rings of dust and rocks. Lying about 1,429 million km (888 million miles) from the Sun, Saturn orbits once every 29 Earth years.

Earth

This image of Saturn was taken by the Hubble Space Telescope and beamed back through space. Compare Saturn with the size of the Earth, shown above it.

Mercury Venus Earth Mars Jupiter Saturn

These planets, and the distances between them, are not shown to scale.

Saturn's moons

Astronomers know that Saturn has at least 61 moons. Here are details of some of them.

Second biggest

Saturn is smaller than Jupiter, but it is still enormous. It measures 116,464km (72,367 miles) across – nine times wider than the Earth.

Gas giant

Like Jupiter, Saturn is a gas giant. It is made up mostly of hydrogen. Its atmosphere also contains a lot of helium, which is a very light gas. This makes Saturn a relatively light planet. In fact, if you could find an ocean that was big enough to drop Saturn into, the planet would float.

Astronomers believe that inside, Saturn may be similar to Jupiter.

Spinning planet

Saturn spins very quickly, taking just ten hours to go around. As a result of this fast spin, the gases in its atmosphere are flung out towards its equator – the imaginary line around Saturn's middle.

Saturn bulges out in the region of its equator.

The gases bulge out, making Saturn fatter in the middle. You can see this even through a home telescope.

Mimas is 390km (244 miles) wide and covered in craters. The impact that created its largest crater nearly destroyed it. Its nickname is the "Death Star".

Enceladus has an icy surface. The Cassini probe has photographed jets and plumes of water vapour shooting out of cracks in its crust.

Tethys has massive craters and long valleys. The longest valley, Ithaca, is 2,000km (1,243 miles) long. Its largest crater, Odysseus, is 400km (240 miles) wide.

Saturn's largest moon, Titan, is even bigger than Mercury. In 2006, the Cassini probe discovered lakes of liquid methane on its surface.

Early observations

Early astronomers, using their unsophisticated telescopes, could not see Saturn's rings in much detail. In fact, when the seventeenth-century Italian astronomer Galileo first saw them, he thought that he was seeing three planets in a row. Later, he became convinced that Saturn had rings around it.

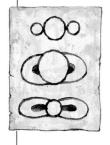

Here are some drawings Galileo made of his early observations of Saturn. They show how he first mistook the rings for planets.

This amazing Voyager 2 image of Saturn's rings was downloaded from one of NASA's websites on the internet.

Saturn's rings

Space probes have sent back lots of information about Saturn's rings. The first space probe to visit Saturn was Pioneer 11. In 1979, it sent photographs of Saturn back to Earth. Later, the Voyager expeditions revealed even more.

★ Saturn's rings are only about 1km (less than a mile) thick. They are made up of particles that range in size from specks of dust to large, icy boulders.

Pioneer 11

★ The rings that are visible from Earth are in fact made up of thousands of smaller ones, called ringlets. The two outermost ringlets are twisted around each other, like strands in a rope.

★ The outer ring particles are kept in place by the gravity of two small moons which orbit Saturn. These are called the Shepherd Moons.

★ Clouds of fine dust, looking like the spokes of a wheel, rotate around Saturn above one of its rings. It is now possible to see these spokes through powerful telescopes.

Disappearing rings

As Saturn and Earth go around the Sun, our view of the rings changes. This is because Saturn lies on a slight tilt (just like Earth and most other planets) so that its rings are also at a tilt.

When Saturn's angle of tilt is side-on to the Earth, the rings almost disappear.

When the top of Saturn is pointing towards us, the rings look like this.

When the top of Saturn is pointing away from us, the rings look like this.

Internet links: For links to the websites for this book go to **www.usborne-quicklinks.com** and enter the keyword "**astronomy**".

URANUS

Ariel

Uranus is the seventh planet from the Sun, lying at a distance of 2,871 million km (around 1,784 million miles). It takes just over 84 Earth years to orbit the Sun. It was first identified as a planet by the British astronomer William Herschel in 1781.

Mercury Venus Earth Mars Jupiter Saturn Uranus

These planets, and the distances between them, are not shown to scale.

Seeing Uranus

At its brightest, Uranus can be glimpsed with the naked eye if you know just where to look. Like the other planets, though, it appears to change its position among the stars. It looks like a star, although it does not twinkle.

Strange spin

Uranus spins on its side. No other planet does this. Many astronomers think that its unusual spin is the result of a collision with a planet-sized object millions of years ago.

Uranus's rings

Like Saturn and Jupiter, Uranus has rings. They were first discovered from Earth in 1977. Then, in 1986, the Voyager space probe photographed and measured them. Mostly, the rings are made up of dust. The outer ring's dust is particularly dark.

Uranus

This picture shows Uranus rolling on its side as it orbits the Sun.

Umbriel

Titania

Oberon

Miranda

What Uranus is made of

The atmosphere of Uranus is mostly hydrogen gas, with helium and tiny amounts of other gases. The upper atmosphere contains a lot of helium, which makes Uranus look blue-green. The planet has a small, rocky core.

Spinning and orbiting

Uranus spins quickly, taking just 18 hours to make one complete turn. Earth takes 24 hours to spin once, but Uranus is far larger, so at its cloud tops it moves far faster than the Earth.

In its orbit of the Sun, Uranus moves through space at about 7km (4¼ miles) per second. In comparison, the Earth moves at nearly 30km (19 miles) per second.

Moons around Uranus

Uranus has at least 27 moons, most named after characters in plays by William Shakespeare.

Its five biggest moons are shown above. Ariel and Umbriel are both dark and cratered, while Titania has deep, long valleys. Oberon is heavily cratered, but little else is known about this moon. Miranda is a small ball of battered ice, only 472km (293 miles) across. It is thought that it may once have been broken apart by a comet.

This grooved feature (bottom left) on Miranda, is known as the Chevron.

NEPTUNE

Neptune was first identified as a planet in 1846 by the German astronomer Johann Gottfried Galle. Neptune is the fourth of the gas giants. It is slightly smaller than Uranus. It spins once every 16 hours.

Mercury Venus Earth Mars Jupiter Saturn Uranus Neptune

These planets, and the distances between them, are not shown to scale.

A photo of Neptune, taken by the Voyager 2 space probe in 1989.

Distant planet

Neptune is over 4.5 billion km (about 2.8 billion miles) from the Sun. It is so far away that it takes nearly 165 Earth years to orbit the Sun.

Neptune cannot be seen with the naked eye, and through binoculars it looks like a star. Powerful telescopes show it as a small, bluish circle.

Featureless

Because it is so far from Earth, astronomers had, until recently, been unable to see Neptune in detail. They assumed that Neptune would be a rather dull-looking planet. However, the space probe Voyager 2's cameras proved that it is similar to the other gas giants. For instance, fierce storms rage across its surface.

Dark spots

Several dark spots have been seen on Neptune. The largest, about the size of Earth, is called the Great Dark Spot. It may be a gigantic storm, like the Great Red Spot on Jupiter.

The Great Dark Spot, shown above, was first seen by the Voyager 2 probe in 1989. But in the 1990s, the Hubble Space Telescope could not find it. Nobody is sure why the Great Dark Spot vanished, or whether it will reappear.

Blue planet

Neptune's bluish appearance comes from the methane gas in its atmosphere, which has a blue colour. Neptune's atmosphere also contains hydrogen, helium and water.

Beneath its dense, thick, cloudy atmosphere, Neptune is thought to be made up of a mixture of molten rock, water, liquid ammonia and methane.

Neptune's moons

Neptune has 13 moons. The biggest of them are Triton and Nereid. Triton is even bigger than the dwarf planet Pluto. Unlike most moons, it orbits in the opposite direction to Neptune's spin, as shown below.

Neptune

Triton

Most of Triton's surface is bright and smooth. It has some dark streaks over its surface and pink ice around its south pole. It has a thin atmosphere.

This photo of Triton shows the smooth part of its surface on the left. A more pitted area is shown on the right. It was taken by the Voyager 2 space probe.

Stormy surface

Long, wispy clouds race around Neptune. They are blown by the fastest winds found on any planet in the Solar System. Near the Great Dark Spot, the winds blow at up to 2,000kph (1,200mph).

One cloud zooms around Neptune once every 16 hours. Scientists have nicknamed this cloud the Scooter, because it scoots over the planet so quickly.

Almost all our knowledge of Neptune came from the Voyager 2 space probe's fly-past in 1989. Voyager 2 found several incomplete rings around Neptune. They were so dark that nobody could see them from Earth.

Internet links: For links to the websites for this book go to
www.usborne-quicklinks.com and enter the keyword "**astronomy**".

35

PLUTO

For a long time, Pluto was considered to be the planet farthest from the Sun. But in 2006 it was reclassified as a "dwarf planet", so now Neptune holds the title. Astronomers are still finding out new things about this distant world, such as discovering new moons.

Mercury Venus Earth Mars Jupiter Saturn Uranus Neptune Pluto

These planets, and the distances between them, are not shown to scale.

Far away and hard to see

Pluto's distance from the Sun varies greatly. At its closest, it is 4.4 billion km (2.8 billion miles) from the Sun. In fact, for 20 years out of its 248-year orbit, it's closer to the Sun than Neptune. At its farthest, it's 7.4 billion km (4.6 billion miles) away. Because Pluto is so distant, it's very hard to see from Earth. Even Earth's most powerful telescopes show Pluto as a tiny circle with no surface markings. But Hubble Space Telescope images suggest that it may look like Neptune's moon, Triton. Pluto's diameter is 2,274km (1,413 miles), slightly smaller than Triton.

Pluto's oval orbit is tilted at an angle compared with the other planets.

Pluto

Neptune

Sun

Earth

Finding Pluto

The planets pull at each other, affecting the shapes of each other's orbits. Before Pluto was discovered, astronomers thought that Uranus and Neptune were being pulled by an unknown planet beyond Neptune. They nicknamed it "Planet X", and thought they'd found it in 1930, when Pluto was discovered by American astronomer Clyde Tombaugh.

Beyond Planet X

Astronomers now know that Pluto is too small to affect the orbits of Uranus and Neptune very much. Astronomers have found other ways to explain their orbits, so a Planet X is now thought unlikely. But that doesn't mean Pluto is alone.

Pluto and its largest moon, Charon.

Pluto's moons

Pluto has three moons. Two, Nix and Hydra, are very small and were discovered by the Hubble Space Telescope in 2005. The largest moon, Charon, was found in 1978. Astronomers studying a photo of Pluto noticed that it looked stretched out. More detailed photos revealed the moon.

Charon is unusually large for a moon. It is nearly half as big as Pluto. Some astronomers think that Pluto and Charon are really a pair of dwarf planets.

Pluto and Charon, as seen through the Hubble Space Telescope.

Pluto's mysteries

Photographs suggest that Pluto has a surface of frozen methane and nitrogen. It may also have a thin atmosphere. Its poles are brighter than its other regions.

A NASA space probe called New Horizons will fly past Pluto in the year 2015. It will take pictures of Pluto's icy surface and moons as it races by. Some astronomers believe it may discover more new moons, or even faint rings around Pluto.

Close together

Pluto and Charon

Earth *Moon*

In space terms, Charon and Pluto are very close to one another. They are only about 20,000km (12,000 miles) apart. The Earth and the Moon are about 384,000km (239,000 miles) apart.

Dwarf planets

In the 1990s, astronomers discovered that Pluto orbits with many other small, icy bodies in an area of space called the Kuiper Belt. Then in 2005, Eris, an object larger than Pluto, was found.

In 2006, a group of astronomers ruled that Pluto and Eris should not be counted as planets because they share their orbit with other objects. They were named "dwarf planets". Other astronomers disagree, and still see Pluto as a planet. There are now three more dwarf planets: Ceres, the largest object in the Asteroid Belt, and Makemake and Haumea, in the Kuiper Belt.

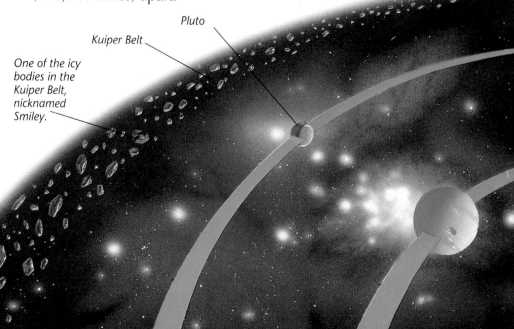

One of the icy bodies in the Kuiper Belt, nicknamed Smiley.

Kuiper Belt

Pluto

ASTEROIDS

Asteroids are large pieces of either rock, or rock and metal. Scientists believe that they are the bits and pieces that were left over when our Solar System formed five billion years ago.

The first sighting

In 1801, an Italian astronomer named Piazzi spotted an object in space through his telescope. At first, he thought it was a small planet. Piazzi named his discovery Ceres.

Soon, other astronomers noticed similar objects. They shone at night like faint stars, so they were named *asteroids*, which means "like stars".

Close-up first

In 1991, the space probe Galileo took the first close-up pictures of an asteroid. The images showed that the asteroid, called Gaspra, is more than 20km (12 miles) across, irregular in shape and pitted with craters. In 2001, a probe called NEAR actually landed on another asteroid called Eros, after orbiting it for a year.

The space probe Galileo showed Gaspra to be dark reddish-brown, with patches of grey and blue. It may be two asteroids joined into one by a collision.

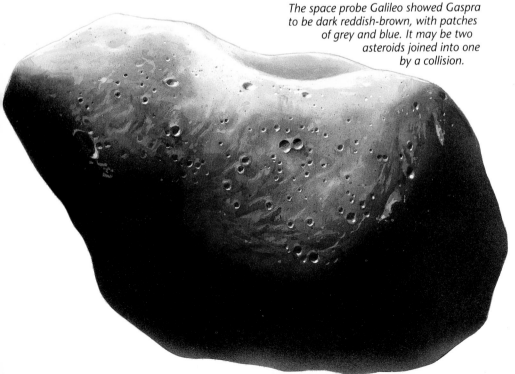

Killer asteroid

Very rarely, asteroids collide with the Earth, leaving large craters. Scientists think that a massive asteroid slammed into the Earth 65 million years ago, causing more damage than thousands of nuclear bombs.

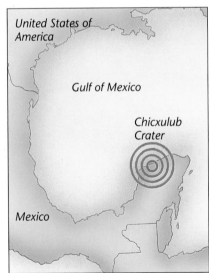

The site of the impact is thought to be the Chicxulub Crater in Mexico.*

It is possible that the force of this asteroid caused tidal waves in the sea and fires over the land that blotted out the sunlight for years. Many types of plants and animals, including the dinosaurs, died out.

**Pronounced "chick-shu-lub".*

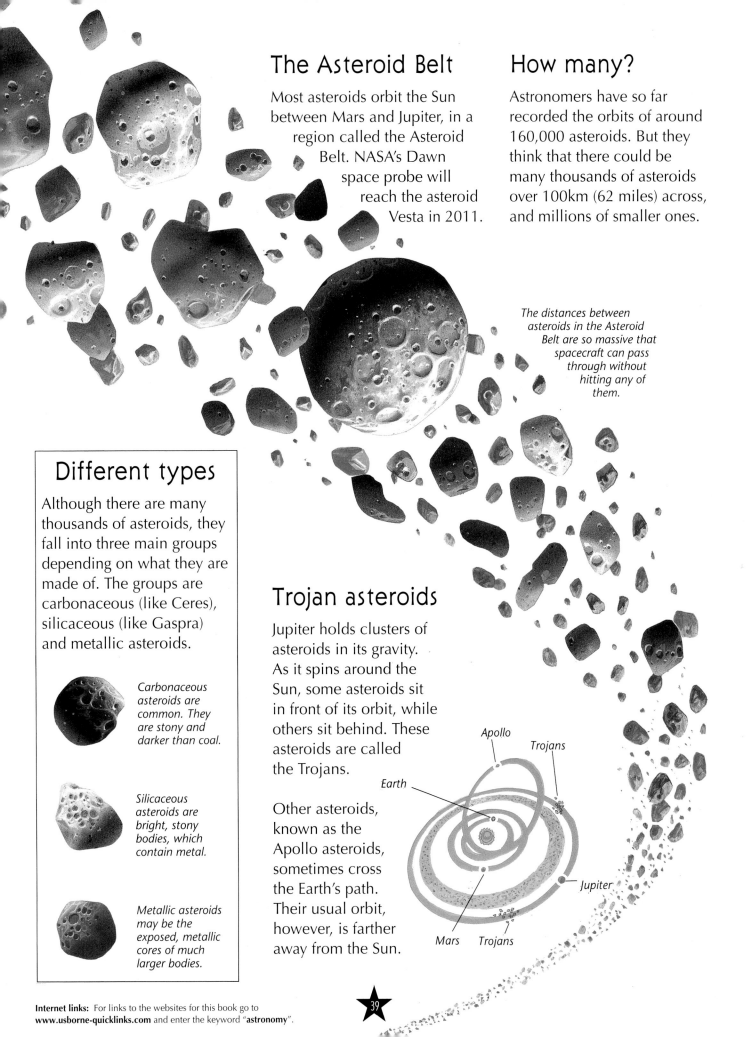

The Asteroid Belt

Most asteroids orbit the Sun between Mars and Jupiter, in a region called the Asteroid Belt. NASA's Dawn space probe will reach the asteroid Vesta in 2011.

How many?

Astronomers have so far recorded the orbits of around 160,000 asteroids. But they think that there could be many thousands of asteroids over 100km (62 miles) across, and millions of smaller ones.

The distances between asteroids in the Asteroid Belt are so massive that spacecraft can pass through without hitting any of them.

Different types

Although there are many thousands of asteroids, they fall into three main groups depending on what they are made of. The groups are carbonaceous (like Ceres), silicaceous (like Gaspra) and metallic asteroids.

Carbonaceous asteroids are common. They are stony and darker than coal.

Silicaceous asteroids are bright, stony bodies, which contain metal.

Metallic asteroids may be the exposed, metallic cores of much larger bodies.

Trojan asteroids

Jupiter holds clusters of asteroids in its gravity. As it spins around the Sun, some asteroids sit in front of its orbit, while others sit behind. These asteroids are called the Trojans.

Other asteroids, known as the Apollo asteroids, sometimes cross the Earth's path. Their usual orbit, however, is farther away from the Sun.

Apollo
Trojans
Earth
Jupiter
Mars Trojans

Internet links: For links to the websites for this book go to **www.usborne-quicklinks.com** and enter the keyword "astronomy".

COMETS AND METEORS

Compared with the Sun and the planets of the Solar System, comets and meteors are small. Scientists believe that, like asteroids, they are pieces of debris left over from when the Solar System formed. They are like pieces of space litter that whizz around the Solar System. Occasionally, you can see them from Earth.

One of the longest comet tails ever recorded was that of the Great Comet of 1843. It was about 330 million km (about 200 million miles) long.

Comets

Comets are chunks of dirty ice mixed with dust and grit. They have oval-shaped orbits, so they spend most of their time far from the Sun and only come near it for a brief time.

The comet's icy nucleus is hidden in here.

Tail

Coma

Glowing tail

The solid part of a comet (the nucleus) is surrounded by a cloud of glowing gases, called the coma.

The coma stretches out into a tail that can become broken up into streamers, with delicate twists and swirls.

How big?

Most comets have a nucleus that is less than 10km (about 6 miles) wide.

As a comet approaches the Sun, the coma can be as long as 80,000km (50,000 miles), with a tail of over 1 million km (600,000 miles).

Seeing a comet

Comets can be seen from Earth only when they are fairly near to the Sun. Most look like smudges of light, even through telescopes.

Some comets have very long orbits which take them far out into the rest of the Solar System. They may only be seen from Earth once every few thousand years. Comets with shorter orbits can be seen more often and it is easier to predict their return.

Between 1995 and 1997, comet Hale-Bopp came into view. It was the clearest comet for nearly a hundred years. Its nucleus may be as wide as 40km (25 miles).

When a comet is far away from the Sun, it all remains solid. It has no tail and it speeds through space like a dirty snowball.

As the comet nears the Sun, the Sun's rays start to melt it. Gas and dust begin to stream out into space forming a cloud which is called the coma.

A constant stream of particles from the Sun, called the solar wind, blows some of the coma out behind it to form a spectacular tail.

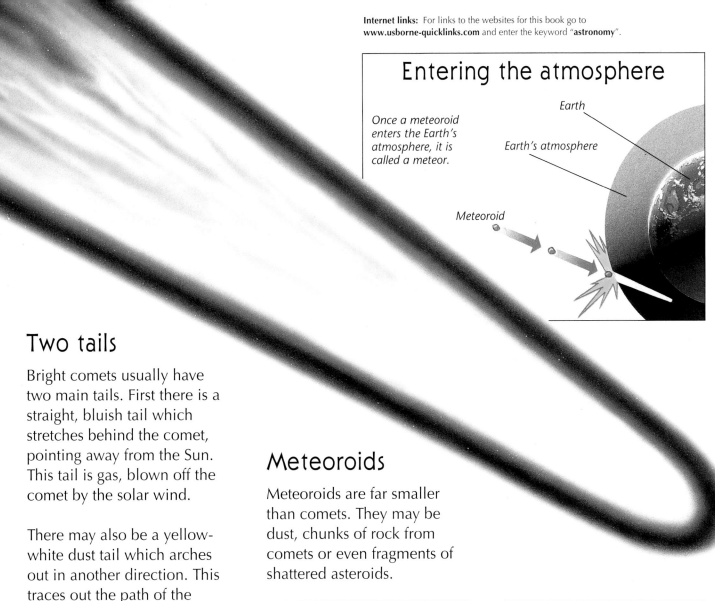

Entering the atmosphere

Once a meteoroid enters the Earth's atmosphere, it is called a meteor.

Earth

Earth's atmosphere

Meteoroid

Two tails

Bright comets usually have two main tails. First there is a straight, bluish tail which stretches behind the comet, pointing away from the Sun. This tail is gas, blown off the comet by the solar wind.

There may also be a yellow-white dust tail which arches out in another direction. This traces out the path of the comet's orbit.

Some comets have more than two tails. A comet known as De Chéseaux comet had seven, fanning out like a peacock's tail.

Dust tail *Gas tail* *Sun*

Meteoroids

Meteoroids are far smaller than comets. They may be dust, chunks of rock from comets or even fragments of shattered asteroids.

Shooting stars

When the Earth crosses the paths of these meteoroids, they burn up as they plummet through the Earth's atmosphere. They make a streak of light which is called a meteor, or a shooting star.

On a clear night you can see a few meteors every hour. When Earth passes through a stream of dust left behind by a comet, dozens of meteors may be seen every hour during one night.

Space stones

Some pieces of meteors survive their fiery plunge through the Earth's atmosphere. They fall to the Earth as charred rocks. Once they hit the ground, these rocks are called meteorites. They are usually dark and very heavy, often looking rusty in places.

Scientists study meteorites because they provide samples of rock from outer space. Most meteorites have been found to consist of rock, iron, or a mixture of both.

41

EXPLORING SPACE

Scientists have been sending rockets up into space since the late 1950s in an effort to learn more about the universe. Since then, many missions have been funded by the USA and Russia (the Soviet Union before 1992), which have vastly increased our knowledge.

Skylab

Space explorers

The most exciting and attention-grabbing explorations took place between 1968 and 1972, when astronauts from the USA journeyed to the Moon on the Apollo missions.

In 1969, during the Apollo 11 mission, Neil Armstrong and Buzz Aldrin became the first people ever to set foot on the Moon.

The Apollo 11 moon mission blasts off from Cape Kennedy, July 16, 1969. Today, Cape Kennedy is officially called the Kennedy Space Center.

Space stations

Space stations orbit the Earth at a distance of about 400km (250 miles). They are laboratories where experiments can be done unaffected by Earth's gravity.

The US Skylab space station was launched in 1973. In 1985, the Russians launched their Mir space station. Both of these have since fallen back to Earth, and now the International Space Station is being built up in orbit by 17 countries.

Living in space

Astronauts living onboard the International Space Station today conduct scientific experiments, observe Earth's weather and geography, and learn how to live and work for long periods in space. This will help astronauts in the future to live safely on the Moon and Mars.

Mir

The Russian space station Mir orbited Earth for 15 years. It was home to space travellers from many different countries. Mir had problems with fires and collisions with other spacecraft, but was still a huge success. The picture below shows Mir in orbit, before it fell to Earth in 2001.

Satellites

There are many man-made objects, called satellites, in orbit around the Earth. Some gather and transmit information about space to scientists on Earth. Others, called communication satellites, pick up radio, TV or telephone signals from Earth, and send them back down to other places on the globe.

Sputnik

The first man-made object ever to go into space was a satellite launched by the Soviet Union on October 4, 1957.

Officially named "Satellite 1957 Alpha 2", it carried a small, beeping transmitter. It became better known by its nickname, Sputnik, which is a Russian word meaning "little voyager".

Hipparcos

In 1989, the satellite Hipparcos was launched by the European Space Agency. For three and a half years, it mapped the night sky in the finest detail ever. Results were published in 1997 and this new information allowed astronomers to calculate how far away thousands of stars and other objects are with greater accuracy than ever.

Planet probing

Since the 1960s, space probes have been sent to explore the Solar System. They have beamed back masses of new information about the planets. One ingenious project was NASA's Galileo mission to Jupiter, launched in 1989. Part of Galileo was a smaller probe (shown below) which split from its mother ship to study the planet's atmosphere.

The central part of the Galileo probe, packed with atmospheric sensors and other scientific instruments.

As predicted by scientists, the Galileo probe was destroyed as it completed its studies of Jupiter's stormy clouds.

Pioneer 10 (which studied Jupiter) and Pioneer 11 (Saturn) have journeyed farther than any other probes. After completing their missions, they coasted far away from our solar system.

This section shielded the probe's delicate measuring instruments as it plunged into Jupiter's atmosphere.

FAMOUS ASTRONOMERS

Ptolemy

Born: AD120, Greece
Died: AD180
Listed many of the star constellations. Said that the Sun and planets all revolved around the Earth. His ideas were accepted as true for the next 1,400 years.

Nicholas Copernicus

Born: 1473, Poland
Died: 1543
Developed a theory that the planets revolved around the Sun. His ideas caused a great scientific and religious debate.

Tycho Brahe

Born: 1546, Denmark
Died: 1601
Observed a supernova (see page 53) in 1572. Although he suspected that Copernicus's ideas were correct, his strong religious beliefs meant that he tried to prove Copernicus wrong. He never did.

Galileo Galilei

Born: 1564, Italy
Died: 1642
Using the recently-invented telescope, sketched pictures of the Moon, Saturn's rings and four of Jupiter's moons. Proved Copernicus's theory.

Johannes Kepler

Born: 1571, Germany
Died: 1630
Published three laws of planetary motion between 1609 and 1619. Regarded as one of the founders of modern astronomy.

Isaac Newton

Born: 1643, England
Died: 1727
Discovered the law of gravity, showing that the movement of the stars and planets could be predicted. Astronomy became much more accurate.

William Herschel

Born: 1738, Germany
Died: 1822
Discovered Uranus in March 1781, using a homemade telescope. His discovery revealed that the Solar System was far larger than anybody had previously thought.

Albert Einstein

Born: 1879, Germany
Died: 1955
Revolutionized science in the early twentieth century with his theories and findings in the subject of physics. His ideas changed the way that scientists thought about and studied the universe.

Edwin Hubble

Born: 1889, USA
Died: 1953
Revealed that the universe is far larger than had been thought. Put forward early ideas of the Big Bang theory.

Clyde Tombaugh

Born: 1906, USA
Died: 1997
Discovered Pluto in 1930, ending a search begun by Percival Lowell in 1905.

Arno Penzias and Robert Wilson

Penzias born: 1933, Germany
Wilson born: 1936, USA
Found evidence of the Big Bang explosion, adding more weight to Hubble's theory.

Carl Sagan

Born: 1935, USA
Died: 1997
A great popularizer of astronomy, who wrote several best-selling books and TV series on astronomy.

Stephen Hawking

Born: 1942, England
Widely thought to be the most brilliant scientist since Einstein. Best known for his work on black holes.

THE STARS

An astronomer watches the stars, with the Milky Way in the sky above.

STAR GROUPS

Stars are not randomly sprinkled throughout the universe. They are grouped in galaxies, which each contain billions of stars. Our Solar System forms a tiny part of a galaxy called the Milky Way.

Galaxies

Galaxies form in different shapes. Four of the most common shapes are: spiral, barred spiral, elliptical and irregular (see right).

A third of all known galaxies are spiral shaped. Most astronomers agree that the Milky Way is a spiral.

Recently, astronomers using sophisticated telescopes have found new galaxies that are bigger and less tightly packed with stars than any they have seen before. They don't give off much light, so they are known as low surface brightness galaxies.

A spiral galaxy. It has a bright middle and two or more curved arms of stars.

A barred spiral has a central bar with an arm at each end.

An elliptical galaxy. It has masses of old, red stars which contain little gas or dust. Elliptical galaxies vary in shape from circular to oval.

An irregular galaxy. This kind of galaxy doesn't really have any fixed shape. They are just like clouds of stars.

The spiral galaxy M100. It is 30 million light years away from Earth.

Nearest galaxies

The galaxies closest to our Milky Way are the Large and Small Magellanic Clouds. These are small, irregular galaxies. The nearest large galaxy after them is the Andromeda Galaxy. This spiral galaxy is the most distant object visible with the naked eye. It is 2.9* million light years away.

The Large Magellanic Cloud (middle) and the Small Magellanic Cloud (top).

This figure is taken from the Hipparcos satellite readings – see page 43.

Seeing galaxies

When you look at a galaxy, you see the combined light of its billions of stars. Through small telescopes, most galaxies appear as smudges of light. They can be seen much more clearly through powerful telescopes.

Galactic groups

Galaxies are not just scattered around the universe, they are grouped together in clusters. Our cluster, called the Local Group, is relatively small, containing about 30 galaxies stretching across 5 million light years.

Star clusters

Inside galaxies, stars tend to group together in clusters. There are two types of star clusters. Open clusters, such as the one shown below, are made up of bright young stars which have just formed and are still relatively close together in space.

The Pleiades group of stars, in the constellation Taurus, is an open cluster.

Globular clusters are much larger than open clusters. They tend to be found above and below the central bulge of a galaxy. There are about 150 known globular clusters in our galaxy, each containing up to a million stars.

A globular cluster. Globular clusters appear like very faint stars to the naked eye.

A Hubble Space Telescope image of the Cartwheel Galaxy in the Sculptor constellation. It is 500 million light years away.

Space collision

The Cartwheel Galaxy, above, is an enormous galaxy, 150,000 light years across. Its rare shape was formed when a smaller galaxy smashed into it. The outer ring is an immense circle of gas and dust which expanded from the core after the collision. Its original spiral shape is now starting to re-form.

Internet links: For links to the websites for this book go to **www.usborne-quicklinks.com** and enter the keyword "astronomy".

47

THE MILKY WAY

Compared with other galaxies, our galaxy, the Milky Way, is relatively large. It measures approximately 100,000 light years across. The Earth and the rest of our Solar System lie about 28,000 light years from the middle of the Milky Way.

The Earth and the Solar System are located here in the Milky Way.

Rotating spiral

Most astronomers are convinced that the Milky Way is a spiral galaxy. Some, though, have suggested that it might be a barred spiral galaxy instead.

Like all spiral and barred spiral galaxies, the Milky Way rotates. Closer to the middle it rotates faster than at its edges. Our Solar System revolves around the middle of the galaxy about once every 225 million years. According to this theory, the Solar System has only rotated once since the earliest dinosaurs walked the Earth.

Seeing the galaxy

On a clear night, you can see a broad, dense band of stars which stretches across the sky. In ancient times, people thought this band looked like a trail of spilled milk. This is how our galaxy gets its name. When you look along this band, you are looking towards the middle of the Milky Way.

The Milky Way. Through binoculars, you can see some of the millions of stars that make up this galaxy.

At least 150 huge globular star clusters hover above and below the middle of the galaxy. Each contains up to a million stars.

Areas of glowing pink, blue and green gas are nebulae, the regions where new stars form.

48

When to look

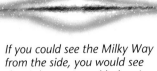

If you could see the Milky Way from the side, you would see that it has a central bulge. Its shape looks like a pair of fried eggs placed back to back.

In the northern hemisphere, the best time to see the Milky Way is between the months of July and September. It also looks impressive on dark midwinter nights.

In the southern hemisphere, the Milky Way is seen at its most spectacular between October and December. This is when it looks most like a trail of spilled milk across the sky.

BIRTH OF STARS

Astronomers have pieced together the story of how stars form by observing the many different stars that can be seen from Earth. Stars change throughout their life and eventually die.

A star's birthplace

New stars form within vast clouds of gas and dust, called nebulae. Some nebulae are bright and some are dark. Dark nebulae are made mostly of dust and so they blot out the light of stars behind them. They look like dark patches of starless sky.

Most nebulae can only be seen through a telescope, but you can see the nebula M42, with binoculars. It lies in Orion (see page 69).

This dark nebula, called the Horse's Head Nebula, is silhouetted against a bright nebula. The Horse's Head also lies in the constellation Orion. You need a powerful telescope to see this nebula.

Horse's Head Nebula

This bright nebula is the Trifid Nebula. The gases in it are so hot that they make the surrounding gas clouds glow in beautiful shades. Hydrogen glows pink, while oxygen glows green-blue. You need a good telescope to see it

Trifid Nebula

These columns of gas and dust are part of M16, the Eagle Nebula

Starting off

Before stars begin to form in a nebula, the clouds of gases and dust swirl around and around. They then form into clumps which grow larger and larger.

Cloud collapse

Eventually, something causes the clouds to collapse. Some astronomers think that this might happen when the clouds pass through the arms of a spiral galaxy.

Some suggest that the shock wave from an exploding star (a supernova – see page 53) might start the collapse.

This image, taken with the Hubble Space Telescope, shows a nebula in the irregular galaxy NGC 2366. It is 10 million light years away.

The brightest star visible in this nebula may be 60 times as big as the Sun.

Shining star

As the cloud collapses, the temperature rises inside. After tens of thousands of years of collapse, a hot core forms. The core gets hotter and hotter until nuclear reactions begin inside, making the clump of gases start to shine. The new star has been born. Most new stars are hot and bright, but some are cooler and dimmer.

Our Sun

At first, most new stars burn very brightly. They appear either blue or white. This state continues for millions of years.

As they get older, they settle down and shine less brightly but more steadily, like our Sun. The Sun is only halfway through its lifespan of around 10 billion years.

Gases and dust swirl.

The clouds collapse.

A hot core forms.

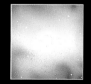
A new star is born.

A star in middle age.

LIFE OF A STAR

Stars burn with different brightnesses and colours. The hotter the star, the bluer it shines. Their lifespans are different too. The smaller the star, the longer it tends to live.

The Cat's Eye Nebula. The red and green areas are clouds of dense, glowing gas.

Lifespans

Stars such as our Sun have a lifespan of about 10,000 million years. Stars smaller than our Sun, called dwarf stars, live longer.

Stars larger than our Sun are called giant stars. The biggest of all are called supergiant stars. They have short lives of only a few million years.

Barnard's star, in the constellation Ophiuchus (see page 65), is a red dwarf star, cooler than our Sun.

The Sun is a yellow star.

Arcturus, in the constellation Boötes (see page 63), is an orange giant star.

This diagram compares the size of some bright stars, including our Sun.

Rigel, in the constellation Orion (see page 69), is a hot blue supergiant star.

Death of a star

Eventually a star's supply of gas runs out and it dies. As they die, stars that are the size of our Sun (or smaller) swell up and turn red. They are called red giants.

Slowly they puff their outer layers of gas, called planetary nebulae*, into space.

White dwarf

A small, almost dead star, called a white dwarf, is left. It is about the size of a planet, and is very heavy and dense for its size. Imagine a golf ball that weighs as much as a truck.

Because it is so dense, a white dwarf generates huge gravity. It eventually cools and fades.

*A planetary nebula has nothing to do with planets.

Explosive death

Stars that are bigger than our Sun have a really spectacular death. First they swell into vast red stars, called red supergiants. Then they blow up with a huge explosion, called a supernova.

Four supernovas have been seen in our galaxy in the last thousand years. They glowed brighter than anything else around them for several days before disappearing.

Dense and heavy

The supernova leaves a rapidly expanding layer of gases and dust with a small spinning star in the middle. This is a neutron star. It is even denser and heavier than a white dwarf. (Imagine a golf ball which weighs as much as a skyscraper.)

Some neutron stars send out beams of radiation that swing around as the star spins. These stars are called pulsars.

Black holes

When the very biggest stars die they form red supergiants. Then they explode into a supernova. However, when they collapse, they shrink so much that they virtually vanish from the universe. They may become what are called black holes – bottomless pits from which nothing escapes.

A digital image of the Crab Nebula. This nebula is the remains of a supernova explosion which took place over 900 years ago. It is ten light years across and is located 7,000 light years away in the region of Taurus. At its heart lies the Crab Pulsar – a neutron star.

Sucked in

Black holes vary in size from being too small to see to the size of a galaxy. They are so dense and heavy that their gravity sucks everything inside them, even light. This means that we can't see black holes; but we can detect them by looking for stars and other objects that are being "eaten". Anything that gets sucked into a black hole is crushed by its gravity. Scientists think that in the middle of our galaxy lies an enormous black hole, surrounded by old red stars.

VARIABLE STARS

Some stars appear to change gradually in brilliance. These are called variable stars and they fall into three main types – pulsating variables, eclipsing variables and cataclysmic variables.

Algol, also known as the Demon Star, is the most well-known variable star. It is really two stars which orbit one another, appearing bright and then dim.

Watching variables

You need to watch a variable star over days, weeks or even months to see it go through a full cycle, or period, of changes. It helps to compare the star with a nearby star which is not variable, so that you can tell whether it is getting fainter or brighter.

Some variable stars' cycles are regular and others are more erratic.

Pulsating variables

Pulsating variables shrink and swell, giving off more light when large and less light when small. They change in size and temperature. They are usually giant or supergiant stars.

The pictures on the right show Mira, a pulsating variable in the constellation Cetus.

March

May

July

September

Eclipsing variables

Some variable stars are not single stars at all. These variable stars really consist of two stars, called a binary, or physical double, star. The stars orbit around each other. Their gravity keeps them swinging around one another.

As one star passes in front of the other, it blocks its light. This reduces the amount of light that you can see from Earth.

The brighter star is called the primary.

The fainter star is called the secondary.

Cataclysmic variables

These are binary stars that are very close together. When the gravity of one of them (usually a white dwarf) pulls material away from the other (usually a red giant), a huge and sudden increase in brightness occurs. This is caused by violent nuclear reactions.

Flaring stars

One type of cataclysmic variable is called a nova. It flares suddenly, then it fades back to its original brightness over several months – or even years if it flared really brightly. Novas can be so bright that they can look like new stars.

Novas are fairly uncommon. There are about 25 each year in a galaxy such as ours. Since 1600, though, there have only been 37 that could be seen with the naked eye.

Multiple systems

Star systems with more than two stars are called multiple systems. Some stars that look like binaries turn out to be multiples when seen through binoculars or telescopes. The star Theta Orionis (in Orion, see page 69) can be seen through a telescope as four distinct stars, known as the Trapezium.

These low-resolution images show two views of a nova. It is 10,430 light years away, much too far for any Earth-bound telescope to detect.

Above, a ring of gas explodes out from the star. Below, seven months later, the gas ring fades as it billows out far into space.

This nova is called Nova Cygni 1992.

Internet links: For links to the websites for this book go to **www.usborne-quicklinks.com** and enter the keyword "**astronomy**".

STAR PATTERNS

Since the earliest civilizations, people have noticed patterns of bright stars in the sky. These patterns are called constellations. At first glance, you may only see what looks like a jumble of twinkling stars. But with practice you can pick out the shapes of constellations.

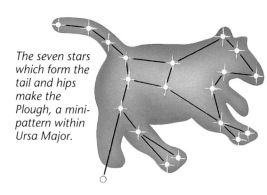

The seven stars which form the tail and hips make the Plough, a mini-pattern within Ursa Major.

Ursa Major, or the Great Bear. Here, the imaginary shape of a bear is drawn around the constellation.

Groups of stars

There are 88 constellations. Maps of all of them are shown on pages 62-75 of this book.

Dividing the stars into constellations helps to find and identify different stars in the night sky. Many constellations were named after characters or objects taken from ancient Greek myths.

Within constellations, there are smaller patterns, called asterisms. The Plough, or Big Dipper, is a famous asterism. It is part of the constellation Ursa Major (see top picture).

Huge distances

The constellations are made up of the most prominent stars in the sky.

From Earth, the stars in each constellation may look fairly close to one another. In reality, they are extremely far apart.

The stars in the constellation Orion, for example, vary between less than 500 light years and over 2,000 light years away from Earth. They simply look like a connected group to us because the stars lie in the same direction.

Pointers

Stars in certain constellations form pointers to other constellations in the sky.

For instance, if you imagine a line running through the two end stars of the Plough in Ursa Major, the line points to Polaris, the North Star. These two useful stars are known as the Pointers.

The star maps on pages 62-75 show some ways of finding constellations by first identifying other stars or groups, and using them as pointers.

This diagram shows the constellation Orion as it looks in the sky (left) and how the stars are really positioned in space (right).

The Pointers in Ursa Major line up with Polaris in the constellation Ursa Minor.

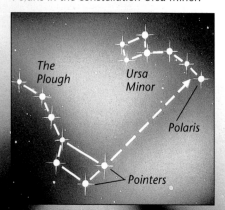

Stars on the move

Stars move through space at very high speeds, but they are so far away that any motion is impossible to detect, except with very powerful equipment. This is why constellations seem to be fixed in the sky.

100,000 years ago, the stars of the Plough were shaped like this.

The stars of the Plough today

In another 100,000 years, the shape will have altered greatly.

Naming the stars

Many of the brightest stars have both a Greek or Arabic name and an English name. The brightest star is called Sirius, a Greek name. Its English name is the Dog Star.

All in Greek

Stars are also known by the name of their constellation, plus a Greek letter. Usually, the brightest star in a constellation is given the first letter of the Greek alphabet, alpha (α). The next brightest is given the second letter, beta (β), and so on. There are only 24 letters in the Greek alphabet, so if a constellation has more than 24 stars, the rest are numbered.

GREEK SYMBOLS AND THEIR NAMES

α	alpha	ν	nu
β	beta	ξ	xi
γ	gamma	o	omicron
δ	delta	π	pi
ε	epsilon	ρ	rho
ζ	zeta	σ	sigma
η	eta	τ	tau
θ	theta	υ	upsilon
ι	iota	φ	phi
κ	kappa	χ	chi
λ	lambda	ψ	psi
μ	mu	ω	omega

The five main stars of the constellation Cassiopeia. These stars give it its W-shape, which is easy to recognize.

DESCRIBING STARS

Star brightness

Star brightness is measured on a scale called magnitude (mag. for short). The actual brilliance of a star in space is called its absolute magnitude. The brightest stars are 0 or even minus magnitude.

✦✦✦✦✦✦✦✦ ✦ ✦ ✦
-1 0 1 2 3 4 5 6 7 8 9

Brightest *Dimmest*
stars *stars*

Each step on this scale indicates an increase in brightness of two and a half times.

Brightness from Earth

From Earth, a very bright but distant star can appear dimmer than a less bright star that is closer to us. A star's brightness when seen from Earth is called its apparent magnitude.

Star colours

Stars are classified by their colour. The hottest stars are blue or white, and the coolest are red.

Each class of star is called a spectral type, and is identified by a letter. The main spectral types are shown in the chart.

Double stars

There are two types of double stars. The first, called binary or physical double stars, orbit each other and are held together by gravity. It is difficult to tell the stars apart without a powerful telescope.

The second type, optical double stars, seem to be close together because they are in the same line of sight from Earth. In fact, they might be far apart. You can see some with the naked eye.

Optical double star

Earth

Numbers

Almost all galaxies, nebulae, star clusters and other features have an identifying number beginning with M or NGC.

M numbers refer to a catalogue made in the eighteenth century by a French astronomer named Charles Messier. NGC numbers refer to the New General Catalogue, drawn up by J. L. E. Dreyer in 1888.

Some features begin with IC, standing for Index Catalogue. This was Dreyer's list of even fainter objects, made in 1908.

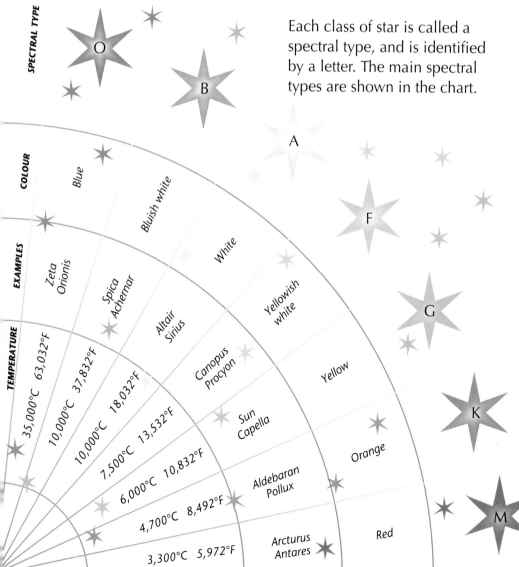

CONSTELLATIONS

The constellation of Crux. The four main stars form the pattern of the Southern Cross.

MAPS OF THE STARS

These star maps will help you to identify constellations in the night sky. The best time to use the maps is around 11pm.

Spotting some of the constellations can be difficult at any time, though. It's much easier from a dark place on a dark, clear night.

Map for northern hemisphere

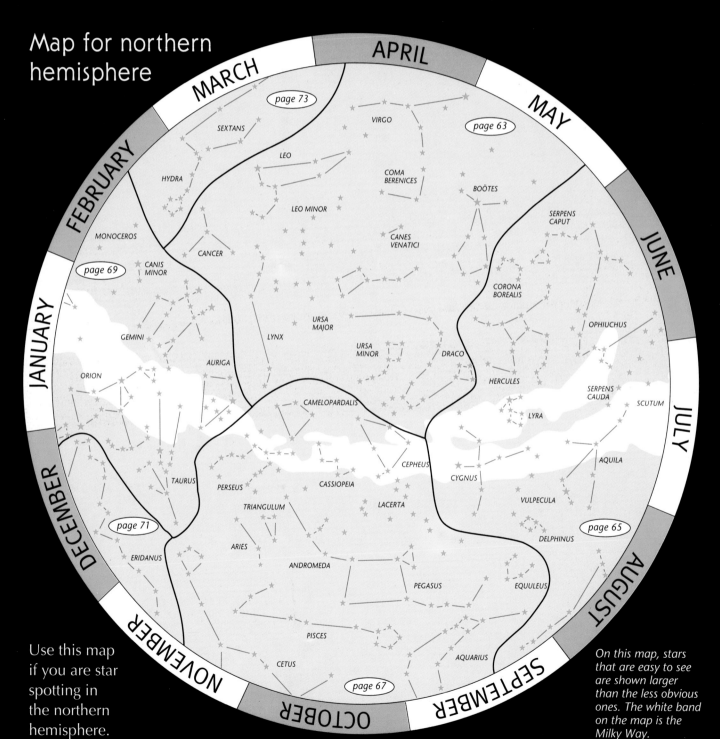

Use this map if you are star spotting in the northern hemisphere.

On this map, stars that are easy to see are shown larger than the less obvious ones. The white band on the map is the Milky Way.

Using the maps

Find the current month in the margin around the edge. Then turn the book around until that month is nearest to you. Face south if you are in the northern hemisphere, and north if you are in the southern hemisphere. The stars in the middle and lower part of the map should be visible in the sky.

Once you know which constellations to look for, you can turn to the larger-scale maps on the following pages. These maps show which constellations are the easiest to make out. Then you can look for the others close by. The page numbers to look up are marked in each section of the maps below.

Map for southern hemisphere

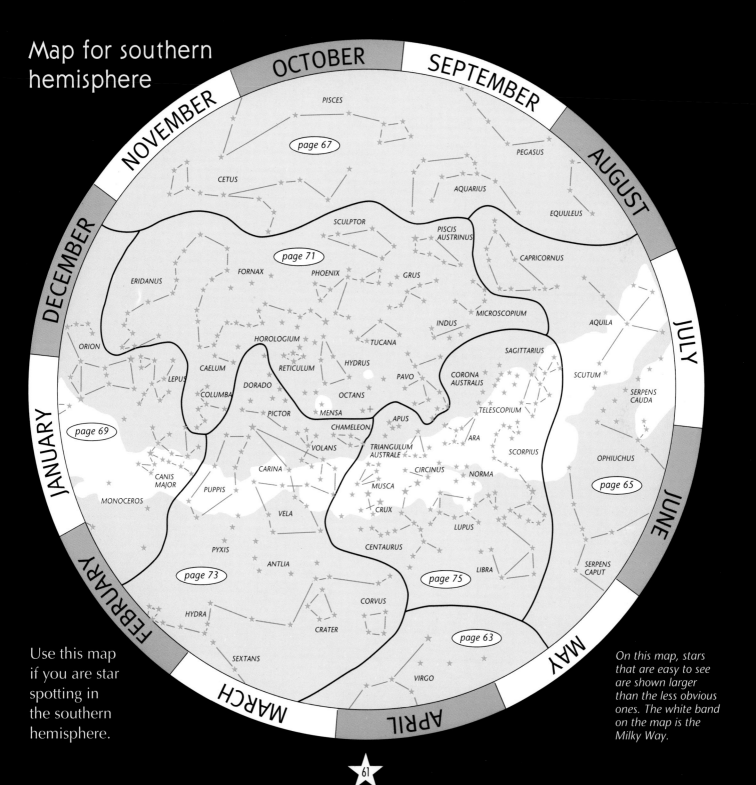

Use this map if you are star spotting in the southern hemisphere.

On this map, stars that are easy to see are shown larger than the less obvious ones. The white band on the map is the Milky Way.

Draco
(the Dragon)

Draco consists of a straggling line of faint stars. The dragon's head is a group of four stars near to Vega, the fifth brightest star in the sky. The tail loops around Ursa Minor.

Canes Venatici
(the Hunting Dogs)

The hunting dogs chase the Great Bear (Ursa Major) and the Little Bear (Ursa Minor) through the sky. Bear hunting was a popular sport in the seventeenth century, when this constellation was named.

Boötes
(the Herdsman)

Try finding Boötes by using the tail of Ursa Major as a pointer. Arcturus, at the base of Boötes, is the fourth brightest star in the sky.

From January 1-6 each year, there is a meteor shower, called the Quadrantids, in the area around Boötes and the tail of Ursa Major. This is not easily visible until after midnight.

Coma Berenices
(Berenice's Hair)

According to a Greek myth, Berenice cut off all her beautiful hair, which the god Jupiter then placed among the stars. The three main stars in the constellation are shown on the map, although it may be difficult to pick them out from other stars.

On a dark night, you can see the Coma cluster, an open star cluster, with the naked eye.

Virgo
(the Virgin)

This constellation represents the goddess of fertility and harvest. Virgo's brightest star is Spica, which means "ear of corn". Spica is 220 light years away from Earth.

Ursa Minor
(the Little Bear)

This constellation's brightest star is Polaris, the pole star. It is the only star in the sky which appears not to move. This is because it is in line with the Earth's axis, directly above the north pole. As the Earth rotates, Polaris stays in the same place relative to it, but other stars appear to move across the sky, around Polaris.

Once you have found Polaris, line it up with a landmark so you can find it again from the same place. It shows which direction is north.

Ursa Major
(the Great Bear)

The seven brightest stars in this constellation make an asterism called the Plough, Saucepan or Big Dipper. The stars Dubhe and Merak in the Plough are called the Pointers. An imaginary line through them points to Polaris, the pole star.

Lynx

This constellation was given its name because only people with good eyesight, like a lynx, can see it. It is a line of faint stars.

Leo Minor
(the Small Lion)

This constellation is very faint and difficult to spot.

Cancer
(the Crab)

These are faint stars between Leo and Gemini (shown on page 69). Cancer contains the spectacular M44 open star cluster, called the Beehive or Praesepe.

Leo
(the Lion)

Leo is one of the few constellations which looks like the thing it is named after – a crouching lion. The head region is sometimes known as the Sickle or Backwards Question Mark.

Around November 17 each year, a meteor shower, called the Leonids, occurs near the head of Leo. This is not easily visible until after midnight.

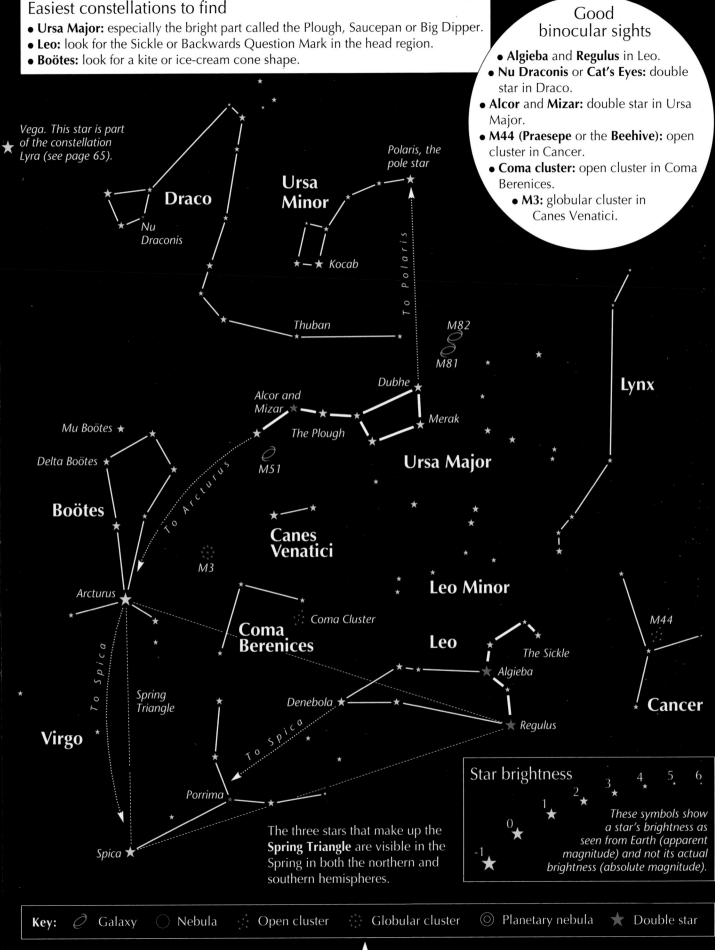

Easiest constellations to find

- **Ursa Major:** especially the bright part called the Plough, Saucepan or Big Dipper.
- **Leo:** look for the Sickle or Backwards Question Mark in the head region.
- **Boötes:** look for a kite or ice-cream cone shape.

Good binocular sights

- **Algieba** and **Regulus** in Leo.
- **Nu Draconis** or **Cat's Eyes:** double star in Draco.
- **Alcor** and **Mizar:** double star in Ursa Major.
- **M44 (Praesepe** or the **Beehive):** open cluster in Cancer.
- **Coma cluster:** open cluster in Coma Berenices.
- **M3:** globular cluster in Canes Venatici.

Vega. This star is part of the constellation Lyra (see page 65).

Polaris, the pole star

Draco

Ursa Minor

Nu Draconis

Kocab

To Polaris

Thuban

M82

M81

Lynx

Dubhe

Merak

Alcor and Mizar

The Plough

Ursa Major

Mu Boötes

Delta Boötes

M51

To Arcturus

Boötes

Canes Venatici

M3

Leo Minor

Arcturus

Coma Cluster

M44

Coma Berenices

Leo

The Sickle

Algieba

Cancer

To Spica

Spring Triangle

Denebola

Virgo

To Spica

Regulus

Porrima

The three stars that make up the **Spring Triangle** are visible in the Spring in both the northern and southern hemispheres.

Spica

Star brightness

-1 0 1 2 3 4 5 6

These symbols show a star's brightness as seen from Earth (apparent magnitude) and not its actual brightness (absolute magnitude).

Key: ⬬ Galaxy ◯ Nebula ⁙ Open cluster ⁙ Globular cluster ◎ Planetary nebula ★ Double star

Internet links: For links to the websites for this book go to www.usborne-quicklinks.com and enter the keyword "astronomy".

CYGNUS TO SERPENS

Cygnus (the Swan)

Cygnus contains a cross shape, called the Northern Cross asterism. It has the bright star Deneb at the top and Albireo at the bottom.

Deneb is one of the brightest known stars in the galaxy. It is over 60,000 times more luminous than the Sun. It forms one corner of the Summer Triangle.

Delphinus (the Dolphin)

Delphinus is compact, with a distinctive shape. The star Epsilon Delphini is 950 light years away, much farther away than the other stars in this constellation.

Sagitta (the Arrow)

Sagitta* consists of four faint stars in an arrow shape.

Capricornus (the Sea Goat)

Some astronomers refer to Capricornus as the smile in the sky. It is a distorted triangle of faint stars.

At one end is the double star, Alpha Capricorni. This consists of the stars, Alpha 1 and Alpha 2. Alpha 2 is also known as Algedi or Giedi. You can just see both stars with the naked eye.

Aquila (the Eagle)

The bright star Altair in Aquila forms part of the Summer Triangle. Altair is the eleventh brightest star in the sky and it is flanked by two fainter stars.

Scutum (the Shield)

Scutum is faint, but just visible with the naked eye. Look for M11, the Wild Duck open cluster in Scutum, near the base of Aquila.

Vulpecula (the Fox)

Vulpecula contains M27, a planetary nebula called the Dumbbell Nebula. In 1967, the first pulsar was discovered in Vulpecula, although this is too dim to see.

Lyra (the Lyre)

Small but easy to spot, Lyra's brightest star is Vega, the fifth brightest in the sky.

Ophiuchus (the Serpent Bearer)

Ophiuchus is a very large group of stars. Ophiuchus is holding a snake, the constellation Serpens, so the two constellations are joined.

Hercules

This constellation is named after a Greek hero. The middle of Hercules looks like a slightly distorted square. This is called the Keystone. M13, one of the best globular clusters in the sky, lies on its right-hand side.

Corona Borealis (the Northern Crown)

This is a semicircle of faint stars between Vega and Arcturus (in the constellation Boötes, see page 63).

Corona Borealis contains a recurring nova, known as the Blaze Star. This last brightened in February 1946 to apparent magnitude 2.3 from its normal magnitude 10. It will not be visible until it brightens again.

Serpens (the Serpent)

Serpens is the only constellation formed of two separate parts: Caput (the head) and Cauda (the tail). They lie either side of Ophiuchus.

In Serpens Cauda is the nebula M16 (the Eagle or Star Queen Nebula). It has an eagle-shaped dust and gas cloud in its middle.

You need a fairly large telescope to see M16 in any detail. Hubble Space Telescope images have revealed stunning areas of star birth within it.

*Sagitta is very faint, and is not shown on this map

Easiest constellations to find
● **Cygnus:** especially the Northern Cross asterism.
● **Lyra:** look for Vega in the Summer Triangle.
● **Aquila:** look for Altair in the Summer Triangle.

In the northern hemisphere, the densest part of the Milky Way runs between Cygnus (on this map) and Sagittarius (see page 75). In the southern hemisphere, it runs between Scutum and Vela.

The Summer Triangle is formed by the stars Deneb, Altair and Vega. It is visible in the northern and southern hemispheres during their respective summer months.

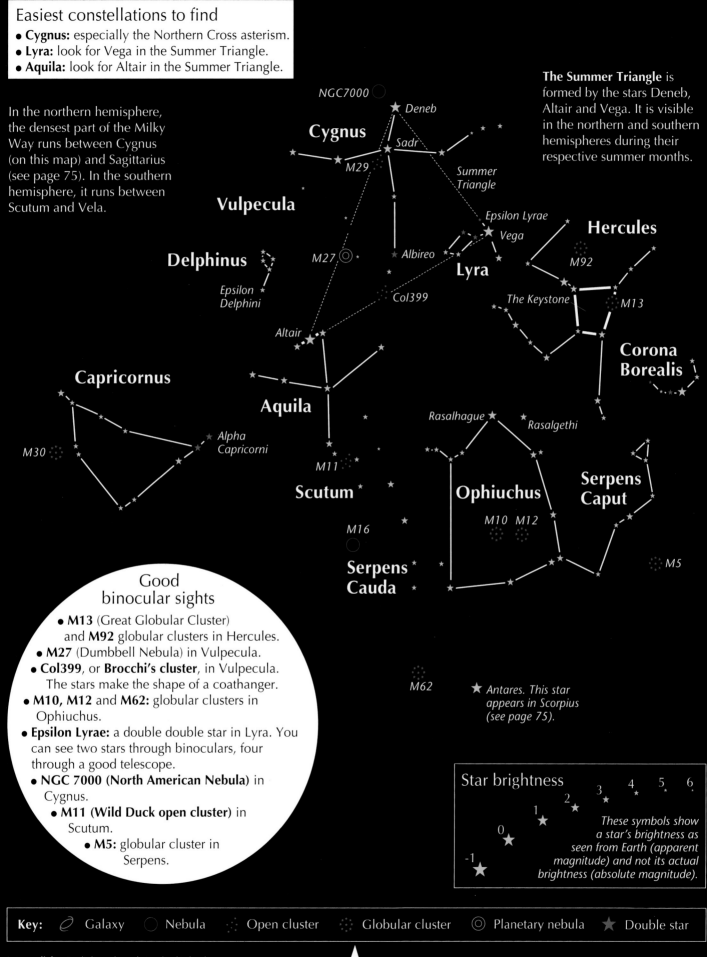

NGC7000

Deneb

Cygnus

Sadr

M29

Summer Triangle

Vulpecula

Epsilon Lyrae

Vega

Hercules

M92

Delphinus

M27

Albireo

Lyra

M13

Epsilon Delphini

Col399

The Keystone

Corona Borealis

Altair

Capricornus

Rasalhague

Rasalgethi

M30

Alpha Capricorni

Aquila

Serpens Caput

M11

Scutum

Ophiuchus

M10 M12

M16

M5

Serpens Cauda

M62

Antares. This star appears in Scorpius (see page 75).

Good binocular sights

● **M13** (Great Globular Cluster) and **M92** globular clusters in Hercules.
● **M27** (Dumbbell Nebula) in Vulpecula.
● **Col399**, or **Brocchi's cluster**, in Vulpecula. The stars make the shape of a coathanger.
● **M10, M12** and **M62:** globular clusters in Ophiuchus.
● **Epsilon Lyrae:** a double double star in Lyra. You can see two stars through binoculars, four through a good telescope.
● **NGC 7000 (North American Nebula)** in Cygnus.
● **M11 (Wild Duck open cluster)** in Scutum.
● **M5:** globular cluster in Serpens.

Star brightness

-1 0 1 2 3 4 5 6

These symbols show a star's brightness as seen from Earth (apparent magnitude) and not its actual brightness (absolute magnitude).

Key: ⬗ Galaxy ◯ Nebula ⣿ Open cluster ⣿ Globular cluster ◎ Planetary nebula ★ Double star

Internet links: For links to the websites for this book go to **www.usborne-quicklinks.com** and enter the keyword "**astronomy**".

65

CAMELOPARDALIS TO AQUARIUS

Camelopardalis (the Giraffe)

It isn't easy to see any of these stars with the naked eye.

Perseus

Perseus was a Greek hero. There are many open star clusters within Perseus but the showpiece is the double cluster of NGC869 and 884.

The eclipsing variable binary star Algol has a period of nearly three days. As one star passes in front of the other, Algol fades to about half its usual brightness.

A meteor shower occurs in Perseus between July 25 and August 20 every year, peaking on August 12.

Andromeda

Andromeda was a princess who was rescued from a monster by Perseus.

Andromeda contains M31, the Andromeda or Great Spiral Galaxy. At 2.9 million light years away, it is the furthest object visible to the naked eye.

Triangulum (the Triangle)

The Triangle is a compact pattern made up of three stars. It is fairly easy to spot on a dark night. It contains M33, the Pinwheel Galaxy.

Aries (the Ram)

Aries is made up of four main stars.

Pisces (the Fishes)

In Greek myth, these were two fishes tied by a long ribbon. The constellation is not easy to find. The most visible part is the circlet under the Square of Pegasus, known as the Western Fish, or Circlet.

Cetus (the Whale)

Cetus contains the variable star Mira. For half the year, Mira is visible to the naked eye. Then it fades to invisibility. It has a period of 331 days.

Cepheus

Cepheus looks a little like the side of a house. In Greek myth, Cepheus was the King of Ethiopia, and married to Cassiopeia (see below). The brightest star is Alderamin.

Delta Cephei is a variable star with a period of 5 days, 8 hours and 48 minutes.

Cassiopeia

Cassiopeia sits side by side with her husband Cepheus. The W-shape* is easy to spot. Two of its end stars can be used as pointers to the constellation Andromeda.

Lacerta (the Lizard)

Lacerta is a zig-zag of faint stars, which is hard to find.

Pegasus

Pegasus was a flying horse in Greek mythology. Three of its stars plus the end star of Andromeda make up the Square of Pegasus. This is fairly easy to spot, as it is one of the largest geometrical shapes in the night sky.

Equuleus (the Foal)

Equuleus is hard to find, even on a clear night. The two stars that form Delta Equuleus, a double star, are extremely close in outer space terms. Even so, they are as far apart as the Sun and Jupiter.

Aquarius (the Water Bearer)

Aquarius isn't easy to find. The small group of stars near the top represents a water jar. The stars below show a stream of water.

Aquarius contains a planetary nebula, Helix, which can be seen through binoculars on a very dark night as a dim blur about half the size of the Moon. It is fairly hard to spot.

From April 24 to May 20, a meteor shower, called Eta Aquarids, appears in this area.

*Cassiopeia is seen as an M-shape for half of the year

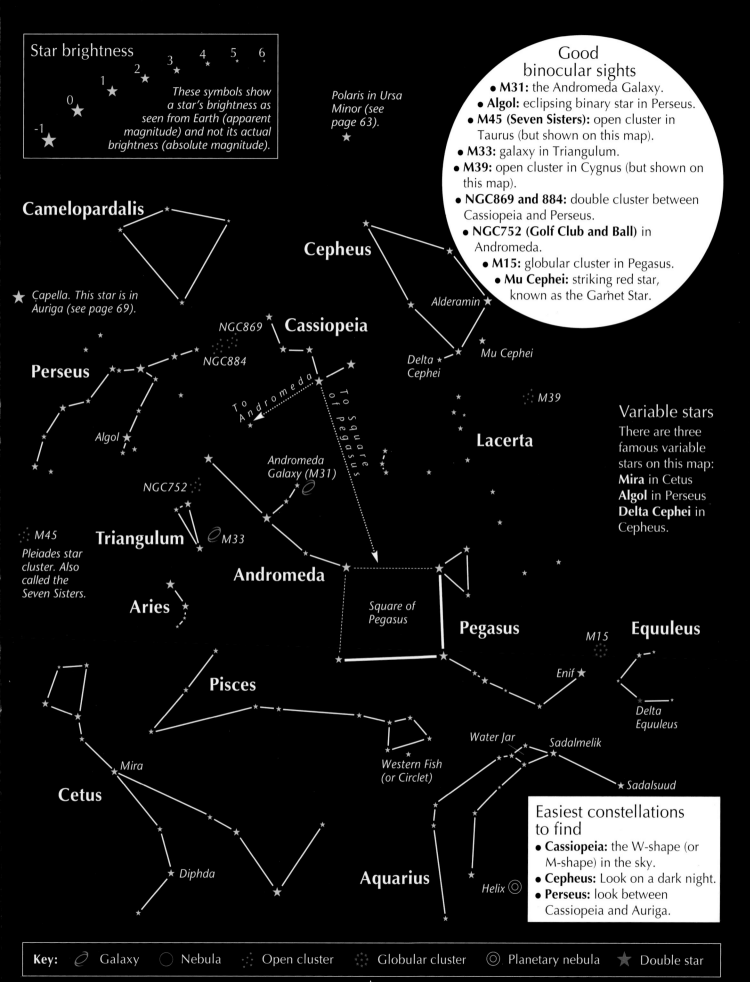

Star brightness

0 1 2 3 4 5 6 -1

These symbols show a star's brightness as seen from Earth (apparent magnitude) and not its actual brightness (absolute magnitude).

Polaris in Ursa Minor (see page 63).

Good binocular sights

- **M31:** the Andromeda Galaxy.
- **Algol:** eclipsing binary star in Perseus.
- **M45 (Seven Sisters):** open cluster in Taurus (but shown on this map).
- **M33:** galaxy in Triangulum.
- **M39:** open cluster in Cygnus (but shown on this map).
- **NGC869 and 884:** double cluster between Cassiopeia and Perseus.
- **NGC752 (Golf Club and Ball)** in Andromeda.
- **M15:** globular cluster in Pegasus.
- **Mu Cephei:** striking red star, known as the Garnet Star.

Camelopardalis

Cepheus

Capella. This star is in Auriga (see page 69).

Alderamin

Perseus

NGC869

NGC884

Cassiopeia

Delta Cephei

Mu Cephei

Algol

To Andromeda

To Square of Pegasus

M39

Lacerta

Variable stars

There are three famous variable stars on this map:
Mira in Cetus
Algol in Perseus
Delta Cephei in Cepheus.

NGC752

Andromeda Galaxy (M31)

M45

Pleiades star cluster. Also called the Seven Sisters.

Triangulum

M33

Aries

Andromeda

Square of Pegasus

Pegasus

M15

Equuleus

Enif

Delta Equuleus

Pisces

Western Fish (or Circlet)

Water Jar

Sadalmelik

Cetus

Mira

Sadalsuud

Easiest constellations to find

- **Cassiopeia:** the W-shape (or M-shape) in the sky.
- **Cepheus:** Look on a dark night.
- **Perseus:** look between Cassiopeia and Auriga.

Diphda

Aquarius

Helix

Key: ◯ Galaxy ◯ Nebula ⋯ Open cluster ⋰ Globular cluster ◎ Planetary nebula ★ Double star

Internet links: For links to the websites for this book go to www.usborne-quicklinks.com and enter the keyword "astronomy".

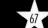

GEMINI TO LEPUS

Gemini (the Twins)

The stars Castor and Pollux in Gemini are often referred to as the Twins. Castor is actually six stars close together, but you cannot see them separately, even through binoculars.

From December 7–15 every year there is a meteor shower, called the Geminids, in this area of the sky.

Canis Minor (the Small Dog)

This constellation represents the smaller of the two dogs that belonged to Orion, the mythical Greek hunter.

Procyon in Canis Minor is the eighth brightest star in the sky – and at only 11 light years from Earth, it is one of the closest.

There are lots of star clusters in the sky around Canis Minor, Monoceros and Canis Major (see below).

Monoceros (the Unicorn)

Monoceros is hard to see. Look along it using binoculars and you should be able to see the many, faint open star clusters that reside there. In the northern hemisphere's winter, this is the brightest part of the Milky Way.

Canis Major (the Great Dog)

This is a compact group of bright stars. Sirius (the Dog Star) is the brightest star in the sky. It is about 8.6 light years away from Earth. There is an open star cluster, called M41, in Canis Major.

Auriga (the Charioteer)

This constellation is shaped like a kite. A distinct but faint triangle, known as the Kids, is nearby. The variable star Epsilon Aurigae is one of the Kids. Every 27 years, it is eclipsed by a mysterious dark companion, possibly a huge disc of gas and dust.

Capella, the sixth brightest star in the sky, is 42 light years away. It is in fact six stars but even with a powerful telescope you can only see one. The star clusters M36, M37 and M38 are nearby.

Taurus (the Bull)

The group of stars that make up the bull's head is known as the Hyades. The bull's eye is the double star Aldebaran.

The Pleiades star cluster is also in Taurus. This is often known as the Seven Sisters, although most people can only see six stars with the naked eye. According to Greek legend, the Pleiades were sisters placed in the sky to protect them from Orion, who was chasing them.

Taurus also contains M1, the Crab Nebula. This is the remnant of a supernova that exploded in 1054. In its middle is a pulsar, the remains of the original star. It spins 33 times per second.

From October 20 to November 30 each year there is a meteor shower, called the Taurids, in this area of the sky.

Orion

Orion was a great hunter in Greek mythology. The constellation contains many bright stars. The blue-white Rigel is the seventh brightest star in the sky. The red star Betelgeuse is a variable star with an irregular cycle.

Look for the Orion nebula just below the three stars that form Orion's belt. It contains Theta Orionis, a multiple system of four stars, also known as the Trapezium.

Around October 22 each year, there is a meteor shower, called the Orionids, in between Orion and Gemini.

Lepus (the Hare)

The hare was the animal that Orion most liked to hunt.

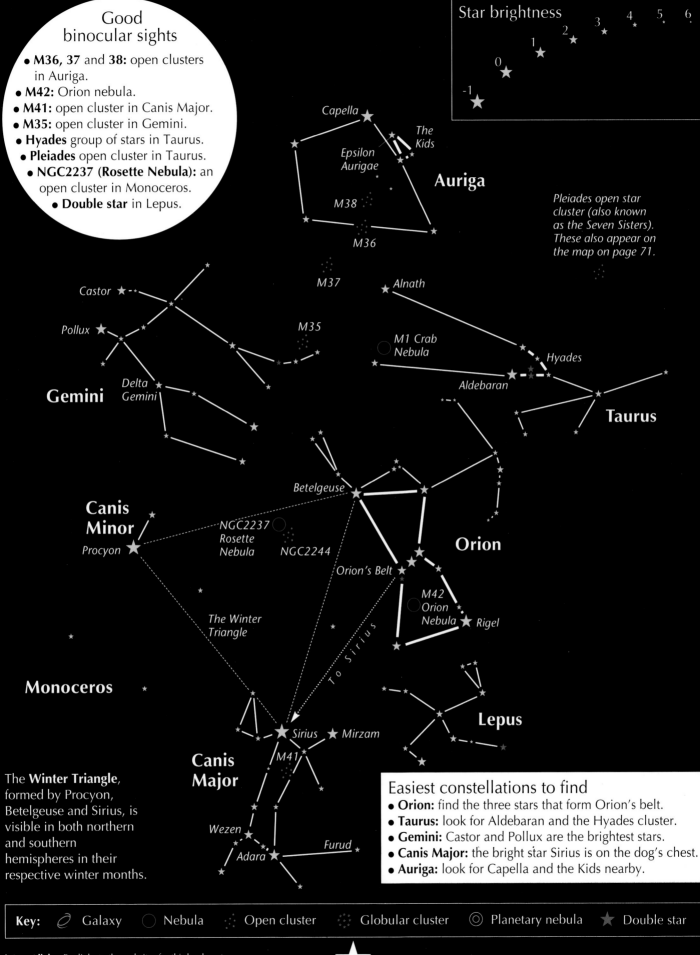

Good binocular sights

- **M36, 37** and **38:** open clusters in Auriga.
- **M42:** Orion nebula.
- **M41:** open cluster in Canis Major.
- **M35:** open cluster in Gemini.
- **Hyades** group of stars in Taurus.
- **Pleiades** open cluster in Taurus.
- **NGC2237 (Rosette Nebula):** an open cluster in Monoceros.
- **Double star** in Lepus.

Star brightness

Pleiades open star cluster (also known as the Seven Sisters). These also appear on the map on page 71.

Auriga

Capella
The Kids
Epsilon Aurigae
M38
M36
M37

Alnath

Taurus
M1 Crab Nebula
Hyades
Aldebaran

Castor
Pollux
Delta Gemini
Gemini
M35

Betelgeuse
Orion

Canis Minor
Procyon
NGC2237 Rosette Nebula
NGC2244
Orion's Belt
M42 Orion Nebula
Rigel

The Winter Triangle

To Sirius

Monoceros

Lepus

Sirius Mirzam
M41
Canis Major

Wezen
Adara Furud

The **Winter Triangle**, formed by Procyon, Betelgeuse and Sirius, is visible in both northern and southern hemispheres in their respective winter months.

Easiest constellations to find

- **Orion:** find the three stars that form Orion's belt.
- **Taurus:** look for Aldebaran and the Hyades cluster.
- **Gemini:** Castor and Pollux are the brightest stars.
- **Canis Major:** the bright star Sirius is on the dog's chest.
- **Auriga:** look for Capella and the Kids nearby.

Key: ⬭ Galaxy ◯ Nebula ⁖ Open cluster ⁘ Globular cluster ◎ Planetary nebula ★ Double star

Internet links: For links to the websites for this book go to www.usborne-quicklinks.com and enter the keyword "astronomy".

COLUMBA TO MICROSCOPIUM

Columba
(Noah's Dove)
This is a distinct group of stars lying near Canopus in Carina (see map on page 73).

Horologium
(the Pendulum Clock)
In this constellation, only the star nearest to Caelum (see below) is easily visible.

Caelum
(the Chisel)
This consists of a few very faint stars.

Reticulum
(the Net)
This is a distinct group of faint stars which lies between Canopus in Carina and Achernar in Eridanus.

Mensa
(the Table Mountain)
Only look for this faint constellation on a very clear night. It is near the Large Magellanic Cloud.

Hydrus
(the Small Water Snake)
The three brightest stars in Hydrus make a large triangle between the misty patches of the Magellanic Clouds.

Octans
(the Octant)
This surrounds the imaginary point directly above the south pole and in line with the axis of the Earth. This point,

marked with a cross on the map, is known as the south celestial pole. Unlike the north celestial pole, which is marked by Polaris (the pole star), there is no star to mark the exact south celestial pole.

Pavo
(the Peacock)
Pavo has several fairly bright stars quite close together. These help to locate it. The variable star Kappa Pavonis changes from dim to bright and back every nine days.

Indus
(the Indian)
Indus runs between Pavo, Microscopium and Grus.

Fornax
(the Furnace)
This small constellation lies next to part of the curve of Eridanus.

Eridanus
Eridanus is a long, winding line of stars named after a mythological Greek river. Epsilon Eridani is 10.8 light years away from the solar system and, in absolute magnitude, is similar to our Sun. Achernar is the ninth brightest star in the sky. It is 85 light years away.

Tucana
(the Toucan)
Tucana has the Small Magellanic Cloud within its

boundary. The star cluster 47Tuc (NGC104) is the second finest globular cluster in the sky, after Omega Centauri.

Sculptor
This consists of faint stars and is very hard to distinguish.

Phoenix
Phoenix was named after the mythological bird that rises from its own ashes.

Piscis Austrinus
(the Southern Fish)
This includes the star Fomalhaut, which is 24 light years from Earth. It may have planets of its own.

Grus
(the Crane)
The brightest star in this conspicuous group is Alnair.

Microscopium
(the Microscope)
The stars in this constellation are faint. It is extremely difficult to make out.

The Small and Large Magellanic Clouds

The Small and Large Magellanic Clouds are irregular shaped galaxies. They are satellite galaxies to our Milky Way galaxy, held close to it by its immense gravity.

This is the lower part of the constellation Orion, (see page 69).

Rigel

Epsilon Eridani

Eridanus

Columba

Caelum

NGC 1851

Horologium

Canopus. This star is in Carina (see page 73).

Reticulum

Large Magellanic Cloud

Tarantula Nebula

Mensa

Hydrus

Octans

South celestial pole

Fornax

Achernar

62Tuc (NGC362)

Small Magellanic Cloud

47Tuc (NGC104)

Phoenix

NGC55

Tucana

Sculptor

NGC253 (Sculptor Galaxy)

Piscis Austrinus

Fomalhaut

Grus

Alnair

Indus

Microscopium

Pavo

Kappa Pavonis

NGC 6752

Constellations to spot

None of these constellations is very easy to make out unless the sky is really dark. In order of visibility, Pavo, Grus and Columba are the best to look out for.

Good binocular sights

- **47Tuc** and **62 Tuc:** globular clusters in Tucana.
- **Small Magellanic Cloud** in Tucana.
- **NGC 6752:** globular cluster in Pavo.
- **NGC 253 (Sculptor Galaxy):** a gash of light about two thirds the size of the Moon.
- **NGC 55:** another galaxy in Sculptor. It looks thinner than the Sculptor Galaxy.

Star brightness

-1 0 1 2 3 4 5 6

These symbols show a star's brightness as seen from Earth (apparent magnitude) and not its actual brightness (absolute magnitude).

Key: ⬭ Galaxy ◯ Nebula ⦂ Open cluster ⦂ Globular cluster ◎ Planetary nebula ★ Double star

Internet links: For links to the websites for this book go to www.usborne-quicklinks.com and enter the keyword "astronomy".

CORVUS TO DORADO

Corvus
(the Crow)

This distinct group of four main stars is in a rather barren area of the sky, so it is fairly easy to spot.

Crater
(the Cup)

The group of main stars in this constellation look a little like a fainter version of Corvus.

Antlia
(the Air Pump)

This group of faint stars is very difficult to spot.

Vela
(the Sail)

Vela's outline is marked by bright stars. When you look at Vela through binoculars, you will see many smaller stars as well.

Along with Iota and Epsilon Carinae, Kappa and Delta Velorum make up the False Cross.

Chameleon

Chameleon is made of four faint stars and it cannot be seen easily, like a real chameleon disguising itself!

Volans
(the Flying Fish)

This distinct group of faint stars is partly enclosed by the constellation Carina.

Sextans
(the Sextant)

This small group of faint stars lies between Leo (see page 63) and Hydra.

Hydra
(the Water Snake)

This is the longest and largest constellation in the sky. It is a sprawling line of mainly faint stars. The head is a conspicuous group of stars.

The only bright star in this constellation is Alphard, sometimes called the "solitary one", since there are no other bright stars nearby.

Pyxis
(the Compass)

This constellation consists of just three main stars between Vela and Puppis.

Puppis
(the Stern)

Lots of stars and open clusters are visible through binoculars in this area.

Carina
(the Keel)

At one end is Canopus, which is 1,200 light years away and is the second brightest star in the night sky. Along with two stars in Vela, Epsilon and Iota Carinae make up the False Cross.

Pictor
(the Easel)

Pictures of Beta Pictoris have shown a circle of material surrounding the star. Many astronomers think this is evidence of planets forming, though none have been seen.

Dorado
(the Swordfish)

Dorado includes the irregular galaxy known as the Large Magellanic Cloud. It is only visible from the southern hemisphere. It looks like a misty patch.

A famous supernova took place in the Large Magellanic Cloud in 1987. It was easily the brightest, and closest, supernova since 1604.

A bright nebula, called Tarantula, can be seen in the Large Magellanic Cloud.

Argo Navis
(the ship)

In ancient times, Vela, Puppis and Carina were part of one huge constellation called Argo Navis. The astronomer Nicolas Lacaille split them up into separate constellations in 1756. The Milky Way runs the entire length of Argo Navis, culminating in brilliant star clouds around the Carinae Nebula (NGC3372).

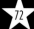

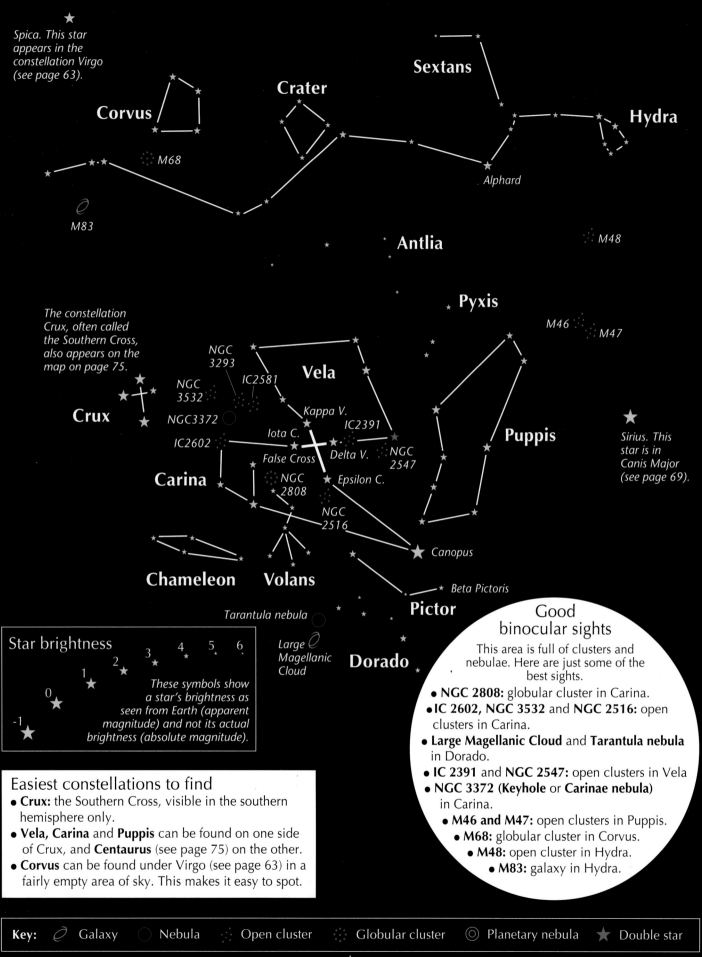

Spica. This star appears in the constellation Virgo (see page 63).

Corvus

M68

Crater

Sextans

Hydra

Alphard

M83

Antlia

M48

Pyxis

The constellation Crux, often called the Southern Cross, also appears on the map on page 75.

M46

M47

NGC 3293

IC2581

Vela

NGC 3532

Kappa V.

Crux

NGC3372

IC2391

Iota C.

Puppis

IC2602

Delta V.

NGC 2547

Sirius. This star is in Canis Major (see page 69).

False Cross

Carina

NGC 2808

Epsilon C.

NGC 2516

Chameleon

Volans

Canopus

Beta Pictoris

Pictor

Tarantula nebula

Large Magellanic Cloud

Dorado

Star brightness

6
5
4
3
2
1
0
-1

These symbols show a star's brightness as seen from Earth (apparent magnitude) and not its actual brightness (absolute magnitude).

Easiest constellations to find
- **Crux:** the Southern Cross, visible in the southern hemisphere only.
- **Vela, Carina** and **Puppis** can be found on one side of Crux, and **Centaurus** (see page 75) on the other.
- **Corvus** can be found under Virgo (see page 63) in a fairly empty area of sky. This makes it easy to spot.

Good binocular sights

This area is full of clusters and nebulae. Here are just some of the best sights.
- **NGC 2808:** globular cluster in Carina.
- **IC 2602, NGC 3532** and **NGC 2516:** open clusters in Carina.
- **Large Magellanic Cloud** and **Tarantula nebula** in Dorado.
- **IC 2391** and **NGC 2547:** open clusters in Vela
- **NGC 3372 (Keyhole** or **Carinae nebula)** in Carina.
- **M46** and **M47:** open clusters in Puppis.
- **M68:** globular cluster in Corvus.
- **M48:** open cluster in Hydra.
- **M83:** galaxy in Hydra.

Key: ⊘ Galaxy ◯ Nebula ⣿ Open cluster ⣿ Globular cluster ◎ Planetary nebula ★ Double star

Internet links: For links to the websites for this book go to www.usborne-quicklinks.com and enter the keyword "astronomy".

SAGITTARIUS TO CRUX

Sagittarius
(the Archer)
Sagittarius is sometimes called the Teapot. It has many bright stars. Above the "spout" is the M8 nebula, where new stars are forming. Other nebulae are visible with binoculars.

Corona Australis
(the Southern Crown)
The faint stars of Corona Australis make a curve.

Telescopium
(the Telescope)
This group of faint stars is near the tail of the large constellation Scorpius.

Ara
(the Altar)
You might find Ara by looking between the bright star Alpha Centauri (in Centaurus) and the tail of Scorpius.

NGC6397, our closest globular cluster, lies in this constellation. It is 8,400 light years away.

Circinus
(the Compasses)
This consists of three faint stars near to the bright star Alpha Centauri in Centaurus.

Triangulum Australe
(the Southern Triangle)
This constellation was first identified by the Italian explorer Amerigo Vespucci, in 1503. (He is more famous for establishing that America is not part of Asia as earlier explorers had thought.)

Apus
(the Bird of Paradise)
Apus is an inconspicuous group of faint stars.

Musca
(the Fly)
This faint constellation is next to Crux, the Southern Cross.

Scorpius
(the Scorpion)
Scorpius is mostly made of bright stars, which form a fairly convincing scorpion shape. Antares is a very bright red star.

With binoculars, you can see many faint open and globular star clusters.

Libra
(the Scales)
Four faint stars form the main part of Libra.

Alpha Librae is a double star. Beta Librae is the only star that appears green to the naked eye.

Lupus
(the Wolf)
Lupus is a distinctive pattern of bright stars, stretching between Alpha Centauri and Antares in Scorpius.

Norma
(the Level)
This is a group of very faint stars. The region is, however, filled with star clusters because Norma lies in the direction of the thickest part of the Milky Way that we see in the night sky.

Centaurus
(the Centaur)
A centaur is a mythical creature, half-man, half-horse.

Alpha Centauri is the third brightest star in the sky. After the Sun, it is the second closest star to us, 4.3 light years away. It is only visible in the southern hemisphere.

The faint Proxima Centauri (visible with a telescope) is Alpha Centauri's companion. It is the closest star to the Earth, 4.25 light years away.

Omega Centauri is the most visible globular cluster in the night sky. It has one million stars and is one of the closest globular clusters to us.

Crux
(the Southern Cross)
This is perhaps the most famous constellation in the southern hemisphere.

Alpha and Gamma Crucis point to the south celestial pole (the point directly above the south pole on Earth).

Easiest constellations to find
- **Sagittarius:** the shape looks a little like a teapot.
- **Scorpius:** you can make out the shape of a scorpion.
- **Crux (the Southern Cross)** makes a clear cross shape.
- **Centaurus:** the short crosspiece of Crux points to Alpha and Beta Centauri.
- **Corona Australis:** look under the Sagittarius teapot.

Sagittarius
M25
Nunki
M21
M20
Ascella
M8
The Teapot

M6
Antares
Shaula
M4
Scorpius
Zeta Scorpii

Corona Australis

Libra
Beta Librae
Alpha Librae

Telescopium

NGC6397
Ara

Lupus

Norma

Triangulum Australe

Circinus

Alpha and Proxima Centauri
Beta Centauri

Omega Centauri

Centaurus

Apus

Coalsack Nebula
Jewel Box
Gamma Crucis
To the celestial south pole
Alpha Crucis
Crux
Musca

Good binocular sights
There is a lot to see in this area. Here are some suggestions.
- **M8 Lagoon Nebula** and **M20 Trifid Nebula** in Sagittarius.
- **M21** and **M25:** open clusters in Sagittarius.
- **M4:** globular cluster in Scorpius.
- **M6 (Butterfly):** open cluster in Scorpius.
- **Omega Centauri** in Centaurus. The best globular cluster in the sky.
- **Coalsack:** dark nebula in Crux. It looks like a dark patch in the sky.
- **Jewel Box:** open cluster in Crux.

Star brightness
-1 0 1 2 3 4 5 6
These symbols show a star's brightness as seen from Earth (apparent magnitude) and not its actual brightness (absolute magnitude).

Key: ⬭ Galaxy ◯ Nebula ⋰ Open cluster ⁛ Globular cluster ◎ Planetary nebula ★ Double star

Internet links: For links to the websites for this book go to www.usborne-quicklinks.com and enter the keyword "**astronomy**".

75

HOME ASTRONOMY

If you would like to identify and observe stars and planets yourself, there are several pieces of equipment that you will find very useful. Here are some suggestions for what you might need.

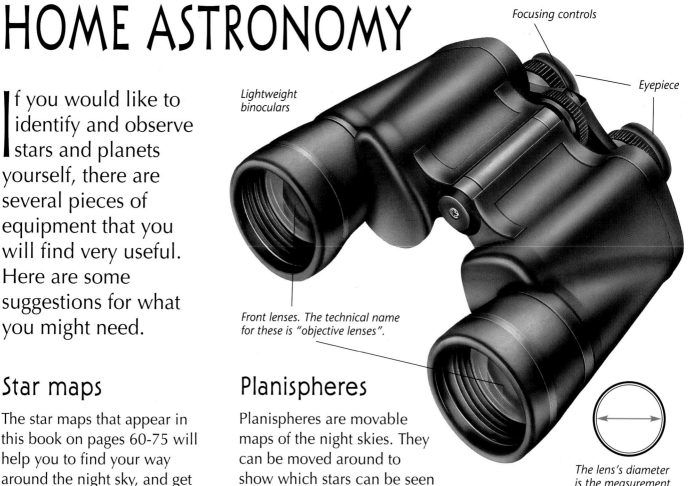

Lightweight binoculars

Focusing controls

Eyepiece

Front lenses. The technical name for these is "objective lenses".

The lens's diameter is the measurement across the lens from one side to the other.

Star maps

The star maps that appear in this book on pages 60-75 will help you to find your way around the night sky, and get to know the different constellations.

Star maps help you to find your way around the night sky.

Planispheres

Planispheres are movable maps of the night skies. They can be moved around to show which stars can be seen at any time. Planispheres are made to be used in particular parts of the world, so make sure you buy one that's correct for your part.

Binoculars

Binoculars are made in different sizes and powers. These are indicated by a pair of numbers, such as 7 x 35, 10 x 50 or 20 x 80. The first number tells you by how many times the binoculars will magnify an object. The second number is the diameter, in millimetres, of each front lens.

Using binoculars

Big, powerful binoculars will show you more than smaller ones. But big binoculars are heavy and will become hard to hold still.

For this reason, it is best to use binoculars that you find comfortable. Try out different pairs, and don't buy any that feel too heavy. Good sizes to try are 7 x 35 or 10 x 50.

If you do use large or heavy binoculars, it is best to mount them on a tripod. This will keep them steady while you observe the sky.

Telescopes

Good telescopes are expensive. The cheaper versions are not very good and few astronomers recommend them. For the cost of a cheap telescope, it is better to buy a very good pair of binoculars.

You can buy telescopes second-hand. Look for advertisements in astronomy magazines and seek the advice of an experienced astronomer before you buy.

What can you see?

With binoculars, you can see a bigger area of the sky. With a good telescope, you can see more detail.

Stars seen with naked eye.

Same stars seen through binoculars.

Same stars seen through a good telescope.

There is a short guide to telescopes on page 80. The telescope below is a refractor telescope. It uses a lens to collect light.

Finder scope. This small telescope helps you line up the main telescope.

Eyepiece

Your telescope will need a mount. Without one, you will not be able to hold the telescope still enough to see anything.

Sky watching

When you go outside, take a flashlight, so that you can read your star maps. To prevent the flashlight's glare stopping you from seeing well in the dark, cover the end with clear, red plastic film.

Don't give up if you can't see very much at first. Your eyes will adjust better to the darkness after about twenty minutes, and you will be able to see more stars.

77

STAR PHOTOGRAPHS

You don't have to be an expert in astronomy or photography to take some really good photos of the night sky. All you need is the right type of camera, and some ideas of what you would like to photograph.

An amateur photograph of the Andromeda Galaxy (M31)

What to look for

To find out what to look for at a particular time of year, look at astronomy magazines, websites and star-gazing apps. They will tell you which of the constellations are in view and whether you can see any special events, such as a comet or meteor shower.

They will give you lots of star spotting tips, too, and will also tell you about new and second-hand astronomy equipment.

The constellation of Orion. You can clearly see Orion's Belt – the three middle stars.

Equipment

★ Camera. It must be a digital SLR camera (DSLR), or a "bridge camera", that can take long exposures. You can buy these second-hand. Ask for advice about inexpensive DSLR cameras at a camera shop.

★ Memory card and battery. You will also need a card reader, either as part of a PC or laptop, or one you can plug into a computer using a USB cable. Always make sure your camera's battery is charged up before you go out.

★ Something to place your camera on. A tripod is best, but if you don't want the expense of buying one, you could just prop the camera on a low wall or car roof, resting it on a pillow, bean bag or wheat-filled "heat bag".

★ A shutter release allows you to take pictures without touching (and moving) the camera. There are two types: shutter release cables (see right) and wireless remote controls. Or you can set the timer delay on your camera.

★ A piece of dark cardboard, big enough to cover the camera lens. The shutter movement makes the camera shake slightly, and can result in blurred photographs. You can use the cardboard as described opposite to stop this happening.

★ A watch that shows seconds.

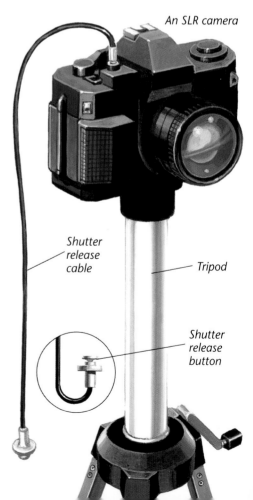

An SLR camera

Shutter release cable

Tripod

Shutter release button

Taking photos

Star photos are much better taken from a dark place away from dazzling street lights. Here's what to do.

Turn the focus ring until a distant bright light is in focus.

The smallest F number (here 1.8) is the widest aperture. It will let in the most light.

1. Place the camera on something stable and aim it towards the sky at the object you want to photograph. Open the lens aperture to its widest – shown by the smallest F number. Set the lens to manual focus and focus on a light on the horizon, the Moon or a bright star. Check the focus on the back screen or by taking a test shot. Keep this focus setting as long as possible.

2. After setting up the camera, leave it for about half an hour to get used to the temperature and conditions outside. Any condensation that may form on the lens will have time to clear.

3. Place the cardboard in front of the lens. Press the button on the shutter release cable and hold it down. Wait for two seconds. Then take away the cardboard but keep holding down the shutter release button.

4. Count the seconds you need (see below), then cover the lens again with the cardboard. Let go of the shutter release button and listen for the "click". Then, remove the cardboard. 20 seconds with a standard 50mm lens will give star trails. Around 6 seconds, with a high ISO setting, will give stars as points.

Star trails

Because the Earth spins, the stars appear to move across the sky during the night. To show this in a photo, follow the instructions on the left, but hold the shutter open for at least ten minutes.

The longer you hold open the shutter, the longer your star trails will be.

A picture like this can look stunning if you include a foreground object, such as a building, a tree, a distant hill or just the horizon.

An amateur photograph of star trails made by the Plough (see page 63).

Top tips

Experiment with exposure times and ISO settings to get the best results.

Finally, load all your photos onto a computer. You can use photo editing software to improve your pictures before printing them or sharing them with your friends. Try cropping them, tweaking the brightness, contrast or colours.

Out and about

When you go outside to watch the stars or to take photos, make sure that you are warm and comfortable.

Even in warm weather, it can become chilly on a clear evening. Wear several layers of clothes and take a hat. If you are going out for more than an hour, take a snack and a hot drink.

Never go out in the dark alone. Go with a parent or guardian, or members of your astronomy club.

Saturn and Jupiter in the night sky taken by an amateur photographer.

TELESCOPES

There are two main types of telescopes for looking at the stars: reflector and refractor telescopes.

Reflector telescope

A reflector telescope uses a mirror to collect the light. It is usually less expensive than a refractor of the same power, but it needs more care. From time to time the mirror has to be re-aligned, and recoated with aluminium to make it reflect properly.

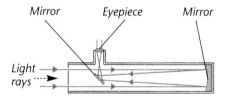

This diagram shows the path of light rays in a reflector telescope.

Refractor telescope

A refractor telescope uses a glass lens to collect the light. There is a labelled picture of a refractor telescope on page 77.

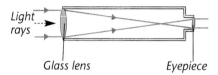

This diagram shows the path of light rays in a refractor telescope.

Telescope sizes

A telescope's power is measured by the size of the mirror or lens it uses. The larger the mirror or lens, the more light can be collected by the telescope and the clearer the image will be. It is not really worth buying a reflector telescope smaller than 100mm (4in) or a refractor telescope smaller than 75mm (3in).

Mountings

You will need a stand or mount to hold your telescope still. Many telescopes are sold complete with one. There are two kinds of mounts – altazimuth and equatorial.

An altazimuth mount allows you to move the telescope up and down (called altitude) and from side to side (called azimuth). It is easier to use than an equatorial mount.

An equatorial mount is set up to allow you to follow the curved path of a star across the sky with one movement.

Accessories

You can buy different parts to attach to your telescope.

Barlow lens Star diagonal

★ Barlow lens. This makes the magnification power of any eyepiece two or three times greater.

★ Star diagonal. This is a right-angle shaped mirror. Use it to look at high-up stars without bending down low.

A reflector telescope

Finder scope. This small telescope helps you to line up the main telescope.

Light comes into the tube of the telescope here. It reflects off a curved mirror at the bottom of the tube.

The magnification eyepieces fit on here. As the reflected light shines through the eyepiece, you see the image.

This telescope is standing on an equatorial mounting.

ASTRONOMY FACTS AND LISTS

An Apollo astronaut exploring the Moon.

Here are some famous constellations with drawings of the things that they are supposed to represent. Compare the shape of the constellation to the drawing. You'll see that often the star pattern does not look much like the shape it represents.

Orion

The star scene shown on the right is dominated by Orion, a great hunter in Greek mythology. Armed with a club and a shield of lion skin, he faces a charging bull, Taurus. The easiest part of Orion to spot is the line of three stars which forms his belt. Below it lie two stars which represent his sword. Orion's two faithful hunting dogs, Canis Major and Canis Minor, stand behind him. At his feet is Lepus the hare, the animal he most enjoys hunting.

Aldebaran

Procyon

CANIS MINOR

Betelgeuse

ORION

TAURUS

Rigel

Sirius

LEPUS

The shape of Canis Major, the large dog, is quite easy to make out. However, you need more imagination to see the shape of the little dog, Canis Minor.

CANIS MAJOR

PEGASUS

Enif

ANDROMEDA

The story of Perseus

To ancient Greek astronomers, the stars on the left represented the myth of Perseus. He killed Medusa, a creature so ugly that anyone who looked at her turned to stone. On his way home, he found Andromeda, daughter of Cassiopeia and Cepheus. She was chained to the rocks, waiting to be devoured by the dreaded sea monster Cetus. Perseus showed Medusa's head to Cetus, who immediately turned to stone, and so Andromeda was saved from death.

Algol

Perseus cleverly used a mirrored shield to help him kill Medusa without looking straight at her. As Perseus cut off Medusa's head, the white, winged horse, Pegasus sprang from her neck.

CASSIOPEIA

PERSEUS

MAP OF THE MOON

The map below shows the side of the Moon that always faces the Earth. This is the view you would see with the naked eye or using binoculars at full moon.

Most astronomical telescopes make things look upside down. If you are using a telescope, turn this book upside down, so that the picture will look like what you see.

Look at the Moon on a clear night. How many of these features can you find?

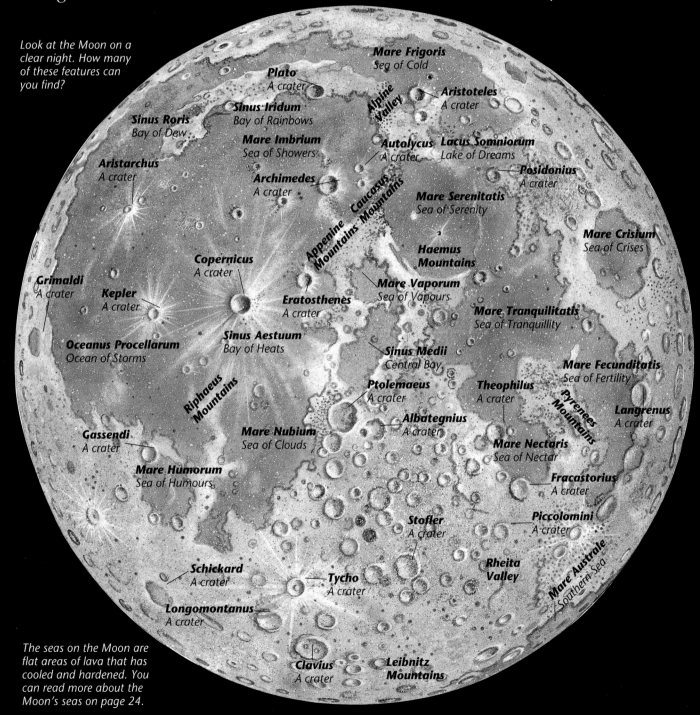

Mare Frigoris
Sea of Cold

Plato
A crater

Sinus Iridum
Bay of Rainbows

Sinus Roris
Bay of Dew

Mare Imbrium
Sea of Showers

Aristarchus
A crater

Archimedes
A crater

Alpine Valley

Aristoteles
A crater

Autolycus
A crater

Lacus Somniorum
Lake of Dreams

Posidonius
A crater

Appenine Mountains

Coucosus Mountains

Mare Serenitatis
Sea of Serenity

Mare Crisium
Sea of Crises

Haemus Mountains

Copernicus
A crater

Eratosthenes
A crater

Mare Vaporum
Sea of Vapours

Grimaldi
A crater

Kepler
A crater

Mare Tranquilitatis
Sea of Tranquillity

Sinus Aestuum
Bay of Heats

Sinus Medii
Central Bay

Mare Fecunditatis
Sea of Fertility

Oceanus Procellarum
Ocean of Storms

Ptolemaeus
A crater

Theophilus
A crater

Pyrenees Mountains

Langrenus
A crater

Riphaeus Mountains

Albategnius
A crater

Gassendi
A crater

Mare Nubium
Sea of Clouds

Mare Nectaris
Sea of Nectar

Mare Humorum
Sea of Humours

Fracastorius
A crater

Stofler
A crater

Piccolomini
A crater

Schickard
A crater

Rheita Valley

Tycho
A crater

Mare Australe
Southern Sea

Longomontanus
A crater

The seas on the Moon are flat areas of lava that has cooled and hardened. You can read more about the Moon's seas on page 24.

Clavius
A crater

Leibnitz Mountains

STARS AT-A-GLANCE

Satellites and space probes are always finding out new things about space. This means that what we know about the universe is always changing.

The lists on pages 84 to 86 show information about the different stars, nebulae, galaxies and meteor showers that are the most famous and easy to see.

Brightest stars

The stars are listed in order of their apparent magnitude, that is, how bright they look when viewed from the Earth.

Name of star	Name of constellation	Brightness (mag.)	Distance from Earth (light years)	Spectral type
Sirius	Canis Major	−1.46	8.6	A
Canopus	Carina	−0.72	1,200	F
Alpha Centauri	Centaurus	−0.27	4.3	G
Arcturus	Boötes	−0.04	37	K
Vega	Lyra	0.03	25.3	A
Capella	Auriga	0.08	42	G
Rigel	Orion	0.1 (variable)	910	B
Procyon	Canis Minor	0.38	11.3	F
Achernar	Eridanus	0.5	85	B
Betelgeuse	Orion	0.5 (variable)	310	M
Beta Centauri	Centaurus	0.6 (variable)	460	B
Altair	Aquila	0.77	16.8	A

Nearest stars to Earth

Name of star	Name of constellation	Brightness (mag.)	Distance from Earth (light years)	Spectral type
Proxima Centauri	Centaurus	11.1 (variable)	4.25	M
Alpha Centauri A	Centaurus	0	4.3	G
Beta Centauri B	Centaurus	1.4	4.3	K
Barnard's star	Ophiuchus	9.5	6	M
Wolf 359	Leo	13.5 (variable)	7.6	M
Lalande 21185	Ursa Major	7.5	8.1	M
UV Ceti A	Cetus	12.4 (variable)	8.4	M
UV Ceti B	Cetus	13.02 (variable)	8.4	M
Sirius A	Canis Major	−1.46	8.6	A
Sirius B	Canis Major	8.5	8.6	DA
Ross 154	Sagittarius	10.6	9.4	M
Ross 248	Andromeda	12.3	10.3	M

Double stars

Name of star	Name of constellation	Brightness (mag.)	Distance from Earth (light years)	Type of star
Alpha Capricorni	Capricornus	4.2, 3.6	1,600, 120	multiple star
Beta Capricorni	Capricornus	3.1, 6	250	physical double
Beta Cygni (Albireo)	Cygnus	3.1, 5.1	390	physical double
Nu Draconis	Draco	4.9, 4.9	120	physical double
Alpha Librae	Libra	2.8, 5.2	72	physical double
Epsilon Lyrae	Lyra	4.7, 5.1	120	double double
Zeta Lyrae	Lyra	4.4, 5.7	210	physical double
Theta Orionis (4 stars)	Orion	5.1, 6.7, 6.7, 8	1,300	multiple star
Theta Tauri	Taurus	3.4, 3.9	150	physical double
Zeta Ursae Majoris (Mizar and Alcor)	Ursa Major	2.3, 4	60, 80	optical double

Variable stars

Name of star	Name of constellation	Brightness (mag.)	Distance from Earth (light years)	Length of cycle	Type of star
Epsilon Aurigae	Auriga	3.3-4.1	4,564	27 years	eclipsing binary
Alpha Cassiopeia	Cassiopeia	2.2-3.1	120	irregular	irregular
Gamma Cassiopeia	Cassiopeia	1.6-3	780	irregular	shell star*
Delta Cephei	Cepheus	3.6-4.3	1,336	5 days 9 hours	pulsating variable
Mira	Cetus	2-10	94	331 days	long-period variable
Eta Geminorum	Gemini	3.1-4	190	233 days	double variable
Alpha Herculis	Hercules	3.1-3.9	218	semi-regular	double star
Beta Lyrae	Lyra	3.4-4.3	299	12 days 22 hours	eclipsing binary
Beta Persei	Perseus	2.2-3.5	95	2 days 21 hours	eclipsing binary
Betelgeuse	Orion	0.4-1.3	310	5 years 285 days	semi-regular

* A shell star rotates at such a high speed that it is unstable and throws off rings of gas. This causes the magnitude to vary.

Star clusters

Catalogue number	Name of constellation	Brightness (mag.)	Distance from Earth (light years)	Type of cluster
M44 / NGC2632 (Praesepe)	Cancer	4	525	open
M41 / NGC2287	Canis Major	5	2,350	open
NGC5139 (Omega)	Centaurus	4	17,000	globular
NGC4755 (Jewel Box)	Crux	5	7,700	open
M35 / NGC2168	Gemini	5	2,200	open
M13 / NGC6205	Hercules	6	21,000-25,000	globular
M45 (Pleiades)	Taurus	1.5	410	open
NGC869/884 (double cluster)	Perseus	4	7,000/8,150	open
M47 / NGC2422	Puppis	6	1,540	open
NGC104 (47Tuc)	Tucana	4	15,000-20,000	globular
M22 / NGC6656	Sagittarius	5	9,600	globular
M7 / NGC6475	Scorpius	3	800	open

SPACE OBJECTS AT-A-GLANCE

Nebulae

Catalogue number	Name of constellation	Name of nebula	Distance from Earth (light years)	Type of nebula
NGC7293	Aquarius	Helix	160-450	planetary
none	Crux	Coalsack	500-600	dark
NGC2070	Dorado	Tarantula	170,000	bright
M42	Orion	Great Nebula	1,300-1,900	bright
M8	Sagittarius	Lagoon	5,000	bright
M20	Sagittarius	Trifid	more than 5,000	bright
M17	Sagittarius	Omega	5,700	bright

Galaxies

Catalogue number	Name of constellation	Name of galaxy	Distance from Earth (light years)	Type of galaxy
none	Dorado	Large Magellanic Cloud	170,000	irregular
NGC292	Tucana	Small Magellanic Cloud	205,000	irregular
M31	Andromeda	Great Spiral Galaxy	2,900,000	spiral
M33	Triangulum	Pinwheel	2,400,000	spiral
M51	Canes Venatici	Whirlpool Galaxy	35,000,000	spiral
M81	Ursa Major	none	7,000,000-9,000,000	spiral
M82	Ursa Major	none	7,000,000-9,000,000	irregular

Major annual meteor showers

A meteor shower is a short but spectacular display of meteors caused by the Earth moving across the orbit of a comet.

Dates visible	Peak time	Name of meteor shower	Associated comet	Name of constellation	No. per hour at peak time
Jan 1-6	4 Jan	Quadrantids	-	Boötes	60
Apr 19-25	21 April	Lyrids	Thatcher	Lyra	10
Apr 24-May 20	5 May	Eta Aquarids	Halley	Aquarius	35
Jul 25-Aug 20	12 Aug	Perseids	Swift-Tuttle	Perseus	75
Oct 16-21	22 Oct	Orionids	Halley	Orion	25
Oct 20-Nov 30	3 Nov	Taurids	Encke	Taurus	10
Nov 15-19	17 Nov	Leonids	Tempel-Tuttle	Leo	variable
Dec 7-15	13 Dec	Geminids	Phaeton (asteroid)	Gemini	75

Astronomical symbols

Astronomers use special symbols to represent the Sun, Moon, planets and the twelve constellations of the Zodiac.

Sun	Moon	Mercury	Venus	Earth	Mars	Jupiter	Saturn	Uranus	Neptune	Pluto

Aquarius	Pisces	Aries	Taurus	Gemini	Cancer	Leo	Virgo	Libra	Scorpius	Sagittarius	Capricornus

The planets at-a-glance

Name of planet	Diameter of planet	Average distance from Sun	Time to orbit Sun	Time to rotate	Number of satellites
Mercury	4,880km (3,032 miles)	58 million km (36 million miles)	88 days	59 days	None
Venus	12,100km (7,518 miles)	108 million km (67 million miles)	224.7 days	243 days	None
Earth	12,756km (7,926 miles)	150 million km (93 million miles)	365.3 days	23hrs 56mins	1 (Moon)
Mars	6,786km (4,217 miles)	228 million km (142 million miles)	687 days	24hrs 37mins	2
Jupiter	139,822km (86,881 miles)	778 million km (483 million miles)	11.9 years	9hrs 50mins	63
Saturn	116,464km (72,367 miles)	1,429 million km (888 million miles)	29.5 years	10hrs 14mins	61
Uranus	50,724km (31,518 miles)	2,871 million km (1,784 million miles)	84 years	17hrs 54mins	27
Neptune	49,528km (30,775 miles)	4,500 million km (2,796 million miles)	165 years	16hrs 6mins	13
Pluto (dwarf planet)	2,274km (1,413 miles)	5,913 million km (3,674 million miles)	248 years	6 days 10hrs	3

Eclipse forecast

Date	Type	Area	Duration
2016 Mar 9	Total	Sumatra, Borneo, Sulawesi, Pacific	04m 09s
2016 Mar 23	Penumbral	Asia, Australia, Pacific, western Americas	-
2016 Sep 1	Annular	Atlantic, C Africa, Madagascar, Indian	03m 06s
2016 Sep 16	Penumbral	Europe, Africa, Asia, Australia, western Pacific	-
2017 Feb 11	Penumbral	Americas, Europe, Africa, Asia	-
2017 Feb 26	Annular	Pacific, Chile, Argentina, Atlantic, Africa	00m 44s
2017 Aug 7	Partial	Europe, Africa, Asia, Australia	01h 55m
2017 Aug 21	Total	N Pacific, US, S Atlantic	02m 40s
2018 Jan 31	Total	Asia, Australia, Pacific, western North America	01h 16m
2018 Feb 15	Partial	Antarctica, S South America	-
2018 Jul 13	Partial	S Australia	-
2018 Jul 27	Total	South America, Europe, Africa, Asia, Australia	01h 43m
2018 Aug 11	Partial	N Europe, NE Asia	-
2019 Jan 6	Partial	NE Asia, N Pacific	-
2019 Jan 21	Total	central Pacific, Americas, Europe, Africa	01h 02m
2019 Jul 2	Total	S Pacific, Chile, Argentina	04m 33s

Where to look

Mercury, Venus, Mars, Jupiter, Saturn and Uranus can all be seen with the naked eye. But they do not always appear in the same place in the sky.

Many astronomy magazines and websites give details of what is visible in the night sky and show you where to look.

Eclipse Predictions by Fred Espenak, www.EclipseWise.com

LANDMARKS OF ASTRONOMY

These two pages give you a quick history of astronomy. They tell you when people made important discoveries that contributed to our knowledge of outer space.

3100BC* The Egyptians begin using calendars, calculated according to positions of stars, to decide when they should plant and harvest crops.

3000BC The oldest known constellation shapes are drawn around this time, by the Egyptians.

2446BC Chinese astronomers notice that Mercury, Venus, Earth, Mars and Jupiter have moved into line with one another. This shows that they are aware that the planets move in space.

6000BC-AD100** Astronomy is first taught in Greek universities.

300BC-AD900 In Central America, the Mayas use their knowledge of astronomy to devise an accurate calendar, which the Aztecs adopt.

AD150 Greek astronomer Ptolemy publishes his Ptolemeic System. According to this, the Earth is in the middle of the universe. Everything else orbits the Earth. Astronomers believe this for the next 1,400 years.

200-1000 The study of astronomy stops in Europe. People's struggle to survive wars and lack of food means that science and learning suffer. Modern astronomers call these years the lost centuries.

Ptolemy

**The years before the birth of Jesus Christ have BC ("before Christ") written after them. The bigger the number, the longer ago it happened.*
***The years after the birth of Jesus Christ sometimes have AD before them. (AD stands for the Latin "anno Domini" meaning "in the year of our Lord".)*

1006 The Chinese observe the Lupus supernova. It shines almost as brightly as a quarter Moon for two months and is the brightest supernova ever, visible in daylight.

Around 1000 An astronomy revival begins in Arabia. The subject is taught again at Baghdad University.

1030 Al-Sufi, from the Baghdad School of Astronomy, draws up the best of the many star catalogues that begin to appear at this time.

1054 The Taurus Supernova is noted by the Chinese. The debris from this supernova can still be seen as the Crab Nebula.

1420 Samarkand Observatory is built in Central Asia by Ulegh Beg.

1543 Copernicus publishes *De Revolutionibus Orbium Coelestium* ("On the Revolution of the Heavenly Spheres"), a controversial book which suggests that the Sun is at the middle of the Solar System.

1572 Denmark. Tycho Brahe observes a supernova.

1604 "Kepler's Nova" is seen in our galaxy by the German astronomer, Johannes Kepler.

1608 A simple refractor telescope is invented by Hans Lippershey in the Netherlands.

1609 Italian astronomer Galileo Galilei builds a telescope which is an improvement on Lippershey's telescope. With it, Galileo begins observing the stars and planets.

1668 England. Isaac Newton builds the first reflector telescope.

1687 England. Newton publishes a book, *Principia*. In it, he proves that the Earth and other planets orbit the Sun.

1758 A comet returns as predicted by the English scientist Edmund Halley in 1705. It is named Halley's Comet in his memory.

Early telescope

1781 France. Comet-hunter Charles Messier publishes a catalogue of nebulae, galaxies and star clusters.

1781 England. William Herschel discovers Uranus.

1801 Italy. The first asteroid is discovered by Giuseppe Piazzi.

1845 Ireland. The Earl of Rosse builds the biggest, most powerful reflector telescope yet made. Called Leviathan, it has a 1.93m (76in) mirror. Astronomers using it discover spiral galaxies.

1846 France. Neptune is discovered by Johann Gottfried Galle and Heinrich Louis D'Arrest.

1877 England. Mars's two moons, Phobos and Deimos, are discovered by Asaph Hall.

1877 Italy. Giovanni Schiaparelli observes deep channels, the "canals", on Mars.

1910 Halley's Comet is seen again. The Great Daylight Comet is also visible, even during the day.

1915-17 Following on from his Special Theory of Relativity, the German scientist Albert Einstein develops his General Theory of Relativity. This theory revolutionizes the way scientists research space, gravity, time and physics.

1927 Belgium. Georges Lemaître proposes that the universe was formed in a huge explosion – the Big Bang theory.

1930 USA. Pluto is discovered by Clyde Tombaugh.

1937 USA. Groter Reber invents the first true radio telescope.

1946 USA. Edwin Hubble helps to build Hale, the biggest reflector telescope yet made.

1948 England. The Big Bang theory is challenged by the Steady State theory of scientists Hermann Bondi and Thomas Gold, saying that the universe will always look the same.

1957 Soviet Union. Sputnik 1, the first artificial satellite, is launched. Sputnik 2 is launched, carrying a dog, called Laika, into space.

1959 The first space probes are sent to the Moon by the Soviet Union.

1961 Soviet Union. Yuri Gagarin becomes the first person in space. The flight lasts less than two hours.

1963 Soviet Union. On June 16, Valentina Tereshkova becomes the first woman to go into space. The flight lasts for nearly three days.

1965 USA. Arno Penzias and Robert Wilson detect weak radio signals from space, perhaps proving that the Big Bang really happened.

1965 US space probe Mariner 4 takes the first photographs of Mars.

Sputnik 1

1966 Soviet space probe Luna 9 is the first to land on the Moon.

1967 The Soviet Union lands the first space probe on Venus.

1968 The USA makes the first manned space flight, Apollo 8, around the Moon.

1969 On July 20, the US Apollo 11 mission lands the first men on the Moon. They are Neil Armstrong, who becomes the first man to walk on the Moon, and Buzz Aldrin.

1969 USA. First pulsar is seen (in the Crab Nebula) by astronomers at Steward Observatory.

1971 US Mariner 9 space probe returns close-up pictures of Mars.

1973 The USA launches Skylab, the first space station.

1973 US Pioneer 10 spacecraft returns close-up pictures of Jupiter.

1974 US Mariner 10 space probe returns the first photos of Venus's cloud tops and Mercury's surface.

1975 Soviet space probes Venera 9 and Venera 10 return the first photos of Venus's surface.

1976 US space probes Viking 1 and Viking 2 land on Mars. They take extensive pictures and samples of the planet's soil.

1977 The rings around Uranus are discovered.

1979 The existence of Pluto's Moon Charon is confirmed.

1979 US space probes, Voyager 1 and Voyager 2, fly past Jupiter, sending back detailed pictures.

1980 US space probe Voyager 2 flies past Saturn. It sends back detailed pictures.

1981 On April 12, the USA launches STS1, the first space shuttle flight.

1986 US probe Voyager 2 flies past Uranus. It sends detailed images.

1986 Soviet space station Mir is launched.

1986 US space shuttle Challenger explodes, killing seven astronauts.

1987 The brightest supernova for several hundred years is sighted in the Large Magellanic Cloud.

1989 US space probe Voyager 2 flies past Neptune. It sends back detailed pictures.

1990 The Hubble Space Telescope is launched from the USA. It is found to have a fault, preventing it from sending detailed images of distant parts of space.

1991 The Hubble Space Telescope is repaired by spacewalking astronauts.

1991 US Galileo space probe takes close-up pictures of the asteroid Gaspra. They are the first close-up pictures of an asteroid.

1995 Comet Hale-Bopp is discovered. Astronomers predict that it will be brightest in 1997.

1997 Comet Hale-Bopp becomes the brightest comet since 1911.

1997 US Mars Pathfinder reaches Mars. It sends back detailed information about the planet's soil, rocks and weather.

1997 The USA launches the Cassini mission to Saturn.

1997 The Mars Global Surveyor arrives on Mars.

1999 The Mars Polar Lander lands on Mars but contact is lost soon afterwards.

2001 The US NEAR probe lands on the asteroid Eros.

2001 After 15 years in orbit, Space Station Mir is deliberately crashed into the Indian Ocean.

The Hubble Space Telescope being repaired

2001 US multi-millionaire Dennis Tito pays $20 million to stay on board the ISS for a week as the first ever "space tourist".

2003 US space shuttle Columbia breaks up, kiling seven astronauts.

2003 US Mars Rovers Spirit and Opportunity begin exploring Mars.

QUESTIONS AND ANSWERS

Q

Many scientists think that the universe started with a massive explosion, called the Big Bang. What was there before this?

A

According to scientists, there was nothing before the Big Bang. Time itself started with the Big Bang.

Q

Is it true that you can see the past by looking out into space?

A

Yes. When you look out deep into space, you are actually seeing light that set out from distant points many, many years ago. The farther away something is, the longer the light has taken to reach you and so the further back in time you are looking when you see it. For example, we see the Sun as it was eight minutes ago, Alpha Centauri as it was four years ago, and the Andromeda Galaxy as it was 2.9 million years ago. Scientists believe that the most distant objects are so far back in time that they give clues about the beginning of the universe.

Q

How big is a black hole?

A

Scientists believe that the distance across black holes may range from microscopically tiny to what are called supermassive black holes. The largest discovered so far is the size of a galaxy and weighs as much as 18 billion Suns!

Q

Can you see other galaxies from Earth?

A

Yes. Using powerful telescopes, many thousands of galaxies can be seen. Even with the naked eye, you can see three: the Large Magellanic Cloud, the Small Magellanic Cloud, and M31, the Andromeda Galaxy. (See pages 67 and 71).

Q

How much longer will the Sun last?

A

Scientists reckon that the Sun should last for about another 4,500 million to 5,000 million years.

Q

How many stars are there in space?

A

Nobody knows for sure. There are about 100,000 million stars in the Milky Way galaxy alone. Astronomers now believe that there are many millions of galaxies in the universe, each with as many stars as our own Milky Way. We will probably never know just how many stars there are.

Q

Why do stars twinkle?

A

As a star's light passes through the Earth's atmosphere, it is bent and broken up. The angle that it bends depends on the temperature of the air. The light passes through both warm and cold air, so it shines at us from different directions at once. The star then appears to flicker.

Star light bending on its way through the Earth's atmosphere.

Q

If you want to find out where north is, Polaris, the northern pole star, points the way. Thuban used to be the northern pole star. How and why has it changed?

A

The Earth spins at an angle but it wobbles as it spins. This means that over thousands of years, the angle at which it spins changes. The wobble causes the north pole gradually to point in a different direction, eventually pointing at a different star.

Q

Could spacecraft land on all the planets in the Solar System?

A

No, only on the solid planets: Mercury, Venus, Earth, Mars and Pluto. Jupiter, Saturn, Uranus and Neptune are all "gas giants", huge balls of gas and liquid with no solid surface. There are, however, plenty of moons which a spacecraft could land on instead.

Q

What does the night sky look like on the Moon?

A

The Moon has no atmosphere so the sky there is always clear. When the Sun is in the sky, it is so bright that it blocks out all the stars, but when it sets, you can see the stars much more clearly than you can from Earth. You can see the Earth in the sky too, looking like a large blue and white marble. With binoculars you can see countries and even some cities. Like the Moon, the Earth goes through phases.

Q

Why is Mars red?

A

Mars's soil contains lots of iron, which has rusted away over millions of years. Rusty iron is red.

Q

Some people claim to have seen aliens. Do they really exist?

A

Nobody knows whether or not aliens exist. Lots of people claim to have seen them but there is no proof. Scientists now think that there are lots of other stars in our own galaxy with their own planets, and so with millions of galaxies in the universe, there could be countless billions of planets out there. Experts now think that there are several places in our own Solar System where there are chemicals which could enable life to exist. These chemicals have been found on Mars, and beneath the icy surface of Europa, one of Jupiter's moons. So far, however, nobody has found alien life in any of them.

Q

How many asteroids are there in the Solar System?

A

Nobody is sure of the exact number of asteroids in the Solar System, but there are certainly thousands. There are so many of them, not only in the Asteroid Belt, but dotted around space, that it is doubtful that they will ever be counted.

Q

Has anyone on Earth ever been hit by a meteorite?

A

Yes, but don't worry too much as it doesn't happen very often. In the early 1990s, for example, a man was struck by a meteorite while driving his car on a motorway in Germany. An unlucky dog was killed by a falling meteorite in the early 1900s.

Q

What is the biggest comet ever seen?

A

The Great Comet of 1811 had a coma that was over 2 million km (1¼ million miles) wide – wider than the Sun. The Great Comet of 1843 had a tail that was 330 million km (about 200 million miles) long – that's long enough to stretch from the Sun to Mars.

Q

Can you see satellites from Earth?

A

Yes, they look like stars which move slowly across the sky. Some appear to blink very slowly, unlike planes which flash relatively quickly. You can see a satellite somewhere in the sky every few minutes.

Q

How do you become an astronaut?

A

The best way to become an astronaut is first to become a scientist, for example a chemist, astronomer or engineer. You will need a university degree and a specialization in a branch of science which is relevant to outer space. It is also useful to learn to fly a plane. Then apply to NASA and ask if they will accept you as an Astronaut Candidate. If they take you on, you may need to train for four or five years, living in the USA. Eventually, you may be lucky enough to be selected for a mission.

Q

Do you have to be a scientist to go into space?

A

No, although most people who go into space are scientists. They conduct useful investigations, for example into the effects of life in space on the human body. It is becoming more common for non-scientists to take part in space missions, and several space tourists have already been into orbit (all millionnaires, who could afford to pay their way). In the future, anybody who is fit enough to travel in space may be able to take a short trip into orbit. However, space trips will still be extremely expensive, so you'll have to be rich as well as fit.

Q

Why do space missions always have to blast off? Why can't they just take off, like planes do?

A

Jet engines need lots of air in order to work. They cannot work in the thin air at the edges of the Earth's atmosphere, so they can't be used to power spacecraft. At present, the only alternative is rockets. They blast energy out of their exhaust jets at an incredible rate, and push the spacecraft upward at a tremendous speed. Scientists are currently working on ways to make jet engines which will work at the edge of the atmosphere. At the moment, space shuttles are the only craft that can land like a plane, but they still need to blast off with a rocket.

Fuel tank

Rocket

Space shuttle

Space shuttle blastoff

Space shuttle landing

Q

How long would it take for a group of astronauts to travel to Pluto?

A

If astronauts flew in an Apollo spacecraft (the type that flew to the Moon), it would take them about 86 years to reach Pluto.

Q

In some science fiction movies, people are transported instantly by being de-materialized and then beamed to another place. Is this really possible?

A

No. To transport a person instantly from one place to another, all of the atoms that make up a person's body would have to be pulled apart, whizzed through space and then rebuilt in exactly the same pattern. As atoms are always moving, it would be nearly impossible to put them back together in the right order.

GLOSSARY

This glossary defines important words to do with astronomy and space. Words in bold type are elsewhere in the glossary.

asterism Small, easily-recognized pattern of **stars**, usually forming part of a larger pattern, or **constellation**.

asteroid Small, rocky object orbiting the **Sun**. Thousands exist in part of the **Solar System** known as the Asteroid Belt, between Mars and Jupiter.

astronomy The scientific study of the universe and the objects in it.

atmosphere A layer of gas that surrounds a **planet** or **star**.

aurora A display of light in the upper **atmosphere** near a **planet's** poles. Caused by **solar wind**.

Big Bang theory A theory which states that the **universe** began in an enormous explosion.

binary star Two **stars** that revolve around one another, locked together by each other's **gravity**.

black hole An invisible region in space that has an enormous pull of **gravity**. Caused by a collapsed **supergiant star**.

cataclysmic variable A type of **binary star** system where, from time to time, one star gains some of the other star's **matter**. As this happens, a huge amount of light is given off.

cluster A group of **stars** or **galaxies** that lie close together.

coma The huge cloud of gas around the icy **nucleus** of a **comet**.

comet A chunk of dirty, dark ice, mixed with dust and grit which revolves around the **Sun** in an oval **orbit**.

constellation A group of **stars** that can be seen as a pattern from Earth.

core The central part of a **planet**, **moon** or **asteroid**. It is made of different materials from its surrounding layers.

corona The outermost part of the **Sun's atmosphere**.

crater A hollow in the surface of a **planet**, **moon** or **asteroid**, caused by the impact of a **meteorite** or an **asteroid**.

crust The outer part of a **planet** or **moon**, made mostly of rock.

day The length of time it takes a **planet** to spin around once.

dwarf planet An object **orbiting** a **star**, larger and rounder than an **asteroid** but too small for a **planet**.

dwarf star A **star** which is smaller than the **Sun**.

eclipse The total or partial blocking of one object in space by another. For example, when the **Moon** passes in front of the **Sun**, the Sun is eclipsed.

eclipsing variable A type of **binary star**, where one of the stars passes in front of the other, resulting in a dip in brightness.

equator The imaginary line around the middle of a **planet**, dividing its northern **hemisphere** from its southern hemisphere.

facula A cloud of glowing gases that surrounds a **sunspot**, hovering just above the **Sun's** surface.

galaxy A group of **stars**, **nebulae**, **star clusters**, **globular clusters** and other **matter**. There are millions of galaxies in the **universe**.

gas giant A type of planet which is made up of gas and liquids surrounding a relatively small **core**.

giant star A star which is larger than the **Sun**.

gravity The force of attraction that pulls a smaller object toward a more massive object. For example, the **Moon** is attracted to the Earth by gravity.

hemisphere Half of a **planet** or **moon**. The top half is the northern hemisphere and the bottom half is the southern hemisphere.

light year The distance that a ray of light travels in one year: 9.46 million million km (5.88 million million miles).

magnitude A **star's** brightness.

matter Tiny particles from which everything is made.

meteor A **meteoroid** that travels through the Earth's **atmosphere**. As it falls towards Earth, it burns up, making a streak of light. Also known as a **shooting star**.

meteorite A **meteor** that hits the Earth's surface.

meteoroid Dust or a small chunk of rock which **orbits** the **Sun**.

meteor shower A short but spectacular display of **meteors** caused by the Earth moving across the **orbit** of a **comet**.

Milky Way A broad band of light that looks like a trail of spilled milk in the night sky. Created by the millions of faint **stars** that form part of our **galaxy**.

Milky Way galaxy The **galaxy** that contains the **Solar System**.

moon Any natural object which **orbits** a **planet**.

Moon The ball of rock which **orbits** the Earth.

multiple system A **star** system containing two or more stars.

NASA The National Aeronautics and Space Administration, which organizes space exploration on behalf of the government of the USA. Projects include the Space Shuttle missions.

nebula A vast cloud of gas and dust where new **stars** often form.

neutron star A small, spinning **star** that is left when a **supergiant star** has exploded.

nova A **star** that suddenly increases in brightness and then fades away. A type of **cataclysmic variable** star.

nuclear fusion A type of activity that goes on inside a **star**, where tiny particles (called atoms) of gas join together to make larger atoms. This process creates huge amounts of heat and light.

nucleus The central point around which other things are arranged. In astronomy, the word is used to refer to the dense part in the middle of a **galaxy** or at the head of a **comet**.

optical double star Two **stars** that appear very close together when seen from Earth, because they are in the same line of sight. However, they are not linked to one another in any way.

orbit The path of one object as it revolves around another. For example, the **planets** orbit the **Sun**.

penumbra An area of light shadow caused by the partial **eclipse** of one object by another.

phase A particular stage in a cycle of changes that occurs over and over again. For example, the **Moon's** appearance goes through several phases as it travels around the Earth every month.

physical double star Another name for a **binary star.**

planet A relatively large object that revolves around a **star**, but which is not itself a star. There are eight known **planets** in our **Solar System**.

planetary nebula Outer layers of gas from a dying **star**, which are puffed into space. From a distance, the layers of glowing gas around the dying star make it look like a **planet**.

planisphere A movable, circular map of the **stars** in the sky that can be made to show the appearance of the night sky at any given time and date.

pointers Two or more **stars** in a **constellation** that show the way to another constellation.

pole One of the two points on a **planet's** surface that are farthest away from its equator.

primary star The brighter **star** in an **eclipsing variable**.

prominence A cloud of gas that bursts out from the **Sun's** surface.

pulsar A **neutron star** that sends out beams of **radiation** which swing around as the star spins.

pulsating variable A **star** which changes in size, temperature and brightness.

radar A method of finding the position and speed of distant objects using beams of radio waves.

radiation The waves of energy, heat or particles from an object.

red giant Type of star that has a relatively low temperature and is many times larger than the **Sun**.

satellite Any object in outer space that **orbits** another object. Man-made satellites are launched into space to orbit a **planet** or **moon**.

secondary star The fainter **star** in an **eclipsing variable**.

shooting star Another name for a **meteor**.

solar Something that relates to the **Sun**, such as a **solar flare**, or **solar wind**.

solar flare A sudden outburst of energy from a small part of the **Sun's** surface.

Solar System The **Sun** and all the objects that **orbit** it.

solar wind A constant stream of invisible particles that is blown from the **Sun's** surface into space.

spacecraft A vehicle made to travel in space.

space probe An unmanned **spacecraft** which collects information about objects in space and sends it back to scientists on Earth.

space shuttle A **spacecraft** which carries people and materials into space. It is launched by a rocket but lands like a plane and can be used again.

space station A large, manned **satellite** in space used as a base for space exploration over a long period of time.

spectral type A class of **star,** shown by the letters O, B, A, F, G, K and M.

star A ball of constantly exploding gases, giving off light and heat. The **Sun** is a star.

Sun A medium-sized **star** that lies in the middle of our **Solar System**.

sunspot One of the dark patches that appear on the **Sun** every now and again.

supergiant stars The brightest **giant stars**. They live for only a few million years.

supernova The explosion of a **supergiant star** which generates enormous amounts of light. The star then collapses to form a **neutron star**, or if the star was very large, a **black hole**.

tail The stream of visible gases that comes off a **comet** as it passes relatively close to the **Sun**.

umbra An area of dark shadow caused by the **eclipse** of one object by another.

universe The word used to describe everything that exists in space, including the **galaxies** and **stars**, the **Milky Way** and the **Solar System**.

variable star A **star** whose brightness changes over time, usually in a predictable way.

white dwarf A type of **star** that is much smaller and denser than the **Sun**. It gives off a relatively dim, white light.

year The length of time it takes a **planet** to **orbit** the **Sun**.

INDEX

Constellations and
asterisms are listed in
bold type, stars are
listed in italics.

Useful addresses

Australia
Sydney Observatory,
1003 Upper Fort Street,
Millers Point,
NSW 2000, Australia.

Canada
Royal Astronomical Society of Canada
203–4920 Dundas St Wt
Toronto ON
M9A 1B7

Fédération des astronomes amateurs du Québec
4545 Avenue Pierre-de-Coubertin
Montréal QC
H1V OB2

Great Britain
British Astronomical Association
Burlington House
Piccadilly
London W1J 0DU

Federation of Astronomical Societies
Mr Shaun O'Dell (Secretary)
147 Queen St
Swinton
Mexborough
South Yorkshire
S64 6NG
(Please enclose stamped addressed envelope)

New Zealand
Royal Astronomical Society of New Zealand
P.O. Box 3181
Wellington

USA
Amateur Astronomers Association
P.O. Box 150253
Brooklyn, NY 11215

For details of astronomy society websites,
go to **www.usborne-quicklinks.com** and
enter the keyword "astronomy".

This edition first published in 2009 by Usborne Publishing Ltd, Usborne House, 83-85 Saffron Hill, London EC1N 8RT. www.usborne.com
Copyright © Usborne Publishing Ltd, 2009, 2008, 2001, 1998, 1994, 1991, 1983, 1977. The name Usborne and the devices are Trade Marks
of Usborne Publishing Ltd. All rights reserved. No part of this publication may be reproduced, stored in a retrieval system or transmitted in any form
by any means, electronic, mechanical, photocopying, recording or otherwise, without prior permission of the publisher. UKE.